Our Aesthetic Categories

OUR AESTHETIC CATEGORIES

Zany, Cute, Interesting

SIANNE NGAI

Harvard University Press
Cambridge, Massachusetts, and London, England

First Harvard University Press paperback edition, 2015
Seventh Printing

Library of Congress Cataloging-in-Publication Data
Ngai, Sianne.
Our aesthetic categories : zany, cute, interesting / Sianne Ngai.
p. cm.
Includes bibliographical references and index.
ISBN 978-0-674-04658-0 (cloth : alk. paper)
ISBN 978-0-674-08812-2 (pbk.)
1. Aesthetics, Modern—20th century. 2. Aesthetics, Modern—21st
century. 3. Postmodernism. 4. Avant-garde (Aesthetics)
5. Categories (Philosophy) I. Title.
BH201.N485 2012
111'.85--dc23 2012009391

To my sisters

Contents

Our Aesthetic Categories

Introduction

THIS BOOK makes a simple argument about the zany, the interest-
ing, and the cute: that these three aesthetic categories, for all their
marginality to aesthetic theory and to genealogies of postmod-
ernism, are the ones in our current repertoire best suited for grasping how
aesthetic experience has been transformed by the hypercommodified,
information-saturated, performance-driven conditions of late capitalism.
This is because the zany, the interesting, and the cute index—and are thus
each in a historically concrete way about—the system's most socially
binding processes: production, in the case of zaniness (an aesthetic about
performing as not just artful play but affective labor); circulation, in the
case of the interesting (an aesthetic about difference in the form of infor-
mation and the pathways of its movement and exchange); and consump-
tion, in the case of the cute (an aesthetic disclosing the surprisingly wide
spectrum of feelings, ranging from tenderness to aggression, that we har-
bor toward ostensibly subordinate and unthreatening commodities). As
sensuous, affective reflections of the ways in which contemporary sub-
jects work, exchange, and consume (and as the cute and the zany in par-
ticular will show, in ways significantly mediated by gender, sexuality, and
class), the commodity aesthetic of cuteness, the discursive aesthetic of the
interesting, and the performative aesthetic of zaniness help us get at some
of the most important social dynamics underlying life in late capitalist
society today. No other aesthetic categories in our current repertoire speak
to these everyday practices of production, circulation, and consumption
in the same direct way.[1]

In this light it stands to reason that the zany, the cute, and the interest-
ing are as ubiquitous in the postmodern literary anthology and museum

of contemporary art as they are on the Internet and television. The vertiginous zaniness of Thomas Pynchon's fiction and Ryan Trecartin's videos, the cuteness of Yayoi Kusama's polka-dotted phallus pillows and Matthea Harvey's poetic homages to domestic objects like the sugar bowl, and the "merely interesting" serial, recursive, variation-based projects of Sol LeWitt and conceptual writer Robert Fitterman are only a few examples. But although their unique reference to production, circulation, and consumption provides the best explanation for their pervasiveness, the zany, the interesting, and the cute are important for the study of contemporary culture not simply because they index economic processes, but also because they give us insight into major problems in aesthetic theory that continue to inform the making, dissemination, and reception of culture in the present. These include the implications of the increasingly intimate relation between the autonomous artwork and the form of the commodity; the complex mixture of negative as well as positive affects resulting in the ambivalent nature of many of our aesthetic experiences; the ambiguous state of the avant-garde, which in a zombielike fashion persists even as its "disappearance or impossibility" is regarded as one of postmodernism's constitutive features; the relevance of aesthetic to critical or other nonaesthetic judgments aimed at producing knowledge (or how one is permitted to link judgments based on subjective feelings of pleasure/displeasure to ones with claims to objective truth); the future of the longstanding idea of art as play as opposed to labor in a world where immaterial labor is increasingly aestheticized; and the "parergonal" relation between art and theoretical discourse itself, all the more pressured with the rise of an institutional culture of museums and curricula that has led art and criticism to internalize each other in historically unprecedented ways.[2] These problems are raised directly and indirectly in theoretical writings by Nietzsche, Adorno, Kant, Hegel, Derrida, and others, but they have also become central to contemporary cultural practice in ways distinctively transformed and amplified by the conditions of postmodernity.[3] Indeed, the zany, the interesting, and the cute seem to offer ways of negotiating these problems affectively, both at the formal, objective level of style (cuteness as a sensuous quality or appearance of objects) and at the discursive, subjective level of judgment ("cute" as a feeling-based evaluation or speech act, a particular way of communicating a complex mixture of feelings about an object to others and demanding that they feel the same).

The zany, the cute, and the interesting are linked to major representational practices that span across different media: comedy, in the case of the zany; romance, in the case of the cute; realism, in the case of the in-

teresting. They are also linked to specific genres and forms. For example, it is easy to see how the commodity aesthetic of cuteness becomes a special issue for twentieth-century poetry, by way of a tendency within the genre that has made it widely, if not always correctly, associated with short, compact texts preoccupied with small, easy-to-handle things, from the plums in William Carlos Williams's icebox and the charms in Frank O'Hara's pockets to the assortment of neatly compartmentalized edibles in Lee Ann Brown's "Cafeteria": "Ice Tea / Cream corn / Fried okra / plus one meat."[4] Cuteness could thus serve as shorthand for what Hannah Arendt calls the "modern enchantment with 'small things' . . . preached by early twentieth-century poetry in almost all European tongues," which she also acerbically refers to as the "art of being happy . . . between dog and cat and flowerpot."[5] For Arendt, the "petite bonheur" of the cute is thus part of a larger cultural phenomenon, the expansion of the charismatically "irrelevant," which she links to the decay of a genuinely public culture: "What the public realm considers irrelevant can have such an extraordinary and infectious charm that a whole people may adopt it as their way of life, without for that reason changing its essentially private character" (52). Yet as Arendt herself concedes, the cute/irrelevant object's charm is powerful enough to be "infectious," to a point at which, in an act of automatic mimesis similar to that induced by film's sensational "body genres" (horror, melodrama, and pornography, which, as Linda Williams notes, compel their audiences to reenact the screams, sobs, and orgasms they see on screen), the admirer of the cute puppy or baby often ends up unconsciously emulating that object's infantile qualities in the language of her aesthetic appraisal.[6] We can thus see why Adorno makes such a point in "Lyric Poetry and Society" of singling out poems that depart from the genre's more representative "delight in things close at hand" in order to resist the bourgeois subject's desire to "reduce [them] to objects of fondling."[7]

Revolving around the desire for an ever more intimate, ever more sensuous relation to objects already regarded as familiar and unthreatening, cuteness is not just an aestheticization but an eroticization of powerlessness, evoking tenderness for "small things" but also, sometimes, a desire to belittle or diminish them further. The aesthetic categories in this study thus do not refer only to a range of objects and objective phenomena (commodities, the act of consumption, and the feminized domestic sphere, in the case of cuteness; information, the circulation and exchange of discourse, and the bourgeois public sphere, in the case of the interesting; performance, affective labor, and the post-Fordist workplace, in the case of contemporary zaniness). By calling forth specific capacities for feeling

and thinking as well as specific limitations on these capacities—a noticeably weaker or cooler version of curiosity, in the case of the interesting; an unusually intense and yet strangely ambivalent kind of empathy, in the case of the cute—they also play to and help complete the formation of a distinctive kind of aesthetic subject, gesturing also to the modes of intersubjectivity that this aesthetic subjectivity implies.[8]

Since cute things evoke a desire in us not just to lovingly molest but also to aggressively protect them, modern poetry might be regarded as cute in another problematic sense. The smallness of most poems in comparison with novels and films, in which the proportion of quotable component to the work as a whole (the paragraph or the shot sequence) is always substantially lower, has made poetry the most aggressively copyright protected of all the genres and thus in a certain sense the genre most aggressively protected from criticism, since anyone wanting to refer directly to the language he or she is analyzing will often have to pay a substantial fee. Susan Stewart's wry caveat in the preface and acknowledgments of *Poetry and the Fate of the Senses* ("Like anyone who writes on poetic forms, I have been restricted . . . by the availability of permissions for reproduction") will thus be familiar to any critic who has tried to write on the genre that copyright laws have indirectly helped define as unusually "tender" speech.[9]

Poetry's complicated and ambivalent relation to an aesthetic that celebrates the diminutive and vulnerable becomes all the more problematic in the case of the avant-garde, which has historically defined itself in opposition to everything for which cuteness stands. Yet as reflected in experimental texts ranging from Gertrude Stein's tribute to lesbian domesticity in *Tender Buttons* to Harryette Mullen's homage to its sections on "Objects" and "Food" in her explorations of the language of women's fashion and groceries in *Trimmings* and *S*PeRM**K*T*, it is clear that the avant-garde has had as much stake in the issues raised by this aesthetic of familiar "small things" as it has had in the powerful experiences of shock, rarity, and/or estrangement that we more readily associate with its projects. The cuteness avant-garde poetry finds itself grappling with thus gives us surprising leverage on the ambiguous status of the contemporary avant-garde in general, and on the closeness between the artwork and the commodity. For it is not just that cuteness is an aesthetic oriented toward commodities. As Walter Benjamin implies, something about the commodity form itself already seems permeated by its sentimentality: "If the soul of the commodity which Marx occasionally mentions in jest existed, it would be the most empathetic ever encountered in the realm of souls, for it would have to see in everyone the buyer in whose hand and house it wants to *nestle*."[10]

If the commodity aesthetic of cuteness is warm and fuzzy, the episte-
mological aesthetic of the interesting is cool, both in the sense of the ironic
detachment Friedrich Schlegel attributed to "das Interessante," an aesthetic
of eclectic difference and novelty embraced by his circle as part of a larger
romantic agenda calling for literature to become reflective or philo-
sophical,[11] and in the technocratic, informatic sense Alan Liu conveys in
his book on postmodern knowledge work.[12] Part of the initial turn in
eighteenth-century literature to the ordinary and the idiosyncratic (that
is, to minor, not-too-deviant differences) that would prepare the ground
for the rise of nineteenth-century realism, the interesting would also be
linked to the new genre of bourgeois *drame* by Denis Diderot and to the
novel by Schlegel and Henry James before enjoying a resurgence with
conceptual art and its aesthetic of information a century later. Always con-
nected to the relatively small surprise of information or variation from
an existing norm, the interesting marks a tension between the unknown
and the already known and is generally bound up with a desire to know
and document reality.[13] It is therefore also, as Susan Sontag suggests, an
aesthetic closely bound up with the history of photography.[14] Troubled
by how the popular use of "interesting" as a notoriously weak evaluation
tends to promote a general "indiscrimination" in the viewing public, Son-
tag trenchantly notes that "the practice of photography is now identi-
fied with the idea that everything in the world could be made interesting
through the camera."[15] If it has become "not altogether wrong to say
that there is no such thing as a bad photograph—only less interesting
[ones]," the reason why photography constitutes "one of the chief means
for producing that quality ascribed to things and situations which erases
these distinctions" is that "the photographic purchase on the world, with
its limitless production of notes on reality," makes everything "homolo-
gous" or comparable to others of its same kind or type.[16] We can thus
glimpse the connection between late twentieth-century conceptual art—
famously obsessed with acts of documentation, classification, and the
presentation of evidence—and a range of realist, print-cultural practices
from the previous century. Indeed, conceptual art's "crucial innovation,"
as Liz Kotz suggests, was its unprecedented pairing of photography with
the language of ordinary/everyday observation: the "notes on reality" ap-
pealing in different ways to successive generations of novelists, from
Theodore Dreiser to Alain Robbe-Grillet to Geraldine Kim.[17]

From Schlegel on "die interessante Poesie" to James on the novel, the
interesting thus has a surprising pedigree in high literary criticism and
theory that the other aesthetic categories in this study lack.[18] Indeed, we
find one of the modern aesthetic's most uncompromising advocates in

Doctor Faustus, Thomas Mann's postwar novel of ideas based on Adorno's theoretical writings on music (including atonal music). As Mann's Schoenberg-like composer puts it, explicitly pitting the aesthetic of the interesting over and against what he disparagingly calls "animal warmth": "Law, every law, has a chilling effect, and music has so much warmth anyhow, stable warmth, cow warmth, I'd like to say, that she can stand all sorts of regulated cooling off."[19] Adrian Leverkühn's theory of a modern art coolly "regulated" by rational principles (much like the dialogue-driven "novel of ideas" itself) not only looks forward to the antigestural, systems-based art of the 1960s but also directly echoes the praise of the interpenetration of art and theory, and the advocacy of detachment over enthusiasm as the proper artistic and critical attitude, promoted by Schlegel and other theorists of "das Interessante" in eighteenth-century Germany. Indeed, Leverkühn's way of justifying his preference for his coolly regulated aesthetic, "Art would like to stop being pretence and play, it would like to become knowledge," calls for the same rapprochement between art and science pursued by Schlegel in conjunction with his advocacy of "interesting" modern poetry: "The more poetry becomes science, the more it also becomes art. If poetry is to become art, if the artist is to have a thorough understanding and knowledge of his ends and means . . . then the poet will have to philosophize about his art."[20]

Always registering a tension between the particular and generic (and thus raising the question of the role of generic concepts in aesthetic experience overall), the interesting's epistemological claims—its desire to know reality by comparing one thing with another, or by lining up what one realizes one doesn't know against what one knows already—have made it especially prominent in genres invested in the overall look or feel of scientific rationality: from the realist novel in the nineteenth-century, with its social taxonomies informed by the proliferation of new scientific and academic discourses, to postwar conceptual art, formally as well as thematically preoccupied with technology and systems. An extension of what Irving Sandler pejoratively called the "Cool Art" of the 1960s, the decade's first wave of system-based painting "characterized by calculation, impersonality, and boredom,"[21] conceptual art would in fact be eventually praised by critics for being "merely interesting" and even for being boring, as in an early essay by Barbara Rose linking conceptualism's serial, "ABC" aesthetic to that of Robbe-Grillet and his "theory of the French objective novel."[22]

More specifically, as an effort to reconcile the idiosyncratic with the systemic, the interesting has been associated with genres with an unusual investment in theory. If, as Amanda Anderson suggests, the "novelistic

tradition, especially in its more intellectualist formations" is fundamentally "interested in the relation between ideas and life, or how one might *live* theory," we can see why James famously singled out interesting as the proper aesthetic standard for this discursively hybrid genre: one keen on "imagining the rigorous critique of custom and convention as a way of life; mediating between the moral life of individuals and a long sociological or historical view of communities and societies; and engaging the relation between existence and doctrine." [23] The novel's investment in the tension between life and theory is perhaps best epitomized by its major innovation, free indirect discourse, and its oscillation between first- and third-person perspectives respectively aligned with the "aspirations of a socially minded moral participant" and a "bleak[er] systems view." [24] It is precisely this tension between individual and system that undergirds the interesting and explains why it also plays such a central role in conceptual art, a body of work similarly preoccupied with the modern relationship between individuation and standardization, and committed to exploring the tension between "existence and doctrine" by staging various clashes between perceptual and conceptual systems. As Mikhail Epstein argues, the judgment of "interesting" is thus an effort to "bridge the gap between reason and surprise, at once rationalizing the improbable and extending the limits of rationality." [25]

In contrast to the rational coolness of the interesting, the aesthetic of nonstop acting or doing that is zaniness is hot: hot under the collar, hot and bothered, hot to trot. Highlighting the affect, libido, and physicality of an unusually beset agent, these idioms underscore zaniness's uniqueness as the only aesthetic category in our repertoire about a strenuous relation to playing that seems to be on a deeper level about work. When brought out by the post-Fordist, service-economy zaniness of performers like Lucille Ball in *I Love Lucy* and Richard Pryor in *The Toy*, the zany more specifically evokes the performance of affective labor—the production of affects and social relationships—as it comes to increasingly trouble the distinction between work and play. The formal dynamics of this seemingly lighthearted but strikingly vehement aesthetic, in which the potential for injury always seems right around the corner, are thus most sharply visible in the arts of live and recorded performance—dance, Happenings, walkabouts, reenactments, game shows, video games—and in the arts of rhythm and movement in particular. Yet as I argue in Chapter 3, "The Zany Science," contemporary zaniness is an aesthetic more explicitly about the politically ambiguous convergence of cultural and occupational performing under what Luc Boltanski and Eve Chiapello call the new "connexionist" spirit of capitalism: the dominant ideology of a capitalism

that has absorbed and adjusted to the "artistic critique" of the 1960s—
but also, as Nancy Fraser stresses, the second-wave feminist critique of
the gendered division of labor—by now encouraging workers, through a
rhetoric of "networking," to bring their abilities to communicate, social-
ize, and even play to work.[26] Yet for all its essentially performative nature,
zaniness is by no means exclusive to the performing arts. From Ishmael
Reed to Kathy Acker to Shelley Jackson, or John Ashbery to Bruce An-
drews to Flarf, so much of "serious" postwar American literature is zany
that one reviewer's description of Donald Barthelme's *Snow White* as
a "staccato burst of verbal star shells, pinwheel phrases, [and] cherry
bombs of . . . puns and wordplays" seems applicable to the bulk of the
post-1945 canon.[27]

What type of aesthetic subject, with what capacities for feeling, know-
ing, and acting, does this ludic yet noticeably stressful style address? The
relation between the objects zaniness refers to and the kind of subject it
implies or speaks to seems more complicated than in the case of other
aesthetic experiences. To find an object interesting is obviously for the
subject to feel interest—and often, under her compulsion to share or pub-
licize that feeling, the first step in activating interest in other subjects as
well. Similarly, cuteness prompts an inadvertent mushing or "cutification"
of the language of the judging subject, turning her speech into murmurs
and coos that recall the "*oo-* intensive names" of the cute snack cakes in
David Foster Wallace's story "Mister Squishy."[28] This verbal mimesis of
the object on the part of the subject reflects how cuteness always "entails
a structure of identification, wanting to be *like* the cute—or more exactly,
wanting the cute to be just like the *self*."[29] But zaniness does not seem to
call forth a subjective response in any way mimetic of itself. This lack of
accord between aesthetic subject and object seems all the more surprising
given zaniness's unique history as a style explicitly *about* mimetic be-
havior. Once deployed in the English language as a verb (a rare thing for
most aesthetic categories), "zany" designated an activity or practice of
imitating the actions of others long before it became the name of an ob-
jective attribute or quality. One might therefore expect our encounters
with this aesthetic of action to be all the more infectious. Yet there is some-
thing strained, desperate, and precarious about the zany that immediately
activates the spectator's desire for distance. In fact, what is most striking
about zaniness is how the image of dangerously strenuous activity it proj-
ects often seems designed to block sympathy or identification as a subjec-
tive response. Think here of the "zany Paraclete" in the Jacobean revenge
play described as a "Road Runner cartoon in blank verse" in the middle
of *The Crying of Lot 49*: a character whose escalatingly violent and yet

strangely and spectacularly redundant actions include his shoving a court-
ier's head into a box, stabbing him, poisoning him, tearing his tongue out
with pincers, brandishing it on a rapier, and setting the impaled tongue on
fire.[30] Much as we might admire the affective and physical virtuosity of
their performances, zanies are not persons we imagine befriending. This
discrepancy is the direct source of both the comedy and the pathos of
The Cable Guy (Columbia Pictures, 1996), a film about a postindustrial
zany whose efforts to become the real friend of the client he helps plug
into networks become increasingly aggressive. If the cute object or per-
son is one we by definition want as near to us as possible (to the point of
phantasmatically crushing, smothering, or even eating it/her, like a "Mister
Squishy" snack cake), the zany object or person is one we can only enjoy—
if we do in fact enjoy it or her—at a safe or comfortable distance.

In addition to precarious situations, zaniness always seems to revolve
around our experience of a zany character, which also makes it relatively
unusual. Although all aesthetic categories invoke human agents endowed
with specific affective and/or cognitive dispositions, these references to
types of aesthetic subjectivity (and usually to ourselves in the first person)
are very different from the act of calling up an objectified, third-person
representation of a real or imaginary agent. It is telling here that in addi-
tion to once functioning as a verb, "zany" is the only aesthetic category in
our repertoire that continues to be used as a noun, referring to the person
charged with the affective task of activating our sense of humor by being,
as it were, "a character." We can thus speak of "the zany" or of "a zany" in
a way in which it is not possible to speak of "a cute" or "a beautiful."[31]
Zaniness more specifically calls up the character of a worker whose par-
ticularity lies paradoxically in the increasingly dedifferentiated nature
of his or her labor. True to the aesthetic's dramatic history in commedia
dell'arte, Pynchon's zany is a servant or "administrative assistant," un-
usually flexible or capable of fluidly switching from task to task; Jim
Carrey's cable guy is an all-around service provider (and, as his client is
shocked to discover, a provider of a variety of affective and social net-
working services other than cable); Ball's Lucy is a housewife and would-
be actor who, from one episode to the other, ends up taking on hundreds
of different jobs.[32] The specific jobs that these postwar zanies hold thus
demand that they be able to take on virtually any job at any moment, in
an incessant flow or stream of activity. This increasingly despecified rela-
tion to working is particularly characteristic of the growing informal-
ity of late twentieth-century postindustrial work (the cultural correlate
of the economic casualization of labor), but it also defines the ideal
worker of nineteenth-century industrial capitalism described by Marx: the

perpetual temp, extra, or odd-jobber—itinerant and malleable—for whom all labor is abstract and homogeneous.

The reference to the worker/character haunts our experiences of zaniness even, I argue, when no overt representations of laboring human beings are involved (as in the case of, say, a zany pinball machine or child's toy). What is most essential to zaniness is its way of evoking a situation with the potential to cause harm or injury—a feeling that could not exist without some reference, however implicit, to a being whom that harm or injury might befall. Post-Fordist zaniness in particular suggests that simply being a "productive" worker under prevailing conditions—the concomitant casualization and intensification of labor, the creeping extension of the working day, the steady decline in real wages—is to put oneself into an exhausting and precarious situation. This can be all the more so in postmodern workplaces where productivity, efficiency, and contentment are increasingly measured less in terms of the "objective exigencies and characteristics of the labor process (levels of light, hours of work, and so forth)" than as a factor of "subjective attitudes" about work on the part of workers.[33] As Nikolas Rose argues, these "subjectivized" images of work are "more than the froth of ideology"; they have fundamentally restructured the social organization of the late twentieth-century workplace (including factories as well as offices) and thus the qualitative or phenomenological nature of work itself. In tandem with this post-Fordist reorientation of the workplace toward the production of "productive subjectivity" (which, as Rose notes, makes strategic use of "all the techniques of the self . . . invented within the therapeutic culture of the 1960s"), late twentieth-century workers in the United States and elsewhere have found themselves working more intensively and for longer hours for equal or shrinking wages—a trend across (though with differing impacts within) a number of occupational and class divisions.[34]

While certain kinds of work have always been affective—women's paid and unpaid caring work in the household, and jobs in the services sector implicitly or explicitly based on that work, such as health care, retail, and teaching—post-Fordist zaniness points to the increasing emotionalization of work in general, a phenomenon now well documented by an increasingly diverse group of sociologists, economists, and activists.[35] For all their playfulness and commitment to fun, the zany's characters give the impression of needing to labor excessively hard to produce our laughter, straining themselves to the point of endangering not just themselves but also those around them. Yet as I have been noting, zaniness forecloses identification with the workers in precarious situations it evokes. This foreclosure can be potentially felt as disquieting and adds an

additional layer to the aesthetic's already complex negativity. Indeed, given the fact that late capitalist subjects increasingly asked to put their affects, subjectivity, and sociability to work across preexisting divisions of labor (including that of gender) are increasingly likely to share the relationship to work that this aesthetic category indexes, one wonders if the zany's distinctive mix of displeasure and pleasure stems not only from its projection of a character exerting herself to extreme lengths to perform a job, but also from the way in which it immediately confronts us with our aversion to that character. Although the argument that zaniness is at the deepest level about work helps account for this savagely playful aesthetic's remarkably longstanding appeal to audiences from the sixteenth century to the present, the aesthetic hardly solicits a sense of workerist solidarity. Indeed, by turning the worker's beset, precarious condition into a spectacle for our entertainment, zaniness flatters the spectator's sense of comparative security, thus hailing her as a kind of phantasmagoric manager or implicit owner of the means of production. Yet the experience of zaniness ultimately remains unsettling, since it dramatizes, through the sheer out-of-controlness of the worker/character's performance, the easiness with which these positions of safety and precariousness can be reversed.

The zany, the cute, and the interesting thus call forth not only specific subjective capacities for feeling and acting but also specific ways of relating to other subjects and the larger social arrangements these ways of relating presuppose. In doing so, they are compelling reminders of the general fact of social difference and conflict underlying the entire system of aesthetic judgment or taste, making that underlying condition transparent in ways in which many other aesthetic categories do not. If this is perhaps most evident in zaniness, the asymmetry of power on which cuteness depends is another compelling reminder. There is no judgment or experience of a object as cute that does not call up one's sense of power over it as something less powerful. But the fact that the cute object seems capable of making demands on us regardless, as Lori Merish underscores—a demand for care that women in particular often feel addressed or interpellated by—suggests that "cute" designates not just the site of a static power differential but also the site of a surprisingly complex power struggle.[36] Finally, the very idea of "interest" points to aesthetic judgment's unique role in facilitating "precise comparisons and contrasts between individuals or groups" and thus in mediating (not to say resolving) clashes and disputes between them.[37] As captured best by the image of the political interest group, as Jan Mieszkowsi notes, "interests never exist as unique, autonomous impulses, but only in and as their collisions with

other interests."[38] The fact that "before it can be considered as a preference or aim, an interest must be understood as a contradiction with other interests" means that "any interest—of a person, a tribe or a state—is [already] a counter-interest."[39]

It is perhaps because the zany, the cute, and the interesting refer to social conflict in these direct and yet highly abstract ways that their meanings are so ideologically equivocal. On first glance, zaniness seems purely a symptom of the "perform-or-else" ideology of late capitalism, including its increasingly affective, biopolitical ways of meeting the imperative to endlessly increase productivity.[40] Yet for all its spectacular displays of laborious exertion, the activity of zaniness is more often than not destructive; one might even describe it as the dramatization of an anarchic refusal to be productive.[41] The increasing zaniness of recent queer performance, moreover—Ryan Trecartin, Kiki and Herb, Felix Bernstein—is all the more interesting given that zaniness marks a specific deviation from camp that can also mark the site of camp's failure, dramatizing the conditions under which it runs up against its own limits.[42] To be sure, zaniness and camp are not incompatible. The two styles of performing have much in common, which is why they are occasionally used to augment or amplify the other. Like zaniness, camp involves a "glorification of character" and makes failure a central part of its aesthetic.[43] As Sontag notes, "things are campy not when they become old—but when we become less involved in them, and can enjoy, instead of be frustrated by, the failure of the attempt."[44] Camp thus involves a "revaluation of failure, of a cultural ambition that in its time simply missed its mark, tragically or poignantly or extravagantly."[45] But while camp thus converts the pain of failure and loss into victory and enjoyment, zaniness highlights its own inability to do this; indeed, the desperation and frenzy of its beseiged performers, due to the precarious situations into which they are constantly thrust, point to a laborious involvement from which ironic detachment is not an option.[46] It is in this sense that the zany marks a set of conditions under which even camp's way of revaluing failure fails.

The ideology of the performative aesthetic of zaniness is thus by no means straightforward. And cuteness, for its part, is by no means an unequivocal celebration of the commodity form, even if it does undeniably "graft commodity desire onto a middle-class structure of familial, expressly maternal emotion."[47] Since consumption is the activity in which one realizes a commodity's use-value, for Marx it technically belongs outside economics proper, "except in so far as it reacts in turn upon the point of departure and initiates the whole process anew."[48] Cuteness, an adoration of the commodity in which I want to be as intimate with or physically

close to it as possible, thus has a certain utopian edge, speaking to a desire to inhabit a concrete, qualitative world of use as opposed to one of abstract exchange. There is thus a sense in which the fetishism of cuteness is as much a way of resisting the logic of commodification—predicated on the idea of the "absolute commensurability of everything"—as it is a symptomatic reflection of it.[49] Finally, although nothing seems more apolitical on first squint than the interesting, we will soon see how its conceptual indeterminacy makes it the one category in our repertoire best suited for linking aesthetic judgments to nonaesthetic judgments, including judgments of a political nature.

The aesthetic categories in this study thus refer to basic human and social competences increasingly encroached on by capitalism over the past half century: affect and emotion, in the case of zaniness; language and communication, in the case of the interesting; intimacy and care, in the case of the cute.[50] Perhaps as a result of the increasing subsumption of these generic competences by capital, the economic processes these aesthetic categories index have also become increasingly intertwined. Indeed, each category indexes a specific conflation of one process with another. Post-Fordist zaniness, for example, points to how taste-driven consumer practices, including playful aesthetic ones, have become systematically integrated into the production process; a development famously allegorized by one of *I Love Lucy*'s zaniest moments, the chocolate-factory episode, in which Lucy is forced to literally exercise her "taste" of the product in order to see it off the assembly line. For its part, the "merely interesting" conceptual art of the 1960s, and in particular its serial, publicity-based forms based on the transmission of messages through systems (the postal system, telegrams, telephones, and so on), provides a prime example of how the production of artworks could come to coincide with what Paul Mann calls the "continuous circulation of discourse-objects." For here "the art object as such need not . . . even exist; only its representation needs to circulate. A description will suffice: that is the lesson of conceptual art."[51]

It is because the zany, the interesting, and the cute index the uncertain status of performing between labor and play, the increasing routing of art and aesthetic experience through the exchange of information, and the paradoxical complexity of our desire for a simpler relation to our commodities that they are "about" production, circulation, and consumption. With the intensified integration of these economic processes—which are also, crucially, modes of social organization[52]—it stands to reason that twentieth-century objects of varying scales abound in which we can see all three aesthetic categories in play at once, from Samuel Beckett's late

modernist corpus, with its recursive poetics of combination and permutation (interesting), themes of laborious or compulsive doing (zany), and sad/pathetic characters obsessed with cookies, dogs, and socks (cute), to Web 2.0 culture in its entirety, with its zany blogs, cute tweets, and interesting wikis. Consider also this passage from *One-Dimensional Man*, in which Herbert Marcuse is noticing how the violent fun and games of the zany, the softening or domesticating properties of the cute, and the informational, technocratic style of the interesting can be strategically deployed in combination to project the subjectivity of one of the world's most famous corporations:

> The Happy Consciousness has no limits—it arranges games with death and disfiguration in which fun, team work, and strategic importance mix in rewarding social harmony. The RAND Corporation, which unites scholarship, research, the military, the climate, and the good life, reports such games in a style of absolving cuteness, in its "RANDom News," volume 9, number 1, under the heading BETTER SAFE THAN SORRY. The rockets are rattling, the H-bomb is waiting, and the space-flights are flying, and the problem is "how to guard the nation and the free world." . . . Here "devices like RAND's SAFE come in the picture." The picture into which they come . . . is a picture in which "the world becomes a map, missiles merely symbols [long live the soothing power of symbolism!], and wars just [just] plans and calculations written down on paper. . . ." In this picture, RAND has transfigured the world into an interesting technological game, and one can relax—the "military planners can gain valuable 'synthetic' experience without risk."[53]

Global warfare reported in a "style of absolving cuteness," further defused as merely "interesting" by the rational language of plans and calculations, and ultimately repackaged as just a zany/fun "game"; as both RAND and Marcuse recognize, the minor aesthetic categories in this study clearly have a certain power of their own, deployed here in a explicit effort to do nothing less than reorganize the relation of subjects to a postmodern geopolitical reality.

History

However suited for the investigation of contemporary aesthetic problems, the aesthetic categories in this study are not exclusive to the late twentieth or twenty-first centuries. Nor are their genealogies exactly contemporaneous. Deriving from commedia dell'arte's stock character of the *zanni*, an itinerant servant modeled after peasants seeking temporary work in wealthy Venetian households, zaniness has a history that stretches back to

the sixteenth-century division of labor and the theater/marketplace culture of what is now Italy.[54] Two hundred years or so later, in tandem with the rise of a bourgeois public sphere made possible by the expanded circulation of printed matter, Schlegel, Novalis, and others in their circle of German romantic ironists felt compelled to identify a distinctively modern style of eclectic and irregular literature, "das Interessante," to be explicitly contrasted with the beautiful literature of the Greeks *(die schöne Poesie)*. Coinciding thus with the expansion of the literary marketplace and the pluralization and professionalization of literary activity in the eighteenth century, the interesting is the only aesthetic category in our repertoire invented expressly by and for literary critics. The cute is the youngest category in this study, first emerging as a common term of evaluation and formally recognizable style in the industrial nineteenth-century United States, in tandem with its ideological consolidation of the middle-class home as a feminized space supposedly organized primarily around commodities and consumption. The invention of the cute thus tellingly coincides with what feminist historians describe as a crucial midcentury shift in the public conception of the domestic realm—from the site of republican virtue and a moral refuge from modern commercialism to the ultimate bastion of that commercialism—that would in turn enable domestic ideology to play a central role in the making of nothing less than American mass/consumer culture itself.[55]

The individual trajectories of the zany, the interesting, and the cute thus seem entirely distinct. Yet all three categories are modern products of the history of Western capitalism, emerging in tandem with the development of markets and economic competition, the rise of civil society, and an increasingly specialized division of labor. As such, they cut across modernism and postmodernism, considered here, after David Harvey's suggestion, less as distinct episodes in the history of culture than as diverging responses to a single process of modernization involving "new conditions of production (the machine, the factory, urbanization), circulation (the new systems of transport and communications) and consumption (the rise of mass markets and advertising)."[56] From the *zanni*-ness of commedia dell'arte to the zany sitcom of Lucille Ball, or from Henry James's championing of "interesting" as the aesthetic of the nineteenth-century novel to the attempt to marry art and information in the notoriously discursive, "merely interesting" conceptual art of the 1960s and 1970s, the aesthetic categories in this study have had a presence in Western culture— and significantly across both mass culture and high art—spanning several centuries.[57] But only in the late twentieth century, I argue, did categories

like these become thinkable alongside one another as part of a single rep-
ertoire, useful for taking stock of transformations in the meaning and
function of aesthetic experience in general.

 In addition to being emergent, gestaltlike qualities that we can attri-
bute to objects of various scales (an individual work like Alfred Jarry's
Ubu Roi may be zany, but so is the genre of Dada cabaret), vernacular
aesthetic categories are widely distributed across time and space, locat-
able in superstructural crannies too copious and diverse to enumerate.
Although the cute, the zany, and the interesting are no less historical than
any of the other concepts or categories used by critics to classify and in-
terpret cultural products ("baroque," "postmodern," "novel," and so on),
from the standpoint of the historicism that has dominated literary and
cultural studies over the past three decades, they will inevitably prove
slipperier simply because they operate across much longer spans of time
and across much wider swaths of culture. This book focuses on the pecu-
liar dominance of these three aesthetic categories in the late twentieth
century and the present. Yet the rise of the interesting as an aesthetic of
information and as the "styleless" style of the distributed-media, often
photography- and language-based work of conceptual artists in the 1960s
and 1970s can be properly understood only if it is traced back to its sig-
nificance for nineteenth-century and early twentieth-century theorists of
the novel, an art form similarly perceived as "discourse that is not worked
into any special or unique style" and thus as a fundamentally miscella-
neous genre—an assortment of "memories and archives, our travels and
fantasies . . . the interesting characters we have met and above all, the
interesting character who is inevitably oneself (who isn't interesting?)"—
embodying the pluralism of the literary marketplace.[58] The centrality of
the interesting to the genre viewed as the "end of genre,"[59] and perhaps
above all to the substantial theoretical/critical discourse that came to sur-
round it, is thus crucial for understanding its later importance for generi-
cally hybrid postmodern art and for the marriage of art and theory in the
mixed-media forms of conceptual art in particular. Similarly, the histori-
cal uniqueness of late capitalist zaniness becomes fully legible only if we
take account of how this performative aesthetic's conflation of role play
and affective labor, already prefigured in the zanni's way of bridging the
worlds of cultural performance and service work, gets mulled over by
Nietzsche as a problem for the philosophy of art in *The Gay Science*, a
late nineteenth-century work of aesthetic theory written in an aggressive,
fast-paced, overheated style as arguably zany in its own way as an episode
of *I Love Lucy*.

Thinking in the way the analysis of an aesthetic category demands—broadly, across traditional period divisions and heterogeneous domains of culture—of course presents challenges that do not arise in the analysis of authors, genres, and the more chronologically restricted styles associated with artistic movements and periods. Particularly given their relative resistance to institutionalization, vernacular aesthetic categories are more difficult to locate in fixed slices of time and space (and for this reason their analysis is more vulnerable to accusations of unscholarly impressionism). Although it is common to find museum exhibits and university syllabi devoted to styles like cubism, genres like the novel, and modes like comedy, vernacular aesthetic categories like the interesting, the cute, and the zany have not seemed capable of drawing institutional structures or discourses around them in quite the same way. Although the interesting, the cute, and the zany are associated with specific practices, they do not give rise to practices stable or consistent enough to be institutionally captured and thus remain more difficult than other styles to delimit in time and in space. This by no means suggests that we abandon their historicization, but rather that we historicize differently. To restrict the analysis of the interesting or the zany to a single artifact, or even to a cluster of artifacts produced in a thin slice of time, would be to immediately cut off a proper analysis of their meaning *as* aesthetic categories, which is to say objects widely distributed across what most literary and cultural scholars would consider culturally heterogeneous areas of time and space.

Indeed, the study of vernacular aesthetic styles not only permits but in a certain sense requires relating artifacts that prevailing, period-based methods of doing cultural history discourage us from considering together: Stein's *Tender Buttons,* Adorno's *Aesthetic Theory,* and the pop art of Takashi Murakami, in the case of cuteness; commedia dell'arte, *I Love Lucy,* and Nietzsche's *Gay Science,* in the case of zaniness. My point in linking these disparate artifacts is not to create funky anachronistic assemblages, but rather to track more carefully the cultural and theoretical problems that the cute, the zany, and the interesting index as they mutate and take on different inflections over time: the loss of the antithesis between the work of art and the commodity form (which evolves into a challenge for the avant-garde in particular); the blurring of cultural and occupational performance (and its implications for the contemporary performance artist); and the increasing mediation of art through the circulation of discourse (and its transformation of the relation between the artist and the critic).[60] Thus, while sacrificing the satisfactions of a chronological precision more readily available to and really better suited for

the analysis of artists, genres, and movements, what one arguably gains in the more panoramic reading of vernacular aesthetic categories is a stronger grasp of the historicity of some of the basic concepts and categories of aesthetic theory itself.[61]

Triviality

Yet the zany, the interesting, and the cute are undeniably trivial. In contrast to the moral and theological resonances of the beautiful and the sublime and the powerfully uplifting and shattering emotions of the sublime and the disgusting, each of these aesthetic experiences revolves around a kind of inconsequentiality: the low, often hard-to-register flicker of affect accompanying our recognition of minor differences from a norm, in the case of the interesting; physical diminutiveness and vulnerability, in the case of the cute; and the flailing helplessness of excessively strenuous but unproductive exertion (and unfocused rage), in the case of the zany. These images of indifference, insignificance, and ineffectuality all point to a deficit of power, which is significantly not the same as the suspension of power that plays a central role in Enlightenment and post-Enlightenment theories of aesthetic freedom. In striking contrast to the autonomy from forms of domination and mastery promised by Schiller's "aesthetic state," in which the relations of power that inform the experience of the acting and desiring subject are momentarily suspended, the cute and the zany confront us with images of the domination and even the humiliation of others in a world fundamentally rent by the division of labor (and as we will see, by gendered and racialized divisions of labor in particular).[62] Indeed, the cute in its insignificance and zaniness in its ineffectuality evoke intrasubjective discord as well as intersubjective or social conflict. One finds a similar discord in the Kantian sublime, which continues to hold a prominent place in theories of postmodern aesthetics and art. Yet the feelings or images of powerlessness that the cute and the zany call up do not "throw the mind into disarray" by signaling its incapacity to cognize an object; nor do they result in shock or astonishment in the face of the other.[63] While for Lyotard the sublime points to a radically self-sufficient "Thing" or "unmasterable presence" indexed by the unavailability of the avant-garde artwork, cute and zany objects present themselves as entirely available, as their commercial and erotic connotations make explicit: "Snuggle/play with me!"[64] Most significantly, although the subject's feeling of domination in the feeling of the sublime is itself powerfully felt, this is clearly not the case with the cute and the zany, where the image of powerlessness called up for us mirrors a certain lack of power in the

aesthetic experience itself. Indeed, the zany, the cute, and the interesting call attention to their own weakness, or relative lack of aesthetic impact, in a way that is significantly not the case for other vernacular aesthetic categories. The glamorous and the handsome, for instance, do something like the exact opposite.

In accordance with their triviality as styles, the aesthetic categories in this study are also strikingly equivocal as judgments. As a direct result of the contradictory mixture of feelings at the foundation of each—unfun and fun, in the case of the zany; interest and boredom, in the case of the interesting, tenderness and aggression, in the case of the cute—to call something zany, cute, or interesting is often to leave it ambiguous as to whether one regards it positively or negatively. To be sure, other aesthetic categories also derive their specificity from mixed or conflicting feelings; the Kantian sublime once again, for example, "is an emotion, a *Rührung*, that alternates between an affective 'no' and 'yes.' "[65] Yet these contradictory feelings are not held in an indefinite tension as the affects of desperate laboring and lighthearted play are by the zany, or as aggression and tenderness are by the cute. What makes the sublime "sublime" is precisely the fact of its emphatic affective resolution, the way in which the initial feeling of discord ends up being unmistakably overwritten by what Kant calls "respect" (or what Burke calls "delight.")[66] This final feeling is singular and unequivocal. And unlike the noticeably weak or low affective charge of the feeling of interest underlying our judgments of the interesting, the intensity of the feeling is strong.

Yet it is arguably the stylistic triviality and verdictive equivocality of the zany, the cute, and the interesting that makes these categories particularly suited for the analysis of art and aesthetics in today's totally aestheticized present, in which it can no longer be taken for granted, as Jan Mukařovský could once state as a matter of course, that "lofty art is the source and innovator of aesthetic norms."[67] Rather, as Hal Foster notes, we inhabit a world in which the "aesthetic and utilitarian are not only conflated but all but subsumed in the commercial, and everything—not only architectural projects and art exhibitions but everything from jeans to genes—seems to be regarded as so much *design*."[68] Foster regards this "neo–Art Nouveau world of total design" with far more skepticism than Jacques Rancière, who for his part takes the concept of "design," qua a commitment to "types" shared by modernists like Mallarmé and Peter Behrens in their otherwise discrepant practices (symbolist poetry and industrial engineering), as an indication of art's ability to call forth the forms of a new kind of collective life. In this manner, Rancière argues, "design" refutes and undermines what he regards as the false opposition of the

autonomy of art and the heteronomy of commercial culture.[69] Yet today this "aestheticization of common life" manages to coexist with and even at times to covertly support what it would seem to stamp out, which is the elevation of "autonomous" art onto a socially and economically exceptional plane of existence: the world of major auction houses, corporate collectors, and megaexhibitions and biennales in global cities formed by massive alliances among businesses, national governments, universities, and regional bodies.[70] In this manner, art as luxury in the age of the "global art system" seems more removed from "everyday" existence than ever—an apartness novelist Geoff Dyer makes central to the surreal mood of *Jeff in Venice, Death in Varanasi.*[71] If there is something false about the dichotomy between "autonomy of art" and "aestheticization of life," I would suggest that it is not because the two have somehow been reconciled through "design" or an "art of living" (Schiller), but because under conditions of late capitalism both have become possible at once.[72]

In this hyperaestheticized world, neither art nor beautiful/sublime nature remains the obvious go-to model for reflecting on aesthetic experience as a whole, or for reflecting on art in its newly displaced relation *to* aesthetic experience as a whole. Paradoxically, in tandem with the new commercial powers consolidating around the global production and consumption of art, the hyperaestheticized postwar society of the United States was one in which "art was to survive by virtue of being weak"[73]: "weak" in the sense of art's increasing dependence on "selective appropriation" from both fringe and mass culture for its very existence; "survive" in the sense that the postwar "art economy was in fact stimulated rather than impeded" by the artists who sought to challenge "modernist complicities with the marketplace" through this route, directly contesting Clement Greenberg's idea that "an art resolutely founded on the problems generated by its own particular medium would escape exploitation either by commerce or by the terrifying mass politics of the day."[74] As Thomas Crow notes, "The new art of simulation took that argument and turned it on its head"; rather than pursue how the arts could "be strengthened in the areas that remained exclusively theirs" (77), postwar artists increased art's dependence on the artistically heterogeneous, beginning with the act of choosing an existing aesthetic that could then be "refine[d] and package[d]" for a smaller group of elite consumers.[75] Crow is thinking not just of pop art, famously quick to embrace the commercialized styles of cuteness and zaniness (in which "weakness" and "survival" are central tropes), but also of "merely interesting" conceptual art, a practice that "while disdaining the trade in art objects . . . had the paradoxical effect of embedding the practice of art more fully into its existing system of

distribution" (81). Indeed, the "weakness" that postwar U.S. art was to embrace in order to survive was the "gift both of 60s reductivism and of the assaults of the conceptual artists on the hallowed status of the object itself" (77). Since the "site of practice shifted from the hidden studio to the gallery," conceptual art "involved intense curatorial activity [that made] artists became more like commercial curators, middlemen for themselves" (82). It consequently evolved into a discursive, media- and/or print-based practice that increasingly sought to legitimate itself with the lingo of the public sphere. As Crow notes, "Charles Harrison, editor of the journal *Art-Language,* laid down the requirement for any conceptual art aspiring to critical interest that it conceive a changed sense of the public alongside its transformations of practice." But "on precisely those grounds" both Harrison and Crow find the "group's own achievement to be limited: 'Realistically, Art and Language could identify no actual alternative public which was not composed of the participants in its own projects and deliberations."[76]

The rise of the weak or trivial aesthetic categories in this study thus takes place in conjunction with an overarching habitualization of aesthetic novelty, an increasing overlap between the domains of art and theory, and a loss of the longstanding tension between the work of art and the commodity form. The "frantic economic urgency of producing fresh waves of ever more novel-seeming goods (from clothing to airplanes), at ever greater rates of turnover," as Fredric Jameson puts it, "assigns an increasingly structural function and position to aesthetic innovation and experimentation."[77] In addition to posing unprecedented challenges for the avant-garde and its theorists in particular (a problem that the cute will enable us to investigate in greater detail), this increasing interpenetration of economy and culture wreaks two particularly significant changes on the concept of art in general. First, a weakening of art's capacity to serve as an image of nonalienated labor, as it had done ever since the inception of aesthetic discourse in the eighteenth century; second, a destabilization of art's more specifically modernist, twentieth-century mission of producing perceptual shocks.[78] In tandem with these seismic changes to longstanding ideas of art's vocation, weaker aesthetic categories crop up everywhere, testifying in their very proliferation to how, in a world of "total design and Internet plenitude," aesthetic experience, while less rarefied, also becomes less intense.[79] The most fundamental changes in the understanding of art, however—the idea of art as unalienated labor and of art as shock or radical surprise—are ones that the aesthetic categories of the zany and the interesting speak to directly, as styles explicitly about the blurring of the distinction between aesthetic and work-related production

and about the dialing down of one's affective response to novelty. They are also changes that cuteness as an aesthetic of powerlessness speaks to in an even more overarching way, insofar as all art in the late capitalist society of high-powered media spectacles is, in a certain manner of speaking, "cute." Thus in what might otherwise be a truly inchoate sea of postmodern styles and judgments, the zany, the interesting, and the cute function something like quilting points, enabling us to conceptualize something like a bounded field or historically delimited repertoire of aesthetic categories in the first place. Moreover, it is telling that as aesthetic categories explicitly about our increasingly complex relations to commodities, performance, and information—utterly ordinary yet in many ways highly peculiar "objects"—the cute, the zany, and the interesting dominate not just mass culture but the most autonomous sectors of artistic production and are thus able to speak to changes in the concept of art and even the avant-garde in ways in which other "everyday" aesthetic categories cannot. Most significantly, as aesthetic categories that strangely dramatize their own frivolity or ineffectuality, the cute, the zany, and the interesting are fundamentally non-theological, unable to foster religious awe and uncoupling the experience of art from the discourse of spiritual transcendence. By contrast, the feeling of the sublime never loses this theological dimension, never seems to fully shake off its way of abetting older forms of religiosity or what Adorno calls the "self-exaltation of art as the absolute."[80] This is the case even when the sublime is invoked to explore resolutely secular problems, as in the case of Joseph Tabbi's postmodern sublime, Bruce Robbins's sweatshop sublime, Amy Elias's historical sublime, and Jameson's geopolitical or paranoid sublime—aesthetic experiences linked to overpowering confrontations with technology, fleeting epiphanies about the inaccessibility of history, and knowledge of a global capitalism that fundamentally exceeds our currrent perceptual and cognitive abilities to capture it. In each case the sublime refers to what is finally or properly unrepresentable.

Classical aesthetic categories like the sublime and beautiful thus make insistent if necessarily indirect claims for their extra-aesthetic power (moral, religious, epistemological, political), asserting not just a specifically aesthetic agency but agency in realms extending far beyond art or culture. In contrast, by forefronting their own aesthetic weaknesses and limitations, the cute, the zany, and the interesting enable a surprisingly more direct reflection on the relation between art and society, and more specifically on how "that very distance of art from its social context which allows it to function as a critique and indictment of the latter also dooms its interventions to ineffectuality and relegates art and culture to a frivo-

lous, trivialized space in which such intersections are neutralized in advance."[81] If "it is the very separation of art and culture from the social—a separation that inaugurates culture as a realm in its own right and defines it as such—which is the source of art's incorrigible ambiguity," as Adorno, Marcuse, and Jameson argue, the ambiguity of the aesthetic categories in this study seems to result from the same splitting.[82] Yet it is possible that the source of their ambiguity resides in a more recent and properly postmodern development involving a de-differentiation of modern society's superstructural "levels" (Althusser) or autonomous, functionally differentiated "systems" (Luhmann): namely, what Jameson describes as a "total culturalization" by a process of radical commodification, which, by now making everything cultural, relegates art and culture to the same "frivolous, trivialized" place.

More specifically, in a culture that hails us as aesthetic subjects nearly every minute of the day, these aesthetic categories are particularly useful for taking stock of how art and aesthetic experience stand in relation to each other once they become structurally decoupled. What better way to think about the implications (for both aesthetic practice and theory) of art no longer being the obvious model for theorizing aesthetic experience than through a set of aesthetic categories each about the weakening of a traditionally conceived border between the aesthetic and the nonaesthetic? What better way to explore the ramifications of how aesthetic experience no longer seems definable by the presence of a single exceptional feeling (say, "disinterested pleasure") than through a set of aesthetic categories based on complicated intersections of ordinary affects? The interesting oscillates between interest and boredom. Aggression is central to our experience of objects as cute. Zaniness is as much about desperate laboring as playful fun. The kinds of subjective agency or capacity called forth by the interesting, the cute, and the zany are thus fundamentally different from the kinds assumed and ratified by the beautiful or the sublime. Yet it would be ridiculous to conclude from this that the cute, the zany, and the interesting are not "genuine" aesthetic categories. All are experiences of a particular kind of form (although, as we shall see, a particularly "formless" or amorphous kind). All are judgments based on feeling rather than determinate concepts or abstract principles. All make the claim to universal validity that every aesthetic judgment makes, and in the same performative mode—if not with the same degree of affective force. Indeed, the equivocal nature of "cute," "zany," and "interesting" as judgments (neither entirely positive nor negative) clarifies something that the beautiful and the sublime tend to obscure, which is that to aestheticize something is not necessarily to idealize or even revere it.

The zany, the cute, and the interesting thus help us imagine what the discourse of aesthetics might become when aesthetic experience is no longer automatically equated with awe, or with rare or conceptually unmediated experience. Something is interesting only if it seems to vary from others of a similar type. For this reason, as Epstein underscores, the interesting involves a checking of awe or wonder on the part of the understanding, a mitigation of the "alterity of the object" by "reason's capacity to integrate it."[83] To call something or someone cute is not necessarily a compliment. And calling someone zany is often synonymous with dismissing him or her as "crazy," a way of simultaneously acknowledging the negativity of the zany person but also that negativity's lack of any real impact on us.[84] In contrast to beauty for Kant, in which one is "subject neither to the law of the understanding, which requires conceptual determination, nor to the law of sensation, which demands an object of desire," cuteness and zaniness evoke subjects under subjection to a number of demands (including, first and foremost, the division of labor).[85] Yet, unlike the sublime, these affective experiences *of* one's subjection to power are not in themselves always or necessarily powerful.

The affective response to weakness or powerlessness that is cuteness, for example, is frequently overpowered by a second feeling—a sense of manipulation or exploitation—that immediately checks or challenges the first. "The rapidity and promiscuity of the cute response makes the impulse suspect, readily overridden by the angry sense that one is being exploited or deceived," as science writer Natalie Angier notes about biological cuteness; indeed, this susceptibility to being taken over seems paradoxically internal to the affective experience of cuteness.[86] The implicit reason is that we judge things cute all too easily, as if there were a deficit of discrimination in the subject's judgment corresponding to or even caused by the cute object's oft-noted lack of articulated features. As Angier observes, the "human cuteness detector is set at such a low bar . . . that it sweeps in and deems cute practically anything remotely resembling a human baby or a part thereof," from the "young of virtually every mammalian species" to "woolly bear caterpillars, a bobbing balloon, a big round rock stacked on a smaller rock, a colon, a hyphen and a close parenthesis typed in succession." This atavistically regressive series of forms underscores that cuteness involves not only a certain softening or weakening of formal differentiation on the side of the object (the more bloblike it is, the cuter it will seem), but also of discrimination on the side of the subject. To be sure, cuteness can be a powerful and even demanding response to our perception of vulnerability in an object; according to the scientists Angier interviews, the pleasure that images of puppies or babies arouse

can be intense as those "aroused by sex, a good meal, or psychoactive drugs like cocaine," acts or substances shown to stimulate the same regions of the brain. Yet because the aesthetic experience of cuteness is a pleasure routinely overridden by secondary feelings of suspicion, there is arguably something weak about it anyway. It is this weakness that allows and even seems to invite what Denis Dutton calls "the sense of cheapness . . . and the feeling of being manipulated or taken for a sucker that leads many to reject cuteness as low or shallow."[87] Note how, even in the context of a project describing cuteness in explicitly biological terms, we find the language of commodities entering the picture ("cheapness"), as if there were no better metaphor for how one might feel "manipulated or taken for a sucker" than our relation to this especially peculiar object. As Lori Merish puts it, the "very banality of cuteness—its mass production and display in a whole range of commercial contexts—suggests the fragility and tenuousness of the cute's hold on us."[88]

Haunted by an image of failure that the experience itself seems to generate, the aesthetic of cuteness thus seems paradoxically coupled with an inability to carry out its own agenda.[89] The same can be said of the zany, defined in the *American Heritage Dictionary* as a "ludicrous" character who "attempts feebly" (that is, poorly) to "mimic the tricks of the clown" in "old comedies."[90] And the same can also be said of the interesting, always just a step away from the "merely" interesting and thus from being boring. Lydia Davis deftly captures this close margin in her microdrama of manners, "Boring Friends":[91]

> We know only four boring people. The rest of our friends are interesting. However, most of the friends we find interesting find us boring: the most interesting find us the most boring. The few who are somewhere in the middle, with whom there is reciprocal interest, we distrust: at any moment, we feel, they may become too interesting for us, or we too interesting for them.

As this deadpan story of social competition makes clear, what is interesting is never inherently interesting but only so in comparison with something else. The objects or persons we find interesting are therefore never stable or permanent: "*at any moment,* we feel, they may become *too interesting* for us, or we *too interesting* for them." It is accordingly the image of "reciprocal interest" that produces the moment of most potential instability and therefore interest in Davis's story, for it is here that the social competition becomes most even and therefore most intense. A kind of dynamic balancing act in its own right, the interesting is an experience of something both stable and changing, predictable and unpredictable. Indeed, when "interesting" is applied as a characterization of

persons in the novel, what it means is often complex or contradictory,[92] as in the case of two of the genre's most beloved protagonists, Isabel Archer and Dorothea Brooke. The fact that the interesting person is one who never seems exactly herself is dramatized also in a particularly vivid way by Nora/Blanche, the conjoined-twin protagonist of Shelley Jackson's *Half-Life*. Epstein underscores this by noting how in Russian "interesting" can be synonymous with "pregnant": "'She is in an interesting state,' one can say. Although she herself is one, there is another entity within her. This, indeed, is precisely the situation of the interesting; it is a form of pregnancy, of potentiality."[93] In "My Interesting Condition" (1990), an essay noted for its anticipation of the shift from gay and lesbian to queer studies, Jan Clausen makes similar use of the interesting ("that old-fashioned euphemism for pregnancy") to process her contradictory feelings upon entering, as a "technically irreproachable lesbian," into a relationship with a man.[94] Rather than recategorizing herself as bisexual, Clausen develops a "resistance to identity" and "willing[ness]" to "remain in identity limbo" that she uses the term "interesting condition" to index (454).

For Schlegel in particular, the interesting is thus "an experience with the possibility of difference . . . with what is different, with what makes a difference, and with what could make oneself or a given state of affairs different," as Mieszkowski notes in his chapter on the interesting in *Labors of Imagination* (114). Its "comparative dynamic" thus brings us to the heart of aesthetic evaluation, since, as many have argued, there is no value without comparison.[95] But for precisely this reason, an object can never be interesting in and of itself, but only when checked against another: the thing against its description, the individual object against its generic type. This makes the interesting both a curiously balanced *and* a curiously unstable aesthetic experience: "the sort of thing that can freely be regarded as indifferent the next moment and be displaced by something else," as Heidegger writes, "which then concerns us just as little as what went before."[96] Although the judgment of interesting is clearly based on a feeling as opposed to a concept (and a notoriously indeterminate feeling at that), its status as an aesthetic judgment always seems strangely insecure.

The possibility of failing to interest is thus as closely coupled to the interesting as the feeling of manipulation is to the cute. Zaniness can be similarly described as an aesthetic about its own unconvincing nature, given its way of dramatizing the exorbitant amount of energy it needs to expend to make us laugh. In this manner, all three aesthetic categories self-generate images of falling short of their own aesthetic goals. The cute, the zany, and the interesting therefore participate in the same paradox as the

sentimental, the ideological, and the obvious, entities whose "identifica-
tion as such depends at least in some measure on [their] perceived failure
to carry out [their] ends."[97] For "if the sentimental text did simply carry
out its ends—if one were deeply moved by it, period—one would not use
the word *sentimental* to characterize it; the use of the word automatically
implies some distance from the sentimental effect," as Jennifer Fleissner
notes.[98] Similarly, as Mieszkowski argues, the "very need to expose the
obvious as obvious suggests that the obvious is never obvious enough for
its own good."[99] Because the cute, the zany, and the interesting are aes-
thetic experiences that seem to undermine our conviction in them as such
(and in which this seeming-to-undermine is paradoxically part of the
overarching semblance or appearance that defines each as an aesthetic
style), it comes as no surprise that they also appear to violate some of
philosophical aesthetics's best-known idioms: distance, in the case of
cuteness, an aesthetic about our desire to fondle things "close at hand";
play, in the case of the zany, an aesthetic ultimately or at the deepest level
about work; disinterestedness, in the case of the interesting, an aesthetic
about . . . interest. These traditional "symptoms of the aesthetic" are made
to stand as close as possible to their antitheses in the cute, the zany,
and the interesting, transforming each category into a kind of "turnstile"
between them.[100] As overt reflections of desiring subjects, these three aes-
thetic categories are also shot through with libido, which may explain
why each in its extreme form has a correlate in one of the three major
Freudian neuroses. The experience of the interesting can quickly turn
into one of obsession, and the experience of soft undifferentiated squishi-
ness that is cuteness, into phobia (by way of disgust). And zaniness is al-
ways already a kind of hysteria.[101]

The fact that feelings of being moved have become vulnerable to being
displaced by or even conjoined to feelings of manipulation does not
mean that there is no longer powerful aesthetic feeling (and certainly not
that there should not be). To the contrary, we inhabit a world in which
we are confronted constantly, if intermittently, with spectacular displays
of aesthetic power, often in close coordination with displays of finan-
cial, political, and military might. Moreover, in a recent departure from
the unhappy split between "genius" and "taste," or artist-oriented and
spectator-oriented aesthetics, which Giorgio Agamben places at the foun-
dation of all modern art and aesthetic theory,[102] contemporary art increas-
ingly seems bent on making itself coextensive with the aesthetic responses
of spectators. From Nicola Barker's *Clear,* a novel consisting almost
entirely of conversations about taste pulled together by an overarching
debate about David Blaine's 2003 notorious "hunger-artist" performance

in London and the vehemence of the public's response to it, to the hundreds of videos posted on the Internet documenting people moved to tears by "ugly-duckling" singer Susan Boyle's first appearance on television, it is clear that what we might call Other People's Aesthetic Pleasures have become folded into the heart of the artwork, essentially providing it with its substantive core. Yet the more intense of these experiences seem to have become as easy to ridicule as to sympathize with or admire. Consider, for example, the media sensation caused by *Double Rainbow*, an amateur video made to capture the beauty of a natural wonder by hiker Paul Vasquez. That natural wonder ended up becoming immediately upstaged, however, even as it was being viewed and recorded, by the emotional extremity of Vasquez's aesthetic response (which was simultaneously recorded). The rainbow was then upstaged yet a second time in the tidal wave of aesthetic responses to Vasquez's aesthetic response, when his video, uploaded to YouTube in early 2010, was viewed by over 20 million people. Aesthetic artifact and affective response were thus conflated in a way that ended up doubly short-circuiting the original object of aesthetic appreciation and leaving it behind. Indeed, the rainbow never seemed to stand a chance of counting as the true "aesthetic object" in this media event, whose epicenter was clearly Vasquez's self-recorded scene of aesthetic praise/appraisal. Opening with laughs and exclamations followed by moans and sobs and finally the anguished question, "What does this mean?" there was something about the sheer intensity and duration of Vasquez's act of aesthetic appreciation that millions of people also seemed to affectionately appreciate but also want to immediately make fun of or belittle, as if such a powerful reaction to an aesthetic spectacle could not be taken seriously or simply left to stand on its own. It was as if those who were aesthetically responding to Vasquez's aesthetic response felt compelled to fill in a feeling of skepticism or manipulation perceived as somehow missing from his original experience, as if, paradoxically, these secondary feelings have become the most reliable sign of the authenticity of contemporary aesthetic experience. The possibility that the rainbow appreciator may have been on drugs was raised. Hundreds of parodies appeared all over the Internet, including an especially funny mash-up overlaying the soundtrack of Vasquez's moans and cries with shots of the minimalist sculpture of Donald Judd. In a fitting sequel, Vasquez was briefly hired by Microsoft to film commercials for its Windows Live photo-editing and enhancing software.[103] The hypercommodified, technologically-mediated conditions of production, distribution, and reception that made the entire episode of *Double Rainbow* possible are the same that have brought our equivocal aesthetic categories to the fore.

Style

The zany, the cute, and the interesting will be approached in this study as subjective, feeling-based judgments, as well as objective or formal styles. Indeed, I would argue that it is impossible to grasp the full cultural significance of any aesthetic category without considering how its functions as judgment and as style relate to each other. As sites in which discursive practices and modes of human intersubjectivity routinely intersect with aspects of what Arendt calls the "thing-world," aesthetic categories are double-sided in more ways than one: they are subjective and objective, evaluative and descriptive, conceptual and perceptual.[104] Aesthetic categories are not for all this exotic philosophical abstractions but rather part of the texture of everyday social life, central at once to our vocabulary for sharing and confirming our aesthetic experiences with others (where interesting is rhetorically pervasive) and to postmodern material culture (where cuteness and zaniness surround us). Yet with notable exceptions, such as Daniel Harris's landmark collection of essays on the styles of commercial culture, *Cute, Quaint, Romantic and Hungry,* and Judith Brown's *Glamour in Six Dimensions,* which brilliantly tracks the links between the deathly style of glamour and the aura of modernist literary form, aesthetic categories have rarely been singled out as primary objects of analysis in literary and cultural studies, and when they have been, rarely as speech acts as well as objective styles. What bearing do the culturally codified ways in which we mobilize the cute, the interesting, and the zany as evaluations have on our perception of them as stylistic qualities, and how does our perception of these stylistic qualities affect our language of aesthetic judgment?

From "Ming dynasty" to "Henry James's 'late' phase," to speak of style is to speak of something that fluctuates among scales of spatial or temporal reference and degrees of institutional codification. Style itself is a "tension between change and stability," as James Ackerman suggests, and as such provides an essential concept (not just a topic among others) for doing nonevolutionary art history.[105] Moreover, all styles are semblances, referring to how things generally "seem," "look," or "appear." As Frank Sibley argues about aesthetic properties, styles are also emergent phenomena, arising out of complex interactions among multiple parts of which they are always more than just a sum.[106] Softness, harmlessness, roundness, and so forth do not automatically give rise to the appearance of cuteness when combined. Richard Neer suggests that styles might therefore be understood as what Wittgenstein calls "aspects," "ways" of perceiving an object (seeing it *as* cute) as opposed to the set of objective qualities perceived.[107]

Constantly shifting in range of spatial or temporal reference as well as degree of institutional codification, questions about style lead quickly to questions of scale and of form. This is true whether we understand "form" as the antithesis of matter ("what seems" as opposed to "what is") or, as Rodolphe Gasché suggests in his reading of Kant's *Critique of Judgment*, as a paraconceptual subjective agency or act, to be contrasted not with the objectivity of matter but with determinate cognition.[108] "Form" here is to be understood as mental activity rather than objective thing, and as the opposite of the mental activity involved in the formation of concepts in particular. "We have been able to create forms long before knowing how to create concepts," as Nietzsche puts it.[109] In any case, it is striking that the forms on which the aesthetic experiences in this study are based tend to challenge some of our most deep-seated and conventional definitions of what "form" is.[110] Zaniness asks us to regard form not as structure but as activity. Cuteness is a response to the "unformed" look of infants, to the amorphous and bloblike as opposed to the articulated or well-defined. Indeed, the more malleable or easily de-formable the cute object appears, the cuter it will seem. Similarly, since interest "always points toward something not yet realized: a wish, an objective, an endpoint to which no particular interest can coincide," the experience of the interesting is essentially anticipatory as well as ongoing or serial.[111] In this manner, the interesting asks us to understand form as temporal as opposed to spatial, diachronic as opposed to synchronic. "Even that which is most interesting could be more interesting," as Schlegel writes.[112] And one sees a similar indeterminacy in the kind of incessant performing we respond to in the zany, which always threatens to dissolve the performer into a stream of undifferentiated activity. The forms that our aesthetic experiences of the cute, the interesting, and the zany revolve around—the squishy or extrasoft blob, the open-ended series, the incessant flow—are thus relatively shapeless or unstructured. One is tempted to describe them as the informal forms specific to late capitalist modernity, and perhaps especially to "disorganized" capitalism and its culture of informalized, casualized work. In each case, the type of form at stake involves some kind of relation to change and/or indeterminacy that uncannily mirrors that of style itself.

For fluctuation and diversity are central to the very concept of style, a notoriously "unstable" category whose "inconsistencies mirror aesthetic activity as a whole."[113] This is especially true if one follows Bakhtin in rejecting the "separation of style . . . from the question of genre," which he holds "largely responsible for a situation in which only individual and period-bound overtones of a style are the privileged subjects of study, while its basic social tone is ignored."[114] Important as Bakhtin's correction

has been for the study of both genres and styles, one of its inadvertent effects has been to make the two confusable. It can be similarly difficult sometimes to fully separate style from modes like tragedy and melodrama, as well as from artistic movements or schools like brutalism and surrealism. Unofficial or vernacular styles like the ones in this study—"informal" in more than one sense—make this already-tricky problem even trickier. The zany, for instance, is a subspecies of comedy (mode), while cuteness, a style that speaks to our desire for a simpler, more intimate relation to our commodities, is arguably a kind of pastoral (genre). Although the cute, the zany, and the interesting are less institutionally codified and/or chronologically restricted than styles like screwball, minimalism, or art deco, they can as easily be annexed to these more temporally and spatially circumscribed styles as they can be folded inside other, even broader categories for organizing cultural objects (such as romance, realism, and comedy). To complicate things further, vernacular, unofficial styles like the cute and the zany can disconcertingly seem to exist on the same continuum as, say, the stark and the robust, aesthetic qualities that have noticeably not given rise to or congealed into recognizable styles, not even ones as informal as the ones in this book.

Is it possible that informal and/or dispersed styles might be particularly useful for studying aesthetic culture as a "whole way of life"?[115] One of Pierre Bourdieu's more trenchant arguments in *The Rules of Art* implies something to this effect. The autonomy of any restricted field of production, according to Bourdieu, ensures that in the works, genres, and movements produced in it, "states of the social world" and other historical content will always be mediated by the field's particular configuration of positions and position takings: "What happens in the field is more and more linked to a specific history of the field, and hence it becomes more and more difficult to deduce it directly from the state of the social world at the moment under consideration" (243). Since vernacular styles like the cute and the zany, unlike artworks, genres, and movements, are not products of restricted fields (although they are by no means unmediated by them), by this account they would seem at least theoretically capable of indexing "states of the social world" more directly, thus providing certain advantages for the analysis of culture as a whole.

However compelling it may be, this possibility needs to be measured immediately against Jameson's well-known argument to the exact opposite effect in *Postmodernism*: that because of the "well-nigh universal practice today of what may be called pastiche," a kind of metastyle made possible by late capitalist culture's "stupendous proliferation of social codes," the analysis of style can no longer count as a legitimate way of doing history.[116] Pastiche's way of emptying out the content of any particular

style would thus reverse a trend in place since the early nineteenth century, when style first became a bearer of meaning or content in individual works of art, as opposed to serving merely as a taxonomic tool.[117] Yet Jameson's argument about the contemporary decline of style's ability to function as a reliable index of sociohistorical conditions needs to be stacked against the way he compellingly relies on stylistic categories throughout *Postmodernism* to make the historical claims about postmodernism that underlie this very point. Messiness and glossiness, in particular, stand out in this magisterial work as styles unusually pregnant with sociohistorical meaning; the look of the photographed interior of a Frank Gehry house in Santa Monica, for example, reflects the "messiness of a dispersed existence, existential messiness, the perpetual temporal distraction of post-sixties life," and thus, in a beautifully snowballing fashion, "the general informing context of some larger virtual nightmare . . . in which psychic fragmentation is raised to a qualitatively new power, the structural distraction of the decentered subject now promoted to the very motor and existential logic of late capitalism itself."[118] Messiness and glossiness are significantly much closer to cuteness and zaniness than "official" or institutionally codified styles like art deco or brutalism, as if, under the conditions of postmodernity, only radically informal and temporally dispersed styles can remain genuine bearers of "historical" meaning.

The informality and triviality of the aesthetic categories in this study is thus, paradoxically, the locus of their historical meaningfulness. It is also worth noting that pastiche, the postmodern metastyle Jameson implicates as the direct culprit in the stripping of historical meaning from all style, is a product of the same pluralism that enabled individual styles to become meaningful in the first place. If before the nineteenth century "contributions to a practice were regarded not as belonging to one style or another, but rather as falling within or being alien to the practice," as the editors of *The Question of Style in Philosophy and the Arts* argue, by the turn of the century the individual arts had become viewed as they continue to be today, as sites for individual artists to experiment—selectively—with a variety of styles.[119] Although "style" was originally associated with ornament, or that "aspect of writing, painting, or building . . . that could be varied without changing the content," the loss of more traditional bearers of meaning or content in artworks—nature, antiquity, absolute standards of reason—led to this "variable element" taking their place, as precisely the new key element of any individual artwork's meaning.[120] Yet at a moment in which "poetic output was so rich and miscellaneous that the young Friedrich Schlegel called it a grocery shop,"[121] the new understanding of art as a site for stylistic experi-

mentation turned "style" into an unprecedented challenge for the modern artist. Suddenly confronted with an "overwhelming repertoire of forms left from the past" (all individually charged and pregnant with meaning), the lucky or perhaps unlucky artist suddenly finds himself "at a loss to find a reliable and justifiable criterion for selecting from these."[122] Selection is thus transformed into a new problem that "das Interessante," theorized by Schlegel as a style about stylistic eclecticism and hybridity, seems to have been expressly invented to solve. The style of the interesting further speaks to the situation of stylistic proliferation that gave rise to it in its strikingly diverse instances of manifestation, which, as we have seen, range from the novel, with its complex and self-contradictory individuals, to the conceptual artist's telegrams, lists, and postcards. Stylistic variety and fluctuation are thus, in a certain sense, not only the "inner" content or meaning of the interesting but also a formal, outwardly visible aspect of the aesthetic style itself.[123]

With the interesting's late twentieth-century mutation into the more explicitly "rational" style of conceptual art, the problem of selection arguably becomes even more central, for here the look of the interesting scandalously seems to suggest the reducibility of aesthetic experience to selective attention itself. This is certainly one way of reading John Baldessari's *Choosing,* a series of photographs foregrounding the eponymous act of selecting grocery shop produce: green beans, carrots, asparagus, garlic, rhubarb. Each row shows a finger pointing to one green bean out of an array of three, then another as the nonchosen beans are replaced with two others, then another as the nonchosen beans are replaced with two others, and so on (Fig. 1). In what seems like a remedial exercising of our ability to recognize very tiny differences, *Choosing* thus makes itself coextensive with the most elemental feature of what Jan Mukařovský

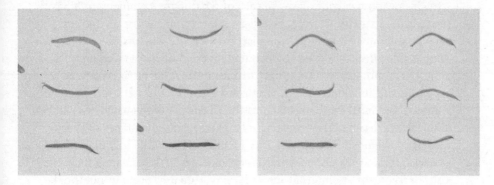

FIGURE I

calls the "aesthetic function," which is simply to "isolate" and direct "maximal attention" to specific objects.[124] In the same blow, its merely interesting look invites us to read the series as a humorous comment on Leonard Mayer's oft-cited theory of style as "choosing within some set of constraints."[125] From this perspective, the seemingly styleless style of Baldessari's series, with its pun on connoisseurship by featuring acts of discerning fine differences between things of a particularly humble type, reads more like another metastyle: a style precisely about how there is "no question of style unless there is the possibility of choosing between alternate forms of expression," as Stephen Ullman puts it.[126] We might therefore read *Choosing* as an allegory both of style's modern elevation to primary bearer of artistic meaning *and* of its concomitant drift into pluralized whateverness. In a sea of stylistic variety, the act of choosing becomes more important than ever to artworks, *Choosing* seems to say, but also, in a certain sense, less so. Eclectic and rational, idiosyncratic yet systematic, the interesting as style thus continues to be historically meaningful under conditions of postmodernity, although one of the things it points to is uncertainty about the significance of any particular style.

The style of *Choosing* thus directs our aesthetic attention to the affectively and cognitively minimal act of selective attention that William James simply referred to as "interest." In its effort to reconcile the individual with the generic, Baldessari's style might also be described as a specifically postmodern response to the modern routinization of novelty in a culture in which, because "the observation of events throughout society now occurs almost at the same time as the events themselves," we routinely encounter what Mark Seltzer calls the "media doubling of the world."[127] One arguably sees this reflected in conceptual art's fascination with the dynamic between pictures and labels, photographs and typescript, images and words. If the interesting speaks directly to this aspect of modern culture, it does so particularly in the case of what many commentators have described as a rising convergence between art and theory, a situation in which, as Bourdieu puts it, "the discourse on the work is [no longer] a simple side effect, designed to encourage its apprehension and appreciation, but a moment which is part of the production of the work, of its meaning and its value."[128] Although this trend would naturally become more of a scandal in the visual arts than in literature—which, as Philip Fisher notes, has had the "constant advantage or disadvantage" of sharing criticism's linguistic medium—art's identification with discourse about art, to a point at which the work or *ergon* comes to depend on a theoretical *parergon* for its internal integrity, has arguably become one of the most important problematics for the making, dissemination, and recep-

tion of art in our time—as important, perhaps, as the loss of the antithesis between the work of art and the commodity.[129]

We have thus arrived at the convergence of art with theory called for by Schlegel in conjunction with his advocacy for the "interesting." Exactly how did this convergence of art with theory come about, and how does the postwar style of the merely interesting come to be a particular reflection on it? In a culture of planned obsolescence devoted to the systematic and even enthusiastic forgetting of older technologies of production and distribution, as Alan Liu notes, it is increasingly institutions that people rely on for histories of making: universities, museums, archives, libraries.[130] A culture in which the making of art is institutionally mediated thus encourages art's internalization of history and thereby theory, as Arthur Danto argues: "When art internalizes its own history, when it becomes self-conscious of its history as it has come to be in our time, so that its consciousness of its history forms part of its nature, it is perhaps unavoidable that it should turn into philosophy at last."[131] Bourdieu makes a similar point, although he links the phenomenon more specifically to the development toward greater autonomy of the field of cultural production: "To the extent that the field closes in on itself, a practical mastery of the specific attainments of the whole history of the genre which are objectified in past works and recorded, codified, and canonized by the whole corpus of professionals of conservation and celebration—historians of art and literature, exegetes, analysts—becomes part of the entry into the field of restricted production." Although this is the case for all producers, the situation is felt most acutely in and perhaps even driven by the avant-garde, "who are [most] controlled by the past when it comes to their intention to surpass it."[132] In much the same vein, Paul Mann argues that the avant-garde is best understood less in terms of its agon with institutions than as the "vanguard of [the] reflexive awareness of the fundamentally discursive character of art."[133]

It could be said, however, that the cultural agent playing the most direct role in promoting the convergence of art and theory that the rise of the interesting comes to index is less "discourse" than the museum. As Fisher argues, the museum's basic technique of display—placing works removed from their original context next to and between others similarly removed from theirs—generates a frame of implicit commentary around each individual work. The placement of a Matisse painting next to a Japanese wood-block print as opposed to a Renoir, for example, functions as a tacit "reading" of the Matisse. This institutional practice spurs artists to try to exert greater control over their work's reception by offering some form of their own commentary in advance—and indeed, by making

use of the museum's own display or dissemination techniques in a preemptive or homeopathic way. Enter the series, which comes to replace the "no-longer-intelligible single work" as the "basic unit" of artistic production from the late nineteenth century onward. From Monet's haystacks to Bernd and Hilla Becher's grain elevators, the serial format offers the perfect strategy for internalizing commentary, Fisher argues, since "only one picture exists at any instant *as a picture,* the others are temporarily explication, frame, and criticism."[134] Indeed, the "power of the series lies in the skill with which each picture can exchange roles; now a sensory experience, exhaustively commented on by the rest of the series; a moment from now, part of the explication for one of the other pictures."[135] In this manner, the artist in the modern culture of museums (and, we might add, university syllabi and literary anthologies) finds a way of controlling the implicit commentary externally conferred by the work's anticipated "neighbors" by supplying it with its own internal logic of betweenness. In creating meaning through this logic of things placed next to or between others placed next to others in turn, there is thus a sense in which the series is an inherently interesting form, one reminding us that *inter esse* means "to be between; in the interval," or "among and in the midst of things." In a related move, art in the modern culture of museums also becomes serial in its anticipation of itself "in some moment of the future, [as] a step within a sequence that anyone living at that moment of the future will think of as its past" (91). Serial and/or interesting art—an art of the ongoing and the in-between—thus comes to prevail in cultures in which the artist routinely "finds himself face to face with an intellectual world that articulates and surrounds his working life with a full-scale History of Art within which he is forced to see himself as an episode" (97).

Ever since its first major theorization as a style by a literary critic, the interesting has indexed this increasingly intimate relationship between art and criticism. Indeed, as Phyllis Tuchman notes in "Minimalism: Art of the Interesting," it was the critical discourse surrounding the minimalist sculpture of the 1960s—serial, modular works typically made of industrial materials—that first "revived Schlegel's 'Cult of the Interesting' for the late twentieth century."[136] In essays ranging from Rose's "ABC Art" to Donald Judd's "Specific Objects," but perhaps most famously in Michael Fried's "Art and Objecthood," which explicitly critiques Judd's use of the term "interesting," debates about interest and boredom have become a canonical part of the history of minimalism.[137] Yet my sense is that as an eclectic, discursive style reflecting the integration of art and theory, the style of the interesting as initially conceived by Schlegel and the German romantic ironists really comes most into its own with conceptual

art, a much more eclectic and miscellaneous, often language-based art made of a much greater range of materials: index cards, invoices, pencil drawings, maps, transcripts, slides, blood samples, photographs. While sharing minimalism's and, indeed, all modern art's preference for serial forms, conceptual art was more explicitly concerned with the kinds of sociality bound up with print capitalism and specific communication technologies; with the postbourgeois public sphere projected by the mass media and its "continuous circulation of discourse-objects."[138] Like the early serialized novel, which integrated the intermittent temporality of its circulation into its very form (chapters), conceptual art drew the dynamics of media distribution into the form of its works as well, which over the decade increasingly took the guise of media objects such as postcards, telegrams, classified ads, posters, magazine articles, and answering-machine messages. Although not all the artists associated with the movement viewed this use of "publicity as medium" as progressive,[139] conceptual art's investment in the interesting seems directly related to its being gripped by the idea that at a "fundamental level works of art are determined neither by aesthetic nor by strictly ideological rules, but rather by *their ability to move through and hence maintain the discursive apparatus.*"[140] Pathways for the dissemination and exchange of information thus became an object of both positive and negative fascination for artists like Douglas Huebler, Robert Barry, and others, who, like the innovative gallerist Seth Siegelaub, found multiple ways of exploring the various implications of the idea that in the postwar "media economy," the value of any artwork becomes "defined above all by its power to generate discourse about [itself]."[141] As Liz Kotz implies, conceptual art's infamous "obsession with the most minimal, redundant, and empty of messages"— which is to say, its investment in the merely interesting—can thus be seen as an attempt to make the process of circulation visible by tracking the movement of information and bodies through systems of transportation and communication (for example, highways, the postal system, and telex lines), which as Jameson notes are also kinds of "media."[142]

It stands to reason that the interesting, as a style explicitly about difference and the acts of comparison that make its perception possible, is itself prone to variation in ways that exceed those of the other aesthetic categories in this study. In other words, what the interesting "looks like," and the forms or materials in which the style tends to manifest itself, tends to fluctuate more dramatically than in the case of the cute or the zany. With its focus on interesting individuals (persons who are at once unique and yet utterly typical), the nineteenth-century novel seems to have little in common with the informational aesthetic of late twentieth-century

conceptual art, which clearly prefers the representation of networks and systems over that of human beings. Yet it is the serial, epistemological, essentially comparative style of the interesting that allows us to see both practices as sharing a commitment to a certain kind of realism, and as efforts to grapple with a strikingly similar set of issues specific to modernity: the routinization of novelty, the tension between individualization and standardization, and the new intimacy between art and criticism. Invested in both cases in checking experiences of "reality" against one's "notes on reality," the style of the interesting speaks directly to the making and disseminating of art under conditions of stylistic multiplicity and variety in a fully mediatized culture; one in which, as George Oppen writes, "we will be told at once / Of anything that happens."[143]

Judgment

To consider aesthetic categories like the cute and the interesting not only as styles of objects but as subjective, feeling-based judgments—relatively codified ways of sharing our pleasure and displeasure with others—is to go straight to the heart of philosophical aesthetics in a way that might make us wonder why so much less attention in recent work on everyday aesthetics has been given to this arguably fundamental aspect of what aesthetic experience in general entails. For Kant, beauty is famously not a stylistic property of objects but rather, as the *Critique of Judgment* progressively reveals, a compulsory sharing of pleasure that refers the subject to a relation among his subjective capacities, which in turn refers him to a relation between the world in general and his ability to know it. Yet in a sense the asymmetry between the attention to style and judgment in current work on aesthetic categories is not hard to understand. The question of judgment can seem to open a can of worms—that of the undeniable relativism of feeling-based evaluations—that threatens to distract from the more concretely satisfying task of analyzing the stylistic properties of objects, by casting doubt about their very objectivity.

In addition, the discursive side of aesthetic categories, which is woven into the fabric of everyday conversation, is both less visible and surprisingly complex. For one thing, as Stanley Cavell shows, aesthetic judgments belong to the especially troublesome class of performative utterances J. L. Austin classified as perlocutionary: actions such as praising, criticizing, complimenting, soothing, or insulting, which, in contrast to illocutionary acts like betting and marrying, are more successfully performed in an inexplicit rather than an explicit form. "Beautiful dress!" is a more auspi-

cious way of complimenting, for example, than intoning "I compliment you"—as if words were magic spells, Cavell notes.[144] The most important feature of perlocutionary utterances for Cavell, as is made particularly evident by the subset he calls "passionate utterances," is the way in which the power to assess their accomplishment shifts from the speaker to the interlocutor.[145] It is the person in the position of possibly receiving a compliment or apology, rather than the one who offers it, who ultimately determines whether the act of complimenting and apologizing has successfully taken place. Cavell illuminates all this by focusing on infelicitous praise as an analogue for aesthetic judgments that fail to be convincing and perhaps even come off as self-aggrandizing or annoying (as when, for example, you suspect that my gushing over the beauty of a Rothko painting has more to do with the display of my cultural capital than anything else). Yet the aspect of the aesthetic judgment brought out by Cavell—its felicity or potential infelicity as verbal action—underscores the philosophical and not just sociological significance of this class of utterances.

Cavell thus brings out the surprising relevance of Austin's philosophy of ordinary language for high aesthetic theory, and particularly for our understanding of "the feature of the aesthetic claim, as suggested by Kant's description, as a kind of compulsion to share a pleasure, hence as tinged with an anxiety that the claim stands to be rebuked"(9). Although it seems entirely possible to form judgments of aesthetic quality privately in our heads, as if aesthetic pleasure was not a feeling reflexively felt to require public confirmation by others, this is not the way in which Kant describes it. As reflected in ¶ 6 and especially ¶ 7 from the *Critique of Judgment,* in which the differences among the pleasant, the good, and the beautiful are laid out first and foremost as differences in how we converse about them, in Kant's account it does not seem possible to judge something aesthetically without speaking, or at the very least imagining oneself speaking.[146] Nor does it seem possible to judge aesthetically without making the necessary "error" of putting one's judgment in the form of a descriptive, third-person statement ("X is cute") rather than in the form of a first-person performative that looks more transparently like the subjective evaluation it is ("I judge X cute"); a form enabling the speaker to intensify the force of her necessary claim that everyone else should make the same judgment. Note the parallel between this error and the issues surrounding the felicity of the perlocutionary act of complimenting. Although saying "I judge this cute" may be a more accurate description of what is really going on when I judge

things than my saying "This is cute," the former is actually far less effective as a judgment than the latter. For aesthetic judgment is less like a propositional statement than an intersubjective demand[147]—which is to say, less like a constative than a performative that performs best when disguised as a constative. In the end, Kant's judgment of beauty destabilizes the same opposition as *How to Do Things with Words,* when Austin discards his initial, heuristic constative/performative distinction for his account of locutionary, perlocutionary, and illocutionary force. Indeed, it is precisely by showing how utterances that look constative are actually performative, or how performativity by no means depends on the "use of the first person singular and of the present indicative active," that Austin is able to develop his account of perlocutionary utterances in the first place.[148]

There is thus something covert or surreptitious, if in a paradoxically overt way, about the rhetorical work of aesthetic categories. One might say that as perlocutionary speech acts similar to apologizing, complimenting, or criticizing, or as performatives that actually do their work best when they are disguised as propositional statements, they produce a kind of semblance or illusion at the level of discourse that corresponds to the more familiar semblance or illusion of style. What Schiller, Adorno, and Langer call *Schein*—a seeming or appearing—is thus central to aesthetic categories on both sides of the judgment/style divide. Building on Frank Sibley's work on aesthetic properties, Gérard Genette underscores this in his account of aesthetic predicates as "persuasive or valorizing descriptions that bridge the abyss between fact and value *without becoming too conspicuous.*"[149] Because the zany and the cute are "semidescriptive or semijudgmental," they are essentially "means [by] which one judges *under cover* of describing."[150] The main difference between aesthetic and nonaesthetic predicates is thus that the "descriptive cover" under which the former "smuggle" their axiological charge (note the language of covert action here) enables aesthetic predicates to function as implicit justifications of themselves (92). This self-justification underscores the way in which all aesthetic judgments presuppose their embeddedness in arguments,[151] which in turn once again reminds us, as John Guillory does, of the "constitutive role of conflict for any discourse of value."[152] Genette explains: "A value judgment does not follow from a factual judgment like 'This painting is square-shaped' [or] 'This symphony is in C major'; however, *it can create the illusion it does* by putting forward as a descriptive term a predicate carrying a positive or negative appraisal: 'This painting is balanced (or immobile),' 'This symphony is majestic (or pompous).'"[153]

Aesthetic judgments, once again, thus produce a kind of illusion or apparitional quality at the level of rhetoric, analogous to that of style, by making it *seem as if* value judgments follow from factual ones. The idea that this is "what our aesthetic predicates help us do"—and perhaps that it is even "what they are for"—enables Genette to make an even more provocative claim (92). Since aesthetic appreciation, positive or negative, always boils down to an act of projection or the externalizing objectification of subjective feeling (as Genette's stresses, "objectification *constitutes* aesthetic appreciation"), aesthetic predicates with descriptive specificity become better "tools of objectification" and, as such, more *rhetorically powerful as aesthetic judgments* than "undifferentiated appreciation[s] such as 'It's beautiful' or 'It's ugly.'" Indeed, Genette suggests that these classic appreciations should be reclassified as purely evaluative "verdicts," or mere "statements of one's positive or negative opinion," rather than as aesthetic predicates proper, which necessarily involve some compression of evaluation with description (92).

Given the importance of this compression and the rhetorical sleight of hand it enables on the part of aesthetic judgment in general, it is not just the case that the judgment "cute" has just as much standing or power as an aesthetic claim as "beautiful." Because "cute" conflates evaluation with description, or the act of judgment with justification, in a way in which "beautiful" does not, by Genette's account the former has even greater force as an aesthetic judgment. Although it may seem counterintuitive to suggest that our most effective aesthetic judgments—the ones with the greatest perlocutionary force—are ones that seem most compelled to implicitly or covertly justify themselves, Genette suggests that it is precisely because "cute" seems to need to make an argument for itself that it becomes all the more forceful as an aesthetic claim, which is to say, a demand necessarily masked in a constative form. It is as if aesthetic discourse, often deeply pleasurable and/or wildly irritating to participate in, in its own right, were at the deepest level a discourse about its own intersubjective and affective dynamics: about the complicated new set of feelings we might feel when we make our pleasures/displeasures public and check them against the pleasures/displeasures of others in what Elaine Scarry calls acts of perpetual "self-correction and self-adjustment."[154] Yet, as the preceding discussion suggests, certain aesthetic judgments seem to make this "basic other-directedness of judgment and taste," which, as Hannah Arendt notes, "seems to stand in the greatest possible opposition to the very nature, the absolutely idiosyncratic nature, of the sense [of taste] itself," more transparent than others.[155] As both Arendt and Lyotard underscore in their readings of Kant's concept

of the *sensus communis*, for Kant, what makes the faculty of judgment stand apart from all the other faculties is the way in which it presupposes or compels us to imagine other people capable of speech and judgment too: "Kant stresses that at least one of our mental faculties, the faculty of judgment, presupposes the presence of others."[156] For this reason, Arendt writes, "One judges always as a member of community, guided by one's community sense, one's *sensus communis*" (75). Indeed, there is an implication that one creates or brings this "community sense" into existence *by* judging. And as Arendt stresses, judging not only presupposes others but others capable of speech: "The *sensus communis* is the specifically human sense because communication, i.e. speech, depends on it. To make our needs known, to *express* fear, joy, etc., we would not need speech. Gestures would be good enough, and sounds would be a good enough substitute for gestures if one needed to bridge long distances. Communication is not expression" (70). For Arendt, the "communication" that Kant's aesthetic judgment always presupposes and invokes—one that clearly goes beyond the making known of needs—is thus, as she says explicitly, "speech." There is thus, by extension, no *sensus communis* (and no aesthetic judgment) without speaking in response to real or imaginary others speaking.

For Genette and others, to make a judgment of aesthetic quality, with its necessary demand for universality, is to project one's negative or positive feelings onto the object in such a totalizing fashion that the subjective basis of the judgment—its grounding in feeling as opposed to concepts—by no means undermines the objectivity of the aesthetic quality as such.[157] As Adorno puts it in *Aesthetic Theory* in an echo of what Ross Wilson calls the "Kantian *Rettung*," or the "attempt made throughout Kant's philosophy to salvage or rescue objectivity by way of the subject," "Even in its fallibility and weakness, the subject who contemplates art is not expected simply to retreat from the claim to objectivity. . . . The more the observer adds to the process, the greater the energy with which he penetrates the artwork, the more he then becomes aware of objectivity from within. . . . *The subjective detour may totally miss the mark, but without the detour no objectivity becomes evident.*"[158] As Wilson notes, Kant's attempt to recuperate aesthetic objectivity through the subject in the *Critique of Judgment* is analogous to his attempt to recuperate objective cognition in the *Critique of Reason* (67). Indeed, in Kant the subjectivity (and performativity) of aesthetic valuation is disclosed as precisely essential, though in a way inevitably obscured by the judgment's necessarily objective (and constative) form. Kant discloses the aesthetic judgment of the beautiful in particular as referring to the subject's own cognitive capacities, if in a

way strangely opaque to the subject herself. Indeed, the fact that the subject of beauty seems both to recognize and not to recognize what her feeling of pleasure actually refers to, a capacity or power on the part of the subject as explicitly opposed to a quality of the object, is, for Kant, what calls for a "critique" of taste in the first place (and as Tom Huhn argues, is what explicitly motivates him to bring in his discussion of the sublime, in which the subjective agency misrecognized in the judging subject's experience of beauty is finally acknowledged).[159]

This reference to a relation among subjective capacities (as opposed to an objective property) is why the Kantian judgment of beauty is conceptless: "pure" in the sense of being radically disconnected from nonaesthetic judgments like "This vase is red" or "This vase is made of plastic" or "This vase was made in China by people making 64 cents an hour." But most judgments of taste—and by Genette's account, the most powerful ones—are, as we saw earlier, compressions of description and evaluation, underscoring Mukařovský's insight that aesthetic value is always a "chemistry" or dynamic interaction between aesthetic and extra-aesthetic values. For Mukařovský, this dynamic defines art as well as "development within the sphere of aesthetics"; indeed, "the degree of independent value of an artistic artifact will be greater to the degree that the bundle of extra aesthetic values which it attracts is greater" (91). Nick Zangwill puts the point even more strongly, arguing that however correct or incorrect, our perception of aesthetic judgments as tethered to nonaesthetic judgments is not only necessary for but constitutive of aesthetic thought: "One cannot think that beauty is bare; it is essential to aesthetic thought to realize that the aesthetic properties of a thing arise from its nonaesthetic properties."[160] This is not very far from Adorno's argument that genuine aesthetic experience, while wholly dependent on a spontaneous subjective response, nonetheless requires a kind of reflection: "Namely, that the substance grasped through the completed experience is reflected and named in its relationship to the material of the work and the language of its forms."[161] Whereas beauty tends to mask this "nonaesthetic dependence" on the part of all aesthetic judgments (including itself), the interesting, the cute, and the zany make it explicit: the interesting by overtly soliciting nonaesthetic judgments in justification of itself (we will see how this works in Chapter 2); the cute and the zany by wearing their descriptive content on their sleeves, producing an appearance of self-justification that in turn creates the illusion of judgments of value being logically entailed by judgments of fact.

Thus although "there is no realm of pure aesthetic experience, or object which elicits nothing but that experience," as John Guillory puts it

(noting in particular that it is "impossible to experience any cultural product apart from its status as cultural capital [high or low]"), the "specificity of aesthetic experience is not contingent on its 'purity'" (336). Obvious as this last point may seem from the standpoint of content-laden aesthetic categories like the ones in this study, the fact that so many intelligent commentators have written as if the specificity of aesthetic experience did in fact hinge on its existing in a pure form, uncombined with other socially meaningful practices, underscores the disadvantages (which I am hardly the first to note) of an aesthetic theory modeled exclusively or even primarily on beauty. Guillory's point about the "mixed condition" of aesthetic judgments—how, in an obvious and yet strangely not-so-obvious way, they can be broken down into any number of extra-aesthetic judgments informed by a variety of social affiliations and interests—also applies to their affective foundations. Although theorists continue to attribute the specificity of aesthetic experience to the presence of a single, exceptional emotion—what Nelson Goodman sarcastically refers to as "aesthetic phlogiston"—most of our aesthetic experiences are based on some combination of ordinary ones.[162] Aesthetic judgments based on clashing feelings, in particular—tenderness and aggression, as in the case of the cute; interest and boredom, as in the case of the interesting—seem to allegorize by reflecting the way in which aesthetic judgments "only make sense as part of [arguments]" and thus disputes between subjects and social groups.[163] Yet not all aesthetic judgments make this argumentative context transparent. Indeed, certain judgments not only seem incapable of acknowledging this underlying state of discursive conflict but also actively work to conceal it.

This strangely covert aspect of aesthetic judgment—its way of referring our feelings of pleasure and displeasure not just to objects or even our own subjective capacities, but also to the social matrix of others with whom we are compelled to share and confirm these feelings in public—is perhaps made most perspicuous by the judgment of "interesting." As evinced by its sheer ubiquity in everyday conversation, "interesting" is in fact the one aesthetic category in our repertoire that explicitly reflects on aesthetic discourse—on how people actually talk about pleasure and value. Davis cleverly captures this discursive orientation in "Interesting," another compressed story of manners consisting entirely of the narrator's judgment of other people's conversation and/or conversational abilities:

> My friend is interesting, but he is not in his apartment.

> Their conversation appears interesting but they are speaking a language I do not understand.

They are both reputed to be interesting people and I'm sure their conversation is interesting, but they are speaking a language I understand only a little, so I catch only fragments such as "I see" and "on Sunday" and "unfortunately."

This man has a good understanding of his subject and says many things about it that are probably interesting in themselves, but I am not interested because the subject does not interest me.

Here is a woman I know coming up to me. She is very excited, but she is not an interesting woman. What excites her will not be interesting, it will simply not be interesting.

At a party, a highly nervous man talking fast says many smart things about subjects that do not particularly interest me, such as the restoration of historic houses and in particular the age of wallpaper. Yet, because he is so smart and because he gives me so much information per minute, I do not get tired of listening to him.

Here is a very handsome English traffic engineer. The fact that he is so handsome, and so animated, and has such a fine English accent makes it appear, each time he begins to speak, that he is about to say something interesting, but he is never interesting, and he is saying something, once again, about traffic patterns.[164]

Note the elusiveness of the aesthetic experience "Interesting" goes searching for. The one friend who is interesting cannot be found where one expects to find him, while the two conversations that seem like they could be interesting finally cannot be experienced as such, since they are in languages that the speaker does not understand. Thus, while showing how the evaluation of interesting functions as a specific index of the ways in which language circulates between different discursive groups, each paragraph defines the aesthetic experience negatively, in terms of a missed encounter or insufficiency of knowledge. Indeed, six of the seven paragraphs in "Interesting" are accounts of why the narrator, in some dialogic context, did not find something or someone interesting. In each case the explanation or justification for the judgment's withholding refers to particular ways of speaking: rapidly, with so much information per minute, animatedly, with an English accent, and so on. In the only paragraph in which it seems like the narrator may have indeed found the speech or speaker interesting, the term "interesting" is conspicuously avoided, replaced for some reason by a euphemism. Instead of "Yet, because he is so smart and because he gives me so much information per minute, I do finally find him interesting," we get: "Yet, because he is so smart and because he gives me so much information per minute, I do not get tired of listening to him."

Comically, with the exception of the missing friend with whom no conversation actually takes place, nothing finally does get judged interesting in "Interesting," a series of accounts of noninteresting conversations. Or more precisely, no judgment of interesting takes place in the story. Rather, "interesting" appears over and over again in the discourse, with a peculiar, almost incantatory insistence that becomes most pronounced at the moments of its denial: "I am not interested because the subject does not interest me"; "What excites her will not be interesting, it will simply not be interesting." On the one hand, we could read this repetition as underscoring the judgment's phatic dimension: "interesting" as communicative static or noise, as an empty word sounded just to test the openness of the channel. On the other hand, it is as if the point of "Interesting" is to demonstrate that "interesting" has so much performative force that even in a story in which a judge repeatedly fails to find the discourse of others interesting, the narrative nonetheless feels saturated with interestingness. For all its dramatization of the act of not finding conversations or conversationalists interesting, in other words, we still feel that "Interesting" justifies its title. Indeed, the entire text of "Interesting" could be read as an effort to show itself as deserving of its eponymous judgment.

"Interesting" thus makes the feeling-based judgment of something as interesting seem paradoxically coextensive with its concept-based justification (a distinctive, logically secondary speech act) in a way that parallels Genette's account of all aesthetic predicates as compressions of evaluation and description. The conflation of judgment and justification staged in "Interesting" is in fact endemic to the use of "interesting" in ordinary conversation, where it is often used to implicitly invite others to demand that those who make this particular aesthetic judgment (already itself a performative demand) take the next step of explaining why. In addition to highlighting the affectivity and performative force of all aesthetic judgments (demands for agreement disguised as "neutral" statements of objective fact), the interesting thus calls attention to their specifically perlocutionary nature, or to the way in which the power to assess their accomplishment shifts from speaker to listener. Always calling for its confirmation by an implicit other (as if somehow aware of its incompleteness without it), the evaluation of interesting ensures the continued circulation of discourse (and information), lubricating the pathways of its intersubjective movement and exchange. In a much more explicit way than the beautiful, the interesting thus makes people's membership in multiple yet potentially overlapping discursive communities as transparent as "interests" themselves. For although interests always "emerge out of a

war of interests, a state of conflict that runs ahead of any specific goal, object, or program,"[165] as Arendt notes, they also "constitute, in the word's most literal significance, something which inter-est, which lies between people and therefore can relate and bind them together."[166]

Adrian Leverkühn's piano teacher in *Doctor Faustus* further underscores the interesting's ability to facilitate this binding—a "web" of social relationships mediated specifically by the circulation of discourse between subjects—just a few pages in the novel before the famous moment in which Leverkühn proclaims his preference for the quasi-scientific detachment of "interest" over passion ("love") as the ideal aesthetic attitude:

> Wendell Kretschmar honored the principle, which we repeatedly heard from his lips, first formed by the English tongue, that to arouse interest was not a question of the interest of others, but of our own; it could only be done, but then infallibly was, if one was fundamentally interested in a thing oneself, so that when one talked about it one could hardly help drawing others in, infecting them with it, and so creating an interest up to then not present or dreamed of. And that was worth a great deal more than catering to one already existent.[167]

Judging something "interesting"—the mere act of singling it out as somehow worthy of everyone's attention—is often the first step in actually making it so. As Mann's narrator puts it, talk of or about the interesting "infallibly" creates interest. Indeed, as Davis's manipulation of the discourse/story relation in "Interesting" wittily suggests, it seems to do so even when, in a certain sense, it does not. For this reason, the judgment "interesting" is explicitly pedagogical as well as performative: "If one was fundamentally interested in a thing, when one talked about it one could hardly help drawing others in, infecting them with it, and so creating an interest up to then not present or dreamed of."

The judgment of the interesting not only highlights but also protracts and extends the dialogic underpinnings of all taste. It thus seems no accident that this aesthetic category, which makes explicit the articulation of aesthetic and extra-aesthetic judgments underpinning all specifically aesthetic discourse, was first theorized by artist-critics (Schlegel, Diderot) who did much of their writing on the practice of their contemporaries in dialogue form. As in the case of Mann's novel, a highly discursive, conversation-driven text deeply informed by Adorno's theoretical ideas about music, the interesting can thus help us think more deeply about the role aesthetic judgments might play in criticism with explicitly extra-aesthetic goals. This question is one that this entire book raises insofar as in it I have repeatedly had to practice a kind of surreptitious judgment or

connoisseurship of my own: that is, to put forward specific objects of vary-
ing scale (and these exact objects as opposed to others) as particularly or
exemplarily cute, interesting, and zany—post-imagist poetry in Chapter
1; 1960s conceptual art in Chapter 2; certain films and television shows
in Chapter 3—even before advancing to any actual discussion of these
objects as particularly good examples of the aesthetic category being
analyzed.[168]

Coda

So, to conclude by more directly confronting a theoretical question that
all the readings of aesthetic categories in this book raise, but which the
style and judgment of interesting seems to embody in particular: how
exactly might aesthetic judgments inform criticism with extra-aesthetic
goals? What role, if any, might judgments of aesthetic value play in a self-
consciously "engaged" work of cultural criticism, in particular?

Alhough Jameson's *Postmodernism* is not often read as a work of aes-
thetic theory, its tour-de-force, 118-page conclusion, published almost a
decade after the article-length version of its much more famous introduc-
tion, tellingly opens with a discussion of this very problem. Jameson notes
how "despite the trouble I took in my principal essay on the subject to
explain how it was not possible . . . simply to celebrate postmodernism or
to 'disavow' it," his act of analysis was repeatedly mistaken as either a
positive or negative appraisal of the entire aesthetic phenomenon (297).
This confusion leads Jameson to more sharply differentiate three kinds of
intellectual activity: "taste," a practice performed by "old-fashioned critics
and cultural journalists" that involves appraisals ranging from personal
opinions to aesthetic judgments proper; "analysis," the "investigation of
the historical conditions of possibility of specific forms"; and the more
complex and explicitly sociopolitical work of "evaluation," with which
Jameson most closely identifies his own work as a Marxist critic.

> Many of these reactions [to *Postmodernism*] seemed to confuse taste (or
> opinion), analysis, and evaluation, three things I would have thought we had
> some interest in keeping separate. "Taste," in the loosest media sense of per-
> sonal preferences, would seem to correspond to what used to be notably and
> philosophically designated as "aesthetic judgment" (the change in codes and
> the barometrical fall in lexical dignity is at least one index of the displace-
> ment of traditional aesthetics and the transformation of the cultural sphere
> in modern times). "Analysis" I take to be that peculiar and rigorous conjunc-
> ture of formal and historical analysis that constitutes the specific task of liter-

ary and cultural study; to describe this further as the investigation of the historical conditions of possibility of specific forms may perhaps convey the way in which these twin perspectives (often thought to be irreconcilable or incommensurable in the past) can be said to constitute their object and thereby to be inseparable. Analysis in this sense can be seen to be a very different set of operations from a cultural journalism oriented around taste and opinion; what it would be now important to secure is the difference between such journalism—with its indispensable reviewing functions—and what I will call "evaluation," which no longer turns on whether a work is "good" (after the fashion of an older aesthetic judgment), but rather tries to keep alive (or to reinvent) assessments of a sociopolitical kind that interrogate the quality of social life itself by way of the text or individual work of art, or hazard an assessment of the political effects of cultural currents or movements with less utilitarianism and a greater sympathy for the dynamics of everyday life than the imprimaturs and indexes of earlier traditions. (298)

This may seem like a surprising tack for Jameson's inquiry to take. Although a much wider gulf would seem to separate contemporary practitioners of "taste" (journalists) from practitioners of "evaluation" (Marxist and other committed critics) than the latter from academics who do "analysis" or "literary and cultural study" (Jameson himself is a prime example of the frequent overlap between the last two groups), the significant difference for Jameson is not the more subtle and/or sociologically closer one between analysis and evaluation but rather between evaluation and taste. It is because taste and evaluation are overtly judgmental that the difference between them becomes "more important to secure."

The paragraph just quoted in which Jameson carefully differentiates taste, analysis, and evaluation is immediately followed by one in which he acknowledges the presence of judgments of taste in *Postmodernism*, though in a desultory way that seems intended to highlight their irrelevance:

As far as taste is concerned (and as readers of the preceding chapters will have become aware), culturally I write as a relatively enthusiastic consumer of postmodernism, at least some parts of it: I like the architecture and a lot of the newer visual work. . . . The music is not bad to listen to, or the poetry to read; the novel is the weakest of the newer cultural areas and is considerably excelled by its narrative counterparts in film and video (at least the high literary novel is; subgeneric narratives, however, are very good . . . My sense is that this is essentially a visual culture, wired for sound—but one where the linguistic element . . . is slack and flabby, and not to be made interesting without ingenuity, daring, and keen motivation.

These are tastes, giving rise to opinions; they have little to do with the analysis of the function of such a culture and how it got to be that way.

Mixed in among other aesthetic predicates ("slack," "flabby") and some purely evaluative verdicts ("not bad," "very good"), "interesting" is clearly being used here as a judgment of aesthetic quality. In case of any doubt, Jameson underscores his judging in his next sentence: "These are tastes, giving rise to opinions; they have little to do with the analysis of the function of such a culture and how it got to be that way." Indeed, "even the opinions are probably not satisfactory in this form, since the second thing people want to know, for the obvious contextual reason, is how this compares to an older modernism canon." Jameson accordingly reformulates his initial opinions to accommodate this comparison, though with little difference in the language of his assessment: "The architecture is generally a great improvement; the novels are much worse. Photography and video are incomparable (the latter for a very obvious reason indeed); also we're fortunate today in having interesting new painting to look at and poetry to read" (299). Here "interesting" stands out even more sharply in its aesthetic function, as the only semidescriptive predicate in a cloud of purely comparative verdicts ("worse," "incomparable").

The next sentence, which also introduces a new paragraph, is as follows:

> Music, however (after Schopenhauer, Nietzsche, and Thomas Mann), ought to lead us into something more interesting and complicated than mere opinion.

Suddenly, "interesting" no longer seems part of the aesthetic vocabulary of taste (or opinion), but rather the very sign of a movement beyond taste into the "more . . . complicated" realm of evaluation that the judgment clearly helps facilitate. Why is it music whose study might "lead us into something more interesting and complicated than mere opinion"? Because music "includes history in a more thoroughgoing and irrevocable fashion, since as background and mood stimulus, it mediates our historical past along with our private or existential one and can scarcely be woven out of the memory any longer" (299). Regardless of what we think of this particular argument, the very idea of a shift from mere judgments of taste (such as the finding of painting and poetry "interesting") to "something more interesting and complicated than mere opinion" (evaluation) allows Jameson to arrive at his final suggestion—that perhaps aesthetic evaluations of postmodernism are relevant to its theorization after all:

> We therefore begin to make some progress on turning our tastes into "postmodernism theory" when we step back and attend to the "system of fine arts"

itself: the ratio between the forms and the media (indeed, the very shape that "media" itself has taken on, supplanting form and genre alike), the way in which the generic system itself, as a restructuration and a new configuration (however minimally modified), expresses the postmodern, and through it, all the other things that are happening to us. (300)

By toggling between and thus helping the critic cross the divide between tastes and sociopolitical evaluations, "interesting" helps him arrive at the following conclusion: judgments of aesthetic value are not just more intimately related to sociopolitical evaluations than may initially appear; if they are performed at the proper scale (as when we "step back and attend to the 'system of fine arts' itself"), they can actually be "turned into" theory and criticism. What Jameson's text suggests about the feeling-based rather than concept-based judgment of "interesting" is that its very function is to produce an elision between different modes of evaluation, an elision facilitated precisely by the judgment's lack of descriptive or conceptual specificity.

Note how Jameson's use of the interesting to negotiate the relation among aesthetic taste, historical analysis, and sociopolitical evaluation overturns, along the way, certain presumptions we might have about the proper "unit" of aesthetic judgment. His text makes it clear that judgments of taste need not apply exclusively to individual artworks, as the canonical texts of philosophical aesthetics would seem to have it (for Kant in particular, the object of the pure judgment of taste is fundamentally singular), nor even just to bodies of work by an individual artist. As reflected by Jameson's remarks about the interestingness of contemporary poetry and painting, one's object of judgment can be as large as an entire genre or medium—a simple point that makes the link between aesthetic judgment and sociopolitical evaluation, which we entirely expect to land on larger or temporally and spatially distributed objects, even clearer.

Revolving as they do around eroticized disparities of power and the ideological repositioning of labor as play, the cute and the zany seem more overtly political than the interesting. Yet it is the interesting, surprisingly, that most directly addresses the question of how one links aesthetic judgments to political ones in the first place. Directly facilitated by the use of "interesting" in his writing, Jameson's argument about how aesthetic judgments might be transformed into theory could also be extended to our current repertoire of aesthetic categories. My wager in this book is that finding a way to grasp this historically specific configuration, if not exactly "system" of aesthetic categories, will be similarly salutary for

getting a handle on postmodernism (and "through it, all the other things that are happening to us"). If the first step in such a project is simply to notice which styles and judgments seem most central or pervasive, the next is to pursue the best explanation for why. This is the more specific quest on which the chapters that follow embark.

The Cuteness of the Avant-Garde

D RAWING ATTENTION to excuses and other emotionally complex speech acts—demands, apologies, compliments, insults—as sites for deeper philosophical investigation into the nature of action, J. L. Austin notes "how much it is to be wished that similar field work will soon be undertaken in, say, aesthetics; if only we could forget for a while about the beautiful and get down instead to the dainty and the dumpy."[1] In this oft-cited remark, Austin gestures at a general class of aesthetic judgments, broad enough to contain both the beautiful and the dumpy, but also at a less explicitly defined subclass of "minor" ones: aesthetic judgments marked, it would seem based on the examples Austin provides, by greater descriptive specificity, and by affects more equivocal, or weaker in intensity, than those associated with the beautiful. Gertrude Stein's unique way of "get[ting] down" to these less powerful aesthetic evaluations in *Tender Buttons* is not likely to be what Austin had in mind: "This which is so not winsome and not widened and really not so dipped as dainty and really dainty, very dainty, ordinarily, dainty, a dainty, not in that dainty and dainty."[2] Yet in this chapter I will be suggesting that poets working in Stein's modernist avant-garde tradition have had an ongoing interest in the subclass of aesthetic categories to which Austin's remark directly but only glancingly alludes. Indeed, I will be arguing that poets have had a particular stake in the meaning and function of "cute," an aesthetic response to the diminutive, the weak, and the subordinate (and as it turns out, an exact cross between the dainty and dumpy) that we might regard as particularly exemplary of the subclass of "minor" aesthetic judgments as a whole.

Before turning my focus fully on the cute, however—aesthetic par excellence of what Jacques Rancière calls the "sleep-filled life of consumption" induced by the "soft totalitarianism of the world of commercial culture"—I want to put some pressure on the very idea of "minor" aesthetic judgments, whose importance for aesthetic theory Austin strongly hints at but, in the end, does not really explain[3]. It seems especially important to do so given that this category or subcategory is by no means one of aesthetic philosophy's official concepts or themes.

Should descriptive judgments like "cute" even be regarded as distinctive aesthetic judgments, as opposed to mere vicissitudes or declensions of the judgment of beauty? Raised as a philosophical problem in the *Stanford Encyclopedia of Philosophy*'s entry "Aesthetic Judgment," the question seems almost willfully to ignore the empirical existence of the numerous, explicitly nonbeautiful aesthetic categories of our historical moment.[4] The difference between the cute and the beautiful can also seem somewhat obvious. As a response to familiar, homey objects imagined as unusually responsive to the subject's desire for an ever more intimate, sensuous relation to them, cuteness contains none of beauty's oft-noted references to novelty, singularity, or what Adorno calls "a sphere of untouchability."[5] Nor does the judgment of cute have any of the links to morality—indirect or direct—repeatedly ascribed to the judgment of the beautiful.[6] Indeed, in vivid contrast to beauty's continuing associations with fairness, symmetry, or proportion, the experience of cute depends entirely on the subject's affective response to an imbalance of power between herself and the object. Yet Burke characterizes beauty in terms virtually identical to those we have just ascribed to the cute in his *Philosophical Enquiry into the Origin of Our Ideas of the Sublime and Beautiful*. For Burke, beauty is precisely an affective response to powerlessness, to what we complacently "love" rather than "admire"[7] (showing "love" to be an emotion not incompatible with contempt),[8] and is aligned with "the idea of weakness and imperfection" brought out foremost by "the beauty of the female sex": "Women are very sensible of this; for which reason, they learn to lisp, to totter in their walk, to counterfeit weakness and even sickness."[9] Just as objects seem most cute when they seem sleepy, infirm, or disabled (as we shall see in more detail shortly), for Burke, "Beauty in distress is much the most affecting beauty" and is associated with an "inward sense" of "melting and languor" mirrored by a physical relaxation of the body: "The head reclines on one side; the eyelids are more closed than usual."[10] Indeed, as Frances Ferguson humorously notes, Burke's account of the beautiful as the weak, feminine, submissive, and sleepy seems infected with a certain "languor" of

its own: "Burke . . . has repeatedly been observed to droop in his dis-
cussion of the beautiful as if he could himself marshal little energy for
its easy pleasure."[11] The question as to whether minor aesthetic catego-
ries like cute are not just variations of beauty is thus not as silly as it
may at first seem. Particularly in comparison with the sublime (which
we admire because it has power over us),[12] beauty for Burke is already
cute, making "cute" seem merely like an alternative name for the same
judgment/experience.

With this in mind, consider the following pregnant, if aside-like, re-
mark from Kant's *Critique of Judgment:* "We often describe beautiful
objects of nature and art by names that seem to put a moral appreciation
at their basis. We call buildings or trees *majestic,* landscapes *laughing* or
gay; even colors are called *innocent, modest, tender,* because they excite
sensations which have something analogous to the consciousness of the
state of mind brought about by moral judgments."[13] Although the point
Kant is underscoring here is relatively straightforward (about the anal-
ogy between the aesthetic judgment of beauty and the moral judgment of
the good), the exact relationship between beauty and the other aesthetic
judgments in this sentence is surprisingly unclear. On the one hand, "ma-
jestic," "gay," "tender" and so on are explicitly described as alternative
"names" for the judgment of beauty. More than the word "beautiful"
itself, these names or synonyms for the same judgment or experience
"seem" to refer, or produce the verbal appearance or illusion of referring,
the object judged on the basis of feeling and therefore on solely aesthetic
grounds to an extra- or nonaesthetic judgment: here, a moral judgment
based on the principles of reason, as Kant makes explicit, as opposed to
an empirical judgment based on the concepts of the understanding. Yet
Kant seems to be using these judgments deliberately in conjunction
with specific kinds or classes of object—"majestic" for large physical
things like buildings and trees, but not for entities without size or exten-
sion like colors; "tender" for colors, but not for large, spatially extended
things like buildings and trees—in a way that suggests that they finally
cannot be synonyms for beauty. If "gay," "majestic," "tender," and so on
are just synonyms for beauty and not qualitatively different aesthetic
judgments or experiences (like the sublime or the disgusting), it cannot
matter what kind of object they describe; beauty for Kant is by definition
indifferent to the concept, purpose, and even existence of its object. Yet
Kant's text inadvertently suggests that it does matter, since in this sentence
the feeling-based judgments of "majestic" and "gay" seem genre-specific,
applicable to certain classes of object as opposed to others. It would there-
fore seem that these aesthetic judgments are "impure" or mixed with

nonaesthetic, conceptual content, in a way in which Kant's judgment of beauty is fundamentally not.

To be sure, Kant's discussion of the majestic, the gay, and the tender is extremely brief, and appears in just a glancing or paranthetical remark. Yet the tiny kink it produces in the flow of his larger argument usefully points to a surprising lack of explicit attention to the metacategory of "aesthetic categories"—that is, to the idea or concept of a highly variegated class of aesthetic categories—on the part of philosophical aesthetics overall. From Kant to Jean-François Lyotard, the tradition has been to build a theory of aesthetic judgment and experience by discussing one or two specific categories at a time, as opposed to making self-conscious reference to the concept of a spectrum or totality. In this manner, the very idea of a finite, historically delimited, highly variegated repertoire of aesthetic categories, and even debate about whether or not that repertoire is, in fact, finite, historically delimited, or variegated, ends up being strangely marginal to the canon of modern philosophical thought even as the problem of aesthetic variety and pluralism lies at the very inception of philosophical aesthetics as a discourse. In tandem with the rise of philosophical writing on new aesthetic categories that focus explicitly on their differences from the beautiful (Friedrich Schlegel on the interessante) or the sublime (Uvedale Price on the picturesque), the eighteenth century is rife with catalogs in which the beautiful and the sublime are discussed cheek by jowl alongside a number of less codified and/or prestigious categories: "magnificence," "elegance," "difficulty," "smoothness," and even "darkness," as in the case of Burke's *Philosophical Enquiry*.[14] Yet neither Burke's extensive catalog of aesthetic emotions nor Schlegel's theory of the modern aesthetic of the interesting seems to require a theoretical appeal to a concept or idea of aesthetic categories in general. "Aesthetic categories" as such do not receive focused attention—are not appealed to as a concept useful for the theorization of aesthetic judgment and experience in general—until strikingly late in the history of aesthetics; indeed, arguably not until Frank Sibley's 1959 essay "Aesthetic Concepts," which grapples not just with the idea of a variegated class of aesthetic categories but also with the curious relationship—or, more accurately, with the curious absence of a total nonrelationship—between aesthetic judgments and judgments of a cognitive or conceptual character.[15] Yet the very idea of "aesthetic categories"—not even to mention that of a subclass of "minor" ones—remains surprisingly marginal to philosophical aesthetics, continuing to lack the status of an official philosopheme.

Nearly every canonical work of aesthetic philosophy depends, at some initial stage, on an act of careful affective discrimination: the "comfortable and quasi-sexual relaxation" of beauty from the "fearful" negativity of the sublime (Burke); the "disinterested" pleasure of the beautiful from the pleasures of the sensationally agreeable and morally good (Kant); the feeling of "melting" beauty from "energetic" beauty (Schiller); the contrast between *plaisir* and *jouissance* (Barthes); Apollonian sereneness from Dionysian frenzy (Nietzsche).[16] This stands to reason given that aesthetic judgments are precisely judgments based on feelings as opposed to principles or concepts. Yet in spite of this, philosophers seem to have had little incentive to regard aesthetic judgments as a variegated class whose principle of internal variation might be tied to an affective spectrum, or to the relative weakness and/or power of the intensities underlying them. Kant does takes a moment in the "Analytic of the Sublime" (second Book of the first Part of the *Critique of Judgment*) to describe how affective states themselves can become aesthetic objects, differentiating "strenuous" from "languid" affections (the former are "aesthetically sublime," whereas the latter are "sensuously beautiful"), but this is not the same thing. For all its careful sorting out of passions, affections, and emotions, Kant's aesthetic system remains organized around two feeling-based judgments and their negations. Affective states can either be judged beautiful or not beautiful, sublime (as in the case of "enthusiasm") or nonsublime (as in the case of "hatred"). Indeed, in a remarkably long, detailed, lambasting discussion of the "tender" emotion to which one becomes "sentimental[ly]" disposed in "romances, lachrymose plays, [and] shallow moral precepts," and also in "forms of religion that "recommend a cringing, abject seeking of favor and ingratiation of ourselves," Kant noticeably stops short of giving this "tender" yet strangely powerful feeling of pleasure in one's own powerlessness a concept of its own, concluding only that it is "not compatible with any frame of mind that can be counted beautiful, still less with one which is to be counted sublime."[17] Burke's text is organized around an extensive inventory of passions varying in duration and intensity, but even here there is no effort to mark off a subclass of aesthetic categories on the basis of an affective gradient. Indeed, in spite of the prominent example of the Kantian sublime, there has been surprisingly little attention to how a class of judgments underwritten by mixed or even contradictory feelings might put interesting new pressures on the theory of aesthetic judgment in general, including the longstanding assumption that aesthetic judgments must always be based on a single and unequivocal feeling: "disinterestedness" or "conviction."[18] Surely there

are other feelings and/or combinations of feelings on which the appraisals of value or quality we feel compelled to share with others in public might be based?

Whether the idea of a finite, variegated class of aesthetic categories (and in particular, one based on a spectrum of historically specific feelings) is ultimately superfluous or useful for building a philosophy of aesthetic judgment, the idea of a subset of "minor" aesthetic categories seems markedly salient for the historical account of the rise of consumer aesthetics in the postwar United States and Europe, as corporate advocates in the rapidly expanding fields of design and advertising sought to show how "mass culture and high art could be reconciled in a radically commercialized Bauhaus venture."[19] Although this marriage of modernism and mass culture may have been "purged of all political and ideological implications concerning artistic intervention in collective social progress," as Benjamin Buchloh argues, the explosion of new, "lite" aesthetic categories either engineered or appropriated and refurbished by the postwar culture industries—the quaint, the wacky, the quirky, and the cool, for example—seems to offer these categories as encapsulations of some kind of reconciliation regardless. Indeed, what these aesthetic categories based on milder or equivocal feelings make explicit, in a way in which categories based on the powerful feelings evoked by rare experiences of art or nature cannot, is the continuousness and everydayness of our aesthetic relation to the often artfully designed, packaged, and advertised merchandise that surrounds us in our homes, in our workplaces, and on the street.

Yet rare aesthetic experiences underwritten by unequivocal feelings continue to be the dominant ones appealed to as models in contemporary theories of art. Theorists of the postmodern avant-garde, in particular, have been repeatedly drawn to Kant's account of the sublime: an aesthetic of sheer force or power explicitly not based on art nor even finally on nature, as Jean-François Lyotard provocatively argues.[20] Yet it is cuteness, a "soft" aesthetic emerging from the sphere of mass culture as opposed to high art and explicitly about the appeal of powerlessness as opposed to power, that seems best suited for the analysis of art as it develops in dialectical relation to commodity culture over the twentieth century. Indeed, if the slackening of tension between autonomous art and the commodity form is the one development that has arguably had the greatest impact on the development of twentieth-century art overall (and on changes in avant-garde theory and practice in particular), one might read the "relaxing" effect of cuteness as an allegory of the development

leading to its own eventual cultural hegemony. With all this in mind, let us finally embark on the analysis of this diminutive aesthetic: one that epitomizes the minorness of not just "minor aesthetic categories" but arguably all art in an age of high-tech simulacra and media spectacles.

Cute Willies

Nothing may seem less propitious for thinking about modernist avant-garde poetry than cuteness. In addition to its close ties with kitsch and the pleasures of easy consumption that Adorno referred to as "culinary,"[21] cuteness is an aesthetic much more evidently rooted in material commercial culture than in the language arts. And while the antisentimental avant-garde is conventionally imagined as hard and cutting edge, cute objects have no edge to speak of, being simple or formally noncomplex and deeply associated with the infantile, the feminine, and the unthreatening.

All these connotations can be glimpsed in the *Oxford English Dictionary*'s list of citations for "cute." Kicked off in 1857 by a female exclamation consisting of four short words (*Virginia Illustrated*: "'What cute little socks!' said the woman"), followed by a reference in 1900 to the style's perceived national specificity (*Daily News*: "A small and compact house, what the Americans would call 'cute'"), the pastiche also contains two Aldous Huxley quotations: "The tiny boy . . . looking almost indecently 'cute' in his claret-coloured doublet and starched ruff" (*Grey Eminence*, 1944) and "a French accent so strong, so indecently 'cute,' so reminiscent of the naughty-naughty twitterings of a Parisian miss on the English comedy stage" (*Time Must Have a Stop*, 1945).[22] While cuteness thus seems to have first emerged as a distinctive judgment and style in nineteenth-century America, the range of objects falling under its application appears to have expanded in the early and middle twentieth century, extending from small things to minor persons: the "tiny boy" and the young "miss." In tandem with this expansion, the value of cuteness seems to shift from unequivocally positive (charming socks) to negative or ambiguous (indecent boy).

Note the prominence of scare quotes in the selection of excerpts, as if to suggest a certain contempt for the word "cute" on the part of those who use it. Indeed, though our first impulse is to think of the cute in visual or tactile terms, the *OED*'s account interestingly directs our attention first and foremost to ways of speaking, both on the part of those who judge objects/persons as cute ("'What cute little socks!' *said the woman*"; "A

small and compact house, *what the Americans would call* 'cute' ") and on the part of cute objects or persons themselves (the "naughty-naughty twitterings of a Parisian miss"). Cuteness thus becomes identified in this sampler of quotations with a feminine and nationally specific way of using language, calling attention to the centrality of discourse (its compulsive use by aesthetic subjects to publicize or share their feelings) to aesthetic judgment in general. Indeed, if "twittering" is how we imagine the language of cute beings, cuteness seems to have a similar effect on the speech of the aesthetic judge. Cuteness generates ever more cuteness by drawing out "small-sized adjectives and diminutive ejaculations" from those who perceive it in others, as one nineteenth-century journalist notes about the female crowds attending what Lori Merish describes as the era's ultimate "cute" spectacle: the wedding of Lavinia Warren and "General Tom Thumb" Charles Stratton in 1863.[23]

Whether in response to socks or to large-scale, mass-mediated spectacles of public intimacy, cuteness solicits a regard of the commodity as an anthropomorphic being less powerful than the aesthetic subject, appealing specifically to us for protection and care. As Merish puts it, the cute "always in some sense designates a commodity in search of its mother," thus "grafting commodity desire onto a middle-class structure of familial, expressly maternal emotion" (186). As in the case of Huxley's tiny boy and Parisian miss, the cute object addresses us as if it were our child. Yet in a way that points to the fundamental equivocality of this address, the kind of tenderness or affection incited by the "almost indecently 'cute' " boy and "miss" is mixed with contempt and even a touch of disgust. The sentimentalism of cuteness is thus already cut with a streak of antisentimentality; it is linked to an absorptive mode of representation in which the "powerless are sympathized with and pitied" (191), but also, at the same time, to the theatrical category of the unsympathetic and/or repulsive "freak" (189). This is why, as Merish also argues, cuteness seems to be a disavowal—at once a repression and an acknowledgment—of otherness. On the one hand, it "stages the assimilation of the Other . . . into middle-class familial and emotional structures," transforming "transgressive subjects into beloved objects"; on the other, it exaggerates social difference, turning beloved subjects into transgressive objects (194). Similarly, if cuteness is a "realm of erotic regulation (the containment of child sexuality) that offers 'protection' from violence and exploitation' " (189), it is clearly also a way of bringing that sexuality out.[24]

While the cute has thus played an ongoing role in the commodification of social difference, Marx implies that there may be something "indecently 'cute' " about the commodity itself. The second chapter of the first

volume of *Capital,* "The Process of Exchange," opens with a comparison of the subject's relation to commodities to that of a man's relation to his children or wards: since commodities "cannot go to market and perform exchanges in their own right," Marx invites his readers to imagine themselves as their "guardians."[25] Abruptly shifting from this image of paternal benevolence to one of sexual violence, the text intensifies its satire by inviting us to imagine these helpless beings in need of adult supervision as objects of potential seduction or even rape: "Commodities . . . lack the power to resist man. If they are unwilling, he can use force; in other words, he can take possession of them" (178). In a footnote, Marx links this characterization of the commodity and its powerlessness to a literary representation of sexually available women: "In the twelfth century, so renowned for its piety, very delicate things often appear among these commodities. Thus a French poet of the period enumerates among the commodities to be found in the fair of Lendit, alongside clothing, shoes, leather, implements of cultivation, skins, etc., also *femmes folles de leur corps*" (the phrase means "wanton women," according to Ben Fowkes, 178n.1). Finally, Marx likens the commodity, now from the point of view of the other commodities with which it is always already in congress, to the female character of Maritornes from *Don Quixote,* sexually interchangeable with other women to the oblivious hero, who thus ends up becoming her lover in spite of her infamous lack of charm.[26] The mocking tone in which Marx makes these comparisons—one that immediately distances the speaker from his act of anthropomorphizing comparison even as that act is being performed—suggests that Marx may be presenting the commodity in what he pointedly wants the reader to recognize as an almost cutely or preciously anthropomorphizing, "story-time" way.[27]

As Marx uses his anthropomorphizing comparisons of the commodity to children and women to underscore, the "fetish character" of commodities is precisely this illusion of their animate personhood: one that marks a phantasmatic displacement of the sociality of human labor onto its products, who will appear to "confront" one another in exchange as if they had social lives of their own. Yet for all his distancing sarcasm, Marx seems compelled to repeat commodity fetishism's personification of the commodity, Barbara Johnson argues, in his very effort to demystify it as false belief.[28] This use of a personification whose "cuteness" Marx clearly wants to highlight and immediately express his disdain for, even as he cannot help but also make use of it, comes to a head when Marx asks his reader to imagine commodities speaking like child actors herded up on stage: "If commodities could speak, they would say this:

our use-value may interest men, but is no part of us as objects. What does belong to us as objects . . . is our value. Our own intercourse as commodities proves it. We relate to each other merely as exchange-values."[29] Forcing his reader to mentally act out a scene in which commodities themselves are compelled to act out or recite lines, Marx's account dramatizes how human producers of commodities come to empathize with the commodity or perceive it from what they imagine to be its own perspective on itself: as an object defined entirely by its "social" relation to other objects in exchange. As the product of concrete human labor, the commodity has use-value but is in a paradoxical way indifferent to it; as Marx notes, "use-values are only realized in use or in consumption," not in the act of exchange that makes them commodities proper.[30] This is why, even though there can be no exchange-value without use-value, Marx as an analyst of the abstraction of labor power or socially necessary labor time as the key to capitalist accumulation in *Capital* actually has very little to say about use-value or the phenomenology of labor per se.[31]

Noting how Marx makes commodities speak precisely in order to make them confess the illusion of animation they promote, Johnson suggests that "this scene of prosopopeia is . . . a sign that the very thing [Marx] is arguing for is too strong for him."[32] One could infer from this that it is difficult to critique the fetishism of commodities—however contemptuously regarded by Marx as an "ersatz" theory borrowed from racist nineteenth-century ethnography, as Keston Sutherland argues, which literary critics have therefore made the mistake of taking seriously—without somehow entering into its logic.[33] We could also read the moment as an effort on Marx's part to underscore the objectivity of the fantasy that the kitsch theory of fetishism enables him to describe, giving us a better picture both of the illusion qua illusion and of how intimately the subject of capital comes to inhabit it. In other words, fetishism's fantasy of animation may be totally kitschy (like the pseudo-theory of fetishism itself, according to Sutherland), yet like the cute object, as Johnson notes, it seems to be "irresistible."[34] Indeed, Marx stresses that the fantasy is compulsory: it "attaches itself to the products of labor as soon as they are produced as commodities and is therefore inseparable from the production of commodities."[35]

Cuteness might be regarded as an intensification of commodity fetishism's kitschy phantasmatic logic but also as a way of revising it by adding yet another layer of fantasy. For as an aesthetic in which the object is imagined not just as an animated being but as one inviting the aesthetic

subject to handle it physically, the cute speaks to a desire to recover what Marx calls the "coarsely sensuous objectivity of commodities as physical objects" that becomes immediately extinguished in exchange.[36] Cuteness is thus a kind of consumer fetishism redoubled; it tries to seize hold of and manipulate, as its "raw material," the unavoidable fantasy of fetishism, itself already an effort to find an imaginary solution to the irresolvable "contradiction between phenomenon and fungibility" in the commodity form (as Adorno puts it in *Minima Moralia*).[37] Although cuteness retains fetishism's overarching illusion (that of the object's animate qualities), it actually wants to deny what, in Marx, these animated commodities go on to say: "Our use-value may interest men, but is no part of us as objects. . . . We relate to each other merely as exchange values." It is precisely the qualitative, phenomenological experience of "use"—occulted by the commodity form much in the same way as labor power occults the qualitative, phenomenological experience of labor—that cuteness attempts phantasmatically to recover at the level of consumption. For as pure "value," the commodity is no longer legible as the product of any concrete form of labor but becomes reduced to what Marx calls "human labor in the abstract"; it thus becomes, in a way eerily mirrored by the blobbishness of the prototypically cute object, a "merely congealed quantit[y] of homogeneous labor."[38]

In its effort to retrieve the "coarsely sensuous objectivity" of the commodity, cuteness thus participates in what Adorno calls "the utopia of the qualitative," a utopia that "takes refuge under capitalism in the traits of fetishism" and therefore shares its uncanny features.[39] As Robert Creeley's three-word poem "The Willys" dramatizes, even the money commodity—the most immediate embodiment of exchange value, according to Marx, or the commodity whose use resides precisely in its exchangeability—can be cutely fetishized, with shiver-producing, even skin-crawling effects:

> Little
> dollar
> bills.

From the diminutive form of the poem and the diminutive meaning of its language to the diminutive nature of the eponymous affect that the poem seems to want to enact or produce ("willies" being precisely a lesser or weaker form of fear or disgust), what is at once cute and slightly repulsive about "The Willys" is its aggressive insistence on applying the phenomenological thing-quality of "littleness" to the medium of

exchange itself. In this manner, the littleness of the poem, while typical of Creeley and other postobjectivist poets working in the wake of "Willy" Carlos Williams, comes to take on an uncanny tinge, as if Creeley were catachrestically "abusing" the idea of exchangeability in order to make his own poetic/objectivist heritage seem strange.[40]

The commodity aesthetic of cuteness is thus a kind of commodity fetishism, but with an extra twist. For while Marx's account emphasizes the phantasmatic intercourse of commodities with other commodities ("confronting" not their human producers but one another in exchange), cuteness revolves around the fantasy of a commodity addressing its "guardian" in the one-on-one, intimate manner associated with lyric poetry. The cute commodity flatteringly seems to want us and only us as its mommy, as Merish underscores; conversely, in a perfect mirroring of its desire, as if we had already put ourselves in its shoes, we as adoptive "guardians" seem to "choose" it. The cute commodity, for all its pathos of powerlessness, is thus capable of making surprisingly powerful demands; as Johnson notes, the purchaser is often "seduced into feeling that buying the product is, in fact, carrying out the wishes of the product itself."[41] The feelings that underpin and traverse cuteness, a sentimental desire for a simpler and more sensuous, more concrete relation to commodities, are thus more multiple and complex than they may initially seem.

Let us now delve further into these feelings by considering, as a ready-at-hand example, the frog-shaped sponge or baby's bath toy shown in Figure 2. With its enormous face (it is in fact nothing but face) and exaggerated gaze (but interestingly no mouth), the bath toy underscores the centrality of anthropomorphism to cuteness. Yet what is striking is how crudely simplified the sponge's features are, as if cuteness were a commercial as opposed to high-modernist primitivism. Realist verisimilitude and formal precision tend to work against or even nullify cuteness, which becomes most pronounced in objects with simple round contours and little or no ornamentation or detail.[42] By this logic, the epitome of the cute would be an undifferentiated blob of soft doughy matter. Since cuteness is an aestheticization of powerlessness ("what we love because it submits to us"), and since soft contours suggest pliancy or responsiveness to the will of others, the less formally articulated the commodity, the cuter.[43] The bath sponge makes this especially clear because its purpose is to be pressed against a baby's body and squished in a way guaranteed to repeatedly crush and deform its already somewhat formless face.

The nonaesthetic properties associated with cuteness—smallness, compactness, formal simplicity, softness or pliancy—thus call up a range of

a b

FIGURE 2

minor negative affects: helplessness, pitifulness, and even despondency. Cuteness might also be said to epitomize the process of affective "objectification" by which all aesthetic judgments are formed.[44] In cuteness it is crucial that the object has some sort of imposed-on mien—that is, that it bears the look of an object unusually responsive to and thus easily shaped or deformed by the subject's feeling or attitude toward it. Although a glamorous object must not have this mien or aspect—in fact, the meta-aspect of looking as if its glamour were being imposed on it would instantly shatter its aura of cool self-sufficiency and thus its glamour—the subject's latent awareness, as she coos at her cute object, that she may in fact be imposing that cuteness upon it is likely to augment rather than detract from her aesthetic experience of it as cute. If aestheticization is always, at the bottom line, objectification (of our subjective feelings and the evaluations underpinned by them), the latter in turn seems epitomized by cutification: the more objectified the object, or the more visibly shaped by the affective demands and/or projections of the subject, the cuter.

Indeed, as Daniel Harris notes, the cute object's exaggerated passivity seems likely to excite the consumer's sadism or desire for mastery as much as her desire to protect and cuddle. Citing the example of Little Mutt, "a teddy bear with a gameleg that a British manufacturer has even fitted with an orthopedic boot," Harris notes how "the process of conveying cuteness to the viewer disempowers its objects, forcing them into ridiculous situations and making them appear more ignorant and vulnerable than they really are." Hence things are cutest when "in the middle of a pratfall or a blunder: Winnie the Pooh, with his snout stuck in the

hive . . . Love-a-Lot Bear, in the movie *The Care Bears,* who stares disconsolately out at us with a paint bucket overturned on his head";[45] or when they appear injured or damaged, like the coffee cup in Russell Edson's "The Fight," which in the last stanza finally surrenders to the man with whom it has been struggling: "The cup cried, don't hurt me, please don't hurt me; I am without mobility, I have no defense save my utility; use me to hold your coffee."[46] If cuteness "in distress" is the "most affecting" cuteness (as we might imagine Burke saying), Edson's prose poems repeatedly dramatize this by featuring mutilated objects crying or squealing or running away from things: the weeping/bleeding eggs in "The Wounded Breakfast," the pitiable hogs crying "only hogs, only hogs" in "A Performance at Hog Theater."[47]

The qualitative and quantitative sides of the commodity cannot be pried apart; in the narrative of *Capital,* as Fredric Jameson notes, their fundamental opposition, set in motion with the act of exchange, seems to give rise to all the other contradictions of capital.[48] By returning us to a simpler, sensuous world of domestic use and consumption, populated exclusively by children and their intimate guardians, cuteness is the pastoral fantasy that, somehow, the commodity's qualitative side as use-value, or as a product of concrete, phenomenological labor, can be extracted and therefore "rescued." Yet this romantic fantasy requires force, a willfulness of imagination arguably reflected in the physical distortions of cute form. "We may twist and turn a single commodity as we wish," Marx writes in his storytelling voice; "it remains impossible to grasp it as a thing possessing value."[49] The desire to fondle and squeeze the object that cuteness similarly elicits—even to the point of crushing or damaging that object—might thus be read as an effort to "grasp" the commodity as a product of concrete human labor. It is as if, in a society fully governed by the rule of exchange, phantasmatically recovering the commodity's occulted use-value, or what Marx calls its "plain" and "homely" form, requires so much counterfactual force on the part of the imagination that "use" can be made visible only in the melodramatic mode of "abuse."[50] Precisely because the qualities of the commodity seem to disappear right in front of us, our need to "twist and turn" its physical body intensifies, as if to foreground how a certain degree of mental violence becomes necessary for regaining intimacy with its phenomenal form.

The commodity's irresolvable split between phenomenon and fungibility thus provides the best explanation of why cuteness activates both our empathy and our aversion. The desire for intimacy with the cute object is linked to a fantasy of rescuing the commodity's phenomenological

side and the concrete, differentiated acts of labor that its "use-value" encodes (including even acts of marketing, which while creating no additional surplus value play a dominant role in shaping what culture perceives as "useful" and how). Yet, in exchange, the abstraction of "value" turns these products of differentiated labor into "merely congealed quantities of homogeneous labor, i.e. of human labor power expended without regard to the form of its expenditure."[51] It is tempting here to read the relatively formless or undifferentiated form of the cute object as an emblem of this "congealed" mass of "homogeneous labor." Yet as Keston Sutherland argues, Marx's term for describing interchangeable abstract labor power, *Gallerte,* is not an abstract noun (making "congealed quantities" an unforgivable error in translation, in Sutherland's view) but a specific food product, an aspic or jelly made from the ground-up body parts of animals.[52] Sutherland continues, "Marx's German readers will not only have bought *Gallerte,* they will have eaten it; and in using the name of this particular commodity to describe . . . [undifferentiated] human labor, Marx's intention is not simply to educate his readers but also to disgust them." Given how the prototypically cute object evokes the same kind of soft squishy form associated with gelatinous matter, we can see how our desire to cuddle with the commodity might often be shadowed by a tiny feeling of repugnance. As Stein puts it in *Tender Buttons,* "A little called anything shows shudders."[53]

As noted earlier, our desire for the cute commodity mirrors the desire it appears to have for us, a mimesis repeated in the compulsion to imitate the "soft" properties of the object in our speech. Conflating desire with identification, or "wanting to have" with "wanting to be or be like," as Merish notes,[54] the experience of cuteness thus produces what Mary Anne Doane describes as a "strange constriction of the gap between consumer and commodity," a shrinking of distance that, like the affect of empathy which indexes it, is strongly aligned with the feminine.[55] Perhaps no work of poetry underscores this better than Harryette Mullen's *Trimmings,* a series of prose poems about women's fashion in homage to the "Objects" section of Stein's *Tender Buttons.* Mullen's use of furs, panties, brassieres, stockings, belts, shoes, and other typically fetishized garments as metonymies for the female body—a figure of closeness or contiguity central to the working of Mullen's favorite linguistic device, the pun—evokes the same intimacy between consumer and commodity epitomized by the cute:[56]

Hand in glove hankers, waves a white flag. Hand to mouth surrenders, flirts with hanky-panky. (56)

If in this poem it is difficult to distinguish the accessory (glove or hand-kerchief) from the body of the woman wearing it (a body itself only visible as parts, as a hand and as a mouth), it is similarly hard to separate its gestures of female powerlessness ("hand to mouth surrenders") from its imagery of sexual eroticism ("flirts with hanky-panky"). We see a similar gendering of cuteness's bad mimesis in the following "fur piece":

> Animal pelts, little minks, skins, tail. Fur flies. Pet smitten, smooth beaver strikes. Muff, soft, "like rabbits." Fine fox stole, furtive hiding. Down the road a pretty fur piece. (48)

Here the language of women's clothing (muff, beaver, tail, fox) doubles as an overtly sexualized, quasi-pejorative language for the bodies of those who wear it (muff, beaver, tail, fox). *Trimmings* thus underscores the way in which "commodity and consumer share the same attributes—appeal to the eye and an empathetic relation to the other—and become indistin-guishable" (Doane, *Desire to Desire,* 32). If, as Merish notes, "appreciating the cute—loving the 'adorable' as culturally defined—entails a structure of identification, wanting to be *like* the cute" (186), it stands to reason that this unusually mimetic aesthetic plays a prominent role in Mullen's explo-ration of the intimacies among gender, clothing, and language.[57] Mullen's subsequent book in her series of tributes to Stein, *S*PeRM**K*T,* a reworking of the "Food" section from *Tender Buttons,* gives us a world of fully stocked consumer plentitude, in which "ad infinitum, perpetual infants goo" (93), "swinging burgers do a soft-shoe" (85), and "some giggling lump of dough, an infantile chef, smiles animatedly at his fresh little sis" (85). In a much more explicit and consistent way than in *Trim-mings,* here one encounters the commodity mediated always by its ad-vertising, and by the advertising genre of the jingle in particular: short, compact, sonorous "bites" of language carefully crafted to be compelling in a way not unlike the poems in *S*PeRM**K*T* themselves. "Aren't you glad you use petroleum?" (69).

Given these associations, it is easy to understand why critics have gone to lengths to avoid the subject of cuteness in the poetry of Stein herself, for they are the same associations repeatedly summoned, by con-temporary reviewers such as H. L. Mencken forward, to reduce Stein's writing to the "naughty-naughty twitterings" of the Mother Goose of Montparnasse, or to what Wyndham Lewis called Stein's "child-personality" and the "child cult" of early twentieth-century modernism in general.[58] Lewis invoked this child cult across his writings, Mark

McGurl notes, as "evidence of the permeation of even the most 'intellectualist' literary projects, such as Gertrude Stein's, by the 'hysterical imbecility' of the mass market"—a realm offering a glut of amusements and identified with sentimentality, preciousness, and the "complete absence of anything observably threatening."[59] Yet, as we have already in some ways begun to see, cuteness's relationship to powerlessness is more complex than it seems. Even in Lewis's savage indictment of cuteness in "Sub Persona Infantis," a cluster of thematically linked essays in *The Art of Being Ruled,* one can detect a note of grudging admiration for the way in which this "child cult" aesthetic puts its displays of weakness to powerful or strategic use:

> When a feminine figure in a costume symbolizing the tenderest years, clinging to a protective arm, in some pastiche of an antiquated relationship, catches sight of a floating mass of air-balls and, capering ecstatically, pleads with her companion, "Oh! Pease, pease, do buy me an air-ball: that lovely gween one!" a situation of probably Mousterian antiquity is reproduced for whoever happens to be observing the display. It is unfortunate, but there it is: people manufacture such pictures and situations out of their sexual interplay, to serve a social rather than sexual vanity.[60]

Marked by a "softened" or lisping, onomatopoeic speech brought out by the allure of the commodity, cuteness for Lewis is linked not only to commodity desire but also to its role in the radical breakdown of traditional familial forms like the generation, with the divide between parent and child collapsed in the figure of the monstrously childlike woman in the same way as the gap between consumer and commodity.[61] Moreover, as Lewis notes in language anticipating Hannah Arendt's indictment of modern poetry's "enchantment with 'small things,'" the rise of the twentieth-century child cult reflects "political decay, the sopping-up and closing-down of the great traditional vents for ambition, and the overthrow of any 'public life' that could claim . . . significance."[62] Cuteness or child cult thus reflects, and seems to legitimate by aestheticizing, a saying no to political power that Lewis finds contemptible. Indeed, cuteness thus seems to be "part of . . . the solution of the problem of 'power,'" since "to make everybody 'like unto little children' is not such a bad way (to start with) of disposing of them."[63] For this reason, as Lewis clarifies in "The Children of Peter Pan," "Were we . . . able to give effect and a lovely concrete shape to our obsessions, we should have our towns at present full of large statues of little children. Every variety of baby boy and baby girl would ogle us from their pedestals."[64]

For Stein herself, as we will see in more detail later, cuteness is any-
thing but precious or safe. The tendency of well-meaning literary critics
to overcorrect in this direction, refusing to acknowledge, even in the case
of a work titled *Tender Buttons,* that there may in fact be something "in-
decently 'cute'" about Stein's writing, points to an embarrassment cute-
ness also increasingly comes to pose to poetry in the twentieth century. As
a genre predominantly if not always correctly associated with unusually
short or condensed texts and also with unusually "tender" or vulnera-
ble speech, modern poetry has been continually forced to negotiate its
relationship to this minor aesthetic category in a way in which the novel
and epic have not. This is especially the case for two subgenres of poetry
that occasionally overlap: lyric poetry, described by Adorno as "the most
delicate, the most fragile thing that exists,"[65] and the imagist and post-
imagist tradition of poems in plain or colloquial language centered on
small everyday things: William Carlos Williams's plums, Frank O'Hara's
charms, Lorine Niedecker's granite pail, George Oppen's single brick,
John Ashbery's cocoa tins, Bernadette Mayer's puffed-wheat cereal,
Thomas Sayers Ellis's balloon dog, and Rae Armantrout's cat, bubble
wrap, and "rubber band, chapstick, tin- / foil, this pen, things / made for
our use."[66]

To be sure, there is nothing particularly cute about Pound's *Cantos,*
Ginsberg's jeremiadic *Howl,* or large-scale "world poems" like Louis
Zukofsky's *A* or Nathaniel Mackey's *Song of the Andoumboulou.*[67] But
short, thing-oriented poetry in the imagist and objectivist traditions of
early Pound, Williams, and Oppen—poems that, for all their seeming dis-
like of metaphor, often invite us to draw metaphorical comparisons
between themselves and the objects they describe—does seem acutely
self-conscious about its relation to cuteness. As Rae Armantrout notes in
"Ongoing," "When an effort / was a small engine // then I loved it / like a
mommy."[68] If the "small engine" from the children's book *The Little
Engine That Could* serves here as a metaphorical "vehicle" for "effort" (as
the poem bluntly informs us, "laying bare the device"), "effort" could in
turn be read as a vehicle for metaphor. Echoing Williams's famous descrip-
tion of a poem as a "small . . . machine made of words," it is "metaphor"
that the poem subsequently puts in the position of the cute device (the
"small engine") driving "Ongoing" forward.[69] Poetic cuteness—affection
for a poetic device simultaneously distrusted as infantile or infantilizing,
or for turning poets significantly not into mothers but "momm[ies]"—is
thus something that "Ongoing" is compelled to grapple with as Arman-
trout both lovingly toys with metaphor and seems compelled to register
a kind of disdain for it.[70]

In a similar vein, Russell Edson's poem "The Toy-Maker" seems to offer a take on twentieth-century poetry's proclivity for a poeisis of "small things":

> A toy-maker made a toy wife and a toy child. He made a toy house and some toy years.
>
> He made a getting-old toy, and he made a dying toy.
>
> The toy-maker made a toy heaven and a toy god.
>
> But, best of all, he liked making toy shit.

Echoing cuteness's constriction of the gap between consumer and commodity, this poem shortens, then lengthens, then finally again shortens the distance between maker and product. Since we are encouraged to read "wife" in "toy wife" as his wife, in the first two lines the male toymaker seems to belong to the same world as his products. But as the list of "toys" begins extending beyond the domestic framework into a metaphysical realm (from "wife" and "house" to "dying," "heaven," and "god"), the distance between maker and product suddenly opens out into a surreal gulf, only to be abruptly reduced again with the "making" of "shit," a word that in its vernacular connotation of "generic/undifferentiated stuff" ends up consolidating all the poem's other images into a single one. Implying also a vague and imprecise relation to objects in the world ("I've got a lot of shit to do") as well as events that are unpleasant yet also, in the ultimate flow of things, inconsequential or ephemeral ("shit happens"), the tiny "shit" nonetheless ends up being the most powerful "toy" in the poem. There is also, of course, the fecal meaning of shit as something one "makes," with this particular image of "making" once again collapsing the distance between toymaker and toy. It would be a toy being who logically would "make," not in the sense of crafting but of excreting, "toy shit." The poem thus toys with how our very ideas about poetry fluctuate between the grandiose and the abject, or between *poieisis* and poo.[71]

Edson provides us with an even cuter (if also grosser) account of poiesis in "The Melting," which begins with a woman who "likes to melt her husband."[72]

> She puts him in a melting device, and he pours out the other end in a hot bloody syrup, which she catches in a series of little husband molds.
>
> What splatters on the floor the dog licks up.

When they have set she has seventeen little husbands. One she throws to the dog because the genitals didn't set right; too much like a vulva because of an air bubble.

Then there are sixteen naked little husbands standing in a row across the kitchen table.

She diddles them and they produce sixteen little erections.

She thinks she might melt her husband again. She likes melting him.

She might pour him into an even smaller series of husband molds. . . .

If cuteness is a way of sexualizing beings and simultaneously rendering them unthreatening, "The Melting" makes the aggressive dimension of this activity explicit. Equating poiesis with domestic activity that is erotic and violent—a process of melting, reducing, congealing, and diddling one's material—the poem is also a testament to that material's ability to cheerily survive its violent miniaturization: "sixteen naked little husbands standing in a row across the kitchen table."

Edson's allegories of poiesis as cutification, or as a process that approximates making candy, underscores the cute's linkage to the acts of consumption, running from "tasteful savoring" to "physical devouring," that Adorno argues brings art into an uncomfortable proximity to "cuisine and pornography."[73] Armantrout makes use of cuteness to flirt with this proximity in "Scumble":[74]

What if I were turned on by seemingly innocent words such as "scumble," "pinky," or "extrapolate"?

What if I maneuvered conversation in the hope that others would pronounce these words?

Perhaps the excitement would come from the way the other person touched them lightly and carelessly with his tongue.

What if "of" were such a hot button?

"Scumble of bushes."

What if there were a hidden pleasure
in calling one thing
by another's name?

As an erotic savoring of "seemingly innocent" words, and as an act of verbal "maneuvering" intended to induce the same excitement in others, this poem directly plays with the idea of poetry as indirect language as sex,

ending with a comment on the eroticism of its own erotic euphemisms. Indeed, "scumble," a technical word in painting for softening the outlines of an existing form or image by rubbing over it with another color, is rather neatly also a euphemism for euphemism, the "hidden pleasure / in calling one thing / by another's name." Armantrout's poetic scumbling of "hot buttons" thus calls attention to an entire cluster of cute semes: the eroticization of the "seemingly innocent," the softening or scumbling of linguistic form, and a preoccupation with lowly poetic devices such as euphemism, innuendo, and pun.

If, in this manner, cuteness surprisingly throws certain aspects of modern poetry into particular relief, modern poetry, as we have slowly and really only just begun to see, brings out a darker and much more complicated account of cuteness. Before deepening our discussion of the intimacy between the style of cuteness and verbal art forms—an intimacy mediated by decades of state-of-the-art advertising—it will be useful to dig a little deeper into the material commercial and/or visual domains of culture in which cuteness always seems more intuitively prominent.

"False Simplicity"

Although cuteness is now integrated into the design of everything from cups to cars, it is still an aesthetic foremost aligned with playthings designed for children. In a series of review essays on toys and the European fascination with their history written in the late 1920s, Walter Benjamin notes that before the nineteenth century, toys were not made or sold by specialized toymakers, but rather by wood-carvers, boilermakers, candlemakers, confectioners, turners, ironmongers, and papermakers. Of these toys for children originally displayed and marketed alongside goods for adults, Benjamin singles out one sold by confectionary shops, consisting of a motto or sound bite of rhyming language surrounded by an anthropomorphized cookie:

> These were flat sugar dolls (or hearts or similar objects) which could be divided easily lengthways, so that in the middle, where the two halves were joined together, there was a little piece of paper with a brightly colored picture and motto. An uncut broadsheet is on display with examples of such confectioner's mottoes. For instance: "I have danced away / My weekly wage today." Or: "Here, you little flirt, / This apricot won't hurt." Such lapidary two-liners were called "devices" because you had to divide the figurine into two parts in order to uncover the motto.[75]

What could be cuter than a poetic "device" or "lapidary two-liner," when nestled snugly inside a cookie? Here we have cuteness emerging literally at the intersection of poem, food, and simplified anthropomorphic figure.

Yet Benjamin is struck by how relatively long it takes for "simplicity" to take hold as an aesthetic ideal for toy design. Citing toy historian Karl Gröber on contemporary German children's preference for the "baby in swaddling clothes" as opposed to dolls dressed in adult garb, Benjamin notes that the demand for "simplicity" in children's toys did not arise until well into the nineteenth century, with the industrialization of toy manu-facturing. "Simple" toys are thus, ironically, products of an industrially advanced age, compelling Benjamin to suggest that we reconceive the aes-thetic idea of "simplicity" less in terms of stylistic criteria than as a factor of means of production; less according to the formal design of the object than in terms of its "materials and technology." Benjamin proceeds to contrast the "genuine and self-evident simplicity" of toys made in the pre-industrial era, when one could still "find carvings of animals at the wood-worker's shop, tin soldiers at the boilermaker's, gum-resin figurines at the confectioner's, and wax dolls at the candlemaker's" with the "false sim-plicity of the modern toy."[76] Although the modern toy, made of softer substances with fewer intricate parts, might seem cuter by contemporary standards, it is clearly cuteness or something like it that Benjamin seems to mean by "false simplicity." The genuinely simple toy, by contrast, bears witness to its process of making in an overt or transparent way (114). At the same time, Benjamin concedes that the modern toy's merely formal (and therefore false) simplicity may have been founded on an "authentic longing to rediscover the relationship with the primitive, to recuperate the style of a home-based industry that at this very time was locked in an increasingly hopeless struggle [with the forces of industrialization]" (114).[77] "Simplicity" (or the desire for it) for Benjamin is thus less simple than it seems, a point he underscores further with the example of folk art, "primitive technology combined with cruder materials" that actually strives to copy "sophisticated technology combined with expensive materials" (119). Noting how "porcelain from the great czarist factories in Russian villages provided the model for doll and genre scenes carved in wood," Benjamin suggests that "so-called folk art is . . . nothing more than the cultural goods of a ruling class that have trickled down and been given a new lease on life within the framework of a broad collective" (119).

In these "doll and genre scenes carved in wood," we can see the link between folk art and kitsch, described by Benjamin in less pejorative terms in a later unpublished fragment ("Some Remarks on Folk Art") as two sides of a "single great movement . . . behind the back of what is known as great art."[78] Exemplified here by "pictures in children's books," both cute kitsch and folk art have a "primitive" quality that solicits a powerful centripetal pull or even a phantasmatic "incorporation" of the aesthetic subject into the object (278). Precisely because the work of kitsch seems

to "address him only," with an intimacy not unlike that of lyric address, the aesthetic subject does not perceive it from a contemplative distance "like a bystander" but rather experiences or inhabits it like an atmosphere, one enveloping him like a coat (278) or pulled over his head like a mask (279).[79] Thus while "art teaches us to look into objects," folk art and cute kitsch "allow us to look outward from within objects" (279). Benjamin's reading provocatively suggests that the soulful gaze of the cute commodity—the ultimate bearer of "false simplicity"—represents *our* gaze, our "look[ing] outward from within": a sign of our own compulsive mimetic identification with the object in response to its unusually intimate address. Yet in other writings Benjamin says a similar thing about "genuinely" simple toys, arguing that these objects invite children to identify with inanimate objects such as "a windmill and a train."[80] Benjamin writes, "Imitation . . . is at home in the playing, not in the plaything," thus locating mimesis not in the object but in the subject.[81] The behavior Benjamin associates with the child playing with the "genuinely simple" toy, which he describes in anthropological terms as "nothing but a rudiment of the once powerful compulsion to become similar and to behave mimetically," is thus exactly the same kind that the "false simplicity" associated with kitsch, folk art, and the modern cute toy elicits. Both seem to speak to, or to complete or call forth, the same mimetic power or faculty on the part of the aesthetic subject.

As many others have done, Benjamin writes about how changes in the overarching aesthetic of toys correspond to changing conceptions of childhood, noting that "it took a long time before people realized, let alone incorporated the idea into dolls, that children are not just men and women on a reduced scale."[82] He adds, "It sometimes looks as if our century wishes to take this development one step further and, far from regarding children as little men and women, has reservations about thinking of them as human beings at all. People have now discovered the grotesque, cruel, grim side of children's life" (101). The hegemony of cuteness in American toy design certainly seems to bear witness to this claim. The emergence of that particularly exemplary cute object, the stuffed animal or manufactured plush toy, for example, can be easily traced to a newfound awareness of the aggressiveness of children that arose with the advent of twentieth-century psychology.[83] Counterintuitively, the turn to soft materials so crucial for the cute toy's demeanor of vulnerability and powerlessness is here precipitated by the need to make toys tougher, more capable of surviving rough use or abuse. It was only once children were no longer imagined as miniature adults, as they were in the eighteenth century, or as naturally moral or virtuous creatures, as they were for a good part of the nineteenth, that manufacturers found the impetus

to produce indestructible toys that could survive the violence with which children were increasingly associated.

It is significant to note, however, the relatively late appearance of the plush toy in the history of American toy manufacturing. Although home-made rag dolls had been used to teach domestic skills to girls since the colonial period, in the decades after the Civil War that marked the emergence of the American toy industry proper, commercially manufactured dolls were made almost solely of hard materials, with easily breakable, finely painted bisque heads mounted on bodies made of wood, pewter, steel, and even "electroplated sheet metal."[84] Like the fully jointed, highly ornate, talking Big Beauty advertised by the American Mechanical Doll Works Company in 1895 (Fig. 3), most of these dolls were also mechanical or machinelike and easily breakable—which is to say, by contemporary standards, not particularly cute. As Miriam Formanek-Brunell argues, the preferences in late nineteenth-century doll design for hard substances and for capturing the movements of the human body rather than its feel or texture were less a result of the American toy industry's attempt to adjust to changing conceptions of the modern child than a reflection of a business economy dominated by male entrepreneurs fascinated with technology and the scientific management of production processes—including Thomas Edison, who had his own factory for the manufacture of phonographic Talking Dolls.[85] Formanek-Brunell contrasts the scientific management of this toy industry with the "maternal materialism" of female Progressive Era dollmakers such as Martha Chase, who finally reintroduced "softness, portability, durability [and] safety" as values into the American toy market through the mass manufacturing of cloth and stockinet dolls.[86] Yet although the Chase Company's dolls were designed explicitly to address new attitudes about children and play (and contributed to a general shift from the representation of adult women to that of babies), they still adhered to a standard of realist depiction antithetical to the aspects of cuteness stressed by its contemporary theorists. Even the more stylistically simplified, "wide-eyed, round-faced, and chubby-cheeked New Kid" popularized in the first decade of the twentieth century by the Campbell Kids and Rose O'Neill's Kewpies had a physical vigor that makes their invention yet another moment in the history of American mass culture where the fullest realization of cuteness seems curiously postponed.[87] Far from being helpless or dejected, as Formanek-Brunell notes, the Kewpies were depicted as alert, energetic social reformers who rescued children and even educated mothers about the welfare of children, while the Campbell Kids just as tirelessly sold soup. It was not until after World War I, long after the invention of the teddy bear, that "cute"

FIGURE 3

toys, in the strong sense of denoting an aesthetic of accentuated helplessness and vulnerability, began appearing in the United States in mass quantities.

In a sense, it is not surprising that an aesthetic of smallness, helplessness, vulnerability, and deformity might find its prominence muted or

checked in the cultural industries of a nation so invested in images of its own bigness, virility, health, and strength. Conversely, in post–World War II Japan, an island nation newly conscious of its diminished military and economic power with respect to the United States in particular, the same aesthetic *(kawaii)* had a comparatively accelerated development and major impact on the culture as a whole, saturating not only the Japanese toy market but also industrial design, print culture, advertising, fashion, food, and the automotive industry. There are historical reasons, in other words, for why an aesthetic organized around a small, helpless, or deformed object *that foregrounds the violence in its production as such* might seem more ideologically meaningful, and therefore more widely prevalent, in the culture of one nation than in that of another. In this manner, art critic Noi Sawaragi traces Japan's postwar fascination with kawaii not only to the nation's diminished sense of itself as a global power but also to the political image of the emperor in its parliamentary monarchy: "In the last moments of his reign, emperor Hirohito had a feeble, weak image. An old dying man is the weakest of creatures.... Hirohito was very popular among the people *as* a cute, old man."[88] Given also what Kanako Shiokawa describes as kawaii's unprecedented surge in popularity during the rapid expansion of Japan's culture industry in the 1960s, it is unsurprising that a self-conscious foregrounding of the violence underpinning the aesthetic runs throughout the work of Yoshitomo Nara and Takashi Murakami, Japanese artists who grew up in the 1960s and began exhibiting in the early 1990s, whose bodies of work allow us to grasp cuteness in one of its most probingly or theoretically worked-out forms.[89] Whether in the form of drawings, paintings, or, more recently, sculptures, Nara's large-eyed children are frequently presented as wounded or distressed, as demonstrated by both the untitled drawing (Fig. 4) in which the phrase "Black Eye, Fat Lips, and Opened Wound" captions one of Nara's signature little girls and *Slight Fever* (2001; Fig. 5), one of a series of acrylic paintings mounted on white plastic plates. In its association with food, the dinner plate does more than merely supply a material support for Nara's images of mutilated or injured children. Evoking the expression "You're so cute I could just eat you up," Nara's use of food-related objects for his interrogation of kawaii becomes extended and exaggerated in *Fountain of Life* (2001; Fig. 6), a sculpture in which seven of what appear to be disembodied dolls' heads are stacked on top of one another in an oversized teacup with accompanying saucer, with tears/water flowing out of their closed eyes. Underscoring the aggressive desire to master and overpower the cute object that the cute object itself appears to elicit, the tie between

FIGURE 4

cuteness and eating that Nara's work makes explicit finds its consumer-culture counterpart in the characters generated by San-X, an edgier and more contemporary incarnation of Sanrio, the company that invented the iconic Hello Kitty. One of San-X's most currently popular figures is Kogepan, who is a slightly burned and dejected-looking bread bun. Described on San-X's website as "a bread [that] has gone sourpuss for being burned . . . that can't help making negative words like 'You'll dump me anyway,'" Kogepan is occasionally depicted not only with a bite taken out of the top of its head, but even baking miniature versions of itself.[90] Kogepan's obvious state of abjection and simultaneous potential for acts of cruelty to less than fully baked Kogepans suggest that the ultimate index of an object's cuteness may be its edibility. Underscoring this link, an

FIGURE 5

untitled drawing by Nara (2001; Fig. 7), in which one of his stylistically simplified children pops out of a package with the label "JAP in the BOX," also highlights cuteness's role in the merchandising and packaging of racial difference.

There is a double irony here, however, in that Nara, like fellow artist and media darling Takashi Murakami, is a master of retail himself.[91] In the tradition of Andy Warhol, both artists highlight by continuing to attenuate the already thin line that separates art from commercial merchandise in a market society. Although one can buy Nara dolls, alarm clocks, wristwatches, postcards, ashtrays, T-shirts, and, of course, dinner plates, it is Murakami who has pushed these bounds furthest, not only by creating both cheap and expensive wares based on his gallery paintings and sculptures (including, in the spring of 2003, a series of Louis Vuitton handbags) but also by inventing a character, Mr. DOB, a red and blue

FIGURE 6

FIGURE 7

mouselike figure originally drawn with an exaggeratedly large head and tiny mouth which Murakami copyrighted in the early 1990s.[92] Created in what Murakami describes as an effort "to investigate the secret of the market survivability . . . of characters such as Mickey Mouse, Sonic the Hedgehog . . . Hello Kitty and their knock-offs produced in Hong Kong,"[93] Mr. DOB's origin as an experiment in species "survivability" echoes Stephen Jay Gould's famous argument about how the "progressive juvenilization" of Mickey Mouse over the twentieth century—his gradual transformation from spiky rodent into a rounder, softer, more wide-eyed character—testifies to the power of biological cuteness as an evolutionary strategy.[94]

DOB is often shown smiling, as he is in the painting *DOB with Flowers* (1998; Fig. 8), situated in a "landscape" composed of anthropomorphized flowers as happy as he is.[95] Although things are changed slightly in the installation *DOB in the Strange Forest* (1999; Fig. 9), which places DOB in a sinister or implicitly menacing environment and depicts him as confused or distressed rather than contented, the menacing objects— eye-studded and deformed mushrooms, recalling the mushroom clouds of the atomic bombs dropped on Hiroshima and Nagasaki—still arguably

FIGURE 8

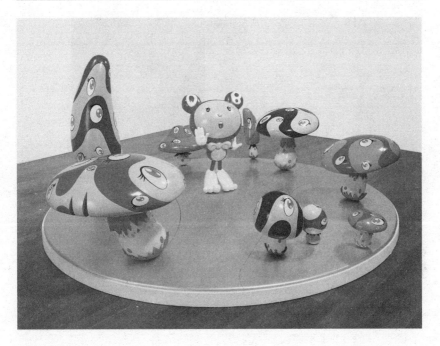

FIGURE 9

remain as cute as both DOB and the smiling flowers that surround him in the earlier painting.

In *And Then, and Then and Then and Then and Then* (1996–1997; Fig. 10), however, an acrylic painting roughly 9 by 11 feet in size, DOB's cuteness seems questionable or under stress, in part because of the huge proportions of his image and the fact that he now has bared teeth. Suggesting a pun on kawaii's sonorous proximity to *kowai,* which means "scary," the surprisingly menacing look DOB assumes in this image is pushed further in subsequent pieces like *GuruGuru* (1998), a vinyl chloride helium balloon 106 inches—nearly 9 feet—in diameter (Fig. 11), and *The Castle of Tin Tin* (1998), an acrylic painting nearly 11 by 11 feet (Fig. 12). In both, DOB has become virtually all eyes, teeth, and blisters, although the signature "D" and "B" on the character's ears still remain legible. These works blurring the line between kawaii and kowai are only two of hundreds of permutations, and increasingly distorted, deformational permutations, to which Murakami has subjected the original DOB ever since his debut as a painting in 1993. Hence while cuteness exaggerates vulnerability, as Harris emphasizes by noting that objects are cutest when maimed or hobbled, Murakami's stylistic mutilation of DOB calls

FIGURE 10

FIGURE 11

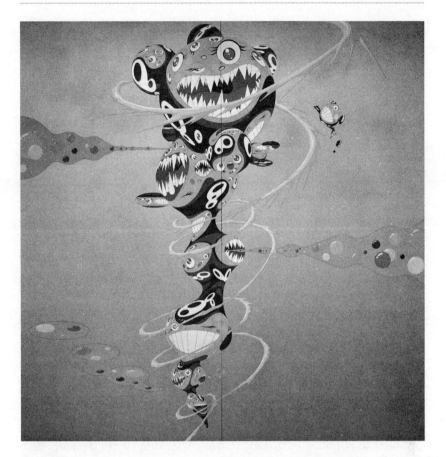

FIGURE 12

attention to the violence always implicit in our relation to the cute object while simultaneously making it more menacing to the observer. The more DOB appears to be the object or victim of aggression, the more he appears to be an agent of aggression. Murakami's DOB project thus suggests that it is possible for cute objects to be helpless and aggressive at the same time. Given the powerful affective demands that the cute object makes on us, one could argue that this paradoxical doubleness is embedded in the concept of the cute from the start, as even commercial generators of cuteness such as San-X seem to realize. Kogepan's cuddliness does not seem incompatible with or compromised in any way by his potential to use and abuse the more diminutive Kogepans, whom he seems to treat either as food or as pets.[96]

How are we to read the unusual readiness with which cute reverses into its opposite? Is it a sign of the aesthetic's internal instability, or how

the experience of cuteness often seems to lead immediately to feelings of manipulation and betrayal? And how are we to read the *vehemence* of the reversal? Is the explosion of DOB's body a testament to the intensity of cuteness's deferred utopian dream? Or does it say something more about our own phantasmatic investment in the narrative of a cute object's "revenge"?

Although it is DOB's pictorial transformation that brings this reversal to the fore, Murakami's character originated not from a visual image but rather from a verbal phrase. According to Murakami, DOB was derived from a synthesis of *dobozite*—a slang term for "why?" *(doshite)* popularized by a manga or comics character noted, like Huxley's lisping and "twittering" Parisian miss, for his "strange accent" and chronic mispronunciation of words—and *oshamanbe,* a catchphrase of Japanese comedian Toru Yuri that puns on the name of a town and the sexual connotations of the syllable *man* in Japanese.[97] Murakami's initial wordplay with *dobozite* and *oshamanbe* resulted not in a drawing or visual prototype of the Mr. DOB character but in a signboard with the two repeated words circling an oval. This piece, eventually titled *DOBOZITE DOBOZITE OSHAMANBE* (1993), was made explicitly for an exhibition on the subject of the jargon of commodity culture: "The plan of the exhibition [*Romansu no Yube* or "Evening of Romance"] was an inquiry into the custom of putting the emphatic suffix 'Z' and 'X' at the end of [every Japanese commodity] from beer to comic book titles. For example, the beer *Asahi Z,* or the *manga* title *DragonballZ.* What makes these products so popular? I managed to make something that was under budget, and dwelled on the oddities of the Japanese language at the same time."[98] DOB, the perfect exemplar of cuteness including its barely-hidden layer of violence, was thus a product of an investigation into the language rather than the imagery of commodity culture. In fact, Murakami elsewhere attributes DOB's origins to his antagonism toward an "anglicized pseudo-letter art" belatedly popularized in Japan by the work of Americans Jenny Holzer and Barbara Kruger: "DOB was my attempt to crush that art scene I despised."[99] With such a remarkably cute object disclosed not just as originating in wordplay but as antagonistically pitted against other kinds of "letter art"—and as the references to Holzer and Kruger suggest, an explicitly committed American "letter art" highly critical of consumer culture, in particular—we are now ready to return from cuteness's significance in pop art and material culture to a deeper account of its role in language and poetry.

Mute Poetics

We have seen how cuteness cutifies the language of the aesthetic response it compels, a verbal mimesis underscoring the judging subject's empathetic desire to reduce the distance between herself and the object. This cutification of the language of aesthetic judgment can be witnessed in the origins of the word "cute" itself. Since "cute" derives from the older "acute" in a process linguists call aphaeresis (the process by which words lose initial unstressed syllables to generate shorter and "cuter" versions of themselves; "alone" becomes "lone," "until" becomes "til"), its etymology strikingly replicates the logic of the aesthetic it has come to name. But there is a key difference between "cute" and these other examples. While cuteness is an aesthetic of the soft or amorphous that therefore becomes heightened when objects are depicted as sleepy,[100] "acute" means "coming to a sharp edge or point" and suggests mental alertness, keenness, and quickness. Cute thus exemplifies a situation in which making a word smaller—or, if you like, cuter—results in an uncanny reversal, changing its meaning into its exact opposite.

Like the flip-flop of power relations dramatized in the DOB series, this reversal mirrors the deverbalizing effect that prototypically cute objects—babies, puppies, and so on—have on those who judge them as such. Resulting in a squeal or a cluck, a murmur or a coo, the cute object seems to have the power to infantilize the language of its infantilizer. Note, for example, how Gertrude Stein's admiring and critical reviewers alike seem compelled to approximate her language and, moreover, to savor or take pleasure in these acts of imitation even when the intent is clearly ridicule: "Babble, baa, baa, Bull";[101] "Her art is the sophisticated development of the child's 'Tiddledy diddlety-fiddlety-doo.'"[102] In much the same way in which Huxley seems to relish neologisms like "orgy-porgy" and "bumble-puppy" even while mobilizing them to attack the easy delights of his brave new world, we find a member of the American literati no less refined than H. L. Mencken pushed into saying words like "tosh" when negatively commenting on Stein's "bebble."[103] Even Wyndham Lewis seems compelled to mimic (and to enjoy mimicking) the lisping speech of the female consumer he despises ("Oh! Pease, pease"). This process of verbal cutification once again redounds on the very word "cute," which is easily reduced to even more diminutive versions of itself: the noun "cutie," the adjective "cutesy," and the adjective "cutesy-poo," all of which receive separate entries in the OED.

Cuteness is thus the name of an encounter with difference—a perceived difference in the power of the subject and object, in particular—that does

something to everyday communicative speech: weakening or even dissolving syntax and reducing lexicon to onomatopoeia. More specifically, it names an encounter with difference that alters the speech of the subject attempting to manage that difference by imposing cuteness on the object. In this manner, cuteness incites a fantasy of the cute object's capacity for retaliation that we already have seen Murakami explore. The same fantasy may shed new light on why *Tender Buttons* features so many "little things"—a cup and saucer, a petticoat, a cushion, a shawl, a purse—described as "hurt" but also as "enthusiastically hurting" other objects of their own genre or kind, not unlike the way Kogepan relates to his pets. As Stein writes, "A hurt mended stick, a hurt mended cup, a hurt mended article of exceptional relaxation and annoyance, a hurt mended, hurt and mended is so necessary that no mistake is intended."[104] Indeed, "hurt and mended" seems as "necessary" to the project of *Tender Buttons* as to the hobbled and bandaged Little Mutt. In the world of this poem, where even cups "need a pet oyster" (49), the subject's murmur or coo to the cute object takes the form of an equally susurrus "alas." Throughout *Tender Buttons* this mournful apostrophe is directed at objects that seem to elicit it on the pathos of their diminutive status alone: "Alas, alas the pull alas the bell alas the coach in china, alas the little" (53). Or as Stein coos in "CHICKEN": "Alas a dirty bird" (54). The world of *Tender Buttons* is thus one in which—alas—there is "abuse of cheese." However, it is also one noisy with "muncher munchers," an aggressive motif we see returning in "A NEW CUP AND SAUCER": "Enthusiastically hurting a clouded yellow bud and saucer, enthusiastically so is the bite in the ribbon" (20).

Just as DOB sprouts alarmingly sharp teeth, Stein's ribbon bites. In keeping not just with *Tender Buttons's* lesbian eroticism but also with what I would like to single out as its cute eroticism, this "sweet" but biting "trimming" underscores the extent to which the "delightfulness" offered by cuteness is "violent." As Stein writes, "What is the use of a violent kind of delightfulness if there is no pleasure in not getting tired of it?" (10). This rhetorical question suggests that the pleasure offered by cute things lies in part in their perceived capacity to withstand extended and unusually rough use, much in the same way in which Mr. DOB, a character created to explore the phenomenon of "market survivability," manages to outlast his own violent disfiguration.[105]

Turning briefly to another model—this time from a midcentury late modernist poet—to further illuminate Stein's double-sided relation to cuteness, let us consider Francis Ponge's "The Potato." In an echo of the defamiliarization of the everyday undertaken by the surrealists (with whom Ponge was associated in the 1920s), the deformation "suffered" by the "homey" objects in this poem also anticipates the fate of Mr. DOB. Appar-

ently incapable of self-preservation, both are "shaken up, knocked around, abused" precisely in order to see if "their form survives." In this light, "The Potato" further underscores an aspect of cuteness that we first glimpsed in Edson's "The Melting"—the apparent ability of the object to withstand the violence that its very passivity seems to solicit. We might call this the violence of domestication, or "tenderization":

> This taming of the potato by submitting it to boiling water for twenty minutes is quite amazing (and as a matter of fact while I write—it is one o'clock in the morning—potatoes are cooking on the stove in front of me). . . .

> A hubbub can be heard: the bubbling of the water. It is furious, or at least at a peak of excitement. It thrashes around angrily, steaming, oozing, sizzling, pfutt, tsitt; in short, terribly agitated on the red-hot grate.

> My potatoes, submerged down there, are shaken up, knocked around, abused, drenched to the marrow.

> The water's fury probably has nothing to do with them, but they suffer the consequences—unable to get out of this situation, they find themselves profoundly changed by it.

> In the end, they are left for dead. . . . If their form survives (which is not always the case), they have become soft and tender.[106]

As suggested by the "bebble" produced by Stein's critics in their efforts to make *Tender Buttons* more digestible (or to condemn it for not being so), cuteness might be described as an aesthetic experience that makes language not just more vulnerable to deformation but also transformation. Similarly, in "The Potato," writing poetry is equated with an act of "submitting" small, round, and compact objects to a furious "bubbling" that makes them "soft" and "tender"—more malleable, (ab)useable, and, as it were, cuter.

The idea that poetry entails treating words like material things that it can use vigorously or even roughly—that it can "scumble," "diddle," or "bubble"—links the verbal objects "abused" by the poets in this essay with the transitional object defined by psychologist D. W. Winnicott. "Affectionately cuddled as well as excitedly loved and mutilated," the infant's transitional object, which, as Winnicott notes, can be a "babbling" or series of words as well as a physical entity like a teddy bear, is an object whose role is precisely to "survive [this] loving, and also hating and, if it be a feature, pure aggression." Winnicott's transitional object is thus the cute object par excellence, informed by the same dynamic of tenderness

and aggression, of survival and use.[107] Objects in *Tender Buttons* are similarly presented as "easily churned and cherished," so much that "CUSTARD" "has aches, aches when" and "a plate has a little bobble, all of them, any so"; indeed, in the world of Stein's poem, "a little called anything shows shudders" (*TB*, 41, 51, 28, 25). Anticipating Ponge's signature use of things as metaphors for words and poems, *Tender Buttons* calls attention to the "tenderness" of language in a broader sense, showing how grammar itself might be subjected to a "heat" that "loosens," "melts," and creates "stains": "Eating he heat eating he heat it eating, he heat it heat eating." Yet, like a parody of Burke's account of beauty as the "relaxing, slackening, and enervating of the fibers of the body, and a consequent . . . fainting, dissolving, and melting away for enjoyment," this process of "tenderization" also seems to produce something more ominous: "Looseness, why is there a shadow in the kitchen, there is a shadow in the kitchen because every little thing is bigger" (*TB*, 36).[108]

Stein's observation that "melting is exaggerating" (35) can in fact double as a description for the manner in which the more "melted-down" the originally compact Mr. DOB becomes, the more monstrously overstated his individual features become. "All the stain is tender," writes Stein near the conclusion of "ROASTBEEF," but although "the result the pure result is juice" (39), "a likeness, any likeness, a likeness has blisters, it has that and teeth, it has the staggering blindly" (45). Calling up the gustatory meaning of "taste" that, as Pierre Bourdieu and others note, always returns to haunt aesthetics, the cuteness of *Tender Buttons* seems to demand not only the representation of delectable objects but the image of something less easily consumable—a blistered, toothy, and staggering something that we would not want to put in our mouths at all.[109] In fact, as *Tender Buttons* progresses from "Objects" to "Food," or as the poems' referents become more edible and therefore cuter, we are increasingly referred to the design of a "monster," or "monster puzzle, a heavy choking" in the text (45). Thus in "Rooms," a place where "there is a whole collection made" and "the whole arrangement is established" (68, 64), we have the announcement that "this is a monster and awkward quite awkward and the little design which flowered which is not strange and yet has visible writing, this is not shown all the time but at once, after that it rests where it is and where it is in place" (74).[110]

Further light on Stein's culinary take on cuteness can be gained by looking at Ponge's "The Orange," which begins with the image of a small, round, and anthropomorphized object being squeezed by a fist, "delighting its tormenter."

> Like the sponge, the orange aspires to regain face after enduring the ordeal of expression. But where the sponge always succeeds,

the orange never does; for its cells have burst, its tissues are torn. While the rind alone is flabbily recovering its form, thanks to its resilience, an amber liquid has oozed out, accompanied, as we know, by sweet refreshment, sweet perfume—but also by the bitter awareness of a premature expulsion of pips as well. (*VT,* 36)

As a nonhuman thing given human features (although it is also quickly deprived of them), Ponge's orange can be read as a figure for a number of personification strategies, including the one that Paul de Man likens to the act of "giving face" and that could be described as cuteness's master trope:

> Prosopopoeia [is] the fiction of an apostrophe to a . . . voiceless entity, which posits the possibility of the latter's reply and confers upon it the power of speech. Voice assumes mouth, eye, and finally face, a chain that is manifest in the etymology of the trope's name, *prosopon poien,* to confer a mask or a face *(prosopon).*[111]

What Ponge's orange highlights is how easily the act of endowing a dumb object with expressive capabilities can become a dominating gesture. To make the orange expressive, in the sense of making it articulate and meaningful but also in the sense of forcing it to expel its "essence," is in effect to subject it to injury: "Its cells have burst, its tissues are torn." Far from being a kind or empowering act, in this poem "giving face" to an object is to make it phantasmatically lose face, an act not just of humiliation but of mutilation.

It is worth noting here that while the cutest toys have faces and often overly large eyes perversely literalizing the gaze Benjamin associates with the aura of autonomous art, other facial features—mouths in particular—tend to be simplified to the point of being barely there.[112] Sanrio's Hello Kitty, for example, has no mouth at all. Thus while de Man equates the endowing of speech with "giving face," "giving face" in cuteness seems to amount to denying speech. The striking incompleteness of the cute visage implies that although the object must be given just enough face to enable it to empathetically return our gaze, a fuller personification becomes impossible because it would symbolically render that object our equal, erasing the power differential on which the aesthetic depends. As Stephen Siperstein notes, the same principle informs roboticist Masohiro Mori's "uncanny-valley" theory, which argues that as stylistically simplified robots begin to look and behave more like actual humans, our affection toward them also grows up to a certain point, after which the resemblance produces a feeling of aversion.[113] (The "valley" refers to the plummet in the affective appeal of the lifelike robot in the graph in Figure 13). Clearly, in order to retain the appeal of being cute without giving us willies (though

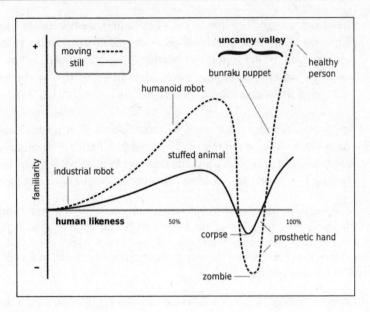

FIGURE 13

as we have seen, attraction and repulsion lie very close together in cuteness), the animated commodity must be somewhat mimetic—but finally not too mimetic—of a person endowed with the capacity for speech.

At the same time, cuteness calls attention to what de Man calls the "latent threat" attending all strategies of rhetorical personification, as he discusses in his reading of Wordsworth. Observing that Wordsworth's *Essays upon Epitaphs* anxiously warns against the use of prosopopoeia even as it relies on and privileges the trope, de Man suggests that by making the dead or inanimate or inhuman speak, "the symmetrical structure of the trope implies, by the same token," that the living human speaker who personifies or throws voice into the nonhuman object can be "struck dumb."[114] In other words, if things can be personified, persons can be made things, just as in Marx's analysis of the commodity form, fetishistic animation and reification constitute "two sides of the same coin."[115] A later image in Ponge's "The Orange" calls attention to this reversal as well:

> Merely recalling its singular manner of perfuming the air and delighting its tormentor is not saying enough about the orange. One has to stress the glorious color of the resulting liquid which, more than lemon juice, makes the larynx open widely both to pronounce the word and ingest the juice without any apprehensive grimace of the mouth. (*VT*, 36–37)

Although "The Orange" begins by highlighting the passivity of the com-modity in its title (a small, compact object we seem invited to regard as an emblem of the short and compact artwork, "The Orange"), it culmi-nates by relocating this passivity on the side of the subject consuming the essence the object/artwork/commodity has been forced to expel.

With the aid of Ponge's account of consumption as coerced rather than voluntary, we are in a better position to understand why *Tender But-tons*'s succession of "little," "tender," "hurt," "abused," "shuddering," and "surrendering" objects needs to arrive, or become visible in its entirety as a "design," in the idea of a "monster." If cuteness is an especially apt index of the ease with which market society turns art into a "culinary" commod-ity, we may suspect that the unpleasantly blistered "monster" that emerges in *Tender Buttons* and Murakami's DOB series invites less a fantasy of art's capacity for revenge on a society that renders it harmless, than a more modest way of imagining art's ability to transform itself into some-thing slightly less easy to consume; or, something that, if indeed con-sumed, might result in "heavy choking" (*TB*, 45). In this vein, the violent implosion of Murakami's tiny, smiling package of cuteness might also be taken as a testament to the falseness of the reconciliation between high art and mass culture promised by the postwar industrialization of mod-ernist aesthetics, which seemed so neatly capsulated in the new taste concepts the new design industries sought to proliferate.

With its exaggerated passivity, there is a sense in which the cute thing is the most reified or thinglike of things, the most objectified of objects or even an "object" par excellence. Turning from the early and mid-twentieth-century examples of Stein and Ponge to a twenty-first century artwork, we can see a similar fantasy of how this hyperobjectification might be impeded or even reversed in Bob Perelman and Francie Shaw's *Playing Bodies*, a series of fifty-two short poems corresponding to fifty-two small white latex paintings (18 by 18 inches), depicting two mouthless dolls or toys—one humanoid, the other a dinosaur—interacting with one another in intimate and loving but also violent and aggressive ways.[116] In most of the poems (by Perelman), the poet speaks as one of the two toys (usually the humanoid one), addressing the other toy as if it, too, were not a mere thing but a subject capable of response, but doing so precisely in order to suggest and highlight its *incapacity* for response. If the speaker in the poem below, for instance, "gives face" to a voiceless entity (the dinosaur), he does so less to endow it with agency than to emphasize his own ability to use it—in this case, as an instrument for writing (Fig. 14). The dinosaur that thus becomes the tool of the writer/speaker, once intimately addressed

FIGURE 14

by him as his poetic principle, is initially "swooned" in a semiconscious stupor or "trance," recalling Harris's observation that cuteness is not just "the aesthetic of deformity and dejection" but "the aesthetic of sleep."[117] And although this comatose object does eventually speak, its speech is limited to a "thin whisper," which is to say, a speech that calls attention to its negative status as barely speech at all:

37

So, poetry, I see you
swooned into steep trance

When I hear
Your thin whisper
My arms are too light
I need your tail to write

It looks like I'm saying this to you
tranced in one oblique line

but your ear is everywhere
without it I'm all over the place

Really, I'm only
using you to write
what you tell me I hear

Just as Ponge's orange is pressed to express, here the literally mouthless
object apostrophized by the subject ("So, poetry") is ruthlessly instrumen-
talized to write. In this sense, the speaker does not so much give voice to
an object as to an operation more or less coextensive with the entire lyric
tradition, from Petrarch's instrumentalization and disfiguration of Laura
to Wordsworth's Lucy poems and beyond. Yet by the end of 37, in spite
of its aggressive handling and transformation into a transmitter for the
words of others, it is actually the object that seems in control, not only of
the poem's speaker but of the poem itself. For in the final lines it is the
speaker who has become a recording instrument, writing what the object
tells him he is hearing. So who is really the tool for whom? *Playing Bodies*
23 (Fig. 15) poses a similar question:

FIGURE 15

23

Take that, That
And try some of this, This
Be yourself, Be
And don't tread on me, Don't

Fuck you, You
And I love it when you call me that, Love
Pleasure always goes twice around the block, Please
So say it again, Sam

One more time, Time
And another thing, Thing
Don't stop now, Now
Or else I'm gone, I

What is striking here, in a poem constructed primarily from already-said language, is the equation of poetic address with attack. The speaker's utterances are clearly aggressive in content ("Take that"; "Fuck you") but even more so in the form they assume: that of an imperative whose language actually gives rise to the proper name of the object addressed ("That," "You"). Implied here is a situation in which the addressee of a violent imperative appears to have no identity distinct from the one the imperative constitutes for him—a situation that becomes particularly ironic in the case of "Be yourself." Yet the speaker's commands produce a kind of echolalia ("that, That"; "this, This"; "now, Now") that in its self-reflecting circularity suggests a failure to establish the addressee as a fully independent and separate entity capable of responding to those commands. In this sense, the powerlessness of the mute object addressed returns as an impotence on the part of the speaker, whose hails stutter and emptily circle back on themselves precisely at the anticipated moment of their completion. It is as if the authority figure's "Hey, you!" in Louis Althusser's scene of interpellation fell short of arriving at the second-person pronoun, doubling back on itself to become an act of hailing one's own incomplete hail. Nothing makes this structural incompleteness clearer than the final line of Perelman's poem, "Or else I'm gone, I," a sentence fragment in which the unstated but implied "you" seems paradoxically erased in the act of being addressed, leaving the lonely and dangling "I" as a remainder.

What Perelman adds to our ongoing investigation of the cute via Stein and Ponge is thus how the aesthetic turns on a failure or incompleteness

at the level of address that counterintuitively suggests a certain immoderation in that address, or an overambitiousness of its bounds or reach, in spite of its traditionally lyric "I-you" intimacy. The focus not just on incompleteness but on the address's possible exorbitant range or goal suggests that there is something larger at stake for Perelman as a poet in his explorations of cuteness than the aesthetic category per se: a meditation on the social status of the avant-garde and the criticisms its ambitions have received from the Left. In fact, arrayed across the twentieth century, all the poetic explorations of cuteness above can be read as a way of grappling with oft-made observations about the literary avant-garde's social powerlessness, its practical ineffectualness in the "overadministered world" it nonetheless persists in imagining as other than what it is.[118] For while the cute is an aesthetic of the small, the vulnerable, and the deformed, the avant-garde's lack of political consequentiality is typically attributed to the short or limited range of its actual address, often taken as a sign of its elitism as a mode of "restricted production" (the criticism of Pierre Bourdieu); its susceptibility to becoming routinized, in spite of its dynamism and commitment to change, and thus to being absorbed and recuperated by the cultural institutions it initially opposes (the criticisms of Raymond Williams, Peter Bürger, and Paul Mann); and a social overambitiousness signaled by the incomplete or unfinished nature of all its projects—an incompleteness that in turn betrays overhasty assumptions about "a harmony between society and artworks that has been preestablished by world spirit" (*AT*, 236) and thus, by extension, an oversimplistic identity between political agency and radical form.[119] As Barrett Watten notes, citing these authors and arguments, these criticisms from the Left offer strong challenges that cannot simply be dismissed or ignored: it "is true, the avant-garde comprises a small group of practitioners at a far remove from the mechanisms of social reproduction. Avant-garde criticality cannot make up for the gap between its stated intentions and actual effects, which must still be seen as relative to its restricted codes and marginal formations."[120] Based on its smallness (size of audience as well as membership), incompleteness (gap between stated intentions and actual effects), and vulnerability (to institutional ossification), these challenges to the agency of the avant-garde seem especially pronounced in the case of its production of poetry, the literary genre most associated with intimate address (lyric), with unusually small, lapidary, objectlike texts (imagism/objectivism), and unusually "tender" speech. We can thus see why cuteness might be explicitly mobilized by the poetic avant-garde as a meditation on its own restricted agency, as well as on the fetishization of its texts.

Twentieth-century poetry's complicated relation to the commodity aesthetic of cuteness thus helps enrich our understanding of the latter by drawing out certain leitmotifs. First, cuteness is not just a style of object but also a style of language, one characterized by nondiscursive "twittering" or "babbling" and by a mode of address that in its intensity and intimacy bears a striking similarity to lyric. Second, our experience of the cute involves an intimate address that often fails to establish the other *as* truly other, as if due to the excessive pressure of the subject's desire for intimacy or to the force of the aesthetic's mimetic compulsion. Failure like this might seem endemic to an aesthetic of powerlessness. Yet it is the very aestheticization of powerlessness in the experience of cute that seems to give rise to a fantasy about the cute object's power, one epitomized by the boomeranging of the aggressive affect projected onto the object back outward and toward the subject. All these cute leitmotifs—they are not exactly concepts—underscore the aesthetic's defining dialectic of power and powerlessness. In accordance with the animating logic of fetishism, cuteness seems to always include a fantasy of the agency of its hyperobjectified objects, even in their most congealed or inert form. After all, as Merish and others note, the cute object seems to insist on *getting something* from us (care, affection, intimacy) that we in turn feel compelled to give. On the one hand, this underscores the way in which all aesthetic judgments, however cloaked as constative statements, are really performative utterances and, more specifically, demands.[121] On the other, it is this compulsion to answer the demand of an object we regard as weaker or subordinate that, as Natalie Angier notes, produces the sense of being strong-armed or manipulated by cuteness, a secondary feeling that can paradoxically undermine the aesthetic power of the original feeling. The subject confronting the cute object thus experiences a sense of both mastery and surrender, explicit relations to force that the cute leitmotif of violence helps cast in sharper relief.

And what of the leitmotifs of muteness and of the scumbling of language also brought forward by poetry's engagement with cuteness? Here, by relaxing the language of aesthetic judgment or by making it less discursive—a process strikingly akin to the "denuding" of the concept by form in Kant's account of beauty as reflective judgment[122]—the cute intersects in a surprising way with a longstanding and paradoxical theory of poetry as noncommunicative speech. This theory animates the work of both Heidegger and Adorno, who, for all their considerable differences and on matters of language in particular, both ground their idea of poetry's essential resistance to communication on the idea of it as an archaic

language. It is this theory of the "primitive, nondiscursive character" of poetry, neatly updated or revived by the primitivist and/or pastoral aspects of the cute, that Adorno in particular captures in the image of muteness, which he invokes as a sign of both the autonomy of art and its disfiguration under the conditions of capitalism.[123] Referring to the oeuvre of Samuel Beckett, where "falling silent" figures prominently as an example of "damaged life" but also of how "the true language of art is speechless," Adorno notes, "It is the fact that a language removed from meaning is not a speaking language that creates its affinity with muteness."[124] Or, as he notes elsewhere, "Under the prevailing rationality, the subjective elaboration of art as a nonconceptual language is the only form in which something like the language of Creation appears. . . . If the language of nature is mute, art seeks to help this muteness speak."[125] Describing all art as "language-like" and yet fundamentally resistant to concepts, Adorno follows Benjamin in characterizing this turn away from conceptual or communicative language as a turn toward "mimetic" language, where, as Shierry Weber Nicholsen underscores, mimesis means "an assimilation of the self to the other, thus a kind of enactment—mimetic behavior" (Nicholsen, 147).

As Nicholsen stresses in her incisive account of Adorno's appropriation of Benjamin's theory of the mimetic faculty—a theory significantly developed in Benjamin's efforts to analyze the aesthetic appeal of toys and kitsch—for Adorno the enigmatic "muteness" of poetry is thus linked not just to its refusal of communicative language, but to its turn toward a mimesis that involves the subject, in a "silent internal tracing of the work's articulations," assimilating herself to the object's form (149). As Nicholsen argues, Adorno's account of mimesis is a direct echo both of Benjamin's motif of the child pretending to be an inanimate object (in "On the Cultural History of Toys" and an unpublished fragment called "On the Mimetic Faculty") and of his image of the aesthetic subject gazing outward from inside a piece of cute kitsch (in his account of the uncanny "simplicity" of kitsch and folk art in "Some Remarks on Folk Art").[126] For Adorno, as Nicholsen glosses, "Every work of art can be seen as a dynamic totality that requires a kind of performance or reenactment by the listener or viewer. The work itself is analogous to a musical score. The recipient—listener, viewer, reader—follows along or mimes the internal trajectories of the work at hand, tracing its articulations down to the finest nuance, just as, more crudely, the mimicking child mimes various aspects of a train or windmill" (149). The cute leitmotifs brought out by the poems in this chapter (the inert object's mute enigmatic gaze, the scumbling

or softening of discursive language, the swapping of positions of person and thing) thus strikingly mirror those Adorno mobilizes to make his claim about the "cognitive yet nonconceptual character" of poetry. This claim is also, as Nicholsen notes, Adorno's claim about "aesthetic understanding" or aesthetic receptivity in general, which for him is less a matter of "conceptual analysis" than a kind of "performance or reenactment" by the reader, listener, or viewer, who will follow the work's "internal trajectories" as one might follow a score (149). As in the case of the cute child compelled, in his own encounter with cute beings or objects, into "cootchy-cooing as much as he is cootchy-cooed," Adorno's adoption of Benjamin's "notion of mimesis as enactment" and of the "work of art as requiring or inciting mimetic behavior in the viewer or listener" is thus explicitly marshaled to shore up his theory of the antidiscursivity of all authentic art, including art in the medium of language.[127]

We might also think of this mimetic assimilation of the subject to the object as a way of phantasmatically countering the image of the commodity as *Gallerte* that Sutherland argues Marx sardonically serves up to the bourgeois readers of *Capital*. If undifferentiated labor in this text gets figured as a quivering, gelatinous food implicitly made up of ground-up human workers, the inverse of or antidote to this image of beings dissolved into food might be the image of a face emerging from inside a cookie. In other words, if *Gallerte* is a horrific version of how a person might disappear into an object, Benjamin's concept of mimesis (and Adorno's use of it) provides us with a "good" version of the same assimilation. As Nicholsen makes clear, for Adorno, the mimetic, nonconceptual language that art uses to imitate natural beauty is "none other than artistic form as such . . . : 'In form, all that is quasi-linguistic in works of art becomes concentrated.'"[128] The "cuteness" of the poetry we have examined underscores this role of form, even as it renders its own language "mute."

Adorno's Cuteness

In its efforts to directly grapple with its vexed relation to this minor aesthetic category, a certain kind of avant-garde poetry has helped us better understand the surprising complexity of the cute's overt simplicity, the unsuspected power of its exaggerated powerlessness. I would like to conclude by suggesting that this poetically expanded concept of the cute can be mobilized in turn to give us a better understanding of Adorno's aesthetic theory. The reader of *Aesthetic Theory*, in particular, who approaches this notoriously dense, paratactic, and unfinished text with an awareness

of the commodity aesthetic's leitmotifs will come away with a realization of their surprising centrality to Adorno's aesthetic thought and thus with a better sense of that thought in general.

The unusually dense and protracted form of *Aesthetic Theory* is in a certain sense anomalous. Among American literary critics, in particular, Adorno is best known for his predilection for essays and for aphorisms that not only flirt with their resemblance to modernist prose poems but to advertising sound bites (like the "device[s]" or "lapidary two-liner[s]" in Benjamin's cookie-toys). This is most famously the case in *Minima Moralia,* Adorno's "subjective" study of the postwar "sphere of consumption," where the cuteness of the aphoristic form is mobilized to make a point about how the fractured nature of "damaged life" resists "explicit theoretical cohesion."[129] Even in their brief pithy titles—"All the Little Flowers," "Dwarf Fruit," "Picture-Book without Pictures," "Little Folk," "Cat out of the Bag," and so on—these short, compact texts on the ephemeral minutiae of everyday existence also bear a resemblance to "cute" genres such as proverbs, jokes, or zingers.[130] *Aesthetic Theory,* for all its own status as an "unfinished torso" that Adorno intended to dedicate to Beckett (whose poetry, plays, and prose reflect a similar preoccupation with minutiae such as cookies, socks, and dogs), is a completely different kind of text; around 400 pages with virtually no paragraph breaks and strangely few citations, it seems the obvious antithesis of cute. Yet it is a work that can be just as well navigated as *Minima Moralia* with cuteness's constellation of images and themes.

The use of a minor commodity aesthetic to read the magisterial work of one of the twentieth-century's sternest critics of "culinary" culture may at first seem something like a critical stunt. The fact that it is not becomes clear if we recognize how seriously Adorno takes the relationship between the two: "Kitsch is not, as those believers in erudite culture would like to imagine, the mere refuse of art, originating in disloyal accommodation to the enemy; rather, it lurks in art, awaiting ever recurring opportunities to spring forth" (*AT,* 239). Both the kitsch commodity and the ambitious work of art refuse the kind of affective catharsis Adorno regards as part of art's "superannuated mythology"; each instead participates in the sublimating work of objectifying actual emotion or converting it into affective semblance: "Although kitsch escapes, implike, from even a historical definition, one of its most tenacious characteristics is the prevarication of feelings, fictional feelings, in which no one is actually participating, and thus the neutralization of feelings." For this reason, "Kitsch parodies catharsis" (*AT,* 239). But so does genuine art: "Ambitious art . . . produces the same fiction of feelings; indeed, this was essential to

it. The documentation of actually existing feelings, the recapitulation of psychical raw material, is foreign to it." For this reason, "It is in vain to draw the boundaries abstractly between aesthetic fiction and kitsch's emotional plunder" (*AT*, 239).

Adorno makes the same point from a different angle in "Art-Object" from *Minima Moralia*, a phrase intended to refer to both art and kitsch. This defense of kitsch significantly falls between "Magic Flute," on the necessary persistence of fetishism even in Enlightenment art and aesthetic experience (which transforms images of domination into those of "gentleness" and "powerlessness"), and "Toy-Shop," in which the play of children with their "little trucks" and "tiny barrels" is explicitly described as an effort to "rescue" the useful or phenomenal form of value (*MM*, 228). In "Art-Object," the link between kitsch and art is ascribed primarily to the role mimesis plays in both practices as a way of representing and thus sublimating fearsome nature: "Accumulated domestic monstrosities can shock the unwary by their relation to works of art. Even the hemispherical paper-weight with a fir-tree landscape submerged under glass and below it a greeting from Bad Wildungen has some resemblance to Stifter's green Fichtau, even the polychrome garden dwarf to a little wight from Balzac or Dickens" (*MM*, 225). Here the art-kitsch relation lies not just in the "abstract similarity of all aesthetic appearance" (as Adorno suggests in *Aesthetic Theory*); rather, kitsch by its very existence "expresses inanely and undisguisedly the fact that men have succeeded in reproducing within themselves a piece of what otherwise imprisons them in toil . . . and an echo of the same triumph resounds in the mightiest works, though they seek to forgo it, imagining themselves pure self unrelated to any model" (*MM*, 225). In other words, the beautiful artwork and the cutesy snowglobe/gnome both exist in part for the instrumental purpose of combating the fearful through imitation, but only kitsch is honest about this use: "The latter's lie does not even feign truth." This leads Adorno in turn to note how kitsch as mass-produced artifact gives the lie to art's "guilty and imperious" postulation of itself as purposeless, or as somehow not tied to rational purposes in particular (*MM*, 226). This appearance denies art's inextricable linkage to and historical emergence from *techne*, a "paradoxical entanglement in the process of civilization [that] brings it into conflict with its own idea" (*MM*, 226). The "blatant feeblemindedess" of kitsch thus "blast[s] into daylight the delusion that was always immured in the oldest works of art and which still gives the maturest their power" (*MM*, 226). Indeed, deploying an image that he repeats over and over in *Aesthetic Theory*, Adorno notes how the "more consequentially [art] distances itself . . . from making, the more fragile its own made existence necessarily becomes: the endless pains to eradicate

the traces of making, injure works of art and condemn them to be frag-
mentary" (*MM*, 226). For Adorno, truly great art thus "keeps a hold on
sensuous life by a moment of harmless pleasure in the *bien fait*" and
therefore avoids "the untruth of those dubbed by Haydn [as] the Grand
Moguls; they, determined to have no truck with the winsome vignette or
figurine, succumb to fetishism by driving out all fetishes" (*MM*, 227).

The cuteness of the "art-object" that will "have truck" with the aes-
thetics of kitsch, as in the case of the poetry of Stein, Mullen, Edson, Ar-
mantrout, Perelman, and others, is thus a kind of fetishism that protects
against fetishism, in part by coinciding with a kind of reification.[131] Al-
though the cute object is an animated object, its exaggerated passivity and
malleability suggest an extreme form of thingification. Indeed, Adorno
claims that the artwork "suffer[s] from its immanent condition as a thing"
(*AT*, 100). In addition to what Fredric Jameson calls "the sheer guilt of Art
itself in a class society, art as luxury and class privilege,"[132] by this "suffer-
ing" or "grieving" Adorno gestures more specifically to "the complicity of
the artwork's thing-character with social reification and thus with its un-
truth" (*AT*, 100).

As in the case of his arguments about art's "fetish character" and/or
intimate relation to kitsch, Adorno's striking refusal to minimize this
"thing-character" is closely related to his most significant thesis in both
Aesthetic Theory and his radio address, "On Lyric Poetry and Society":
that society is most active in an artwork when the artwork is most dis-
tanced from society and from the realm of sociopolitical action. This so-
cial ineffectuality or powerlessness, Adorno notes, makes all art seem not
only undignified but even "ridiculous and clownish" (*AT*, 119); indeed,
the "childish seems to contaminate the whole existence of art (*AT*, 92).
Although it is always the case that "artworks fall helplessly mute before
the question 'What's it for?' and before the reproach that they are actually
pointless," in the face of historical catastrophe, art's impotence is so
magnified that it begins to look silly: "The manifest absurdity of the
circus—Why all the effort?—is *in nuce* the aesthetic enigma" (*AT*, 121,
186). Closely linked to the modes of checked or limited agency that Stein,
Ponge, and Perelman bring out in their poetic engagements with cuteness
(inert or passive thingness; silence or muteness; woundedness or defor-
mity), the comportment of "ridiculousness" becomes crucial for Ador-
no's more extensive reflections in *Aesthetic Theory* on the aesthetic
power *made available* by art's social ineffectuality. Although "the pro-
gressive spiritualization of art in the name of maturity only accentuates
the ridiculous all the more glaringly," art's ridiculousness for Adorno is
also "part of a condemnation of empirical rationality; it accuses the ra-
tionality of social praxis of having become an end in itself and as such

the irrational and mad reversal of means into ends" (*AT*, 119). Hence while "the shadow of art's autarchic radicalism" is its essential "harm-lessness," in the artwork "the unconditional surrender of dignity can become an organon of its strength" (*AT*, 29, 39). It is this surrender of dignity, a sign that "art partakes of weakness no less than of strength," that grounds Adorno's oft-noted admiration for the "violent kind of de-lightfulness" exemplified by genres like the circus and slapstick cinema, for Paul Verlaine's ability "to turn himself into the passive tumbling in-strument of his poetry," and for Klee's ability to produce a kind of "radi-calized . . . reification [that] probes for the language of things" (*AT*, 39, 60).

We are here confronted with what Jameson describes as *Aesthetic Theory*'s trickiest (and by no means unambiguously successful) critical maneuver. This is Adorno's specifically Marxist defense of the social in-effectuality of the autonomous artwork and of high-modernist artworks in particular, "hermetic" artifacts that "through their powerlessness and superfluity in the empirical world . . . emphasize the element of power-lessness in their own content" (Adorno, *AT*, 104). In Adorno's text it is never entirely explained how a work of art comes to be "social through and through by virtue of its very antisociality" (Jameson, *LM*, 177), a dialectical thesis that runs the risk (as Adorno himself notes elsewhere) of devolving into a glib catchphrase because of its memorably counter-intuitive and singsong, jinglelike quality. In "On Lyric Poetry and Soci-ety," Adorno explicitly acknowledges the punchline-like aspect of this argument by comparing it to the actual punchline of a political cartoon: "You may accuse me of so sublimating the relationship of lyric and so-ciety in this definition out of fear of a crude sociologism that there is really nothing left of it; it is precisely what is not social in the lyric poem that is now to become its social aspect. [Here you might] call my attention to Gustav Doré's caricature of the arch-reactionary deputy whose praise of the *ancien régime* culminated in the exclamation, "And to whom, gen-tlemen, do we owe the revolution of 1789 if not to Louis XVI!"[133] Adorno repeats this Doré quotation in "Warning: Not to Be Misused" in *Minima Moralia*, in which he raises the danger of the dialectic's appropriation by sophists: its "principle of constantly and successfully turning the tables" reduced to a "formal technique of apologetics unconcerned with con-tent" (*MM*, 245).

So how are we to understand Adorno's argument about art's asocial sociality in a nonsophistic way? As Jameson notes, even "*Aesthetic Theo-ry*'s ingenious philosophical solution to this problem—the concept of the work of art as a windowless monad . . . in fact, for all practical intents

and purposes, leaves it intact" (*LM,* 177). Here let me suggest that a theory of cuteness, routed through the work of poets who have felt compelled to wrestle with this aesthetic of powerlessness directly, can help us achieve a better understanding of the problem. More specifically, it can help us see how Adorno himself comes to address the problem through a set of leitmotifs almost exactly identical to those associated with this kitsch aesthetic.

Adorno opens the "Society" section of *Aesthetic Theory* by describing aesthetic autonomy as a sociohistorical phenomenon, a product of "the bourgeois consciousness of freedom that was itself bound up with the social structure" (*AT,* 225). Stressing the social origins of art's posture of remoteness from society, Adorno writes that "if, in one regard, as product of the social labor of spirit, art is always implicitly a *fait social,* in becoming bourgeois art its social aspect was made explicit" (*AT,* 225). In becoming autonomous (by becoming bourgeois), art becomes increasingly preoccupied with the notion of itself as a specialized domain, but also and at the same time with its relationship to its outside. As Adorno puts it, the new and distinctive obsession of bourgeois art becomes "the relation of *itself* as artifact *to* empirical society" (*AT,* 225; emphases added). Since this relation to its outside can become art's defining concern only after it has become autonomous, and since this relation to "empirical society" is always, in the last instance, one of "powerlessness and superfluity" (*AT,* 104), the project of autonomous art increasingly becomes a guilt-ridden meditation on its own social impotence. It is as if once art finally achieves its distance from society, it no longer has the option of leaving the social question of its relation to society alone. The art/society question thus becomes a "wound" that can never be fully healed because it is one that art incessantly worries, the scar at which it must constantly scratch or pick.

Art's reified "thing character" becomes the ultimate index of its social ineffectuality. Yet both the "thing character" and the "fetish character" of the autonomous artwork are what allow it to criticize a "total exchange society in which everything is heteronomously defined" (*AT,* 226). If the "truth content of artworks, which is indeed their social truth, is predicated on their fetish character," Adorno argues that the "thing character" of art has a similar importance as well: "Art keeps itself alive through its social force of resistance; unless it reifies itself, it becomes a commodity" (*AT,* 227, 226). Cuteness dramatizes a similar situation, since its surprisingly complex mode of commodity fetishism always involves a hyperintensification of the thingishness of things. Just as Adorno mobilizes kitsch to show how there is a "fetishistic element [that] remains admixed in artworks" which, in resisting "the principle of heteronomy [that]

is the principle of exchange," becomes the "strongest defense of art against its bourgeois functionalization" (*AT*, 227), reification in a similar reversal becomes "first and foremost a positive, that is to say a valorized, concept" in *Aesthetic Theory*, described not only as essential to any work of art but also as a homeopathic "poison" that art needs to swallow "in order to permit the aesthetic a continuing . . . existence in a wholly reified world" (Jameson, *LM*, 180, 181). In this manner, both the "principle of death" (Adorno, *AT*, 133) that is reification and the animistic principle of fetishism "change their valences as they pass" "from the social to the aesthetic (and vice versa)" (Jameson, *LM*, 180).

In an indirect and clearly inadvertent continuation of the eighteenth century's focus on art as an expression of power (in the subjective form of genius), late twentieth-century aesthetic theorists from Pierre Bourdieu to Laura Mulvey have tended to focus on art and aesthetic experience as both instruments and mystifications of dominance (social dominance). Preoccupied in contrast with art's weakness or relative lack of power in the social realm, Adorno's attention to the "cuteness" of artworks—their muteness, or mimetic resistance to communicative or conceptual speech, their hidden relation to violence, their toylike quality, their kitsch factor, and their ridiculousness—reflects another, less traveled pathway in aesthetic theory. Indeed, Adorno's focus on art's reified and fetishistic elements—its at once fully "objectivated" and yet kitschily animated character—suggests that art cannot flex its power or even meditate on its relation to power without coming to terms in some way with its powerlessness. The convergence in *Aesthetic Theory* of all the cute's leitmotifs sheds further light on the surprising complexity and power of cuteness and shows it to be much more than a synonym for "coziness" *(Gemütlichkeit)*. It also sheds light on *Aesthetic Theory*'s reliance on evocative constellations of images and leitmotifs as opposed to the theoretical concept proper, in a mimesis of the very "mimetic language" Adorno attributes to the artwork: "One does not understand a work of art when one translates it into concepts . . . but rather when one is immersed in its immanent movement; I should almost say, when it is recomposed by the ear in accordance with its own logic, repainted by the eye, when the linguistic sensorium speaks along with it."[134] In this account of aesthetic experience, Nicholsen argues, the "experiencing subject carries out quasi-logical operations with material that is quasi-sensuous."[135] As she also suggests, something similar seems to be happening sentence by sentence in *Aesthetic Theory*, as if to reenact rhetorically, in the genre of philosophical writing itself, Adorno's larger claim for "an inextricable connection between the rational and the aesthetic."[136]

To be sure, the word "cute" never appears in *Aesthetic Theory* (although other American English words do). Nor does Adorno leave the qualities we associate with this aesthetic untouched by critical suspicion. Even when he is arguing, for instance, that "foolish subjects like those of *The Magic Flute* and *Der Freischütz* have more truth content through the medium of the music than does the *Ring,* which gravely aims at the ultimate," he warns that "the ridiculous, as a barbaric residuum of something alien to form, misfires in art if art fails to reflect and shape it. If it remains on the level of the childish and is taken for such, it merges with the calculated *fun* of the culture industry" (*AT,* 119). Adorno's wariness about the aesthetic misuse of ridiculousness mirrors his reservations about a nonreflective privileging of the ugly, which, while allowing art a unique way of denouncing "the world that creates and reproduces the ugly in its own image," leaves the possibility "that sympathy with the degraded will reverse into concurrence with degradation" (*AT,* 49). Or, as he puts it even more trenchantly in *Minima Moralia,* in a comment on the tendency of guilt-ridden intellectuals to morally beatify the "simple folk," "In the end, the glorification of splendid underdogs is nothing other than glorification of the splendid system that makes them."[137]

But in spite of these more cautious reflections, it is telling that for all the literary examples Adorno draws on in *Aesthetic Theory* to suggest how art's powerlessness in a society of total exchange and instrumental rationality might in fact be the very source of its aesthetic power (examples mostly drawn from the work of cosmopolitan modernists such as Baudelaire, Poe, Kafka, Mann, and Beckett), the only work cited in this enormous, almost entirely quotation-free text—and strikingly cited in its entirety—is a "little poem" by Eduard Mörike called "Mousetrap Rhyme" (*AT,* 123). Another poem by Mörike, whom Adorno describes with somewhat condescending affection as the "hypochondriacal clergyman from Cleversulzbach, who is considered one of our naïve artists," takes central stage in "On Lyric Poetry and Society" ("LPS," 49). There, in his reading of the Mörike poem, "A Walking Tour," Adorno points out that Mörike summons a "classicistic elevated style" to counterbalance the poem's overarching sentimentalization of home, "the clinging to one's own restricted sphere that . . . makes ideals like comfort and *Gemütlichkeit* so suspect" ("LPS," 49). But whereas Mörike's classicism in "A Walking Tour" is said to protect his poem from being "disfigured by *Gemütlichkeit*" or reduced to an "object of fondling," the Mörike poem integrated into the body of *Aesthetic Theory,* while taking similar "delight in things close to hand" ("LPS," 51), seems noticeably antisentimental from the start:

MOUSETRAP RHYME

The child circles the mousetrap three times and chants:
Little guest, little house.
Dearest tiny or grown-up mouse
boldly pay us a visit tonight
when the moon shines bright!
But close the door back of you tight,
you hear?
And careful for your little tail!
After dinner we will sing
After dinner we will spring
And make a little dance:
Swish, Swish!
My old cat will probably be dancing with.
(*AT,* 123–124)

Nestled in the center of *Aesthetic Theory,* this short, compact text, like the tiny victim intimately addressed by the poem's infantile speaker, both thematizes and formally reflects, in its singsong prosody, the oscillation between domination and passivity, or cruelty and tenderness, that we have repeatedly seen the aesthetic of cuteness bring forward. For although "if one restricted interpretation to its discursive content, the poem would amount to no more than sadistic identification with what civilized custom has done to an animal disdained as a parasite," Adorno reads the poem's very appropriation of the generic "child's taunt" as a powerful critique of the ritual, even if in this usage the poem seems to most passively acquiesce to it: "The poem's gesture, which points to this ritual as if nothing else were possible, holds court over the gapless immanence of the ritual by turning the force of self-evidence into an indictment of that ritual" (*AT,* 123, 124). In this manner, once appropriated by the poem, the child's taunt "no longer has the last word"; in fact, to "reduce the poem to a taunt is to ignore its social content along with its poetic content" (*AT,* 124).

These comments are preceded by a more general discussion of committed art's necessary abstinence from explicit acts of political evaluation, illustrated by references to the appropriative tactics of artists like William Carlos Williams, Georg Trakl, and Bertolt Brecht.[138] Yet Adorno finally chooses a canonically minor poem about children, violence, and the "small things" of domestic life to make his point about how art "judges exclusively by abstaining from judgment" (*AT,* 124), an important corollary of the main thesis of *Aesthetic Theory* that cuteness has helped illuminate. In the end, in the only close reading of a poem, or of any cited

work, in all of *Aesthetic Theory,* Adorno's interpretation of "Mousetrap Rhyme" as "the nonjudgmental reflex of language on a miserable, socially conditioned ritual, [which] as such transcends it by subordinating itself to it" (*AT,* 124), reinforces one of its simplest but most important claims: that art has the capacity not only to reflect and mystify power but also to reflect on and make use of powerlessness.

Merely Interesting

KEPTICAL AS ACADEMIC ANALYSTS of art and literature have grown since the late twentieth century about the role of aesthetic judgments in criticism, there is nonetheless one evaluation that continues to circulate promiscuously—if often, in a telling way, surreptitiously—in virtually all contemporary writing on cultural artifacts: "interesting." What is the significance of this feeling-based judgment's persistence in critical discourse? Is it a compulsive tic left over from an overtly evaluative way of doing criticism? Or, as the minimal, least obtrusive claim of value possible for the cultural object being commented on (that it is worth, if nothing else, the attention the writer is paying to it), has it become a convenient way of making aesthetic evaluations on the sly? Either way, "interesting" seems easy to dismiss as just a phatic buzzword circulated primarily in academic or professional coteries. Yet, as I will be arguing in this chapter, there is something more substantive and relevant for the understanding of critical practice—and for contemporary aesthetics—behind the judgment's ongoing appeal.

Certainly, there is little consensus even among criticism's most self-conscious practitioners about what criticism really is. For Pierre Macherey, literary criticism is explicitly not history; he notes that for all its popularity, "the expression 'literary history' . . . has failed to supplant 'criticism' "; it is even necessary to "posit [the two terms] antithetically."[1] Yet as Macherey rightly observes, the term "criticism" remains ambiguous. On the one hand, it implies a "gesture of refusal, a denunciation, a hostile judgment"; on the other, it "denotes (in its more fundamental sense) the positive knowledge of limits, the study of the conditions and possibili-

ties of an activity" (3). Although Macherey views the latter definition, "criticism-as-explanation," as more "fundamental" than that of criticism as "judgment," he points out that "we pass easily from one sense to the other as though they were merely aspects of a single operation, related even in their incompatibility" (4). Indeed, Macherey speculates that the discipline of criticism is perhaps "rooted in [this very] ambiguity, this double attitude." Yet in the course of developing his theory of "symptomatic reading," which in the end rejects the idea of criticism as explication (the "empirical fallacy"), the idea of criticism as judgment (the "normative fallacy"), and even the idea of criticism as interpretation when understood as the extraction of a meaning already concealed in the text (the "interpretive fallacy"), Macherey finally concludes that the activities of judgment and criticism are fundamentally separate (86).

In doing so, Macherey repeats one of the foundational moves of German romanticism as performed in the writings of Friedrich Schlegel and Novalis, for whom the epistemological conception of "art as idea" or reflection entailed a new theory of the criticism of art that would in turn entail an explicit break with judgment.[2] The critical tendency for Schlegel, in his own words, involves an effort "to understand and explain [the work of art], rather than to appraise it judgmentally"; thus "in complete antithesis to the present-day conception of its nature," as Walter Benjamin notes writing in 1919, for the early romantics "criticism in its central intention is not judgment" but rather "reflection [on a work], which can only, as is self-evident, unfold the germ of reflection that is immanent to the work."[3] Understood as an "eliciting of a latent reflexivity attributed to the object," the romantic concept of criticism that continues to underlie our contemporary understanding of "critical reading," Michael Warner notes, also "rests . . . on earlier developments, such as the apparent universalization of the critical role in the public sphere."[4] In this manner, each era's prevailing concept of criticism or critical reading "might be largely projected from [its] circulatory practices."[5]

Of course, criticism has at times been deliberately conflated with taste, as Benjamin notes about the "present-day" of his own essay on the German romantics. But for the most part, from Schlegel to Macherey, theorists of criticism have insisted on the fundamental separation of criticism from judgment. Over time, this latter view has become almost universally accepted by critics in the academy, if not in journalism.[6] While "one might think" that "critical reading . . . would be reading that reflects on its own aesthetic judgments," as Warner puts it, "one would evidently be wrong" (25). For even as critical reading, while no longer identified with acts of repudiation or praise, manages to retain its "identification with an ideal

of critique as a negative movement of distanciation" (24), "professional-
ized literary criticism has for the most part given up the business of taste-
making" (25). To this day, half a century after the "technician[s] of taste"
Macherey polemically advanced his theory of criticism against in the late
1960s have "dwindled to extinction in academia," but also after the
much more recent revival of aesthetics and turn against symptomatic read-
ing in literary studies, the term "criticism" remains almost wholly identi-
fied with the explanation and/or interpretation, as opposed to the evalu-
ation, of literary works.[7] Judgment and analysis are thus no longer assumed
"to accompany and imply one another," as they have been in certain times
past.[8] Yet the persistence of the interesting as both judgment and style
points to the continuing possibility of this imbrication, for reasons that
will emerge fully by the end of this chapter.

Difficult as it often is to recognize "interesting" as an aesthetic judg-
ment (that is, as a subjective, feeling-based evaluation), the interesting
seems even harder to understand, intuitively, as an objective style. Yet the
conceptualization of the interesting as a style—and as a distinctively mod-
ern, contemporary style—has a surprisingly long and even prestigious his-
tory. Described first as an aesthetic of eclectic difference in the last decades
of the eighteenth century (in what the German romantic literary critics
called "interessante" literature), it eventually morphs into a late twentieth-
century aesthetic of difference as information (the "merely interesting"
look of conceptual art). Tracking this shift in the style or appearance of
the interesting, from that of difference as eclecticism to difference as in-
formation, will enable us to shed new light on the parallel use of "inter-
esting" as a judgment and thus, by extension, on the ambiguous status of
aesthetic judgments in criticism. Indeed, across late eighteenth-century
German literary criticism and late twentieth-century U.S. art, we will see
how this aesthetic category plays a direct role in the mediation of feelings
and concepts, relating them "even in their incompatibility."[9]

To be sure, the evaluation "interesting" is not restricted to aesthetic
contexts. People find things aesthetically interesting, but also scientifically
interesting, historically interesting, sociologically interesting, psychologi-
cally interesting, ethically interesting, politically interesting, and so on.
That the specific objects and situations judged interesting vary widely
according to discipline or institutional context should come as no sur-
prise. What is striking is the consistency of the judgment's function: that
of ascribing value to that which seems to differ, in a yet-to-be-conceptualized
way, from a general expectation or norm whose exact concept may itself
be missing at the moment of judgment. Moreover, regardless of the par-
ticular objects and situations to which it is ascribed, the judgment always

seems underpinned by a calm, if not necessarily weak, affective intensity whose minimalism is somehow understood to secure its link to ratiocinative cognition and to facilitate the formation of social ties. In *The Passions and the Interests,* for example, Albert O. Hirschman calls attention to how an idea of "interest" shaped by early modern practitioners of statecraft—one regarding it as a "reasonable self-love" capable of countervailing the potentially destructive passions of men—played a central role in seventeenth- and eighteenth-century efforts to legitimate capitalism before its actual triumph. At a moment when the task of managing unruly impulses was explicitly delegated to the state, in light of what Machiavelli and Hobbes noted to be religion and moral philosophy's manifest failures to accomplish the goal, "concern for improving the quality of statecraft" led to the "first definition and detailed investigation of interest."[10] Interest, if not quite the judgment of interesting founded on it, thus makes its passage into the texts of classical economy in a surprisingly belated and counterintuitive fashion, Hirschman argues: only after being routed through political discourse as a "calm desire," theorized in explicit contrast to greed, ambition, and the desire for power, with the ability to abet the state in its specific task of binding fractious, potentially destructive individuals together (32–33).

Isabelle Stengers argues that "interesting" in science involves a similar binding of subjects to subjects. Noting that "interest" derives from *interesse,* "to be situated between," Stengers asserts that interesting scientific propositions are those that associate the greatest and most diverse number of actors—where "actor," understood as any entity with the power to transform the action of any other, is now expanded to include not just scientists but all nonhuman "phenomen[a] studied" as well as corporations and policy makers.[11] Indeed, Stengers polemically adds, "I would go so far as to affirm that no scientific proposition describing scientific activity can, in any relevant sense, be called 'true' *if it has not attracted 'interest'* " (83; emphasis in original). Stengers thus rejects the idea that the interest underlying the judgment of "interesting" in science is reducible to an association with money or desire for gain: "To interest someone does not necessarily mean to gratify someone's desire for power, money, or fame. Neither does it mean entering into preexisting interests." Rather,

> To interest someone in something means, first and above all, to act in such a way that this thing—apparatus, argument, or hypothesis in the case of scientists—can concern the person, intervene in his or her life, and eventually transform it. An interested scientist will ask the question: can I incorporate this "thing" into my research? Can I refer to the results of this type of measurement? Do I have to take account of them? In other words, can I be

situated by this proposition, can it place itself between my work and that of
the one who proposes it?" (83–84).

In science, for Stengers, "interesting" is what links or reticulates actors;
it is not just an adjective but a verb for the action of associating. To inter-
est another subject by judging a third party interesting (and it is always
through the mediation of this interesting third party) is thus to situate her
in a network of multiple actors. The more actors, and the more diverse,
the more interesting. As Stengers notes, the "most heterogeneous interests
are, contrary to belief, always capable of associating, and this is without
doubt one of the sources of their bad reputation. It does not matter that
you are interested in my proposition for different reasons than mine; from
the moment that you accept the conditions whereby it interests me, you
interest me" (84).

Stengers's point about what "interesting" means and does in science has
been picked up and underscored by sociologist Bruno Latour in his adja-
cent advocacy for a "sociology of associations" defined quite explicitly as
the writing of "interesting" accounts. Here, in tandem with Latour's idio-
syncratic use of "network" to mean a technique of describing rather than
the object described, "interesting" becomes a synonym not just for "net-
worked" or "networklike" but also for "well-written" and "good."[12] In-
deed, the fact that "interesting" reticulates actors—joins and situates them
in a network—is exactly what makes it an "indicator of literary value" or
"benchmark of literary quality" for all writing in the social sciences. In a
specifically "literary" fashion, "interesting" thus implicitly testifies to the
activity of "assembling the social" itself, which for Latour is intimately
tied to circulation: "If the social is something that circulates in a certain
way, and not a world beyond to be accessed by the disinterested gaze of
some ultra-lucid scientist, then it may be *passed along* by many devices
adapted to the task, *including* texts, reports, [and] accounts" (127). These
texts, reports, and accounts become significant mediators in a process of
tracing connections that for Latour is the only guaranteed way of mak-
ing the social "appear": "To put it in the most provocative way: good
sociology has to be *well written;* if not, *the social doesn't appear through
it*" (124; emphases added). The sociologically interesting is thus an ex-
plicitly discursive and even "literary" or aesthetic achievement. Making
the social appear entails writing "interesting" texts, which in turn entails
tracing "ties that transport transformation" across a radically expanded
number of agencies. The meaning and function of "interesting" in La-
tour's sociology are thus strikingly similar to what "interesting" means for
Stengers in science. In both cases, what makes "interesting" of value is how
it links heterogeneous agents or agencies together. More specifically, the

judgment seems to create or facilitate kinds of "betweenness"—relays, conduits, associations—that in turn facilitate the circulation of ideas, objects, and signs.[13]

As a judgment of value or quality tied to the association of heterogeneous agents, "interesting" thus points to how a "scientist is never a 'subject' alone before his 'object.'" For Stengers, there is no conflict between this idea of science as inherently interested/interesting and scientific "hardness" or objectivity. To the contrary, "A hard science cannot by nature be isolated"; it is precisely one marked by the "proliferation and multiplication of interests around its object" that has "gained the means of organizing its connection" with a plurality of other sciences.[14] Moreover, in science, it is only interesting propositions that are "capable of authorizing an indefinite multiplicity of readings and interpretations," that is, "of being utilized as evidence in the most diverse situations, and thus also of being disqualified as evidence" (86). Evidence, which does not preexist scientific activity but is what scientific activity strives to create, thus plays a central role in the linking of diverse actors that in turn makes things scientifically interesting (85–86). Put simply, what is interesting/reticulating in science is evidence. The work of science is essentially the "invention and production of reliable witnesses," which means that it always faces in two directions: while scientists "work their 'object,'" they simultaneously "think about their colleagues, about the way they might counter or reinterpret the evidence, invalidate it or demonstrate its 'artifactual' character" (85, 86). This orientation toward other subjects in the creation and presentation of evidence—an orientation we might call "forensic" in the sense of sharing the conventions of argument in both courts of law and in academic debate—calls attention to a deeper connection between the interesting, evidence, and the formation of discursive publics. Such a connection will emerge with greater clarity when I turn to the interesting's centrality to a postwar conceptual art preoccupied with the mass-mediated circulation of discourse, signs, and information.

Writing about history as well as science, Mikhail Epstein underscores Stengers's link between the interesting and evidence in his account of the former as the "relationship of provability to probability."[15] Epstein writes, "What makes a certain theory interesting is its presentation of a consistent and plausible proof for what appears to be least probable. In other words, the interest of a theory is inversely proportional to the probability of its thesis and directly proportional to the provability of its argument" (78). For example:

The probability of the old man Fedor Kuzmich being the same person as Tsar Alexander I is very small, so any historical evidence in support of that

theory would present great interest. . . . Similarly, among the most interest-
ing theoretical propositions of the twentieth century are those of relativity
and quantum physics, the conclusions of which challenge common sense to
the extreme, leading to a situation in which the ultimate improbability nev-
ertheless seems to possess scientific provability.

The least interesting theories, meanwhile, are those that (1) prove the
obvious, (2) speculate about the improbable without solid proof, or, worst
of all, (3) fail to prove even the obvious. (79)

Epstein continues,

If wonder involves the measure of improbability, then reason provides the
measure of provability. We now see that the category of the interesting
emerges as the measure of tension between wonder and understanding or, in
other words, between the alterity of the object and reason's capacity to inte-
grate it. On the one hand, an object offering a proliferation of wonders
without any reasonable explanation diminishes its potential to be interest-
ing because we give up all hope of rationally integrating such a phenome-
non. On the other hand, the evacuation of wonder that guarantees an easy
triumph for reason undermines our interest as well. (79)

As Epstein implies, the experience of the interesting begins with a
feeling—inquisitiveness, curiosity, wonder—falling somewhere between
an affect and a desire. It is thus a judgment based not on an existing con-
cept of the object but on a feeling, hard to categorize in its own right, that
in spite of its indeterminacy aptly discerns or alerts us precisely to what
we do not have a concept for (yet). Thus, in a similar if more narrowly
disciplinary spirit, Steven Knapp argues that what is properly interesting
in literary studies (his phrase is "theoretically interesting") is a "gap be-
tween authorial intention and literary content" that inevitably generates
wonder about authorial agency.[16] From a distinctively "theoretical" point
of view, what it means to be interested in literature is thus to be interested
in analogies between authorial agency and the kinds of agency repre-
sented in texts (or, more simply, in analogies between authors and texts).
Are these analogies themselves the product of an authorial intention? For
Knapp, only discourse that generates this epistemophilic feeling for a
reader—a feeling that, upon discerning the lack of a concept for the dif-
ference it encounters, seems to immediately embark on a search for one—
can be said to be "interesting" in a distinctively literary-theoretical way.

From the hard sciences to sociology to literary studies, the interesting
thus seems to be a way of creating relays between affect-based judgment
and concept-based explanation in a manner that binds heterogeneous
agencies together and enables movement across disciplinary domains.
But what does the judgment's shared usage in so many different contexts

say about the specifically aesthetic use of "interesting," which is what I am primarily concerned with here? Is there even in fact such a thing? Have we not just witnessed how it might be internal to the interesting to toggle between aesthetic and nonaesthetic judgments? Given this ambiguity, what light might a specifically aesthetic use of "interesting" shed on the role of other, less affectively equivocal aesthetic judgments in criticism? Does its frequently automatic use by critics (usually as the blandest or most noncommittal form of praise) call for rethinking—or does it simply corroborate—what most now regard as the superfluous relation of feeling-based judgments to criticism's task of producing knowledge? Even when "interesting" is drawn on explicitly for the evaluation of artworks, what affective/aesthetic, much less critical, power could such a vague and nonspecific judgment have?

The affective as well as conceptual indefiniteness of "interesting" raises another metacritical question. Both Stengers and Epstein tie "interesting" to the discursive presentation of proof or evidence for judgments made in explicitly nonaesthetic, concept-oriented contexts (science, history, religion). There is thus, as I have noted, a forensic dimension to the interesting. But what counts as evidence when we are trying to justify or convince others of the rightness of aesthetic judgments? These judgments are explicitly based not on determinate concepts nor on abstract principles but on inescapably subjective feelings of pleasure or displeasure that, as Kant implies, we nonetheless cannot *not* share.[17] What will be accepted as evidence when, paradoxically by using concepts (that is, nonaesthetic judgments), we try to get others to arrive at the same aesthetic judgments, by coming to feel the same feelings?

Questions like these come to the fore when such affectively and conceptually mixed efforts at evidentiary justification are considered integral, not incidental or counterproductive, to what cultural criticism does. This view noticeably underwrites the Frankfurt school tradition of Marxist aesthetics, where diagnoses of the "damaged life" of capitalist modernity are often built directly on, and are virtually impossible to isolate from, complex and often indirect arguments for the superiority of Mahler over Schoenberg (Theodor Adorno), Mann over Kafka (Georg Lukács), or Mallarmé over Stevens (Fredric Jameson). It also underwrites the not entirely different practice of Stanley Cavell, who in *Philosophy the Day after Tomorrow* defines "criticism" not as the sharing of pleasure per se, but as the concept-based justification of a pleasure-based claim for a particular cultural object's worth.[18] With elegant reflexivity, Cavell attempts to justify this account of criticism via an examination of difficulties surrounding the act of praising in the Fred Astaire musical *The Band Wagon* and,

more specifically, difficulties surrounding the act of a white dancer attempting to praise black dance without condescending to or simply appropriating it. Cavell notes that although his approach to criticism as the justification of praise/appraisal is not particularly argumentative, doing criticism "non-polemically or non-argumentatively . . . does not mean [agreement] with everything that I find calls for a response."[19] Rather, "Criticism in my writing often tends either to invoke the idea that Kant established for 'critique,' namely articulating the conditions which allow a coherent utterance to be made, or a purposeful action to enter the world, or else to provide an explication or elaboration of a text . . . *that accounts for, at its best increases, which is to say, appreciates, my interest in it*" (6, emphasis added). Cavell's subsequent explication of a complex scene of praising in a film he clearly finds interest-appreciating and therefore artistically praiseworthy (although he never says so directly) opens out into an Austin-inspired analysis of the perlocutionary nature of praise itself, a "passionate utterance" or speech act Cavell takes as synonymous with the judgment of beauty as theorized by Kant and, by extension, as a synonym and model for thinking about aesthetic judgment in general.[20]

The question of how we use nonaesthetic, concept-based judgments to support feeling-based aesthetic judgments, including ones based on complicated mixtures of displeasure with pleasure, is worth examining more closely in light of the fact that we do it all the time, without recourse to general principles. As Frank Sibley puts it in more technical language recalling Hume's problem of induction, the "nonaesthetic properties" of objects—properties arising from nonaesthetic or conceptual judgments—do not supply criteria for our evaluations of them as, say, elegant, cute, or gaudy. The absence of general principles for the application of these "aesthetic concepts," which Sibley is quick to set apart from "verdicts," or purely evaluative judgments of merit and defect such as "mediocre" or "excellent," preempts us from reasoning that an object must be "cute" *if* it is small, soft, and unthreatening. Although small, soft, and harmless things frequently are cute, the properties of smallness, softness, and harmlessness cannot be deduced from these instances as logically sufficient conditions for applying the concept. Yet the fact that there are no logically binding connections between the nonaesthetic qualities of an object and what Sibley calls its "aesthetic character" does not mean that there is no connection. Why else is it clearly not right to describe large, angular, and intimidating things like skyscrapers or metal shredders as cute? Indeed, granted that it is "impossible for a person to verify or infer [that a thing has a certain aesthetic quality] by appealing . . . only to nonaesthetic properties," why is it that when we are asked by others to supply evidence

in support of our aesthetic judgments, we do so precisely by pointing out the nonaesthetic features on which that aesthetic quality appears to depend?[21] If not one of logical entailment, what *is* the relationship between aesthetic and nonaesthetic features—and by implication, judgments—that enables us to link them together? This question has a direct bearing on the ultimate relevance of feeling-based evaluations to critical practices aimed at producing conceptual knowledge, especially in practices organized around the historical study of artworks. It also bears directly on the philosophical matter of the relationship between aesthetic experience and knowledge in general, a question that has remained controversial within, and arguably even constitutive of, aesthetics ever since Alexander Baumgarten proclaimed it a "science of sensible cognition" in 1750.[22]

Sibley's investigation of the not-logical but also crucially not-illogical relationship between aesthetic and nonaesthetic features thus shows the difficulty of fully separating a philosophical inquiry into the nature of aesthetic judgments from the seemingly ancillary, merely rhetorical question of how we use nonaesthetic judgments (facts and concepts, in particular) to convince other people of their rightness afterward. Indeed, for Cavell, it is the second question (about justification) that provides the key to the first (about judgments). Cavell begins by defining aesthetic judgment as a pleasure-based claim that the subject is compelled to make public by speaking, which is what Kant's analysis of the beautiful implies. Laying the speaker open to potential "rebuke" from others, aesthetic judgment is thus a speech act and what J. L. Austin calls a perlocutionary speech act in particular. In the absence of conventions governing its felicity (which do exist in the case of illocutionary acts such as betting or marrying), the real significance of the perlocutionary act for Cavell lies in the way in which the power to determine the act's felicity shifts from the speaking/ judging "I" to the listening "you" (as is the case for acts such as complimenting and insulting, which can only really be said to have taken place if the person to whom they are addressed thinks so). In light of this fundamental exposure to public disputation and even potential ridicule, the question of what Kant's aesthetic judgment is—"a kind of compulsion to share a pleasure, hence . . . tinged with an anxiety that the claim stands to be rebuked"—becomes more or less coeval with the question of how one will subsequently support it.[23]

While the interesting is the only aesthetic category in our repertoire with this special relationship to evidence, it is also the one for which the issue of evidence becomes most problematic or acute. Someone who succeeds in convincing me of the rightness of her judgment of an object as cute will have done so by getting me to perceive it as she does, and she

will have done this by directing my attention to its diminutive size, soft-ness, and unthreatening demeanor. But in contrast to what Sibley calls the "notable specific dependence" of aesthetic character on nonaesthetic features, the interesting does not seem particularly tethered to any such features. To be sure, what we find interesting does seem bound up with the perception of difference or novelty against a backdrop of the expected and familiar. One could therefore argue that the nonaesthetic feature or judgment that the interesting depends on is that of being "different" or "new." Yet features like "different" and "new" are fundamentally compar-ative or relative (new how? different compared with what?) and are thus more unstable, provisional, and ultimately transient than nonaesthetic features such as "round" or "bright." There are thus no nonaesthetic fea-tures specifically or finally responsible for anything being interesting, just as there are none for things being different or new. In fact, it seems as if virtually any nonaesthetic feature, including features not immediately per-ceivable without knowledge or information, can be singled out as evidence in support of this judgment. Because the problem posed by the interesting is thus not a dearth of admissible evidence but rather the proliferation of too many possible kinds, the task of legitimizing this particular evaluation becomes unusually difficult to the extent that it also becomes unusually easy. Anything can presumably count as evidence at one moment or an-other for the interesting—meaning also that no piece of evidence can void or rule out a judgment of "interesting"—and so no particular kind of evi-dence will ever seem especially or finally convincing.[24]

The most characteristic thing about the interesting is thus its lack of distinguishing characteristics, which makes its "deduction," as literary critic, poet, and novelist Friedrich Schlegel wrote in 1797, "perhaps the most difficult and complicated task" within "the entire realm of the science of aesthetics."[25] Let us take a closer look at what he means by this in the following section.

Schlegel's Aesthetic of Difference

With the exception of its special relation to difference or novelty (but perhaps more precisely because of it), the interesting might be described as an aesthetic without content, and thus ideally suited to the idea of the modern subject as a reflective, radically detached or "ironic" ego.[26] This was in fact how the German romantic literary critics of the late eighteenth and early nineteenth centuries—the first to regard and codify the interest-ing as a literary style—defined "das Interessante." At a moment marked by a radically expanded and accelerated circulation of printed media and

the emergence of a bourgeois public sphere, by an unprecedented explosion of new literary genres and the nascent professionalization of literary criticism, it was Schlegel who first defined modern, interesting literature in direct opposition to the beautiful art of the Greeks.[27] Whereas "die schöne Poesie" of classical antiquity is objectively rule bound, universal, and disinterested (befitting a culture in which, supposedly, no metaphysical gap exists between man and nature, and no "striving" is therefore necessary to represent the ideal), "die interessante Poesie" is restlessly subjective and idiosyncratic, "content to take nothing less than everything for its province; resolved to possess and to express the entire range of human experience; [and] more interested in the individual variant than in the generic type."[28] In *On the Study of Greek Poetry* (written 1794–1795, published in 1797), Schlegel's primary example of modern, "interessante" literature, the corpus of Shakespeare, is accordingly described as "not purely objective; rather it assumes an entirely individual stamp and peculiar local color; it is entirely taken up in a specific style" (*OSGP*, 116). Yet it is precisely this stylistic specificity that points to "interessante" literature's overall lack of a specific direction or goal:

> The general orientation of poetry—indeed, the whole aesthetic development [*Bildung*] of modernity—toward the interesting can be explained by this lack of universality, this rule of the mannered, characteristic and individual. Every original individual that contains a greater quantity of intellectual content or aesthetic energy is *interesting*. I said deliberately: *greater*. Greater, namely, than the receptive individual already possesses: for the interesting demands an individual receptiveness, indeed, often a momentarily individual mood. Since all magnitudes can be multiplied into infinity, it is clear why a complete satisfaction can never be attained in this way, why there can be no *endpoint* when it comes to the *interesting*. . . . The more often the longing for a complete satisfaction that would be grounded in human nature was disappointed by the individual and mutable, the more ardent and restless it became. Only the universally valid, enduring, and necessary—the *objective*—can fill this great gap; only the beautiful can still this ardent yearning. (35)[29]

Note how Schlegel assigns a specific temporality to the interesting: that of the interminable or perpetually ongoing. Open to endless particularization because no laws govern its determination by any content in particular, interesting literature has no "endpoint" other than the subjective individual, who embarks on a "restless" quest for eclectic novelty, or for "individuality that is original and interesting," that is guaranteed never to satisfy him fully.[30] This is because what counts as "interesting" is that which "contains a greater quantity of intellectual content or aesthetic energy. . . . I said deliberately: *greater* . . . than the receptive individual

already possesses" (35).[31] As Jan Mieszkowski underscores in *Labors of Imagination,* the interesting for Schlegel is thus ultimately a matter of comparison based not on kind but on degree. "Since all magnitudes can be multiplied into infinity," Schlegel writes, "Even that which is most interesting could be more interesting. . . . All quanta are infinitely progressive" (35, 72). There is thus a sense, as Schlegel's fellow *Athenaeum* contributor Novalis notes, in which what is most interesting is the "presentation of an object *in series*—(series of variations, modifications, etc.). For example, as Goethe presents the persons of Wilhelm Meister, the beautiful soul, Nathalie."[32] An "experience of confronting something 'greater' than oneself, an abiding engagement with 'more,'" as Mieszkowski puts it, the interesting does not culminate in any "objective" meaning; rather, as both Schlegel's account and Goethe's ironic novel of self-realization suggest, it is "only by encountering something interesting, that is, something more interesting than ourselves, that we become individuals."[33]

The interesting is thus a style of serial, comparative individualization. Yet as Mieszkowski stresses, this individuality is "essentially adrift, isolated from any universal concept that would stabilize the interacting units," since it hinges on the subject's "'receptiveness' to an open-ended process of comparisons whose function as either the synthesis or analysis of varying quanta of content remains completely uncertain."[34] It is this fundamental adriftness that leads to the "restless" striving and serial, ongoing circulation of the interesting and to its failure to produce a "complete satisfaction." Schlegel accordingly relates the rise of the interesting to what he repeatedly describes in *On the Study of Greek Poetry* as the "anarchy" of modern German literature and criticism: "Philosophy poeticizes and poetry philosophizes: history is treated as poetry and poetry is treated like history. Even the types of poetry exchange their very definition. A lyrical mood becomes the object of a drama, and dramatic material is forced into lyrical form" (18).[35] The problem is not just art's generic hybridity, however, but its historically unprecedented pluralism. As Schlegel puts it, "Here one finds—as if one were in a general store of aesthetics— folk poetry and courtly poetry next to one another" (20). In this expanded literary marketplace, every subcultural public or audience finds its own interesting, properly specialized commodity, as Schlegel notes with a mixture of sarcasm and awe:

> There are Nordic or Christian epopees for the admirers of the north and Christianity; ghost stories for the lovers of mystical horrors, Iroquoian or cannibalistic odes for the lovers of cannibalism; Greek costume for antique souls; knightly poems for heroic tongues; and even national poetry for the dilettantes of Germanness! Nonetheless, it is pointless to draw out of all

these realms the richest abundance of interesting individuality! . . . With every
pleasure the desires become only more violent; with every allowance the
demands rise ever higher, and the hopes for final satisfaction become ever
more distant. The new becomes old; the unusual becomes common; the
frisson of what is charming becomes dull. With its own power and artistic
drive diminished, languid receptivity subsides into an appalling impotence.
(20–21).

Schlegel suggests that this situation, in which "each [higher and lower
poetry] has its own public, and each of which goes its own course uncon-
cerned for the other," promotes an "obsession to imitate" (39), a passion
for sampling and pastiche that in turn reinforces modern literature's
generic and stylistic miscegenation, its domination by "artificial assem-
blages" produced by "chemical experiments in the arbitrary division and
mixture of the original arts and the pure types of art" (30). Such imita-
tion and remixing reinforce art's national hybridity as well, as Schlegel
ambivalently notes about the "multifaceted foreign influence" on contem-
porary German literature (23): "Even peculiarity does not seem to have
specific and fixed boundaries. French, English, Italian, and Spanish poetry
often seem to exchange their national characters, as if they were in a
masquerade. German poetry almost presents a complete geographical
specimen collection of all national characteristics of every age and every
area of the world" (20). The rise of the interesting—a new, nonbeautiful,
comparative aesthetic style explicitly about aesthetic variety—thus seems
to emerge in direct response to the diversity of the expanding literary
marketplace. Yet for Schlegel, the "crisis of the interesting" (38) finally
reflects German literature's overarching loss of direction: "It is obvious
that modern poetry either has not yet attained the goal toward which it
is striving, or that its striving has no established goal, its development
[*Bildung*] no specific direction, the sum of its history no regular continuity,
the whole no unity" (17).

At the dawn of its mass circulation, modern literature thus confronts
the critic with the following question: how does one assign an aesthetic
"character"—a purpose or "inner principle" of development—to this
historically unprecedented state of aesthetic "anarchy"? As Schlegel him-
self notes, "*Lack of character* seems to be the only characteristic of mod-
ern poetry; *confusion* the common theme running through it; *lawlessness*
the spirit of its history; and *skepticism* the result of its theory" (20). But
at the same time, he notes, "It is clear that in the strictest and most literal
sense there can be no characterlessness. What one tends to term an absence
of character is either a character that has become effaced and essentially
unreadable or a character that is extremely complex, complicated, or

puzzling." Schlegel thus concludes that there is indeed "*a common element* in that thorough anarchy evident throughout the entirety of modern poetry, a *characteristic trait* that could not exist if there were no *common inner foundation*" (22). What is this unifying concept for modern literature's anarchic aesthetic heterogeneity? The character of its historically distinctive characterlessness? More simply, in the vastly expanded repertoire of aesthetic categories, is there one aesthetic category that somehow embodies the fact and problem of aesthetic pluralism itself? "Interessante": an endless and yet remarkably "provisional," fundamentally fleeting or transient experience of difference. "The new becomes old; the unusual becomes common; the frisson of what is charming becomes dull" (100, 21).

For Schlegel, "interessante" also seems to mark a convergence of art with conceptual discourse about art, or an internalization by art—which consequently becomes philosophical or "reflective"—of the "relation between theory and praxis" (23). This may be in part why Schlegel, in his discussion of "interessante" style in general, never strays in his examples from literature, art in a discursive/conceptual medium. And for Schlegel, literature seems most interesting when it becomes invested in a kind of realism—that is, when it takes up a specific interest in the relation between representation and reality, or between the subject's idealized image of the world and the world as it truly is.[36] In a preface to *On the Study of Greek Poetry* added two years after the manuscript was initially submitted to the publisher, most likely to respond to the intervening publication of Schiller's highly influential *On Naïve and Sentimental Poetry,*[37] Schlegel likens the interesting to Schiller's concept of the "sentimental," whose characteristic trait is precisely its reference to the relation between the real and the ideal. In contrast to "naïve" poetry, which knows no gap between itself and nature (and therefore no striving), the subject of sentimental poetry restlessly reflects on what he knows to be his subjectively mediated and idealized impressions of nature, and on the gap that lies between these impressions and the real. The interesting, Schlegel suggests, is obsessed with a similarly epistemological set of problems. Whereas "objective" poetry "has nothing to do with reality," but "strives only after a *play* [or] *appearance* that—as the most unconditioned truth—would be valid and legislative" (98), "interesting poetry" follows the "sentimental" in having an explicit interest in the "reality of the ideal, the relation between the ideal and real, and the reference to the individual object of the idealizing imagination of the poeticizing subject" (99).[38]

Interesting literature, however, remains an essentially directionless literature, founded on and tending to perpetuate "unsatisfied longing" as

opposed to the contentment arising from disinterested contemplation of the finality of beautiful form (18). For Schlegel, there is thus something "formless" about the interesting as the serial repetition of an encounter with difference: "Utterly indifferent at bottom to all form, and full only of an unquenchable thirst for *content,* the more refined public demands of artists only *interesting individuality.* As long as there is an *effect,* as long as the effect is *strong and new,* the public is . . . indifferent to the manner in which . . . it occurs" (20). Modern poetry, "especially in more recent ages," is thus marked by the *"total predominance of the character-istic, individual, and interesting"* (24). It is furthermore marked by the *"restless, insatiable striving after something new, piquant, and striking* despite which, however, longing persists unappeased" (24).

However, as we can already see in his preface, in which the acknowl-edged overlap between his account of the interesting and Schiller's account of the sentimental seems to begin to soften his regard of the former, Schle-gel's negative opinion of the interesting famously underwent a 180-degree reversal as he began to draw from his initial account of this explicitly nonbeautiful aesthetic in *On the Study of Greek Poetry* to develop what would eventually become his mature theory of "romantic" literature.[39] As Kathleen Wheeler informs us, "By 1797, Schlegel had published his first fragments in the journal, *Lyceum der Schöne Kunste,* in which he devel-oped his idea of 'romantische Poesie' out of the earlier concept of 'inter-essante' literature, leaving behind his purist tendencies and embracing a non-objective, relativist aesthetic."[40] The ambivalent account of the inter-esting thus becomes absorbed by his unequivocally positive theory of the romantic; as A. O. Lovejoy notes, "The 'romantische Poesie' of which we hear so much after 1798 was simply the 'interessante Poesie' of the earlier period."[41]

In tandem with this shift, Schlegel's primary example of romantic/in-teresting literature increasingly becomes the novel, the hybrid, varie-gated, all-inclusive genre that he bluntly describes in later writings as "a romantic book."[42] This association made in his later writings (the roman-tic with the novelistic) enables Schlegel to further sharpen his original contrast between classical/beautiful and romantic/interesting literature.[43] Whereas classical poetry "adheres to mythology and avoids specifically historical themes," Schlegel writes in "Letter about the Novel," romantic literature is "based entirely on a historical foundation."[44] Moreover, as an aesthetic of comparative individuality first glimpsed in Shakespeare's commitment to the representation of "the eccentric oddities and failings attendant on [unique individuals]," the interesting would logically come to a certain head in a genre increasingly devoted, after Goethe, Richardson,

and Fielding, to the histories of ordinary yet "original" people.[45] As Schlegel puts it in *Athenaeum* #146: "the novel permeates all modern poetry."[46]

Since the essence of the romantic/interesting work of art is reflection and thus a kind of "criticizability," we can see how Schlegel's theory leads not just to the privileging of the essentially conceptual art of the novel, but also to what Benjamin describes as a new emphasis on the "austere sobriety" of art, or on art as the "prosaic" and "antithesis of ecstasy."[47] Interesting art, including poetry, is thus fundamentally prose.[48] In Schlegel's 1800 manifesto "Dialogue on Poetry" and other writings published in the *Athenaeum*, "interesting" also seems to refer to how a work can still be somewhat "good" even when it is largely "bad," or to how an explicitly nonbeautiful work—mixed, transitory, impure in terms of affect as well as genre—can still have value or quality. He writes in *Athenaeum* #416, "Even by the most ordinary standards, a novel deserves to become famous when it portrays and develops a thoroughly new character interestingly"; indeed, even a bad popular novelist like Friedrich Richter "is probably interesting in the greatest variety of ways and for most contradictory reasons" (*Athenaeum* #421).[49] Once an explicitly nonbeautiful aesthetic becomes conceivable, "distinct from truth or morality [but having] the same rights as these" (*Athenaeum* #252), so does the idea of the interesting as an aesthetic category.[50] Defending the "colorful hodgepodge" of Richter's best sellers as not only "interesting" but the "only romantic productions of our unromantic age," Schlegel underscores that "interesting" means "romantic," which also means "mixed": "Indeed, I can scarcely visualize a novel but as a mixture of storytelling, song, and other forms" ("Letter about the Novel").[51]

Its association with the novel thus helps Schlegel embrace the interesting as part of a broader "romantic" agenda advocating the creation of new hybrid styles and genres; a shift from enthusiasm to detachment as the proper stance for writers and critics to adopt toward literature; an encouragement of the active reader through a deliberate use of "incomprehensibility"; and the making of literature increasingly like criticism while also making criticism more literary.[52] "Poetry should describe itself, and always be simultaneously poetry and the poetry of poetry," as *Athenaeum* #238 prescribes.[53] Schlegel thus calls for a "theory of the novel" that "would have to be itself a novel that would reflect imaginatively every eternal tone of the imagination," one in which, because of the new genre's inclusivity and promiscuous mixing of other forms and genres, "Dante's sacred shadow would arise from the lower world, Laura would hover heavenly before us, Shakespeare would converse intimately with Cervantes, and there Sancho would jest with Don Quixote again" ("Letter about the Novel").[54] As Schlegel puts it elsewhere, "Novels are the

Socratic dialogues of our time. Practical wisdom fled from school wisdom into this liberal form" (*Lyceum* #26).[55] Schlegel accordingly praises *Wilhelm Meister* for being "as much a historical philosophy of art as a true work of art," even though our "usual expectations of unity and coherence are disappointed . . . as often as they are fulfilled" by the novel's "cultivated randomness" ("On Goethe's *Meister*").[56]

It is the absence of a determining principle that leads to this "cultivated randomness," which keeps the romantic writer (and critic) moving from one interesting particular to the next even while knowing that "a complete satisfaction can never be attained in this way."[57] The interesting thus walks hand in hand with romantic irony, which G. W. F. Hegel describes disparagingly in his lectures on aesthetics as the subject's radical detachment from "determinate reality and particular actions, [and thus from] what is universal in its own right."[58] Although Hegel attributes the craze for this "genial God-like irony" directly to "Herr Fried. von Schlegel" (although "many followed him in prating about it then, or are prating of it afresh just now"), he also traces its underlying idea back to Johann Gottlieb Fichte and his establishment of an "utterly abstract and formal" I as the "absolute principle of all knowledge, all reason and cognition," such that "every characteristic, every attribute, every content is annihilated by absorption into this abstract freedom and unity."[59] For Hegel, then, the radical detachment that makes the interesting so compatible with irony, as well as with the kind of art that wants to become science or philosophy, is precisely what makes it complicit in advancing the end of art.[60] If art is the expression of a definite content or meaning in a sensory medium, the reflective detachment characteristic of the modern artist cannot be adequately expressed by his own art.[61] Anticipating late twentieth-century criticisms of postwar conceptual art for its "perceptual withdrawal" or noticeable lack of sensuous appeal,[62] Hegel claims that an art whose content is a concept or "abstract proposition" poses a problem that properly belongs not to art but to philosophy, thus reentrenching the division Schlegel enlisted his concept of interesting/romantic art to overthrow.[63] On this Schlegel is adamant: "Every art should become science, and every science should become art; poetry and philosophy should be unified" (*Lyceum* #115).[64] For precisely this reason, the "keystone" of a "real aesthetic theory"—one that begins with the recognition that modern art is not reducible to beauty and that there is perhaps even an "absolute antithesis between art and raw beauty"—would be a "philosophy of the novel" (*Athenaeum* #252).[65]

Thus while the romantic artist's lack of attachment to a particular worldview and his consequent ability to "take on any subject-matter or artistic style" are what finally make the rise of "interessante" literature

an exciting and positive development for Schlegel, Hegel's take on the emergence of this comparative/relativistic aesthetic is far less optimistic. As he notes, "In our day . . . criticism, the cultivation of reflection, and . . . freedom of thought have mastered the artists too, and have made them, so to say, a *tabula rasa* in respect of the [content and form] of their productions. . . . Today there is no material which stands in and for itself above this relativity, and even if one matter be raised above it, still there is at least no absolute need for its representation *by art*" (Hegel, *Aesthetics*, 1:605). Modern, interesting literature's discursive, reflective self-criticality is thus, for Hegel, a telling symptom of art's nonessentiality in modern culture overall. Indeed, Hegel's personalized attack on Friedrich Schlegel and his brother in his *Aesthetics* as "greedy of novelty in the search for the distinctive and extraordinary," and thus prone to falling "into admiring the mediocre, ascribing universal worth to what was only relatively valuable, and [boldly endorsing] a perverse tendency and subordinate standpoint, as if it were something supreme," doubles perfectly as an indictment of the eclectic, relativistic, and therefore ultimately indeterminate aesthetic that Schlegel came not only to critically diagnose but also to endorse (Hegel, *Aesthetics*, 1:63, 64).

The interesting seems at first glance to be an aesthetic entirely about particularization, yet its relativism ultimately precludes it from having a concretely particularized content. This lack would seem, on Hegelian grounds, to disqualify the interesting from the realm of aesthetics proper. Yet one suspects that this nonaesthetic appearance may be why the judgment continues to be favored by critics who find aesthetic evaluation relevant to critical practice, since the interesting's lack of definite content is exactly what enables it to move between judgments of aesthetic and nonaesthetic character, creating relays from one to the other and thus between "criticism as appreciation (the education of taste)" and "criticism as knowledge." If judgment in general has become suspect in criticism, viewed as irrelevant or even obstructive to the more fundamental activities of explication, interpretation, symptomatic reading, or whatever, this would seem particularly the case for judgments based on feelings rather than concepts, and more specifically, feelings related not to what an object is known to be, but rather solely to how it appears or seems. Whether invoked in the spirit of science, history, or art, the evaluation of "interesting" is always affective (however minimally or equivocally so). "Interesting" can thus be a way of linking feeling-based judgments to concept-based explanations under the radar—even making it appear as if aesthetic evaluations have a logical relation to facts. Indeed, the movement the interesting enables between aesthetic and nonaesthetic judg-

ments mirrors a relay between pleasure and cognition internal to the experience of the interesting itself, as will be explained in the next section as I turn to the curious feeling that underpins it.

Interest's Affective Ambiguities

If the interesting marks a tension between wonder and reason, increasing in direct proportion to the acuteness of that tension, the feeling that underpins it seems to lie somewhere between an object-oriented desire and an object-indifferent affect. For Silvan Tomkins, for example, interest seems to be the minimal condition of experience in general, "a necessary condition for the formation of the perceptual world."[66] Similarly, for William James, interest is that without which "consciousness of every creature would be a gray chaotic indiscriminateness, impossible for us to even conceive."[67] He writes:

> Millions of items of the outward order are present to my senses which never properly enter into my experience. Why? Because they have no interest for me. My experience is what I agree to attend to. Only those items which I notice shape my mind—without selective interest, experience is utter chaos. Interest alone gives accent and emphasis, light and shade, background and foreground—intelligible perspective, in a word. (402)

"Interest" is thus a particularizing attachment to an object (one that endows it with empirical qualities); yet the feeling seems to have no qualities of its own.[68] Indeed, at times "interest" seems synonymous with "attachment" in general, the ego's barest or simplest form of relation or receptiveness to "items of the outward order." In his discussion of the "general structures of receptivity" defining "prepredicative" experience in *Experience and Judgment,* Edmund Husserl makes a similar point, associating interest with the very "lowest level of the [ego's] activity," its mere "tending" toward an object of perception before attributing qualities to it. This basic tending "awaken[s] an *interest* in the object of perception as existent," which leads in turn to an "ego-realizing structure of expectancy."[69] Interest, for Husserl as much as for Schlegel, thus has an intimate relation to the futurity of progressive ego individuation, as well as to that "ego-realizing" process's ongoing temporality. This is because in the "firm orientation on the object" that arises with prepredicative interest, "there is an intention which goes beyond the given . . . and tends toward a progressive *plus ultra.* It is not only a progressive having-consciousness-of but *a striving toward a new consciousness* in the form of an interest in the enrichment of the 'self' [by] the object which is forthcoming *eo ipso* with the prolongation of the apprehension" (82; emphasis added).[70]

For Husserl, as for James, interest seems to facilitate a transition from passive to a more active kind of attention. It is ambiguous, however, whether selective or prepredicative interest (always interest in something as existing) is enduring or fleeting. Another ambiguity surrounding interest is whether it is ultimately about the self or the other, an ambiguity reflected not just in the phenomenology of interest but in how the term is commonly used today. As Mieszkowski elaborates, "On the one hand 'interests' name that which is most proper to a person or group; they are ostensibly the motivations or predilections that define an agent's particularity. On the other hand, 'interests' designate a dynamic that takes the self beyond itself, grabbing its attention and turning its gaze outward."[71] Because the "one constant here is the self—the one who is interested," it is not hard to "see how it could be argued that interest is always a question of self-interest, that one is first and foremost interested in one's own ability to be interested" (112). Epstein makes a similar point: "The interesting involves us in the 'inter-being' of external objects, but the root of the *inter esse* is within ourselves. There is an interior relation between my actuality and my potentiality: I can be unpredictable and surprising to myself. The interesting functions as a kind of mediator between me and myself, to the extent to which I may be different from what I am."[72] Yet as Schlegel might say, it is precisely the experience of difference or of one's receptiveness to the "greater" or "more" that accounts for that interesting self-difference. In other words, as Mieszkowski puts it, since "[as] self-interest, interest is always interest in the other-than-self," "the self-interested self is by definition "other-interested."[73]

But how can a term used to mean "fascinating" also come to mean "boring"? How can interest be at once "an articulation of affect and entirely affect neutral"?[74] As Mieszkowski notes, this ambiguity parallels the way in which interest is "sometimes treated as a means to an end, other times spoken of as if it were a goal in its own right" (113). We similarly find interest described as both strong and weak, as both enduring and fleeting, as both a libidinal desire and also the dispassionate antithesis of passion. We have already seen how, on this last premise, the "interests" were counterintuitively praised for their ability to countervail the impulses of man in the Hobbesian state of nature. Freud's distinction between "interest" and "libido" echoes this older division of interests from the passions, with the former defined as the investment of energy proceeding from the ego's "self-preservative" instincts (often curiously weak), and the latter as the much stronger energy directed by the ego toward objects of sexual desire.[75] A similar contrast lingers around Teresa Brennan's effort in *The*

Transmission of Affect to distinguish between particularized intensities like anger and the "feeling of a calming and discerning variety" she calls "feeling intelligence."[76] The indeterminate nature of the latter endows it with its ability to register the presence of particularized intensities; that is, qualified emotions not to be confused with the undifferentiated feeling that attaches to and senses them. As Brennan explains, although the "passions now claim to be a class *of* feeling, rather than something discerned *by* feeling," our continued practice of speaking of "the feeling *of* envy" or "*of* anger" suggests that there is a more basic or generic, undifferentiated type of feeling that detects these feelings for consciousness, briefly "attaching" itself to one before moving on to the next.[77] The mild and nonspecific feeling Brennan calls "feeling intelligence" but also refers to as "living attention" (in order to further sharpen its distinction from the feelings it helps us discern and perhaps even differentiate) looks very much like the general "receptiveness" that underpins Schlegel's concept of the interesting.[78] Indeed, in its ability to move from one feeling to the next without ever becoming permanently affixed to any, Brennan's contentless feeling behaves somewhat like the detached ironic ego who produces reflective, "interessante" art.[79]

It should therefore come as no surprise that philosopher Ralph Barton Perry, student and biographer of William James, defines "interest" in his book *General Theory of Value: Its Meaning and Basic Principles Construed in Terms of Interest* (1926) as the most naked or minimal kind of judgment, the basic tendency of the "living mind to be *for* some things and *against* others."[80] More ambiguous in intensity and less erotically charged than its feminized, more avidly epistemophilic cousin curiosity (long regarded, as Hans Blumenberg shows, as the "libido of theory," both the driving force of reason and a potential threat to it from within), for Perry, this basic *"state, act, attitude or disposition of favor or disfavor"* is the "original source and constant feature of all value."[81] Conversely, Perry defines value, in its generic form, as "any object . . . [of] any interest."[82] If there is something generic about the judgment "interesting" that underwrites its striking diversity of applications, it thus seems to have something to do with the radical indeterminacy of the feeling at its foundation.

Schlegel's account of the interesting as style suggests that the judgment likewise stems from a feeling provoked by the impression of an as-yet-unqualified difference, or of a purely quantitative "greater." The judgment "interesting" is thus at once conceptual and nonconceptual: conceptual in that some standard is clearly required for the perception of

difference in the first place (different from what?); nonconceptual in the sense that the concept for that perceived difference is affectively registered as missing. Provoked by the absence of a name for the difference that one is nonetheless registering, the experience of the interesting is essentially a feeling of not-yet-knowing. If aesthetic judgments are evaluations based on feelings related to how things appear, and not on concepts of what they are, this seems to make "interesting," an evaluation based on a feeling that explicitly registers the absence of a concept, a kind of zero-degree aesthetic judgment that perhaps provides the best model for thinking about evaluation in general. For the interesting gets at the imbrication of the affective and conceptual that underlies all judgment, as a feeling of not-yet-knowing (an affective relation to cognition) accompanied by a lack of conceptual knowledge about what exactly we are feeling (a cognitive relation to affect).

As opposed to there being a distinctively aesthetic use of "interesting" that exists alongside distinctively scientific, sociological, historical, or literary-theoretical uses, what this suggests is that the judgment "interesting" is in some sense fundamentally aesthetic, or that its object is always aesthetic, even when it is applied in nonaesthetic domains. Even if one argues that "interesting" is a radically indeterminate value that, for precisely this reason, fluctuates between aesthetic and nonaesthetic judgments (scientific, historical, moral, or whatever), this fluctuation seems internal to the specifically aesthetic use of "interesting" as feeling-based evaluation. Indeed, understood as an affective response to unqualified difference, or as a judgment/experience that proceeds from a feeling that registers both conceptual absence and the operation of cognition even in the face of that absence, the interesting is suprisingly not dissimiliar from beauty as conceived by Kant. The key difference is that in the case of the former, the perceived lack of concept triggers its immediate pursuit. By affectively situating the judging subject in relation to her lack of conceptual knowledge, the interesting launches us on a search for its own criteria. As Cavell puts it, "Kant's location of the aesthetic judgment, as claiming to record the presence of pleasure without a concept, makes room for a particular form of criticism, one capable of supplying the concepts, which, after the fact of pleasure, articulate the grounds of this experience in particular objects. The work of such criticism is to reveal its object as having yet to achieve its due effect. Something there, despite being fully opened to the sense, has been missed."[83] This is exactly what the judgment "interesting" makes explicit. The question that always attends this evaluation is this: what was it that I must have noticed and simultaneously not noticed about the appearance of the object in order to have judged it in-

teresting? "Noticed" because my attention must have been drawn by some aspect of that appearance; "not noticed" because here I am clearly in a state of wonder about what exactly that aspect was. This wonder is itself a bridge to a more active desire to know.

We have already seen how Epstein links the interesting to a correlation between reason and the surprise of wonder. Silvan Tomkins similarly notes the connection between "interest-excitement" and the experience of the unexpected, which prompts him to classify the former with fear and startle (or surprise) in his system of affects. Unlike the feeling of being startled, however, which tends to dissipate as quickly as it flares up (thus making startle the "resetting affect"), interest has the capacity for duration and is fundamentally recursive, returning us to the object for another look. What we find interesting is typically something we compulsively come back to, as if to verify to ourselves that it is still interesting and thus potentially to find it interesting again—a dynamic that makes the interesting not just about the unexpected but also about the familiar, not just about difference but also about repetition.[84] In encoding this promise of a second and possibly third, fourth, or nth + 1 encounter, the interesting narrativizes aesthetic experience, giving it both an anticipatory and a retrospective orientation. In contrast to the "suddenness" Karl Heinz Bohrer celebrates as the essence of every aesthetic relation, here aesthetic experience unfolds in a succession of episodes akin to the "steps of thought" Philip Fisher associates with wonder. Although unlike wonder, which, as Fisher emphasizes, is a "rare" experience in which our affective response to novelty is intense, the surprise of the interesting is both common and often mild.[85] Indeed, there is a sense in which "interesting" simply means surprising—but not that surprising. It is also worth underscoring here that the interesting's tie to the experience of the unexpected or surprising by no means contradicts its fundamental recursivity; it is an aesthetic category that binds difference and repetition together.

Tomkins accordingly perceives interest as required for systemic complexity, for "shift[ing] from one perceptual perspective to another, from the perceptual to the motor orientation and back again, from both the perceptual and the motor to the conceptual level and back again."[86] Because of its capacity also to produce "sustained immersion—[where one is] able to come back again and again to the same problem until there is a breakthrough," Tomkins also views interest as a necessary condition for the physiological and psychological support of any "long-term effort and commitment," from scientific work and political activism to, say, reading a 900-page novel.[87]

Tomkins's references to "long-term effort" and the recursive temporality of "com[ing] back again and again" return us to the link between the interesting and ongoingness.[88] In contrast to both sublime feeling, which is a "sudden blazing, and without future," and the feeling of the beautiful, which in its own way also involves the "pause of diachronic time," the experience of the interesting is at once anticipatory and continuous.[89] It is this temporal orientation that, in conjunction with its lack of descriptive content, makes the interesting so useful as a syntactic placeholder, enabling critics to defer more specific aesthetic judgments indefinitely. "Interesting" thus becomes particularly handy as a euphemism, filling the slot for a judgment conspicuously withheld. But in addition to using "interesting" to replace or postpone aesthetic judgments, we also use the term to facilitate our return to the object for judging at a later moment, like putting a sticky note in a book. As if founded on a "feeling of incompleteness" that makes it anticipatory as well as recursive (what is anticipated is precisely a return),[90] calling an object interesting in this regard is to make a silent promise to the self: come back to this later. This clearly has something to do with the feeling of interest that lies at its core, which for Perry ensues from the attunement between a subject's expectations and the "unfulfilled phases of a governing propensity . . . that is at any given time in control of [our] organism as a whole."[91]

The interesting thus contains what Perry calls a "forward reference in time" that is central also to Nelson Goodman's argument in his classic paper on artistic forgeries that future aesthetic encounters are not only implied by but also an active factor in determining the nature of our aesthetic encounters in the present.[92] The judgment "interesting" thus registers the simple fact (strangely overlooked by much aesthetic philosophy) that time makes a difference in aesthetic evaluation—an acknowledgment that by no means necessarily requires it to sacrifice its claim to universal validity.[93] Indeed, no other aesthetic category in our contemporary repertoire (not the beautiful, not the sublime, and certainly not the cute or the zany) has the same relation to time, not to mention the interesting's complex involvement with a multiplicity of temporalities: the temporality of ongoingness or sequential progression, of anticipation, of recursion, of lingering, and of transience or change in general.[94] And because aesthetic experience—in much postmodern theory in particular—continues to be generally conceived from the model of the sublime as a kind of thunderbolt, or in terms of instantaneity, suddenness, and once-and-for-allness,[95] the extended time frame of the interesting seems to partly explain why it is so prone to not being recognized as an aesthetic value, even in contexts where feeling-based judgments are explicitly

called for or expected. Indeed, at first glance, the interesting seems to violate every aspect of Kant's account of aesthetic judgment and, above all, its dictum that the judgment of taste be "entirely disinterested" (that is, founded on a feeling of "satisfaction or dissatisfaction" detached from any representation of the object as useful or even existing).[96]

"Interesting" looks like the antithesis of disinterestedness. There is, however, a sense in which its indeterminate affect makes the two seem less different than alike, which may also explain why the interesting is so prone to turn boring. Trivial Pursuit, the mass-produced version of a long-standing English public-house entertainment, shows how dialectically inseparable the two modern affects are. Thousands of people over the past few centuries have clearly found trivia interesting, but just as obviously trivial. Much like the way in which the interesting toggles—is itself a toggling—between aesthetic and nonaesthetic judgments, the wavering between the boring and the interesting seems internal to the interesting.[97] This seems a direct consequence of the specific nature of the feeling at its root, a feeling so indeterminate that it can even be hard to say whether it counts as satisfaction or dissatisfaction, or feels good or bad to feel (in contrast to the unequivocal feelings of pleasure/displeasure that give rise to judgments of the beautiful/disgusting). Things can therefore be interesting in an irritating way, as well as in a pleasantly exciting one; in both cases, interest begins as a feeling of not knowing exactly what we are feeling. This affective uncertainty is clearly the source of the association of the interesting with ambivalence, coolness, or neutrality—affects not only associated with irony but with the modern scientific attitude. It also lies at the root of why we suspect that people often say that things are interesting when they are not yet sure exactly how they feel about them. There is thus a sense in which the true opposite of "interesting" is not a disinterested but rather an explicitly interest*ed* judgment, as Giorgio Agamben suggests in his gloss of Hegel's view of the rise of the ironic artist as signaling the end of art's relevance for culture as a whole: "Only because art has left the sphere of *interest* to become merely *interesting* do we welcome it so warmly."[98] Or, as Nietzsche suggests by invoking Stendhal, art consigns itself to being merely interesting only at the moment when, as a price for autonomy, it gives up its *promesse de bonheur.*[99]

"Interesting" almost always seems to come with "merely" attached to it, as if to highlight its structural indeterminacy, or what Hegel would call its lack of content. Yet everything I have said above suggests that the interesting, far from being an ahistorical abstraction, does have a historically specific and even "sensuously particularized" content. The interesting is a distinctively modern response to novelty and change—or, more

precisely, to novelty as it necessarily arises against a background of boredom, to change against a background of sameness. (This already marks off the interesting as conceptually different from other aesthetic categories: novelty is totally irrelevant to the concept of cuteness; the experience of beauty has nothing in particular to do with the experience of change.) The interesting is thus an aesthetic experience that enables us to negotiate the relationship between identity and difference, the unexpected and the familiar. It also enables us to negotiate the relationship between the possible and the actual, or as Schlegel might put it, between the ideal and the real, and is therefore an aesthetic invested in a kind of realism. Moreover, it is an aesthetic whose difference from others resides in its indeterminate or minimal affect, its functional and structural generality, its seriality, its eclecticism, its recursiveness, and its future-oriented temporality. In addition to explaining its rise in particular cultures at particular moments (modern Europe, but not ancient Greece), these characteristics make the interesting more central to the history and theory of certain genres than others, for reasons that I will explore further in the following section.

The Interesting and the Ordinary

We have already seen how Schlegel aligns the comparative aesthetic of "interesting" with the "liberal form" of the novel, an art founded on discursive concepts in a way in which music and painting are not. Writing almost a century later, in a contiguous effort to develop a theory and criticism of the novel that will legitimate its still-tenuous status as art,[100] Henry James crystallizes this insight by singling out "interesting" as the idiosyncratic genre's particularly salient, if also particularly minimal, standard of aesthetic worth. He writes in "The Art of Fiction," "The only obligation to which in advance we may hold a novel, without incurring the accusation of being arbitrary, is that it be interesting. That general responsibility rests upon it, but it is the only one I can think of."[101] The specific attributes James lists in support of the novel's overall claim to artistic standing in this seminal work of literary criticism—openness to impressions, capacity for absorbing new experiences, and ability to thrive "upon discussion, upon experiment, upon curiosity, upon variety of attempt, upon the exchange of views and the comparison of standpoints"—are thus explicitly gathered under the umbrella of "interesting." These attributes are strikingly shared by *Portrait of a Lady*'s Isabel Archer, a character notably proud of her open-mindedness and receptiveness to new experiences—that is, of her ability to take interest in things—who also

explicitly seeks to become interesting to other people; to become, to quote James's imaginary advice in "The Art of Fiction" to a novice novel writer, "one of the people on whom nothing is lost."[102] Serialized in the *Atlantic Monthly* and *Macmillan's Magazine* (1880–1881) before being published in single and triple volumes by Houghton Mifflin and Macmillan, respectively, *Portrait* is a novel in which themes of interest and boredom explicitly drive the plot: Isabel interests herself in other people, some good (like Henrietta Stackpole) and others bad (like Madame Merle); Ralph Touchett stakes all his money on Isabel because, like the reader, he finds her interesting; Osmond marries Isabel out of boredom but also out of a self-interest that Ralph's interest essentially makes possible. *Portrait* is thus a novel in which interests of all kinds swarm around the ambitious, full-of-potential, complex, and contradictory female protagonist, whose choice as such James alludes to as artistically risky in his preface, wondering if such a "frail vessel" can be strong enough to hold up the genre's heavy architecture.[103] Indeed, interest coalesces around Isabel with such unusual, even aggressive intensity that one suspects that the female character "affronting her destiny" doubles as a figure for the novel in its aspirations to art.[104] If, as Rita Felski notes, the novel "constitutes the first posttraditional genre, a 'chameleon' form characterized by a seemingly infinite formal and thematic flexibility," it stands to reason that for James, there could be no stylistic concept better suited to capture its stylistic indeterminacy than interesting, an aesthetic explicitly about difference, eclecticism, and the tension between ideal and reality, the possible and the probable.[105]

In conjunction with the swarming of interests around the novelistically risky figure of Isabel, a character on whom other characters take risky bets and who takes multiple risks herself, the tension between the actual and the possible suggests that for James, "interesting" also means complex: a mixed-up or in-between, even contradictory state. (As we saw in the introduction, "interesting" is "a form of pregnancy, of potentiality."[106]) One can thus see the link between interest and risk. For James, as for Schlegel, this risk comes from a radical receptiveness to otherness that modifies the self and, as Latour might say, overtakes it or makes it deviate from its original course of action. (For Latour, the writing of "interesting" or "risky" sociological accounts—the two adjectives are used synonymously—must therefore entail paying close attention to the ways in which agency is "other-taken."[107]) Highlighting interest's fifteenth-century Old French meaning as compensation for injury or damages (the greater the damage, the greater the interest), Mieszkowski makes a similar point: because the interesting is an "experience with what is different,

with what makes a difference, and with what could make oneself or a given state of affairs different," the "state of being interested is always the state of not yet knowing what one will get."[108] Interest is thus "never a sure thing; it always involves a risk, and the return on one's investment is anything but guaranteed." Epstein follows up on this last point to connect this idea of interest more directly to its economic associations with lending and investment. Taking up the challenge in Raymond Williams's observation that "it is exceptionally difficult to trace the development of interest [from an economic term to] the now predominant sense of general curiosity or attention," Epstein notes that the shared idea connecting the two usages is the correlation of higher value with higher risk and therefore lower probability of profit: "An idea is more interesting—that is, it generates a higher interest—if its assumptions are less probable. The less predictable a narrative is, the more interesting (engaging, fascinating) it is. Similarly, higher financial interest is reaped from a more risky investment: the probability of its return is lower, thus the potential gain should be higher."[109]

"Interesting" means unstable, mutable, subject to change. James's self-conscious appeal to this aesthetic concept for his theory of the novel is accordingly directly motivated by his dissatisfaction with literary critic Walter Besant's standard of "good," a value Besant thinks can be deduced from objective criteria. James, in contrast, makes clear that the "innumerable" reasons why a novel might strike us as interesting are irreducibly subjective and discoverable only after the fact: "The ways in which [the novel] is at liberty to accomplish this result (of interesting us) strike me as innumerable. . . . They are as various as the temperament of man, and they are successful in proportion as they reveal a particular mind, different from others."[110] ("But what is the use of being interesting," Gertrude Stein asks in her generically ambiguous text, "Henry James."[111]) There is thus an overlap between the interesting and the English concept of the picturesque, another anticlassical, nonbeautiful aesthetic category invented to embrace aesthetic irregularity, particularity, and variation. As Edgar Wind notes, "'Interesting' is . . . the decisive word in which Uvedale Price . . . tried to sum up the 'roughness,' 'sudden variation,' 'singularity,' 'irritation,' and 'abrupt kind of intricacy' which he ascribed to the Picturesque . . . : 'And the whole way up the lane, they met with so many interesting objects, that they were a long while getting to the top of the ascent.'"[112]

With a similar emphasis on diversity, James's proposal of "interesting" as the novel's signature style aims at the same target which Mikhail Bakhtin invokes his concept of "heteroglossia" against years later: the "widespread

point of view" that regards novelistic prose as "discourse that is not worked into any special or unique style," but rather "the same as practical speech for everyday life, or speech for scientific purposes, an artistically neutral means of communication."[113] Contrary to this, James suggests, the novel does have a distinctive style, albeit one defined precisely by its stylistic heterogeneity. James's appeal to the interesting is thus central to his effort to develop a theory of the novel, a larger project that strikingly recalls Schlegel's appeal to the interesting in his effort to establish literary criticism as a new and relatively autonomous science/art. Both examples suggest that the history of the interesting (and its usage in contemporary criticism) is in some deep way bound up not just with the history of the novel and/or novel theory but also with the history of literary criticism—or, more specifically, with the institutionalization and professionalization of literary criticism, in its association with a public sphere projected by the circulation of print.[114] We once again see the interesting aligned not just with modern literature's proclivity for generic and stylistic hybridity, but also with its proclivity for "reflective" criticism and theory. As James notes in "The Art of Fiction," "The successful application of any art is a delightful spectacle, but the theory too is interesting, and though there is a great deal of the latter without the former I suspect there has never been a genuine success that has not the latent core of [the conviction that theory provides]."[115]

As an ambiguous feeling tied to an encounter with difference without a concept, which then immediately activates a search for that missing concept, the interesting's way of linking affect and cognition seems to have made it particularly suited for bridging the gap between art and theory. It is thus not accidental that the primary theorists of interesting style in the eighteenth and nineteenth centuries were literary critics as well as novelists attempting to establish the artistic legitimacy of their relatively youthful genres. In a similar vein, Peter Brooks traces James's investment in the interesting to Denis Diderot's "effort to establish the new genre of *drame,* which owes much to the novels of Richardson and in some ways prefigures melodrama." Brooks elaborates, "Diderot's definition of *le genre sérieux,* intermediate between tragedy and comedy—but explicitly not a mixture of the two—addresses itself to the 'interesting' in life." With this proposal of "serious attention to the drama of the ordinary," Brooks notes, "we are near the beginnings of a modern aesthetic in which Balzac and James will fully participate: the effort to make the 'real' and the 'ordinary' and the 'private life' *interesting* through heightened dramatic utterance and gesture that lay bare the true stakes."[116] Susan Sontag draws the same connection, singling out opera, along with the novel, as the

"archetypal art form of the 19th century, perfectly expressing that period's . . . discovery of the 'interesting' (that is, of the commonplace, the inessential, the accidental, the minute, the transient)."[117]

Yet from Gertrude Stein's massive experiment narrating the history of everyone in *The Making of Americans*, to the obsessive variations and permutations in the novels of Samuel Beckett, Georges Perec, and Alain Robbe-Grillet, to the investigations of addiction—endless desire that can only be coped with serially, "one day at a time"—in Italo Svevo and David Foster Wallace, it is clear that the interesting has also continued to be a dominant aesthetic for the novel well into the twentieth century and beyond.[118] In these sprawling, encyclopedic works often explicitly about seriality or ongoingness, the authors seem to have deliberately increased the proportion of boredom in the ratio of boredom to interest, as if engaging in an experimental quest to discover what the absolute minimal condition of "interesting" might be. Around what other genres or art forms does this aesthetic about the tension between difference and repetition, actuality and possibility, and individuation and standardization come to consolidate over the course of the twentieth century? And how does its concept transform or change while remaining, in the dialectical spirit of the interesting itself, more or less the same? Note how we have already witnessed a slight mutation of the aesthetic category—one might even say a cooling of its temperature—in the century between Schlegel and James. Although both link the eclectic, diachronic aesthetic of the interesting to the novel, a temporally extended, heteroglossic form uniquely suited for depicting the modern subject's relation to difference, by the end of the nineteenth century the interesting seems much more explicitly linked to a kind of everydayness. While Schlegel prefers the exotic "arabesques" of Cervantes and Goethe, James's models are Eliot and Turgenev.

Strangely, in tandem with the intensification of its investment in knowledge, over the nineteenth century the interesting becomes increasingly associated with "the commonplace, the inessential, the accidental, the minute, the transient." On the basis of these qualities, Sontag links the interesting not just to the novel but to the "indiscriminate" practice of photography, "identified with the idea that everything in the world could be made interesting through the camera."[119] Sontag elaborates, "The photographic purchase on the world, with its limitless production of notes on reality, makes everything homologous [and therefore interesting]," since "what makes something interesting is that it can be seen to be like, or analogous to, something else."[120]

Note the shift in emphasis from difference to typicality in this account of the interesting, although as a comparative aesthetic it must always keep both in tension. As we have seen, something can be recognized as different and therefore interesting only if there is a standard or type from which the particular object can be perceived to deviate: a type that will also make individual instances of the type recognizable as "homologous." The greater emphasis on typicality in the difference/typicality relation that underpins Sontag's account of interesting photography suggests a shift in the overall meaning of the aesthetic with the rise of new technologies of reproduction, one in which the interesting, while never ceasing to exist as a dynamic between the standard/generic and the individual/particular, becomes increasingly associated with the dominance of the standard/ generic. As this happens, the judgment of interesting seems to turn in- creasingly pejorative: merely interesting, as Sontag's comment implies.

Reconceived as an aesthetic of *typical* difference, or of particularity already mediated by type, the interesting's new inflection might be corre- lated with the rise of what Jacques Rancière calls the nineteenth century's new "trade in collective imagery": the circulation of newspapers, adver- tising catalogs, encyclopedias, novels, and other media objects "giving members of a 'society' with uncertain reference points the means of seeing and amusing themselves in the form of defined types."[121] Roland Barthes refers to this body of imagery or knowledge enabling the "social negotia- tion of resemblances" as it informs the aesthetic reception of photography as *studium*, a "general interest" that explicitly "requires the rational inter- mediary of an ethical and political culture."[122] In contrast to the "prick" of a photograph's "punctum," an asignifying detail perceived suddenly in all its sensuous, material immediacy (and to which the only proper re- sponse appears to be an equally sudden, purely affective pang), the *studium* "derives from an *average* affect, almost from a certain training" (26). Merely interesting photographs—photographs that are "invested with no more than *studium*" and therefore provoke "only a general and, so to speak, polite interest"—are thus photographs that inspire aesthetic atten- tion of the lowest order, what Barthes calls the "very wide field of uncon- cerned desire, of various interest, of inconsequential taste: *I like / I don't like*" (27). He stresses: "The *studium* is of the order of liking, not loving; it mobilizes a half desire, a demi-volition; it is the same sort of vague, slip- pery, irresponsible interest one takes in the people, the entertainments, the books, the clothes one finds 'all right'" (27). Between Schlegel/James and Barthes/Sontag, the epistemological intensification of the interesting, as it becomes increasingly associated with what Sontag calls "notes on

reality," seems accompanied by a noticeable dropping of its affective temperature. For Sontag in particular, "interesting" comes to mean not so much "different" as the domestication of difference by rationality.

Barthes, for his part, significantly defines this low-affect, barely aesthetic attitude in terms of a specific critical practice, for as "a kind of education" or general cultural knowledge, the *studium* explicitly solicits the spectator to "read the Photographer's myths in the Photograph" (28). The merely interesting photograph is thus defined not only in terms of the weak or minimal feeling it provokes (one Barthes describes as "unconcerned", "vague," "irresponsible," and "inconsequential") but also in terms of the type of criticism it inspires (semiological decoding or demystification). A photograph that provokes nothing more than "general interest" (or, more specifically, a "wide field" of "various" interests, none apparently pressing enough to exclude any of the others) is precisely one that asks to be "read" from the basis of general cultural knowledge in order to reveal the general cultural knowledge that informs it. We might therefore define the interesting as that which solicits the kind of criticism that the early Barthes practiced in *Mythologies* and which the later Barthes pointedly wrote *Camera Lucida* against, as if to "expiate the sin of the former mythologist, the sin of having wished to strip the visible world of its glories, of having transformed its spectacles and pleasures into a great web of symptoms and a seedy exchange of signs."[123]

As Rancière argues, this desire to atone for the perceived excesses of symptomatic reading leads Barthes to create a false impasse between the cognitive act of demystifying interpretation (in which, according to Barthes, the photographic image is reduced to "discourse encoding history") and a purely affective response (in which the photographic image is similarly reduced to "raw material presence").[124] As if to repent of "having spent much of his life saying: 'Look out! What you are taking for visible self-evidence is in fact an encoded message whereby a society or authority legitimates itself by naturalizing itself,'" Barthes develops his concept of *studium* as that which invites passionless, mechanical, academic decoding so he can directly oppose it to the intense and spontaneous response solicited by the *punctum* (which turns the photograph into a nondiscursive, self-evident materiality, the direct and immediate "emanation" of the body once placed in front of the camera). Yet for all its affective minimalism, the "general interest" associated with *studium* is still an aesthetic or feeling-based response, albeit one of the lowest order ("liking, not loving"). At the same time, it is an aesthetic response explicitly defined by a kind of critical impulse or activity ("read[ing] the Photographer's myths in the Photograph"). Far from reinforcing the divide be-

tween criticism and aesthetics, it could be argued, the *studium* of Barthes's merely interesting photography embodies the seam between them.

This marriage of criticism and aesthetics, already touted in the writing of the German romantic theorists of the interesting, was a goal also shared by the conceptual art of the 1960s and 1970s in the United States, a key stage in the "further rationalization of the esthetic process in general" in which the modern aesthetic of the interesting would come to play its next major role.[125] It is worth noting here that conceptual art's "crucial innovation," according to Liz Kotz, was precisely that of linking photographs—and especially photographs "invested with no more than *studium*"—to language.[126] In an era of heightened suspicion about all media images, it was in fact the generic, discursive *studium* that arguably attracted a new flock of postwar artists to photography, precisely because of the way in which the *studium* invited one to turn the pure presence or material "obviousness" of the auratic image into "something to be decoded and explained." Indeed, conceptual art's polemical turn to the discursive aesthetic of the interesting seems to have been a reaction, at least in part, against the raw or "wordless image" produced by an earlier generation of abstract expressionists and color field painters; if not exactly that of "stripping the visible world of its glories," its goal was to reveal art as mediated by the "rational intermediary of an ethical and political culture."

For both German romantic literary critics like Schlegel and theorists of the novel like James, the interesting was an aesthetic of difference in the form of individual idiosyncrasy or variation. With the rise of conceptual art—which, unlike its predecessors, would come to increasingly embrace the slippage between the interesting and the "merely" interesting— interesting becomes an aesthetic of difference as information. If interessante poetry was already a kind of "specimen collection" for Schlegel,[127] interesting conceptual art becomes even more so, particularly as it further develops into an aesthetic of forensic evidence or proof. One sees this in works ranging from Eleanor Antin's *Blood of the Poet Box* (1965– 1968), 100 blood samples and a typed specimen list collected in a wooden slide box, to Ed Ruscha's *Stains* (1969), a portfolio of 75 spots made by objects ranging from urine to gunpowder to pepper sauce. In his *Artforum* essay "Systems Esthetics" (September 1968), artist, critic, and curator Jack Burnham links the inventory-based format of projects like these to a new, "oblique" style of criticism, "pioneered between 1962 and 1965 in the writings of Donald Judd," in which the critic simply enumerates qualities of the art object.[128] Noting how this minimal style of criticism "resembles what a computer programmer would call an entity's *list struc-*

ture, or all the enumerated properties needed to physically rebuild an object," Burnham further associates it with parallel tendencies in the novels of Alain Robbe-Grillet (165). Once again we find the interesting at the intersection of the novel, criticism, and serial form.

Conceptual art is thus where the interesting most powerfully reemerges, after Diderot, Schlegel, and James, as a focal point for debates about nonbeautiful aesthetic values or qualities, new and hybrid genres, and the increasingly intimate relationship between art and discourse (or information). Insisting on visual art's "parallels, if not identity, with the systems of linguistic signs" in its larger effort to renew the "Duchampian quest for a nonretinal art" through a "strategy of 'perceptual withdrawal,'"[129] conceptual art's signature style, like that of the novel, was at first widely misdescribed as a non-style or absence of style. It is more accurate to say that interesting conceptual art sought to replace the look of art-historical styles with what Donald Kuspit called "the look of thought."[130] The landmark 1966 exhibition, *Working Drawings and Other Visible Things on Paper Not Necessarily Meant to Be Viewed as Art,* curated by artist Mel Bochner for the New York School of Visual Arts—photocopies of memos, lists, blueprints, diagrams, and invoices by architects, composers, mathematicians, and visual artists presented in four black ring binders interspersed with pages from *Scientific American*—was a prime example of this aesthetic. Written in conjunction with his next show, *Art in Series,* at the Finch College Museum of Art (November 1967), Bochner's *Artforum* essay "The Serial Attitude" (December 1967) attempted to link the ethos of his previous show with a more radical conception of serial technique, distinguishing the thematic variations of those merely "working in series" (such as Monet and de Kooning) from works more rigorously based on "serial method," or planned from the beginning using an algorithm or scheme: permutation/combination, rotation/reversal, and so forth. Discussing the importance of "uninterpreted systems" (basically, language alphabets) to the serial projects of artists like Jasper Johns and Sol LeWitt, Bochner intones:

> Many interesting observations have been made about uninterpreted systems which are directly applicable to the investigation of any array of elements obeying fixed rules of combination. Studies of isomorphic (correspondence) relationships are especially interesting.[131]

Although Bochner is not trying to be funny or self-contradictory, Ed Ruscha would embrace the comedy of the interesting's tendency to become a self-validating tautology: "I'm interested in what is interesting."[132]

Discussing *Art by Telephone,* a proposed exhibit for the Museum of Contemporary Art in Chicago in which recorded phone calls by artists giving fabrication instructions to their manufacturers were to be included as part of the displayed works, Burnham writes that "for systems, information, in whatever form conveyed, becomes a viable esthetic consideration."[133] In the same spirit, Ruscha likened his early work *Royal Road Test* (1963), a series of captioned photographs meticulously documenting the aftermath of the act of hurling a Royal typewriter out of a speeding Buick onto a desert highway, to a "police report": "What a police photographer would produce in a report on how somebody was killed."[134] Here, in a desire to pursue something like Schlegel's desire for an art unified with rational discourse (but in a "rationalized" way the romantics could hardly have dreamed of), art mimics not just documentary evidence but paperwork. Thus completing a turn away from an older "aesthetic of industrial production and consumption" epitomized by minimalism and pop to "an aesthetic of administrative and legal organization," conceptual art became the incubator in which the interesting—always already an aesthetic about difference—developed into an aesthetic of information (and more specifically, as we shall see, into an aesthetic about the technologically mediated dissemination of information).[135] For information was understood by its postwar theorists as precisely the basic form of difference. As Gregory Bateson most famously put it, information is "a difference that makes a difference."[136] Similarly, for Niklas Luhmann, information is that which "can only appear as (however small) a surprise."[137] But this is also exactly what interesting means: surprising—but not that surprising.

With its idioms of information, inventory, documentation, and research (especially in the case of what Burnham called "systems-based" work), the "cool," clean look of conceptual art was not just that of "thought" but that of post-Fordist knowledge work. As Sol LeWitt commented in "Serial Project #1, 1966": "The serial artist does not attempt to produce a beautiful or mysterious object but functions merely as a clerk cataloguing the results of his premise."[138] Conceptual art's "neutral" style thus did not have a neutral meaning, as Jeff Wall contentiously noted in 1985, but could be seen as a depressing reflection of art's "powerless mortification in the face of the overwhelming political and economic machinery that separates information from truth."[139] But the ultimate weakness of conceptual art for Wall and others, as Thomas Crow underscores, resided in "its failure to generate any subject matter free of irony."[140] Echoing Hegel's objection to interesting literature and its ironic producer at the turn of

the preceding century, Wall's claim that conceptual art "could undertake no subject matter in good faith" thus resurrects the lack of specificity that we have seen haunting theorizations of the interesting from the very beginning, and in a way that places the question of its own historical specificity front and center.[141] Although the "serial attitude" of art in the 1960s seemed to many, as it did to Schlegel and his circle in the 1790s, like the ethos or style of modernity itself, can the rationalized, even bureaucratic style of conceptual art really be said to be the same as that of "interessante" literature? Should not the differences between the way this aesthetic developed in early industrial Europe and in the post-Fordist United States matter more than the similarities?

The interesting, I argue, is an aesthetic about this very tension between difference and typicality—or standardization and individuation—in capitalist modernity writ large. Much as it arose with the dramatic expansion of print circulation in the 1790s, its resurgence in the 1960s was spurred by the growth of new media and new communication technologies that led the way in transitioning the United States from an automated into an informated and networked society, as tracked by Alan Liu with special attention to the rise of coolness.[142] There is arguably an even closer connection between the interesting and the postwar information aesthetic of cool than between the interesting and ironic detachment, though the cool is already nascent in the latter.[143] Low or indeterminate affect, stylistic pluralism and hybridity, and the seemingly endless pursuit, in the felt absence of any totalizing vision, of the next new thing and then the next one after that all make the interesting as specific to, and as revealing about, American postmodernism as German romanticism. So is there a significant difference? No and yes. Both the interessante, philosophical literature of the 1790s and the "merely interesting," media-conscious conceptual art of the 1960s are responses to novelty and change in a capitalist culture in which change is paradoxically constant and novelty paradoxically familiar. I ask the reader to keep this continuity in mind as I now turn to a closer examination of conceptual art and to the questions raised at the beginning of this chapter about the relevance of aesthetic evaluations to criticism. For while anticipated by crucial aspects of the ready-made, minimalism, Happenings, Fluxus, and pop, conceptual art marks the moment at which the increasingly "dematerialized" artwork—or more precisely, the increasingly information-based artwork—would most clearly become "the ultimate subject of a *legal definition* and the result of *institutional validation*."[144] For this reason, this body of work becomes ideal for delving deeper into the forensic dimensions of the interesting, the aesthetic judgment whose radically blank nature most conspicuously raises

the issue of how we justify or supply evidence for aesthetic judgments in general.

Difference as Information

In addition to its fascination with blood samples, stains, phone conversations, invoices, and other kinds of "evidence," conceptual art shared what Franco Moretti describes as detective fiction's basic paradox: "It must tell ever-new stories because it moves within the culture of the novel, which always demands new content; and at the same time it must reproduce a scheme which is always the same."[145] Sharing what Niklas Luhmann describes as the mass media's function of "stabiliz[ing] a relationship of redundancy and variety in everyday culture," and thus securing a "constantly renewed willingness to be prepared for surprises,"[146] detective fiction according to Moretti "links a continuous novelty of content to a perennial fixity of the syntax."[147]

Continuous novelty of content based on a fixity of syntax is perhaps the fittest description of the books of documentary-style photographs of vernacular objects that Ed Ruscha published between 1962 and 1973. Widely described by critics as inaugurating the generic, anonymous look of conceptual art in general, these included *Twentysix Gasoline Stations* (1962), *Some Los Angeles Apartments* (1965), *Every Building on the Sunset Strip* (1966), *Thirtyfour Parking Lots in Los Angeles* (1967), *Nine Swimming Pools and a Broken Glass* (1968), *A Few Palm Trees* (1971), and others. Given the banality of the subject matter and the calculated distances at which the examples of each type were photographed (for an overall effect of technical "neutrality"), these generic-looking compilations were clearly engineered to keep affect on a low burner, generating at most tiny flickers of interest not unlike the eponymous "small fires" presented at regular intervals in *Various Small Fires and Milk* (1964) (Fig. 16).

As Ruscha noted in interviews, each of his books was generated from a type plus a quantity, "a particularly effective attention-grabber," as Luhmann points out, since "quantities are always informative . . . any particular number is none other than the one mentioned, neither larger nor smaller."[148] Number and type—"twentysix" and "gasoline stations"— were thus primary determinants of each series, making the iconic significance and technical quality of the images of secondary concern. Once his titles were decided, Ruscha stressed, everything else amounted simply to "plugging anything I thought of into that system."[149] As evinced from just a brief survey of artworks, exhibitions, and art-related publications

FIGURE 16

from the late 1960s to the early 1980s—*Eleven Sugar Cubes; Some Photographic Projects; 36 Houses; "9 in a Warehouse"; Seven Translucent Tiers; Seventeen Artists in the Sixties; Sixteen Sentences; 23 Pieces; "Five Questions Answered"; 41 Fabric Swatches; 3 Speeds, 3 Temperatures; 10 Works; 46 3-Part Variations on 3 Different Kinds of Cubes*—the attraction to this sort of "system" was clearly widespread.[150]

In spite of each book's paratactic style of presentation, Ruscha claimed that order was crucial to their overall look: "The pictures have to be in the correct sequence, one without a mood taking over."[151] The progression of individual images—each a slightly different example of the type of object named in the title—was thus designed to forestall this specific mood by evoking, in its place, a feeling paradoxically defined by its vagueness and indeterminacy: "This book had an inexplicable thing I was looking for, and that was a kind of a 'Huh?' "[152] Ruscha likens this inquisitive, simultaneously affective and cognitive response to "a sort of 'itch-in-the scalp' " and describes it as an ethos explicitly pursued in the work of his contemporaries: "I just use that word to describe a feeling *a lot* of artists are attempting to bring out [right now], and some are doing it very well."[153] Ruscha may have had in mind early conceptual works such as Hilla and Bernd Becher's photographs of cooling towers, grain silos, and other industrial architectural forms (Fig. 17), first published in book form in 1960 as *Anonymous Sculpture: A Typology of Technical Construction*, and John Baldessari's collection of slides, *The Back of All the Trucks Passed While Driving from Los Angeles to Santa Barbara, California, Sunday 20 January 1963* (1963).[154]

These photographic series underscore the significance of "typology" for the interesting: "gasoline station," "cooling tower," "palm tree," "truck." By defining beauty as pleasure without interest, where interest in X means interest in the existence of X, Kant famously moots the relevance of the type of entity judged beautiful (given our indifference to whether the object exists, the class of objects it belongs to could not be less relevant). In contrast, because the interesting is an experience of difference or novelty, and "in order to recognize novelty we need familiar contexts," the experience of the interesting is entirely dependent on generic classifications.[155] As James notes, "Everything . . . becomes interesting from the moment it has closely to consider, for full effect positively to bestride, the law of its kind. 'Kinds' are the very life of literature."[156] In other words, the judgment "interesting" hinges on recognition of its object as being meaningfully different from others of its type—an emphasis that by no means contradicts its concomitant emphasis on difference or variety. Indeed, Ruscha strove to capture the "neutral" ethos of the generic precisely

FIGURE 17

through a strategy of variation, a dialectical tension that runs not only across the sixteen books he made between 1962 and 1973, but also across all his serial projects from the early 1960s to the present.[157] In keeping with Daniel Buren's approach to color in his stripe paintings ("I am not saying pink is neutral, or gray is neutral, but a gray striped canvas then a blue striped one then another in green, and so on . . . hinders by successive and equal repetition any significance for any of them"),[158] *Various Small Fires* presents us with a blowtorch, a highway flare, lit matches,

and so on. In its serial form and its thematization of variation and triviality, *Various Small Fires* might be taken as an allegory of the interesting itself: modest flickers of affect activated by successive encounters with minor differences from an existing norm (in this case, provided). But why end this series of encounters with difference with milk, a "small surprise" that would seem to symbolically cool off or extinguish the low affect of all the previous ones? According to Ruscha, "Milk seemed to make the book more interesting."[159]

X, then Y, then Z: the aesthetic character Ruscha wanted his books to have clearly hinged on a progressive *plus ultra* that Ruscha invokes elsewhere to distinguish the period style his books helped define from that of an earlier generation of abstract expressionists. While the latter "approached their art with . . . instant-explosiveness,"[160] collapsing "the whole art process into one act," Ruscha "wanted to break it into stages."[161] Sol LeWitt showed a similar propensity for displaying the "intervening steps" between conception and execution, as he described in "Paragraphs on Conceptual Art" (1967): "If the artist carries through his idea and makes it into visible form, then . . . all intervening steps—scribbles, sketches, drawings, failed work, models, studies, thoughts, conversations— are of importance. Those that show the thought process of the artist are sometimes more interesting than the final product."[162] Indeed, even LeWitt's final products—"serial expansions" such as *Variations of Incomplete Open Cubes* (1974), for example—adopted the "interesting" look of these "intervening steps."[163] Bound thus to a diachronic rather than synchronic idea of form, which as Stanley Fish, Peter Brooks, and Catherine Gallagher note is an intrinsically more difficult concept of form to grasp,[164] the interesting look of conceptual art could thus be described as the look of in-betweenness. This is exactly how David Hockney describes it in "Beautiful or Interesting?" (1964), a dialogue with Larry Rivers published in *Art and Literature:*

> LR: Now let me ask a serious-type question: would you prefer your work to be thought beautiful or interesting?
> DH: Putting it like that I think I'd rather have it thought beautiful. It sounds more final, it sounds as if it did something. Interesting sounds on its way there, whereas Beautiful can knock you out.
> LR: Beautiful you connect with the old masters, except for someone like Bosch, sort of beautiful and interesting. I think "interesting" more like Duchamp coming along and cracking glass? You can't say that's beautiful—not in the way Renoir's beautiful, although the idea may be.
> DH: Surely it's now beautiful—first it was interesting, now it's beautiful . . . ?

LR: I must have had in mind—and there's a little spleen in it—that we are surrounded by a whole nation of artists in the other camp saying anything beautiful is soft, old-fashioned, and these sort of people are making the "interesting" works of art.[165]

Whereas beautiful is "final," interesting is in medias res, "on its way" to a "there" whose actual destination is uncertain. Echoing Schlegel's elucidation of the interesting (which has "no endpoint") in opposition to the beautiful (which is "universally valid, enduring, and necessary"), here the contrast between the two aesthetic categories is similarly drawn in terms of time. Moreover, like Schlegel at the end of his preface to *On the Study of Greek Poetry*, in which he describes the interesting as an intermediate, transitional stage and even a "necessary propaedeutic" for the "endless perfectibility of the aesthetic disposition" (*OSGP*, 99), Hockney and Rivers stress the ephemerality of the turn to the interesting in the work of their contemporaries, as if to hint at its inability to achieve art-historical permanence. Just as what is cool now is not likely to be cool next season, "First it was interesting, now it's beautiful" implies that one of the unique things about the interesting is its susceptibility to displacement by other aesthetic qualities. Hockney's comment implies that a work can start out being "interesting" but end up somewhere else. Yet because "interesting" lacks the specific characteristics that enable the "voiding" of other aesthetic concepts, it also seems capable of coexisting alongside or being coupled with other aesthetic values in a way in which other aesthetic values are not. It is virtually impossible to find an aesthetic object that can be said to be both elegant and garish. But because the interesting has no determinate features that might rule out the application of other aesthetic concepts, it is easy to think of objects that are at once garish and interesting, elegant and interesting, and even beautiful and interesting (as Rivers notes).

Hockney and Rivers align "interesting" with the antiaesthetic of Duchamp, or with what Ruscha would call the "non-arty": "The photographs I use are not 'arty' in any sense of the word," but rather "technical data like industrial photography." He continues, "To me, they are nothing more than snapshots"; i.e., they are merely interesting, invested with nothing but *studium*.[166] Yet Ruscha would probably concur with Hockney's comment on the instability of the interesting, since he wryly commented in 1982 on how vulnerable to history (and nostalgia) the intentionally moodless look of his books would prove to be: "Now that I look back on it, it's beginning to get harder to find a gas station that looks like that. It's beginning to look like the '60s. . . . In the future this book is going to look totally dated; and that's the one thing I was totally against."[167]

The generic, anonymous look of the interesting artwork was thus a distinctively "1960s" look. In highlighting this irony, Ruscha points to a

fundamental tension between modernity's rationalizing and abstracting tendencies and its emphasis on the ephemeral and contingent, which Mary Ann Doane argues the photographic series (the form clearly favored by conceptual artists) was essentially invented to resolve. The contrapuntal use of a scheme or typology in a medium that marks "the culmination of a tendency in the history of art that rejects the general, the ideal, and the schematic . . . [for] the particular, the singular, the unique" (although note that we have also seen Barthes and Sontag characterize photography in exactly the opposite way) could also be read as a way to reconcile two kinds of time: the fleeting instant seized by the photograph and the duration necessary to perceive any series or extended form.[168] This clash between instantaneity and duration became increasingly visible in works over the 1960s. Indeed, conceptual art's effort to counterbalance its reliance on fast or rapidly distributable media (printed matter, photos, photocopies, magazines, telegrams) with slow or time-consuming formats (language-based art, the earthwork, performance or process-based art) was arguably a response to the rapidly accelerated powers of circulation in the postwar United States overall.

As one critic notes, cars and the modern freeway system, which vastly expanded after 1956 after the passage of Eisenhower's Highway Act, are clearly the "missing link" between Ruscha's books of photography, literally connecting his apartments, pools, palm trees, parking lots, and gas stations.[169] Another implicit influence is the news, the "program strand" of the mass media "most clearly recognizable as involving the production/ processing of information" and thus of the "interesting and newsworthy."[170] Ruscha notes: "I had a vision that I was being a great reporter when I did the gas stations. I drove back to Oklahoma [from Los Angeles] all the time, five or six times a year. And I felt there was so much wasteland between LA and Oklahoma City that somebody had to bring the news to the city. It was just a simply, straightforward way of getting the news and bringing it back."[171] Transportation (getting to Oklahoma from Los Angeles) and communication ("getting the news and bringing it back") are here conflated as a single process of circulation. We see the same fascination with the continual motion of bodies and information in Ruscha's "Information Man," published as part of a 1972 interview with the artist in the *New York Times:*[172]

I had a daydream once not long ago about an imaginary person known as the Information Man, and I wrote it down. Let me read it to you:

The information man is someone who comes up to you and begins telling you stories and related facts about a particular subject in your life. He came up to me and said, "Of all the books of yours that are out in the public, only 171 are placed face up with nothing covering them; 2026 are in vertical

positions in libraries, and 2715 are under books in stacks. The most weight on a single book is sixty-eight pounds, and that is in the city of Cologne, Germany, in a bookstore. Fifty-eight have been lost, fourteen have been totally destroyed by water or fire; two-hundred sixteen books could be considered badly worn. Three hundred and nineteen books are in positions between forty and fifty degrees. Eighteen of the books have been deliberately thrown away or destroyed. Fifty-three of the books have never been opened, most of these being newly purchased and put aside momentarily. . . . Three of the books have been in continual motion since their purchase; all three of these are on a boat near Seattle, Washington.

Now, wouldn't it be nice to know these things?"[173]

Fifty-eight lost, eighteen thrown away, three moving on a boat: Ruscha's fantasy about tracking the circulation of his printed objects "out in public" seems driven by a fascination with numbers, which, as Luhmann notes, are informative regardless of whether one understands the context in which they are applied (for example, "whether or not one knows what a gross national product is").[174] Numbers are thus, in a sense, merely interesting, generating "sudden moments of insight without any substance" and "simultaneously more information for those who already have some knowledge."[175] As the primary agent behind the dissemination of merely "nice-to-know" facts about the circulation of printed matter, Ruscha's information man looks like an obvious avatar for the conceptual artist, here applying the quantitative logic driving the production of works like *Twentysix Gasoline Stations* to track their circulation in the public at large.

Ruscha was particularly fascinated by the tempo of the circulation of mass media, as reflected in his comments on the "pacing" of his own book production, which during the 1960s gradually increased from one to three a year:

ER: Everything in the media is paced for people's pace. *Time* magazine comes around once a week and that's about the time you've forgotten the last one. Or *Popular Mechanics* or what have you. A newspaper. . . . All the media are filtered that way to the cycles we live in. . . . It's all paced out.

WS: Does that apply to your own work?

ER: The way to produce art is the same way as the media, to sort of go with that rhythm.[176]

In its very attempt to convey an easygoing attitude, Ruscha's claim that the "way to produce art is the same way as the media, to sort of go with that rhythm" (on the grounds of a supposed harmony between "people's pace" and that of the media) points to a larger, period-specific anxiety about the technologically accelerated circulation of information as well

as commodities, which was clearly accelerating to rates far beyond that of the production rhythms of most artists in the 1960s.

The radical speedup of circulation and subsequent dramatic reduction of the time between production and consumption in virtually all aspects of American social and cultural life were especially felt in the sphere of advanced art, traditionally associated with "long-term" rather than "short-term" returns on initial investments of labor and time.[177] In contrast to the relatively rapid attainment of symbolic and economic profits by commercial and middlebrow artists, as Pierre Bourdieu notes, avant-garde producers in fields of restricted production have traditionally acquired recognition slowly. But because of rapid changes in technology for exchanging and circulating information and new venues for distribution and exhibition, the increased speed with which experimental art in the 1960s could be publicized and sold, as Alexander Alberro notes, made avant-garde "consecration" take place at rates that suddenly put the question of what counts as avant-garde practice in a confusing light.[178] If it is a hit in a week as opposed to a decade, how "avant" can it be? As one curator lamented in 1966, "Advocacy and support of experimental art has now gained such a hold on the American imagination that the normal lag time between artistic invention and its public acceptance is disappearing."[179]

Alberro's *Conceptual Art and the Politics of Publicity,* which narrates the rise of conceptual art through the career of the masterful publicist, exhibitor, and art dealer Seth Siegelaub, shows how the speedup in the circulation and dissemination of information had a radical impact on virtually every aspect of art-related activity in the 1960s, including its mode of reception. Over the decade, accelerated press coverage changed "serious avant-garde collecting . . . from a private depreciated 'act' of commitment to untested ideas into a conspicuous public activity that drew more and more eager recruits from the new age of affluence."[180] In addition to giving experimental art an investment value—we might say an appreciating interest—that "had long evaded the contemporary art market," the new "publicity economy" shifted the task of its legitimation to the new class of art consumers, which for the first time also included corporations seeking to "establish a reputation for progressiveness" by buying and displaying art.[181]

One surprising casualty of the intensified publicity feeding the experimental art boom, Alberro notes, was the scholarly art critic, increasingly squeezed out in favor of gallery owners, corporate collectors, the popular news media, and artists themselves as the "central conduit between artists and their audiences."[182] The social function of shaping public perception

of art, once primarily performed by putatively disinterested professionals, could now be performed by others much more quickly (and often more glamorously). This development most noticeably distinguishes the rise of the interesting as an aesthetic of difference as information in the 1960s from that of the interesting as an aesthetic of comparative individualization in the 1790s. Although modern, "interessante" literature emerged as a response to equally dramatic changes in circulation (the expansion of the literary marketplace and the bourgeois public sphere, in particular), its upshot was an expansion of the critic's role in the creation of new art-consuming publics and the shaping of public taste, as the career of the Schlegels demonstrates most vividly. The rise of merely interesting art in the 1960s, however, seemed to signal the exact opposite.

This shift was not perceived by all critics as negative, however. Lucy Lippard notes briskly in a 1969 interview: "If *Time* and *Newsweek* were more accurate, they'd probably be better art magazines than most of the art magazines. . . . If you respect the art, it becomes more important to transmit the information about it accurately than to judge it."[183] In a tape-recorded interview by Patricia Ann Novell for her curatorial project *Eleven Interviews* (1969), artist Stephen Kaltenbach makes the same point on grounds virtually identical to Lippard's—that the main goal of art is to transmit information rather than to make claims about its aesthetic quality, as if the two were inherent opposites:

> PN: On what grounds does an observer judge, evaluate your work?
> SK: The idea can be evaluated. Nothing else can. People are accepting the possibility that you can't criticize this kind of work, and as a result the really imaginative art critics are into passing out information rather than making their own value judgments. In a sense, they are really becoming artists.[184]

The more the 1960s critic relinquishes making value judgments for the task of "passing out information," the more she resembles the 1960s conceptual artist. This proposition seems to both affirm and contradict Schlegel's understanding of "interessante" as a sign of the modern convergence of art and criticism. For Schlegel, "interesting" indexes the intensified role of the critic in art and culture, while for Lippard and Kaltenbach (and as we shall soon see, Michael Fried), the emergence of art in the idiom of information—art that is interesting or not interesting "just as one is informed or isn't"—appears to mark some kind of critical attenuation or negation.[185] Here the fates of "interesting" and "critical judgment" seem to go in opposite directions. Lippard repeated this point during a radio show with artists Douglas Huebler, Dan Graham, Carl André, and Jan

Dibbets in 1970: "One of the things I like about so-called conceptual art is that while it communicates itself, or else it doesn't, just as objects do or don't, it gets transmitted much more rapidly. Print, photos, documents get out much faster and more people see them. Then critics become unnecessary because the primary experience is their audience's own." Lippard continues, "The responsibility lies with the audience instead of an intermediary. Maybe that's what people don't like about it. The public likes . . . value judgments . . . which is why all this quality bullshit is dominant."[186]

In spite of her effort to distance herself from "value judgments" and "quality bullshit," as a critic Lippard clearly *was* invested in judgments of value or quality; as she said, she "lik[ed]" conceptual art and thought it worthy of critical attention.[187] What is striking, then, about her seeming concession to the attenuation of the critic's historical role as mediator of the public's relation to art (and her willingness to cede that cultural function to *Time* and *Newsweek*) is its basis in terms that at once contradict and imply concurrence with its underlying rationale: if one "respect[s] the art," that is, judges the art to be important and affecting (that is, interesting), what one says about it will ultimately take a backseat to the sheer fact of its being talked about. Criticism would therefore seem to offer only a slower version of what publicity (and conceptual art) already provides: information. It is therefore not surprising that "by 1965 . . . articles which criticized an artist's work began to have the same effect as articles which praised it."[188] Most ironically, for all this intensified publicity, by around 1970 most conceptual artists were acknowledging that the main audience of their work would be other conceptual artists. Joseph Kosuth observed in his introductory note as American editor of *Art-Language* (1970):

> The audience of conceptual art is composed primarily of artists—which is to say that an audience separate from the participants doesn't exist. In a sense, then, art becomes as "serious" as science or philosophy, which doesn't have "audiences" either. It is interesting or it isn't, just as one is informed or isn't.[189]

From the side of the subject, conceptual art "is interesting or it isn't," just as "one is informed or isn't"; from the side of the object, "it is interesting or it isn't" just as it "communicates itself or . . . it doesn't." Both comments suggest that publicity's heightened impact on the determination of value in the art world of the 1960s extended into art making as well as reception, with techniques of dissemination and distribution increasingly folded into the act of production.

This process, of course, was always a two-way street. As Alberro shows, Siegelaub's innovative publicity strategies, which included the organization of exhibitions existing entirely in the form of catalogs, the placement of notices in magazines claiming to be "documentation" of the exhibitions they advertised, and advertising by telephone and direct mail, clearly developed in response to the challenge of showing the kind of work being done by the artists he sponsored: art that was material but imperceptible (Robert Barry's installations of radio carrier waves, magnetic fields, ultrasonic sounds, and electronic energy fields); art that was coextensive with language (Lawrence Wiener's *Statements*); art that existed in multiple times and locations simultaneously (Douglas Huebler's *Location Pieces*); and art that depended on audience participation for its existence (Sol LeWitt's instruction-based *Wall Drawings*). At the same time, it seems likely that the artists Siegelaub promoted may have unconsciously or deliberately incorporated his techniques for distributing their work into that work, as in the case of Barry's *Inert Gas Series / Helium, Neon, Argon, Krypton, Xenon / From a Measured Volume to Indefinite Expansion / April 1967 / Seth Siegelaub, 6000 Sunset Boulevard, Hollywood, California, 90028 / 213 HO 4-8383*, a mailed poster containing a telephone number that, if called, connected the listener to a tape recording that described Barry's act of releasing the gases into the atmosphere. Interesting conceptual art was both an instance of and an art about this absorption of modes of circulation into modes of production.

In addition to mimicking art-specific strategies of disseminating information like the poster and the catalog, conceptual art became interested in all the ways and forms in which information might be displayed: telegrams, memos, spreadsheets, newspaper ads, specimen cases, list structures, notarized certificates, graphs, geological surveys, spectrometer analyses, card catalogs, surveillance reports. As it thus made use of an increasingly wide array of forms and media objects to pursue its resemblance to the science-fair project, boardroom presentation, or information booth, over the decade the look of merely interesting conceptual art evolved into the look of display or exhibition as such. Baldessari at once represents and seems to comment on this tendency in *A Person Was Asked to Point* (1969), a series of photographs of a male hand "pointing to things that were interesting to him" (Figs. 18a and 18b). Read by one art historian as a cheeky riposte to painter Al Held's sardonic remark "'All conceptual art is just pointing at things,'"[190] *A Person Was Asked to Point* was recursively enfolded into Baldessari's next serial artwork, *Commissioned Paintings*, a "showing" of the work of amateur artists that Baldessari describes as follows:

a b

FIGURE 18

The procedure: First I visited many amateur art exhibits. When I discovered a painter I asked if he or she would do a painting on commission. The problem of providing interesting subject matter (to avoid their usual choice of schooner ships, desert cacti, moonlit oceans, etc.) was solved by a series I had just finished which involved someone walking around and pointing to things that were interesting to him. I presented each artist with approximately a dozen of these slides from which to choose. They were asked to paint a rendition as faithfully as possible, the idea being that the art would emerge. Upon completion, each painting was taken to a sign painter and the artist's name affixed thus: "A Painting By . . ."[191]

Here art (or, more exactly, the interesting art of the conceptual artist) becomes coeval with the act of showing art—and even more precisely, with the act of showing art that depicts the act of showing (Fig. 19). With some obvious condescension, the *Commissioned Paintings* series thus suggests that what most sets the advanced artist apart from the middlebrow painter is precisely the act of exhibition traditionally associated with the role of the curator or gallery owner. "Interesting" is what shores up this difference: "The problem of providing interesting subject matter (to avoid their usual choice of schooner ships, desert cacti, moonlit oceans, etc.) was solved by a series I had just finished which involved someone . . . pointing to things that were interesting to him."[192] For all its seeming modesty and lack of distinguishing qualities, here "interesting" is being explicitly claimed as the signature of ambitious or "serious" work, that is, as the signature of an art self-identified with presentation. Barry arguably pushed this tendency furthest (inspired in part, one suspects, by the strategies Siegelaub used to display Barry's own work) in his *Robert Barry Presents* series from the late 1960s and early 1970s, works that consisted of Barry's "showing" work by other conceptual artists and even shows of conceptual

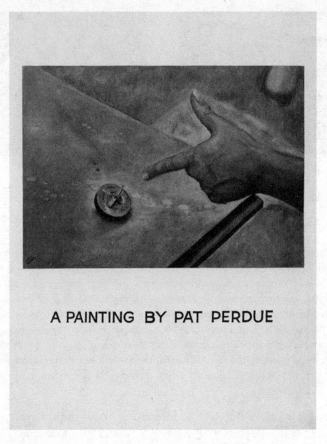

FIGURE 19

art organized by professional curators, as in *Robert Barry Presents Three Shows and a Review by Lucy R. Lippard* (1971).

Far from being devoid of style, affect, or sensuous qualities, the distinctive look and feel of sixties conceptualism was not just that of public display but also that of signs and discourse on the move, or information in the act of being circulated. This became especially evident in the rise of mail and communications art in the second half of the decade, from the *First-Class Mail Art Exhibitions* organized by the New York Graphic Workshop (1964–1965) and the photo-essays circulated by Robert Smithson and Dan Graham in magazines to the curated projects distributed in the "bulletin-exhibitions" of *Art and Project Bulletin* and the boxlike *Aspen* magazine (1965–1971). One thinks also of John Giorno's *Dial-A-Poem* (1968–), fifteen phone lines connected to answering machines

providing callers with a live reading, which Giorno claimed spawned "real" information services offering sports scores and stock quotes by phone.[193] Projects like these shed light on why conceptual art quickly became an international affair: thematically preoccupied with and formally plugged into communication and distribution networks, it was unusually easy and inexpensive to communicate and distribute.[194] The conceptualist drive to make a means of disseminating and circulating information about art (and increasingly a means of disseminating and circulating art itself) internal to the process of artistic production is perhaps best exemplified, however, by On Kawara's telegrams (1970–), which presented recipients with evidence of the fact that (at least at the moment of the sending) the artist/sender was "STILL ALIVE." We also see conceptual art's "postal unconscious" in Kawara's *I GOT UP AT* (1968–1979), a series of postcards mailed daily to two people around the globe, depicting the place he was situated on one side and rubber-stamped on the other with data informing them of the date, address, and exact hour he awoke (Fig. 20).[195]

Douglas Huebler—another Siegelaub artist, like Barry—similarly made use of the postal system in *42nd Parallel*. Joining the widespread preoccupation with ways of displaying information to a more explicit interest in the representation of time, *42nd Parallel* was first presented as follows in *Douglas Huebler: November 1968*, the first of a series of "exhibitions" existing solely in catalog format curated by Siegelaub:

> *42nd Parallel.* 11 certified postal receipts (sender); 10 certified postal receipts (receiver); 3040 miles (approximate). 14 locations, A'–N', are towns existing either exactly or approximately on the 42° parallel in the United States. Locations have been marked by the exchange of certified postal receipts sent from and returned to "A"—Truro, Massachusetts. Documentation: ink on map; receipts.

With its meticulous gathering of courtroom-ready "evidence" (certified postal receipts), Huebler's attempt to use the tempos built into an infrastructural technology for the circulation of printed material to give form to a highly abstract, inhabitable space is notably forensic in ethos. Huebler notes, "*42nd Parallel* used an aspect of the United States Postal System for a period of time to describe 3,000 miles of space and was brought into its completed existence through forms of documentation that in fact 'contain' sequential time and linear space in present time and place."[196] The existence of the merely interesting artwork here comes to coincide paradoxically with a presentation of documentary evidence for its existence—that is, evidence of something having been circulated, in

FIGURE 20

the same vein as Kawara's telegrams and postcards, and more specifi-
cally, evidence of a duration, of a specific period of time required to dis-
seminate information through a system or network otherwise difficult to
perceive.

With these themes of evidence and the temporality of its circulation in
mind, let us return to Kosuth's and Lippard's explicit alignment of the
look and feel of the interesting with the look and feel of being informed,
and their concomitant arguments about how conceptual art (which is
"interesting or it isn't, just as one is informed or isn't") inaugurated a key
shift in the basic conditions of art's reception. It would now be "more
important" for critics, on the basis of cues given by the work itself, to
"transmit the information about [the artwork] accurately than to judge
it." This relinquishment of aesthetic judgment was widely viewed as an
ideological hallmark of the advanced art of the 1960s overall, as evinced

above all in its embrace of the interesting. Most famously, in "Art and Objecthood," Michael Fried cites Donald Judd's comment, "A work needs only to be interesting," as confirmation of his suspicion that "the literalists have largely avoided the issue of value or quality":

> Judd himself has as much as acknowledged the problematic character of the literalist enterprise by his claim, "A work needs only to be interesting." For Judd, as for literalist sensibility generally, all that matters is whether or not a given work is able to elicit and sustain (his) interest. Whereas within the modernist arts nothing short of conviction . . . matters at all. (Literalist work is often condemned . . . for being boring. A tougher charge would be that it is merely interesting.)[197]

Note Fried's implicit restriction of judgments of "value or quality" to ones based on strong and unequivocal feeling: "conviction." It is only by way of this initial restriction that Fried is able to refer to the judgment "interesting," with its mixed or ambiguous affect, as an obvious sign of the purported indifference to "value or quality" that defines "literalist sensibility."[198] As Frances Colpitt, James Meyer, and David Raskin all point out, this was an explicit misreading of Judd, for whom "interesting" clearly meant "of value" or even "good."[199]

To shore up his contrast between evaluations founded on conviction and interest (and his subtle exclusion of the latter, feeling-based judgment from aesthetic judgment or experience proper), Fried strikingly overlays it with the contrast between two kinds of time.[200] While the judgment of conviction results from something "grasped or intuited or recognized . . . or seen *once and for all*" (165; emphasis added)—that is, as "a kind of instantaneousness" (167)—the judgment of "interest" ensues from an experience of "endless or indefinite duration," exemplified for Fried by sculptor Tony Smith's description of a highway drive on the unfinished New Jersey Turnpike (166). Informed by the same chronotopes of transportation and communication that organize the work of Ruscha, Kawara, and others, this description of highway driving as the model for artistic practice is what Fried uses to link "interesting" to the temporality of what Husserl calls the "progressive *plus ultra*" of interest, to "go[ing] on and on." As Fried states, "Endlessness, being able to go on and on, even having to go on and on, is central . . . to the concept of interest" (166). And it is precisely this ongoing temporality, so central to the serial, diachronic art of the novel, that for Fried disqualifies "interesting" from counting as a judgment of value or quality, which, for Fried, seems capable of taking place only in the instant of "conviction": "The concept of interest implies temporality in the form of continuing attention

directed at the object while the concept of conviction does not" (167). In denying any aesthetic meaning to interest, Fried thus ends up excluding "continuing attention directed at [an] object" from the kind of engagement that results in claims of aesthetic value, leaving us with a very unusual understanding of what it means to be aesthetically engaged.

For all their major differences as critics, Fried and Lippard thus agree that interesting conceptual art preempts or is indifferent to "the issue of value or quality" in a way self-evidently signaled either by the art's discursivity or communicativeness (Lippard: "It communicates itself or else it doesn't") or by its "on and on" temporality (Fried). Although Lippard casts this supposed indifference to quality in a positive light and Fried in a negative one, the assumption in both cases is that judgments of value or quality (instantaneous and final) and acts of communicating information (discursive and ongoing) are mutually exclusive, that aesthetic judgments are somehow the opposite of acts of transmitting information, and that the transmission of information has nothing whatsoever to do with the act of aesthetic evaluation. Are these assumptions true?

To think about this question more deeply, let us consider Richard Serra and Philip Glass's *Long Beach Island, Word Location* (1969) as presented in *Letters,* a catalog/exhibition curated by Philip Simkin in the form of documents in a box:

LONG BEACH ISLAND, WORD LOCATION

In a 30-acre area of marshland and coastline 32 polyplanar speakers were placed in chosen locations so as to cover the site.

The word *is* was recorded on a 15-minute tape loop and became the sound source for the speakers. The volume was controlled so that the speakers did not interrelate, but could only be heard within their proximity. In other words, two speakers could not be heard in the same area. Each sound dissolved in a given space.

The placement of the specific word in location points to the artificiality of a language. The imposition of the word as symbol negates the experience of the place. Conversely the experience of the place denies itself in relation to the word. (For by defining itself in relation to language it denies its meaningfulness independent of definition.)[201]

Even if *Long Beach Island, Word Location* were viewed in person (which would by no means be a physically easy feat), its vastly extended form (thirty-two emissions of sound distributed over thirty acres of land) would not only preclude it from being taken in all at once but also make it extremely difficult to perceive at all. For this reason, as with the descriptions, inked maps, and postal receipts that "complete" Huebler's *42nd Parallel,* the work's documentation is not merely supplementary but intrinsic to

its form and points once again to the merely interesting artwork's identi-fication with evidence. One suspects that Fried would not have hesitated to describe this conflation of the work with its discursive description as a kind of "literalism." Yet *Long Beach Island, Word Location* is hardly a case of "what you see is what you see" (Frank Stella); and it is not really a representation of the idea of art as idea (Kosuth).[202] What Serra and Glass's work rather asks us to "see" or perceive—and also to form an idea about—is precisely the dissonance between sensory experience and idea that their artwork describes. A wide range of interesting conceptual art-works explores the same friction, from LeWitt's *Variations of Incom-plete Open Cubes,* which, as Jonathan Flatley notes, strives for "a par-ticular, and particularly maximized, tension between perception and conception," to Huebler's "road-trip" pieces ("I realized that I was mea-suring sense impressions against conceptual knowledge, the conceptual knowledge being maps") to Mel Bochner's serial projects ("In what I am doing the synthesis is in the contradiction of the visible and the men-tal").[203] In repeatedly staging this clash between conceptual knowledge and sensory perception (one importantly not reconcilable by the revelation of one mental faculty as superior to the other, as in the Kantian sublime), merely interesting conceptual art helps us see that the aesthetic judgment "interesting," which places us in an affective relationship to the fact of our not knowing something, encodes an analogous clash between knowledge and feeling. Again, what was it that I must have noticed and simultane-ously not noticed about the object in order to have judged it interesting? Noticed because my attention had to have been drawn by something about it that seemed different; not noticed because here I am, wondering what the content of that difference was. Like the not-logical yet also not-illogical relationship between nonaesthetic features and aesthetic judg-ments, there is thus a double negative at the heart of the interesting: a not knowing exactly what it is that we are feeling, and a feeling about this very fact of not knowing (which can feel exciting or irritating).

The dissonance between knowing and feeling in the subjective judg-ment "interesting" thus tellingly corresponds to the friction between ideas and sensory experience in the interesting conceptual artwork. Dennis Oppenheim strikingly invokes interesting as the very sign of this friction, as if it were a kind of spark or "small fire" produced by it, in a comment on *Time Line* (1968), a series of photographs documenting his 3-mile-long "plotting" of the International Date Line at the U.S.-Canadian boundary on a frozen river in Maine: "Some interesting things happen [in my work] process: you tend to get grandiose ideas when you look at large areas on maps, then you find they're difficult to reach so you develop a strenuous

relationship with the land."[204] Mirroring the clash staged between the generality of words and the particularity of place in *Long Beach Island, Word Location,* the interesting is situated here between the instantaneous flash of ideas and a physical experience that takes time to develop, between the spontaneous conceptualizing we do when we glance at maps and the durée of the body's relationship to the spaces they represent. *Time Line* thus shows how the "maximized tension" between concept and perception in merely interesting conceptual art is also, crucially, a tension between two temporalities. As with the efforts of Ruscha and other early conceptualists to counteract the instant seized by photography with the duration embodied by the series, the dissonant conjoining of temporalities in later works like *Time Line* hints at a similarly complex temporality in the judgment of the interesting itself. While objects do tend to strike us as interesting immediately or spontaneously, the interesting then proceeds to slow things down.

To explain what I mean by this succession of temporalities, it helps to turn back to Serra and Glass's work. The first two paragraphs of *Long Beach Island, Word Location* are clearly a verbal description of *Long Beach Island, Word Location:*

> In a 30-acre area of marshland and coastline 32 polyplanar speakers were placed in chosen locations so as to cover the site.
>
> The word *is* was recorded on a 15-minute tape loop and became the sound source for the speakers. The volume was controlled so that the speakers did not interrelate, but could only be heard within their proximity. In other words, two speakers could not be heard in the same area. Each sound dissolved in a given space.

Note that although this description is seemingly an aid to our perception of *Long Beach Island, Word Location,* it is actually describing how the work's sensory elements resist perception: "Two speakers could not be heard in the same area. Each sound dissolved in a given space." More ironically, the very words that ostensibly help us get a sense of the place delimited (thirty acres of marshland) are informing us that the "word as symbol" negates the "experience of . . . place."

> The placement of the specific word in location points to the artificiality of a language. The imposition of the word as symbol negates the experience of the place. Conversely the experience of the place denies itself in relation to the word. (For by defining itself in relation to language it denies its meaningfulness independent of definition.)

This third paragraph is noticeably different from the preceding two. For one thing, it looks a lot less like a description of *Long Beach Island, Word*

Location, and more like an interpretation of it. More specifically, it looks like a justification of the work's significance, as if it is being offered directly in response to the anticipated question: Why is *Long Beach Island, Word Location* interesting? Why indeed? Because by distributing spoken language across a natural environment to demonstrate how "the experience of place denies itself in relation to the word" and "the imposition of the word . . . negates the experience of place," it gives us both an abstract idea and a palpable sense of a discord between concept and perception (and between their respective temporalities). Regardless of whether we actually become convinced by these statements that *Long Beach Island, Word Location* is an arresting and important work, their function in the work is clearly that of supplying information in support of its implicit claim to be interesting, and in a manner that curiously subordinates the moment of judgment (which we oddly become aware of only retroactively) to the more conspicuously time-consuming presentation of evidence on its behalf. There is thus a reversal of the importance typically assigned to these events on the basis of their temporal succession. Obviously, there has to be judgment before there can be a justification, just as a thing has to be produced before it can be exhibited and circulated. But much in the way in which strategies of display and circulation came to be incorporated into the production of merely interesting conceptual artworks, here the act of presenting justification for judgment starts to push its way into the frame of judgment itself.

Serra and Glass's collaboration in *Letters* thus shows how the conceptual artwork becomes coextensive with evidence in support of its claim to quality or value, though in a manner that almost furtively embeds that claim, whose basis in ambiguous feeling makes it easy to miss from the start, inside the evidence presented in support of it. Does this suggest that the evidence is actually more arresting and important than the claim? One sees a similar convergence of interesting artwork and evidence for its interestingness in Robert Barry's *Art Work* (1970), part of the landmark *Information* show curated by Kynaston McShine at the Museum of Modern Art in New York:

ART WORK

It is always changing. It has order. It doesn't have a specific place. Its boundaries are not fixed. It affects other things. It may be accessible but go unnoticed. Part of it may also be part of something else. Some of it is familiar. Some of it is strange. Knowing of it changes it.[205]

Why might one find *Art Work,* or really any artwork, as its generic title invites us to ask, interesting? Because it manages to be at once "familiar"

and "strange"; because while "it has order," "it is always changing"; because "it affects other things." In addition to supplying justifications for why someone might find it interesting (on exactly the formal grounds it names), *Art Work* works almost like a point-by-point definition of the interesting as I have explored it so far: as a diachronic aesthetic that embodies the "capitalist oxymoron"[206] of serial novelty ("some of it is familiar"; "some of it is strange"); as an aesthetic that attempts to reconcile modernity's rationalization and abstraction with its emphasis on the contingent and ephemeral ("it has order"; "it is always changing"); as a judgment with an unusually wide range of nonaesthetic and aesthetic applications ("it doesn't have a specific place"; "its boundaries are not fixed"); as an aesthetic judgment easily combined or coupled with other assessments of aesthetic quality ("part of it may also be part of something else") and as one so low in affect that it is chronically easy to miss ("it may be accessible but go unnoticed"). In a less obviously thematic way than Antin's *Blood of the Poet Box* or Ruscha's *Stains,* Barry's *Art Work* seems to want to make itself coextensive with evidence. But now not just in the form of documentation used to make the existence of the work public, but in the form of information presented to "make a case" for its claim to aesthetic quality—if only or merely that of being "interesting." Casting a new light on conceptualism's documentary and informational idioms—its fascination with the kinds of things typically exhibited as "proof" in legal and scientific contexts (receipts, data, invoices, and so on)—Barry's *Art Work* suggests that the "merely interesting" artwork not only bears the "look" of evidence but in fact becomes aesthetic evidence, both in support of its implicit self-judgment of quality and, in the curious form of an afterthought, of that judgment having taken place. To be sure, the information presented by the conceptual artwork to make its case for this claim may not always be coextensive with its form; this immanence seems specific to later works coterminous with their own documentation or based entirely on language. But even in cases where no justification is readily available, the claim to interestingness poses the problem of its justification immediately, as if to explicitly solicit a demand for it from someone else.

In recognizing how it diverts our attention from feeling-based judgments (quick/instantaneous) to concept-based justifications (slow/ongoing) and thus how its relation to justification connects to its relation to time, we can see what most significantly sets "interesting" apart from other aesthetic evaluations. Precisely because of the features that at first seemed to disqualify it from aesthetic experience altogether (semantic indefiniteness, affective ambiguity, recursive yet anticipatory temporality), what is

unique about the judgment "interesting" is that it inevitably diverts attention away from itself so as to throw the spotlight entirely on the question of its own legitimation. It is a judgment that slides us from judgment *to* justification, that hurries past the first moment in its eagerness to arrive at the next. (In this manner, "interesting" performatively conflates judgment and justification, reveals itself as a speech act that acts upon other speech acts.) In contrast, when someone proclaims that she finds a tree or a poem beautiful, the force of the conviction underlying the judgment tends to route our attention immediately back to the sheer event of her having found it so. This is why it can be so strangely difficult to respond to someone's passionate declaration that something is beautiful, whether one agrees with the person's judgment or not. Whether we nod in sympathetic agreement or politely say nothing, we are likely to feel like any response we might have to the response of the judging subject, however not unwelcomed, is somehow beside the point. As Hockney and Rivers note, there is something "final" about the beautiful, which often seems to double as a signal that the period of aesthetic evaluation and even experience has ended. Even if one agrees with the judge of beauty, but in a way that becomes especially conspicuous if we disagree, her emphatic judgment's primary reference seems to be to itself, calling attention to itself as an emphatic judgment in a way that seems to make any other potential judge's response to that judgment (and thus the relationship between aesthetic judges) irrelevant to what the experience ultimately includes or means.

On the other hand, when someone feels compelled to make public his evaluation of an object as interesting, we seem equally compelled to ask immediately: why? Here, aesthetic evaluation seems no longer finalized by the act of making an aesthetic claim but rather to have just gotten on its way. I would therefore slightly amend Cavell's compelling definition of aesthetic judgments as speech acts that shift the power of gauging the act's felicity from the "I" to the listening "you" (thus explicitly soliciting a response from the other) by noting that not all judgments of aesthetic quality do this equally. Facilitated by the very features that at first glance seemed to disqualify the interesting as an aesthetic judgment proper, the judgment of "interesting" seems to solicit a "why" from others precisely in order to create an occasion for the judge to make her evidence or reasons public. This is perhaps why we tell people we find things interesting not only when we find them nonbeautiful but also when we find them beautiful. The interesting is thus not a true antithesis of beauty, nor devoid of the claim to universal validity that for Kant distinguishes aesthetic judgments from judgments of taste.[207] When I am compelled to make

public my appraisal of something as interesting, I am speaking precisely from my conviction that it is objectively worth paying attention to and appraising, regardless of my appraisal's vulnerability to time. When we judge, say, a bad movie to be interesting (and when we say interesting, we often do mean "bad but nonetheless interesting"), we are therefore essentially making a plea for extending the period of the act of aesthetic evaluation: let us keep on talking about this movie; let us continue giving it attention even though it is not particularly good. Exactly on the basis of our conviction that the object merits our going on—merits stretching the moment of aesthetic appraisal to include its discursive and intersubjective aftermath—we tell people we find works interesting when we want an opportunity to show them our evidence or to present support for our claims of value in a way capable of convincing them of their rightness. In other words, we tell people we find works interesting when we want to do criticism.

Far from being a style without content or a judgment that is somehow not genuinely aesthetic, the deepest content of the aesthetic category of the interesting is precisely that of the justification of aesthetic judgments in general. For this reason—additional to those Colpitt, Meyer, and Raskin already note about its use in Judd's writings on minimalism—the term's dominance in the discourse surrounding conceptual art is far from indicating the latter's avoidance of the "issue of value or quality." By soliciting a demand from another person to show them our evidence—a demand that suggests a deeper connection between the two things Fried finds problematic about the merely interesting artwork than his own essay seems to realize (first, that it "implies temporality" or duration; second, that it resembles a demanding person),[208] the interesting actually extends what aesthetic evaluation might mean or encompass within its parameters: not just the spontaneous, feeling-based act of judgment but that judgment's discursive and narrative aftermath. Indeed, no aesthetic judgment seems better suited to epistemologically enrich the power of aesthetic judgments by extending the period and disclosing the intersubjective and dialogic possibilities of this communicative act. By making art coincide with evidence at so many levels (in a way that entirely distinguishes it from minimalism), the conceptual, discursive, forensic art of the 1960s seems especially exemplary of this potential. If no aesthetic judgment moves us faster away from judgments to justifications than "interesting" (as opposed to making the latter seem merely incidental to what it means to make an aesthetic claim), what could be more interesting than art that equates itself to the presentation of evidence through and through? All of this sheds light not only on the centrality of the interesting to conceptual

art but also on its ongoing appeal to critics. In addition to the way the interesting suspends a once-and-for-all appraisal in favor of a "continuing attention directed at the object" that might help us figure out why it made us go "Huh?" in the first place, the power of this seemingly mild aesthetic lies in the surprisingly ambitious way in which it redefines the process of aesthetic evaluation as including the other's subsequent demand for us to justify it. There is thus a deeply pedagogical dimension to the interesting as well, for in the effort to provide evidence capable of proving the rightness of our judgment to our questioner (which will, of course, take time), we are likely to seek and present additional information about the work and also to debate with him about the work—not only for the final end of convincing him but as a way of enlisting him to convince us or help us arrive at a fuller understanding of why we thought the work was interesting to begin with.

Diachronic and informational, forensic and dialogic: the aesthetic of the interesting has the capacity to produce new knowledge. From Adorno on the products of the culture industry to Cavell on Hollywood screwball comedies, all contemporary criticism is thus, in some sense, an implicit provision of evidence for why the object that the critic has chosen to talk about is interesting (which can be for "innumerable" reasons, as Henry James reminds us, including ones grounded in feelings of ambivalence and dislike). The interesting thus shows a way out of the deadlock between the old idea that the task of criticism is to produce verdicts of artistic greatness versus mediocrity, or of artistic success versus failure, and the more generally accepted idea that criticism should try to purge itself of aesthetic evaluation entirely (since, given its institutional context, it cannot help but tend to reproduce values already set in place). The assumption here is that if one wants to be critical of how aesthetic values are historically and institutionally reproduced and of the social consequences of their reproduction, one should cut these evaluations out of the picture entirely. Yet in neither reducing criticism to the making of aesthetic judgments nor presuming that indifference to aesthetic value is a necessary prerequisite for understanding the various forces behind the production of value, the interesting cleaves through the opposition between aestheticism and philistinism. In doing so, it keeps the possibility alive that a critic might actually continue the task of influencing public judgment, if only in the modest way of suggesting that some texts are more worth paying attention to than others and then supplying reasons why.

It is here that we can begin to glimpse why the fact that the judgment "interesting" seems peculiar to restricted or what Kosuth calls "serious" communities (groups based on specialized knowledge in which

"an audience separate from the participants doesn't exist") does not necessarily entail an exclusivity that belies its claim for universality. Although it may be true that "interesting" always begins life as the judgment of those in the know (as seems in keeping with how its recognition of novelty requires a preexisting knowledge of frameworks), the demand for justifications that it solicits from others, which in turn creates the occasion for one to supply them, suggests that this aesthetic of and about circulation is actually aimed at enfranchising outsiders and thus expanding the boundaries of the original interest group. "Interesting" is both what makes "serious" subcultural groups cohere in the first place and what makes it possible for people to belong to many of them, creating the webs of filiation that make these interest groups overlap. Much in the same way it bestrides aesthetic and nonaesthetic judgments, the interesting crosses the border between the common and the specialized, bespeaking a desire to open up the "serious" group founded on the possession of specialized knowledge (but without dissolving its autonomy) in a way that once again points to its special relation to pedagogy.[209]

LeWitt once remarked that for the conceptual artist to "make art mentally interesting to the spectator," his work had to become "emotionally dry." As Jonathan Flatley aptly notes, this did not mean that conceptual work was unemotional (93); "dryness" is, after all, an affective quality. The aim seems to have been that of making the act of perceiving less instantaneous and more durational by calling attention to the pathways between conception and perception, idea and execution, sight and thought, judgment and justification. These "in-betweens" are ones that the conceptual work tried to make the viewer not only grasp but feel, as if in order to restore the temporal middle, or the "lag" between production and reception in danger of being lost by the increase in circulation's temporal powers.[210] This desire gives us a new way of understanding interesting conceptual art's preoccupation with the experience of duration or the ongoing, a trope repeatedly connected, as we have seen, with the circulatory chronotopes of the new twenty-four-hour news cycle and the postal system, the highway and the car. Indeed, it gives us a new way of understanding what Pamela Lee describes as the preoccupation of art in the 1960s with time in general.

In the same essay in which Kosuth proclaims that conceptual art "is interesting or it isn't, just as one is informed or isn't," he shores up this definition of conceptual art by citing the following comment by Clement Greenberg as a foil: "Aesthetic judgments are given and contained in the immediate experience of art. They coincide with it; they are not arrived at afterwards through reflection or thought."[211] Looked at closely,

Greenberg's claim about the inextricability of judgment from aesthetic experience does not help Kosuth prove that conceptual art, for all its preoccupation with "reflection or thought," made no claims to aesthetic quality. Indeed it did make such a claim: that it was interesting. Greenberg's stress on the instantaneity and finality of aesthetic judgments does helpfully disclose, however, why aesthetic judgments are not in themselves interesting, while their more slowly formulated, open-ended justifications are. This is why concept-based justifications of feeling-based judgments will always play a key role for critics who have an interest in producing knowledge about the objects that interest them—including the "merely interesting" ones.

The Zany Science

U NDER A LATE capitalist mode of production privileging ever more elastic relations to work and personality, is there something increasingly funny about character as an aesthetic form? Invoking Bergson, Adorno suggests as much in "The Stars down to Earth," his 1953 analysis of the astrology column of the *Los Angeles Times* as a window onto the mass appeal of systematized irrationality.[1] For Adorno, the column's insistent encouragement of extroversion, networking, and flexibility—"Be more social"; "Get out of yourself; make every new association possible"; "Lose no time [in getting your plans into execution]; contact all friends able to help; expand into new outlets in all directions"— reflects how the "development of spontaneous personality" encouraged by the postwar service economy makes the very concept of "character" seem comically rigid.[2] If the Fordist/Taylorist capitalism of the nineteenth and early twentieth centuries made people laugh at characters incapable of adjusting to new roles and social situations quickly (an inflexibility Bergson famously captures in his image of "something mechanical encrusted on the living"), how does one respond to characters who seem almost too good at doing so?[3] If the rigidity of others is what makes us laugh, can an absolutely elastic subject—one who is nothing but a series of adjustments and adaptations to one situation after another—be genuinely funny?

And what might gender have to do with all this? Although the *Los Angeles Times* horoscopes explicitly project the image of a male businessman as their implied reader (a "vice-president" whose identity ironically

lies in his social fluidity, or ability to "get out of [him]self" and "expand into new outlets in all directions"), Adorno provocatively argues that the actual readers deriving pleasure from this image of male success in the workplace were women, "isolated" or unwaged housewives presumably reading for the pleasures of the vicarious leap across the male/female and productive/reproductive labor divide.[4] Given the ideological power of the freshly reconsolidated gendered division of labor in the United States in the early 1950s, Adorno's claim about the relation between the astrology column's actual and projected readership certainly seems plausible.[5] But what if the discourse of self-empowerment implicitly addressed to this hyperactive male character appealed to female readers because something about his characterization struck them not as fascinatingly exotic, but rather as fascinatingly familiar?

Consider the American housewife played by actress Lucille Ball in the situation comedy *I Love Lucy*, which has continued to run on network and cable television (and now on the Internet) ever since it premiered on CBS in 1951. One of television's first "reality shows," in the sense of constantly referring to the off-set lives of its actors,[6] which supposedly owed its existence to Ball's effort to find a way to work alongside the professionally and romantically itinerant Desi Arnaz,[7] *I Love Lucy* turns on the doggedly persistent, comically strenuous efforts of Lucy Ricardo to break into the world of artistic and cultural production she reverently calls "showbiz." This challenge requires an initial outlay of capital that Lucy must obtain either by quickly picking up a new skill, like French or ballet (Fig. 21)[8] or by taking on a temporary job involving some kind of affective service work: selling and then unselling salad dressing on television; babysitting and managing child talent; working as a magician's assistant; opening a women's dress boutique; competing in a game show (Figs. 22, 23, 24).[9] And if not by taking a job in retail or services, then by impersonating somebody with one: hot-dog vendor, hotel bellhop, celebrity chauffeur (Fig. 25).[10] "Ricky Needs an Agent" (May 16, 1955) is a prime example of how things get zany when these occupational performances excel far beyond Lucy's expectations. Clad in a power suit and glasses, Lucy masquerades as her husband Ricky's official representative or agent to pressure MGM, the studio to which Ricky is contracted but for no specific job, into making him a movie deal. To arouse MGM's interest in Ricky, Lucy brags that he has been offered a Broadway musical and is so convincing about this competitive threat that she ends up persuading the studio to release Ricky from his contract entirely. This unintended consequence then commits her to spending the rest of the episode performing the role

FIGURE 21

FIGURE 22

FIGURE 23

FIGURE 24

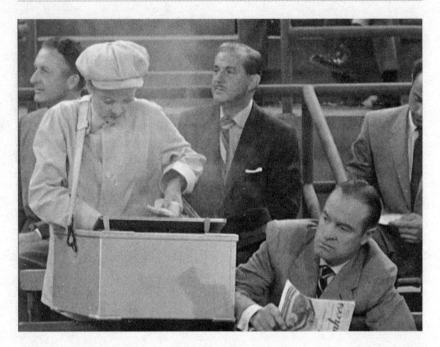

FIGURE 25

of "herself," Ricky Ricardo's wife Lucy Ricardo, in order to convince MGM of the existence of a "crazy woman"—a zany character—running around impersonating Ricky's agent.

Note the metonymic slippage between roles and occupations: housewife → actor/agent → zany. Whether as real labor or as a playing at its forms and appearances that ends up generating indistinguishable effects, each of Lucy's temporary occupations requires her to put on a costume and act like someone else, as if to suggest a new instability in the postindustrial United States between the activities of performing a role and working a job, including all the nonspecific jobs that seem to fall under the single role of housewife. Mainstream American television's most famous housewife thus anticipates zany performance artist Linda Montano's job-oriented experiments in fusing art with everyday life from the early 1970s—*Home Nursing* (1973), *Becoming a Bell Ringer for the Salvation Army* (1974), *Odd Jobs* (1973)—in a tradition of feminist art-making preoccupied with the overlap between cultural performance and service-economy labor.[11]

To be sure, it is what one critic calls the "basic incompetence of the Lucy Ricardo character" that so many have found funny.[12] As exemplified best as in a scene from "The Ballet" when Lucy's unfeminine failure to bend

gracefully results in her leg getting stuck in the bar, the sitcom's "zany [and] talentless housewife" is comical because of her failure to be as "flexible" as required by the roles she assumes in her pursuit of paid work—an unremitting succession that in turn seems to be a formal echo of the multiple roles already demanded by the informal or unpaid job of housewife and mother (which also entails being a cook, teacher, chauffeur, cleaner, and more).[13] Yet, as dramatized by the maniacal nature of her incessant activity, it is precisely Lucy Ricardo's job incompetence in the spheres of production and reproduction alike—her failure in both arenas to be sufficiently flexible, her lack of talent as a performer—that transmits the "star image" of Lucille Ball and thus the character of a virtuosic performer utterly expert at quickly learning and adapting to new roles.[14] The dialectic between social inflexibility and flexibility in comedy famously noted by Bergson is thus played out here in the oscillation between the character Lucy Ricardo (always straining unsuccessfully to be many things at once) and the actor Lucille Ball (whose consistency becomes visible across that very multiplicity of roles) staged in episode after episode of *I Love Lucy* (Figs. 26, 27, 28, 29).

However jealously guarded by Ricky Ricardo, the culture of professional performing in *I Love Lucy* is not represented as exclusively or

FIGURE 26

FIGURE 27

FIGURE 28

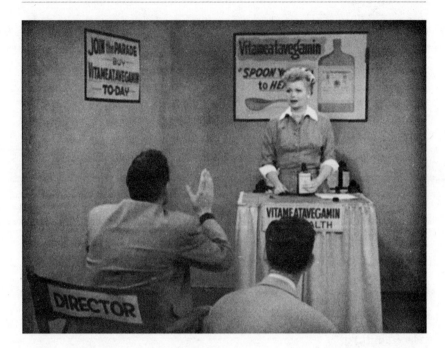

FIGURE 29

distinctively feminine. On the contrary, "showbiz" is pointedly portrayed as a world equally made up of female performers, from the fictional actresses and dancers working alongside Ricky who repeatedly inspire Lucy's jealousy and the retired vaudevillian who is her best friend and sidekick (Ethel Mertz, played by Vivian Vance) to the female celebrities who frequently made guest appearances on the comedy as themselves (Betty Grable, Tallulah Bankhead, Hedda Hopper, and Ida Lupino, among others). Far, then, from reinforcing the distinction between male and female, paid and unpaid, and public and private worlds of work, Lucy's frenetic style of doing points to a lack of substantial difference between the kinds of performing called for in both domains. Is not every extra job that we see this housewife take on as a means to enter the world of cultural or aesthetic performance a job that already involves performing? Although Lucy Ricardo's efforts to break into showbiz by way of multiple odd jobs never succeed, do not these very failures testify constantly to the virtuosity of the professional actress Lucille Ball? Cultural performance and job performance, two modes of activity that seem separated by a number of sociological divides, are thus revealed through Lucy Ricardo's zaniness—her particular style of incessant doing—to be more alike than different.

Zaniness is the only aesthetic category in our contemporary repertoire explicitly about this politically ambiguous intersection between cultural and occupational performance, acting and service, playing and laboring. Intensely affective and physical, it is an aesthetic of action in the presence of an audience that bridges popular and avant-garde practice across a wide range of media.[15] If the sitcom of Lucille Ball is quintessentially zany, so also is the Dada cabaret of Hugo Ball. Walkabouts and guerrilla street theater are zany,[16] but so are the commercials of Crazy Eddie (Fig. 30). Hyperattuned and ultraresponsive to the behavior of those around her, the zany performer's zaniness is most acutely brought forth in social situations, which is why one rarely finds a zany acting zany alone. Rather, zanies tend to be paired with or against other agents: often a minder (Don Quixote with Sancho Panza) or others to be minded (Mrs. Doubtfire with his or her charges), although the chaotic nature of the style often makes it unclear exactly who is minding whom.[17] In any case, zaniness often entails action by multiple zanies: Lucy and Ethel, Bouvard and Pécuchet, and Wakko, Yakko, and Dot, the triad of cartoon Animaniacs who made their first appearance on American television in a pilot episode called "De-Zanitized."[18]

Zany performers are constantly in motion and in flight from precarious situations in particular, whether in the form of rocket missiles, as in the case of the Warner Brothers cartoon *Roadrunner,* or, more complexly,

FIGURE 30

in a text to which I will soon return, conscription into endless nanny work for the wealthy white families of south central Louisiana, as we find Richard Pryor in the closing moments of *The Toy* (1982), sprinting down a lonely rural highway as the camera telescopes in on his retreating figure like the sight of a rifle (Fig. 31). Like a round of Frogger, Kaboom! or Pressure Cooker, early Atari 2600 video games in which avatars have to dodge oncoming cars, catch falling bombs, and meet incoming hamburger orders at increasing speeds, or a Thomas Pynchon novel, bombarding protagonist and reader with hundreds of informational bits that may or may not add up to a conspiracy, zaniness is essentially the experience of an agent confronted by—and endangered by—too many things coming at her at once. Even the President in Madeline Gins's poem *WHAT*

a

b

c

d

e

f

g

FIGURE 31

THE PRESIDENT WILL SAY AND DO!! (1984), described by its author as a Nietzschean exploration of "Power and Being," seems hysterically besieged by an endless succession of projects described in language resembling instructions for a Happening or Fluxus performance: "FILL THE OCEAN WITH COTTON!"; "HAVE ALL BIRDS WEAR VEILS TO LOOK MORE MYSTERIOUS!"; "AMOEBAS SHOULD ALL FACE IN THE SAME DIRECTION!"; "DROP WORDS OUT OF CONVERSATION AND SHATTER!"[19] As stands to reason for an aesthetic of action pushed to physically strenuous extremes (and an aesthetic of an intensely willing and desiring subjectivity), zany works of language tend to be filled with performative utterances and to bristle with markers of affective insistence: italics, dashes, exclamation points, full capitals.

If the experience of zaniness is one of physical bombardment, Nietzsche's seemingly haphazard aphoristic style has been noted for producing a similar effect on readers, mixing voices, styles, and tropes in an aggressive rhetoric that Robert Pippin, Jacques Derrida, and Kenneth Burke have respectively described as loaded with "booby-traps," as barbed or "spurred," and as "a sequence of darts."[20] Characterizing the typical page as a "battlefield of thought," Burke adds, "His sentences are forever striking out at this or that, exactly like a man in the midst of a game, or enemies" (88). The assailing effect of Nietzsche's style is perhaps most pronounced in *The Gay Science,* "the book that suddenly presents all the images and formulations so famously identified with Nietzsche's name, many for the first time,"[21] including the philosopher's call for an antiepistemological relation to knowledge in the form of an "instinctive"[22] aesthetics of laughter: "Precisely because we are at bottom grave and serious human beings—really, more weights than human beings—nothing does us as much good as a *fool's cap:* we need it in relation to ourselves—we need all exuberant, floating, dancing, mocking, childish and blissful art" (¶ 107, 164). One might thus read the style of *The Gay Science,* an "antitheory conducted in images, metaphors, and similes" (Pippin, 121), as, in Nietzsche's own words, an "experiment" in how one might "incorporate" or "embody" truth (see ¶ 11 and ¶ 110; cited by Pippin, 39). As Jon McKenzie argues, Nietzsche's style thus anticipatorily invokes the experience of "being challenged" central to a Cold War American culture in which "performance" designates not just the performance of artists but also that of washing machines, shampoo, and cars, and thus something to be "optimized" through various "experiments" and "tests."[23] This concept of performance, tracked and developed by McKenzie in his remarkable book *Perform or Else,* is also central to zaniness. Here challenges primarily take the form of encounters with multiplicity, the contingent,

and the unforeseen,[24] whether in the form of clay balls hurled at flower-pots in Claes Oldenburg's strangely not-so-gay Happening *Gayety* (1963) or the dropping of furniture from trees in Allan Kaprow's *Birds* (1964). As Daniel Harris writes, "In their purest form, zany comedies are struc-tureless journeys through worlds of dangerous and volatile objects. Every prop, every character, is . . . a potential projectile."[25] This would make *The Gay Science*—a barrage of what Avital Ronell calls "experimental language shots," fired off in its explicit effort to make "laughter [form] an alliance with wisdom" (¶ 1, 74)—the zaniest of all philosophical texts[26] and, as Nietzsche makes clear, a particularly testing or challenging "com-edy of existence" (¶ 1, 75). To "pick my roses," as he saucily puts it in one of his "rhymes," one must be willing to "stoop and stick your noses / Between thorns and rocky views, / And not be afraid of bruises // For my joy—enjoys good teases" (¶ 9, 45). Emphasizing the same images of risk and potential injury, Burke likens the Nietzschean text to an act of house-wrecking: "As men, having the same restlessness of insanity . . . will con-vert their rooms into a replica of their own unsettled state, externalizing their moods in torn bedding and shattered furniture, so [Nietzsche] vigor-ously constructed pages that put the raging of his brain before us" (88).

We can thus see how zaniness, as an effort to parry the incessant chal-lenges of others, lends itself to the stylization of social conflict and war, from the fierce clashes staged between men and women in Kaprow's early, gender-conscious Happenings (where acts of household demolition play a prominent role) to the battles between the little girls and their various antagonists in the illustrated novel by Henry Darger inspiring Ashbery's *Girls on the Run*. "A carousel is burning," the penultimate line of this "dis-junctive and unpredictable, often zany" poem (to cite Langdon Hammer's characterization of Ashbery's style in general),[27] points to how zaniness often seems to involve the destruction not just of any object but of ones specifically designed for fun, as if in revolt against the compulsory pleasure that defines it.[28]

The zany thus has a stressed-out, even desperate quality that immedi-ately sets it apart from its more lighthearted comedic cousins, the goofy or silly. Although zaniness is playful in all its manifestations across genres, media, and cultural strata, it is an aesthetic of action pushed to strenuous and even precarious extremes. Yet the vehemence of this style of inces-sant activity (which plays no particular role in our experience of the goofy and the silly) also seems to have been a factor in making it a long-standing source of laughter and enjoyment for over three centuries, from Punch and Judy to *Tom and Jerry*. We find the same complicated imbrica-tion of affects in *The Gay Science*, where for all Nietzsche's visible effort,

Julian Young writes, "the only kind of gaiety . . . achieved is a kind of manic frivolity which is really no more than a symptom of desperation and despair."[29] Regarding the "laughter" of Nietzsche's text as similarly "hollow" and "stagey," Wyndham Lewis links these qualities to what he takes to be the main problem with the philosophy of this "vociferous showman": "that what [Nietzsche] did (or suggested other men should do) with their superfluous, creative energy was to go on fighting and struggling: just as though, in short, they had not been provided with a margin for play or a superfluity of energy at all."[30] In other words, for all *The Gay Science*'s insistence on a "merrier disposition," "will to enjoy[ment]," and "will to illusion" as ways to repudiate the pessimism of modern knowledge and its paralysis of the will to "ACTION," Nietzsche was "so impregnated with the pessimism of Schopenhauer and his health so broken by his experiences in the Franco-Prussian War that he could not imagine, really, the mind doing anything else with itself than what it did in post-Darwinian or Schopenhauerian pessimism: to just go on contemplating the horrors of existence. And in reality the will to enjoy was dead in Nietzsche, much as he clamoured for latin lightheartedness" (118).

Whether Nietzsche had "cheerfulness" *(Heiterkeit)* or a more euphoric "joy" *(fröhliche)* as an ideal for his philosophy turned against "philosophy," as Robert Pippin notes, the "fact that his prose often lapsed into a shrieking intensity, the occasional hysteria, the drift into the maudlin and sentimental, the hatred venting through some passages" suggests a failure to sustain either.[31] The tension in *The Gay Science* between its gay subject matter and its zany tone thus points to a dialectical tension between the two affects. Although gaiety is a lighthearted affect of the winners of history with whom Nietzsche solicits his "rightful readers" to identify (making zaniness the disposition of history's losers),[32] it seems that neither can really be thought of without the other. Zaniness, an affect as well as a style ostentatiously about gaiety—the affect that for Nietzsche best represents the nature of "higher type[s]" willing to allow their instincts to "lead [them] astray to perform inexpedient acts" (¶ 3, 77)—is what emerges precisely when an all-too-obvious effort to express and thus produce that gaiety fails.[33] This affective failure becomes all the more noticeable in *The Gay Science* given the explicit claim Nietzsche makes in this text for the philosophical significance of an aesthetics in the mood of joy.

Far from being "mocking, light, fleeting, [and] divinely untroubled" like the art explicitly called for in *The Gay Science* (¶ 4, 37), the art of the zany is frantic and beset. It thus points to how something like the opposition between the Apollonian and the Dionysian continues to inform Nietzsche's aesthetic theory long after his public renunciation of *The Birth of*

Tragedy, the text in which he first describes the two art-impulses and the death (but also the possible eventual revival) of the one genre capable of reconciling them. I stress "something like" because in spite of their superficial similarity, Dionysian frenzy is not quite zaniness, being devoid of the latter's associations with situational desperation and precarity, as well as with self-conscious clowning and buffoonery. Moreover, unlike the cathartic, boundary-dissolving power of frenzied states, there is something impotent and "reactive" about the zany's incessant activity, which tends to maintain or even reinforce social boundaries (including the boundary between actor and audience). The gay/zany opposition thus cannot be neatly mapped back onto the Apollonian/Dionysian, although the affectivity of the older opposition remains instructive. Although Nietzsche regards both as "life-affirming" and "creative," for example, there is clearly a world of difference between the "light," "fleeting" art extolled in the aphorisms and lyrics of *The Gay Science* and the manic, ferocious, highstrung art of "strong affects" Nietzsche calls for elsewhere. While *The Gay Science* praises a "divinely artificial" art that "like a pure flame, licks into unclouded skies" (¶ 4, 37), *Twilight of the Idols* seems to indicate its author's preference for something in a much more earthy register:

> If there is to be any aesthetic doing and seeing, one physiological condition is indispensable: frenzy. Frenzy must first have enhanced the excitability of the whole machine; else there is no art. All kinds of frenzy, however diversely conditioned, have the strength to accomplish this; above all, the frenzy of sexual excitement, this most ancient and original form of frenzy. Also the frenzy that follows all great cravings, all strong affects; the frenzy of feats, contests, feats of daring, victory, all extreme movement; the frenzy of cruelty; the frenzy in destruction; the frenzy under certain meteorological influences, as for example the frenzy of spring; or under the influence of narcotics; and finally the frenzy of overcharged and swollen will.[34]

Which does Nietzsche ultimately call for: a light, cheerful, ethereal art, or an art that is convulsive, vehement, and almost painfully embodied? A "divinely untroubled" art that floats weightlessly apart from human existence on earth, or an art full of "overcharged and swollen will"? Nietzsche's vacillation between the heavy and light affects of frenzy and cheerfulness significantly mirrors the affective contradiction at the zany aesthetic's heart. This vacillation becomes most conspicuous in *The Gay Science,* devoted perhaps more than any of Nietzsche's other works to the discussion and hierarchical sorting of a variety of instincts, affects, and passions: irritability, envy, avarice, love, pity, contempt, piety, dignity, ambition, acuteness, industriousness, virility, languor, and more.

Since feelings of pleasure or displeasure lie at the foundation of every aesthetic experience, the affective contradiction that zaniness exemplifies is one that goes straight to the heart of philosophical aesthetics. Could what keeps *The Gay Science* from embodying the kind of joyfully embodied philosophy Nietzsche so stridently calls for in it be in any way related to what makes the zany itself so anxiously shrill? Because the zany insists so strenuously on pleasure and more specifically on the pleasure of the activity of spontaneous, goalless play, the problem of art's "ever broken promise of happiness" seem more intensely concentrated in this aesthetic than in any other.[35] It therefore seems important to be as precise as we can about the reason for the zany's paradoxically entertaining failure to be joyful, or for why it becomes such a key example of the "euphoria in unhappiness" Herbert Marcuse finds endemic to the culture of advanced industrial societies.[36] What is eating the zany? Why is she so desperate and stressed out? And why have so many found this mix of desperation and playfulness so aesthetically appealing?

My simple answer to this question is that this playful, hypercharismatic aesthetic is really an aesthetic about work—and about a precariousness created specifically by the capitalist organization of work.[37] More specifically, as one might already discern from the strenuous performances of Lucy Ricardo (and their unique way of disclosing the artistry of Lucille Ball), zaniness speaks to a politically ambiguous erosion of the distinction between playing and working: from the exhausting pursuits of "fun while learning" in *Bouvard and Pécuchet* (a novel that for all its comedy has "nothing lighthearted about it," according to Raymond Queneau)[38] to the "raucous corporate culture" of Southwest Airlines personified in the "oddball ways" of its "colorful" CEO Gary Kelley (noted for convening meetings in which he addresses his employees in female drag).[39] In all its appearances across the *longue durée* of a modernity never entirely identical or reducible to capitalism but driven primarily by its contradictory logic of incessant expansion, and perhaps most conspicuously since the last half of the twentieth century, it is this cross-coupling of play and work—one marked by an increasing extraction of surplus value through affect and subjectivity, in particular—that provides the best explanation for the contradictory mix of affects that makes the zany what it is, and also such an interesting problem for philosophical aesthetics.

To describe the intensely affective/subjective style of zaniness as a style not just about work, but about the "putting to work" of affect and subjectivity for the generation of surplus value (as we will see in much more detail soon),[40] is to describe it as an aesthetic about production. But precisely insofar as our understanding of production—already a "certain mode of social cooperation and the application and development of a

certain body of social knowledge," as Raymond Williams reminds us—
has widened over the course of the past half century to include acts of
working or performing not originally included in Marx's definition.[41]
Increasingly though still not uncontroversially acknowledged as neces-
sary for the production of value as well as material wealth (and thus
as "productive" in a specifically Marxist sense), these acts range from
the caring and domestic work of waged and unwaged women (the cul-
turally devalued "reproductive" labor brought to light by second-
wave feminism) to the labor of teachers, artists, and information workers
(the "immaterial" or "virtuosic" labor foregrounded by Italian neo-
Marxism).[42] The kind of work zaniness indexes extends across both
subcategories of labor (reproductive and immaterial). In addition to forc-
ing us to revisit and think across this latest incarnation of the feminist/
Marxist divide, the zany qua aesthetic of incessant doing, or of perpetual
improvisation and adaptation to projects, also invites us to invert Berg-
son's famous thesis about comedy. If the "psychological calcifications
which make an individual comical in an aesthetic sense . . . are bound
up with his incapacity to cope with changing social situations,"[43]
perhaps there is something fundamentally anticomical and even patho-
logical—that is, something fundamentally zany—about those who do
nothing else.

The unfunnyness of total or absolute adaptability, while arguably
brought to a head by the flexible network capitalism of our current mo-
ment, goes a long way toward explaining the discomforting aspect of all
of modernity's zanies. Far from being "divinely untroubled," zaniness proj-
ects the "personality pattern" of the subject wanting too much and trying
too hard: the unhappily striving wannabe, poser, or arriviste.[44] The utter
antithesis of ironic cool, the perspiring, overheated zany is a social loser
not only in the vein of Bouvard and Pécuchet but also of Rameau's nephew,
the "failed musician, frequenter of the drawing rooms of the not-so-great,
immoralist, leech, and stupendously gifted mime" whom Diderot invents
in his 1765 dialogue exploring the difference between modernity's genu-
ine artists (Rameau himself, a brilliant musician) and its mediocre peda-
gogues (his nephew).[45]

As Joseph Roach argues, the "sweaty antics" of the nephew testify
to the fact that his "entire nature is impromptu."[46] They also testify to
his occupational überrole—one assumed due to economic necessity—of
amusing/servicing/educating the rich. The nephew's "sycophantic visita-
tions to the homes of his patrons" are thus directly correlated with his
professional failure as an artist. Yet these visitations are also "minor mas-
terpieces of instantaneous self-invention: he can burst like a thunderclap,
whine like a lap dog, or whip up any buffoonery the lady of the house

desires" (Roach, 123). A virtuosic performer in this feminized, less prestigious domain (the semiprivate drawing room, as opposed to the orchestra hall), Rameau's nephew performs with what would seem to be the detachment requisite for shifting so rapidly from one role to another. Yet he also seems to perform with not enough distance from his emotions, which are at once spontaneously generated and quite visibly put to work. There is perhaps no better index of this representation of affective spontaneity as effort than the nephew's perspiration, as singled out by his philosophical interlocutor and also by Roach: "The sweat, which, mixed with the powder in his hair, ran down the creases of his face was dripping and marking the upper part of his coat. What did he not attempt to show me? He wept, laughed, sighed, looked placid or melting or enraged. He was a woman in a spasm of grief, a wretched man sunk in despair, a temple being erected . . . a storm, a hurricane, the anguish of those about to die, mingled with the whistling of the wind and the noise of thunder."[47]

The wild seesawing of the nephew's actions in the story thus mirrors the discursive unevenness of his rhetorical style, remarked by the observer as "now elevated, now colloquial," in an informal genre whose own stylistic hybridity may have inspired that of the later Nietzsche (as Jacques Barzun notes, *Rameau's Nephew* is "part satire, part character sketch, part gossip column").[48] Diderot's zany passes out, foaming at the mouth, after this performative feat, which has followed an equally strenuous one in which he has pantomimed the sounds and movements of an entire opera, including the ballet, the choruses, all the individual instruments as well as the musicians playing them, the audience members, and, of course, the singers/characters/actors:

> He jumbled together thirty different airs, French, Italian, comic, tragic—in every style. Now in a baritone voice he sank to the pit; then straining in falsetto he tore to shreds the upper notes of some air, imitating the while the stance, walk and gestures of the several characters; being in succession furious, mollified, lordly, sneering. First a damsel weeps and he reproduces her kittenish ways; next he is a priest, a king, a tyrant; he threatens, commands, rages. Now he is a slave, he obeys, calms down, is heartbroken, complains, laughs; never overstepping the proper tone, speech, or manner called for by the part. (67)

On regaining consciousness after his collapse from this succession of perfect imitations, the nephew has no real grasp of what he has done, suggesting that the performances are in control of the performer and not vice versa.[49] The very virtuosity of the nephew's performance thus paradoxically underscores his status as artistic failure:[50] "When I take my pen by myself, intending to write, I bite my nails and belabor my brow but—no

soap, the god is absent" (78). This dual status as virtuoso/loser recalls the nephew's simultaneously privileged and subservient position as entertainer in the drawing rooms of the wealthy: "I was their dear Rameau, pretty Rameau, *their* Rameau—the jester, the buffoon . . . the saucy rogue, the great greedy boob" (19). In a motif repeated throughout the dialogue, the multiple list of terms for "zany" here and elsewhere (jester, buffoon, rogue, boob) verbally echoes the succession of roles we see this zany repeatedly being asked to play. For if the nephew is a "bundle of charms," he is also, anticipating Bouvard and Pécuchet and also Lucy Ricardo, a bundle of what he calls "trade idioms": styles of occupational doing associated with "the financier, the judge, the soldier, the writer, the lawyer, the public prosecutor, the merchant, the banker, the workman, the singing teacher, the dancing master" (32). Yet the nephew links his remarkable fluency in the manners and mores of multiple professions to his own overarching "position" and thus to the economic necessity that mandates it: "The needy man doesn't walk like the rest, he skips, twists, cringes, crawls. He spends his life choosing and performing positions" (82).[51]

If Diderot's eighteenth-century pedagogue/imitator cuts a particularly memorable figure in the history of zaniness, so does the opera buffa character of Figaro, whose aria "Largo al factotum della città" from Rossini's *Barber of Seville* (based on Pierre Beaumarchais' 1775 stage comedy *Le Barbier de Séville* and first performed in Rome in 1816) has become the veritable theme song of zaniness. Well known to several generations in the late twentieth-century United States after unforgettable renditions by Bugs Bunny, Woody Woodpecker, Tom and Jerry, and other *Looney Tunes* characters, the aria with its 6/8 triplets, allegro vivace tempo, and alliterative, tongue-twisting lyrics is not just about work but also famously hard work to perform.[52] These formal features mirror the content of the lyrics, which testify not only to the factotum's "on standby" position and generalized relation to labor ("Pronto a far tutto / la notte e il giorno / sempre d'intorno in giro sta"; "Ready to do everything / Night and day / Always on the move"), but also to his accelerating state of "frenzy" ("Ahimè, che furia!") in attempting to meet all the demands of others ("Tutti mi chiedono, tutti mi vogliono, / donne, ragazzi, vecchi, fanciulle. . . . Pronto prontissimo son come il fulmine: sono il factotum della città"; "Everyone asks for me, everyone wants me / Ladies, young lads, old men, young girls. . . . Swifter and swifter, I'm like a thunderbolt: I'm the factotum of the city").[53] Although we first encounter Figaro working as "barber, wigmaker, surgeon, gardener, apothecary, vet—in short, Jack-of-all-trades" for Don Bartolo, his previous employment as a servant in the household of Count Almaviva is what inspires the count to ask him for help in his

relationship with Rosina (Don Bartolo's ward).[54] The plot Figaro devises to help his old employer in his romance becomes, in effect, the zany plot of *The Barber of Seville,* revolving around this fundamental act of affective or relational labor.

Like opera buffa itself, the history of zaniness can thus be traced further back to commedia dell'arte, the actor-driven, largely improvisational professional theater of sixteenth-century Italy, and its stock character of the zanni (Fig. 32): an itinerant servant, modeled after peasants forced by droughts, wars, or other crises to emigrate from the hills near Milan to Venice in search of temporary work.[55] (As commentators have noted, Beaumarchais's factotum is loosely modeled after a popular zanni variant called Brighella.)[56] Being a temporary and itinerant worker in a household aligned the zanni, interestingly, with the performers in the troupes who played him, since these actors, like the Provençal troubadours Nietzsche invokes as the mascots of *The Gay Science,* were also temporary workers moving from court to court. Zaniness thus begins as a style tied to the artistic representation of a person of a specific historical type: a character

FIGURE 32

defined by a specific kind of labor or relation to labor (Fig. 33). But zaniness also bears a special relationship to the category of character as such—that is, to the mediated representation of real or fictional agents—that I would argue no other aesthetic category shares (Fig. 34).[57] One glimpses this legacy in the fact that "zany" is one of the few aesthetic categories in our contemporary repertoire that can be used as a noun. Indeed, while virtually all our current aesthetic categories, from the beautiful down to the cute, turn in various ways on the objecthood of objects or the thingness of things, our experience of zaniness is often that of a zany person. The zaniness of Diderot's nephew, in particular, suggests that the style evokes a kind of person/character who implodes the concept of character from within, contesting the stability of any formal representation of personhood by defining personhood itself as an unremitting succession of activities. This would in turn explain in Bergsonian terms why the zany,

FIGURE 33

FIGURE 34

a character undermining the very idea of "character" qua "rigidified per-
sonality pattern," is both funny and unfunny at once.[58]

 The radically improvisational, even formless style of doing we call za-
niness thus begins as the style of a kind of person defined by a specifically
nonspecific kind of work: personal services provided in the household on
a temporary basis. It is worth noting here that because commedia dell'arte
troupes had professional actresses in them by around 1560, an aspect of
extradiegetic performance that would have a direct impact on textual/
diegetic matters such as character and plot, the zanni soon had a female
counterpart, the *zagna*, who, like him, would have been placed in the

household of a *vecchio* such as Pantalone in the role of his servant. As Robert Henke notes, the "master/servant agon" central to the plots of commedia dell'arte thus recurs as a division of labor at the level of character system, since in a certain sense the metanarrative task of plotting was delegated to the zanni/zagna, put in charge of finding ways to repair the social relationships damaged by the vecchio's inappropriate amorous pursuits.[59] This relational activity further aligns the fictional character/worker of both sexes with commedia dell'arte actors and actresses, since, as Henke notes, commedia dell'arte troupes frequently assisted with "cross-courtly negotiations" in a northern Italian court system "held together by a delicate network of diplomatic and matrimonial alliances."[60] The association of zaniness with the labor of service continues to inform the concept as it travels from Italian into English, where from the late sixteenth up to the nineteenth century (after which the primary use of "zany" seems to switch from noun to adjective), the term comes to refer primarily to a comic performer, working in the marketplace as the assistant of a more skilled or experienced clown, buffoon, or mountebank, who "imitates his master's acts in a ludicrously awkward way" *(OED)*. Once it comes to designate this second-degree role of mimicking another mime, in English the use of "zany" becomes "almost always contemptuous" *(OED);* as one character puts it in Ben Jonson's *Every Man out of His Humour,* "They despise him, for indeed / He's like a zany to a tumbler / That tries tricks after him to make men laugh" (act 4, scene 1, 85–87). The term comes to connote a "hanger-on, parasite," as in Horace Walpole's description of Boswell's *The Journal of a Tour to the Hebrides, with Samuel Johnson* (1785) as the "story of a mountebank and his zany."[61]

In his recommendations for how the zanni should be played, contemporary commedia dell'arte director Antonio Fava stresses that "zanni, though ragged and blundering, is not a mendicant or freeloader; he is a worker in search of a job. Though he creates disasters, he does not do so maliciously but rather with the best of intentions of a proud and honest worker."[62] Fava wants to emphasize that the labor that defines this comic performer is both real and also serious: real in spite of the supposed intangibility of its end products (affects and social relationships); serious in spite of the association of zanni with, well, zaniness—the boisterous, unruly behavior we associate primarily with shirking, not working. Linking zaniness exactly to the rebellious play of the "mendicant or freeloader" whom Fava contrasts to the "honest worker" above, this far more common contemporary connotation can actually be traced back to yet another division of labor in the commedia dell'arte character system. Henke writes,

"All of Scala's scenarios have one additional male servant, which intro-
duces a dramaturgical distinction at this status level. The so-called sec-
ondo zanni [Arlecchino] contrasts Scala's Pedrolino, or primo zanni, by
performing as a verbal and gestural virtuoso in directions that need bear
no relationship to the primary or supplementary plots."[63] In a thematic
echo of the "structural tension between the linear, well-constructed plot
based on a literary model and the centrifugal improvisations of the
stand-up performer" that gave rise to commedia dell'arte in the first place
(a semiscripted, semiextemporized genre developing at the crossroads of
orality and literacy, Henke argues), it is the secondo zanni who seems to
have become more famous over the centuries, ultimately stealing the spot-
light from the first in the popular imagination. This zanni, often under-
represented in written scenarios precisely because his actions did so little
to further the plot (23), is a "potentially anarchic improviser . . . who
could become a potential obstacle to the very plots his primo zanni col-
league was attempting to promote" (23)—and all the more so since the
secondo zanni was typically a virtuosic "[master] of verbal dilation . . .
[with a] penchant for occult and pseudo-erudite knowledge" (27). Such
"polymath wizardry" is best exemplified, Henke shows us, in "La dottrina
del Zanni," a popular "zanni poem" first published in 1587, which tells
the story of a zanni's journey from the Bergamo hills to Venice, where,
after first feeling awed by the diversity of the crowds, he immediately sets
about learning a wide range of practical and liberal arts: pharmacology,
grammar, music, poetry, philosophy, natural science, and astrology.
This ability to speedily master specialized bodies of knowledge (whether
spurious, scientific, or occult) underlies the spontaneous displays of eru-
dition associated with the secondo zanni and anticipates the spectacu-
larly inexpedient performances of his nineteenth- and twentieth-century
descendants.[64]

Commedia dell'arte thus presents two distinct ways of being zany—the
"honest worker" approach of the primo zanni, with his dutiful plotting
and diplomatic maneuvering; and the "anarchic improvis[ations]" of the
secondo (Henke, 23)—which eventually converge by the late nineteenth
century. From the short-lived but passionate plunges of Flaubert's zanies
into fruit farming, beer making, landscaping, archaeology, geology, his-
tory, child rearing, adult education, and other activities to Lucy's reckless
forays into fashion retail, television marketing, salad-dressing manufac-
turing and distribution, and ballet, to name only a few, zaniness seems to
promote a sense of character as nothing but a series of projects and ac-
tivities.[65] It is precisely this continuous succession of activities that con-
stitutes this aesthetic of action's form. Yet given the rapidity of transition

from one project to the next ("project" itself designating a specifically short-term, transient form of action), the form of zany performance involves a certain deformation of the forms of activity, a certain indifference to their qualitative differentiation. Indeed, for all the devotion of figures like Lucy to the particular task or job of the moment, the final image of action her zaniness produces is one of an undifferentiated, chaotic swirl.

In an early modern public culture defined by a convergence of marketplace and theatre,[66] "zany" thus names a place where occupational and cultural performance already intersect, anticipating the metonymy between character, worker, and actor we saw dramatized in *I Love Lucy*. It is this metonymy that I would like us to keep in mind as I turn to some of the more specific meanings that zaniness acquires in the late twentieth century and the arts of the present.

Post-Fordist Zaniness

Consider the roving provider of a household service whom Jim Carrey plays in the 1996 film *The Cable Guy*. In this dark comedy, the job of the eponymous, late twentieth-century service worker is to get his customers "plugged in": integrated into a technological network that they will not need to understand in order to use. The cable guy is thus a prime example of what Anthony Giddens calls an "access point": a person with specialized knowledge who mediates the relationship between laypeople and modernity's "abstract systems."[67] Since modernity is defined by the fact that "no one can completely opt out" of these systems (which are large and impersonal and do not "answer back"), Giddens describes encounters at access points as "peculiarly consequential," since it is here that the emotion on which modern exchange most depends, trust, is produced via the worker's public display of friendly reassurance (84). Workers at access points could thus be redescribed, using concepts from other sociologists, as "front region" service providers (Erving Goffman) who do "emotional work" (Arlie Russell Hochschild), which Hochschild explicitly invokes Stanislavski to describe in her now-classic study of Delta flight attendants, *The Managed Heart: Commercialization of Human Feeling* (1983), as the production of real affect through "deep acting."[68] Thanks to these performances, regular encounters with the representatives of abstract systems can "easily take on characteristics of friendship and intimacy" (Giddens, 85–86). But "real friendship" at access points is by no means the norm, which is exactly why the system representative's emotional work becomes so "peculiarly consequential." Modernity's access points are not only "points of connection . . . at which trust can be built

up," but also "places of vulnerability" for abstract systems: "Although everyone is aware that the real repository of trust is in the abstract system, rather than the individuals who in specific contexts 'represent' it, access points carry a reminder that it is flesh-and-blood people (who are potentially fallible) who are its operators" (88). Since "bad experiences at access points may lead to a sort of resigned cynicism or disengagement from the system altogether" (90–91), the "demeanor" of the access-point worker requires a careful affective balancing act. For while the "facework commitments which tie lay actors into trust relations [at access points]" involve demonstrations of trustworthiness explicitly associated with friendship, these performances need to simultaneously convey an attitude of 'business as usual' or 'unflappability' " (86), a balance between intimacy and the kind of public detachment Georg Simmel called "reserve."[69]

As the story of a late capitalist zany who takes the simulation of intimacy expected at access points too literally, making increasingly aggressive efforts to really be his client's friend,[70] *The Cable Guy* relates the failure to achieve this balance to the specific kind of labor its main character performs. Everything in the film rests on the conceit of the service provider lacking "reserve" and constantly violating the principle of distance that underlies it, as evinced in the very first interaction between the cable guy and his client Steven (Matthew Broderick). After installing Steven's cable with unappreciated flair, the cable guy offers to educate him about "how this whole thing works" by taking his new "preferred customer" out to the woods at night to see the Cable Company's giant satellite dish (which turns out to be a surprisingly lovely aesthetic experience). Steven politely says, "Sure, we should do that someday," thinking that this will be the end of it. "How about tomorrow?!" brightly shoots back the cable guy. From this point forward, after his official job of getting Steven plugged into the cable network is complete, the zany cable guy, like a living version of Facebook, voluntarily provides his client with the bonus service of social networking, devising complex machinations to keep Steven, recently jilted by his fiancée and extremely depressed, linked to his coworkers, friends, and family, and thus from sliding into an alienated and unproductive stupor in front of his television.

Like Lucy as Ricky's agent, or the zanni/zagna as the vecchio's, the cable guy plots, schemes, and hustles in an unremitting effort to repair Steven's relationships to others when these seem in danger of breaking down. The affective ambiguity of these socializing acts on Steven's behalf comes across most vividly in the film's four scenes of unfun fun: first, a casual basketball game with Steven's coworkers, which the cable guy, the only man to arrive (over)dressed in a uniform, or in what therefore comes to look more like

a basketball-player costume, ruins by overplaying or competing far too enthusiastically, using another player's back to make a slam dunk that shatters the backboard (Figs. 35a-e); second, a mock joust at a fantasy theme restaurant called Medieval Times in which the cable guy, now literally costumed in chain mail and whirling a mace, once again participates much too fervently for Steven's comfort (Figs. 36a-b); third, a karaoke party where, clad in fringed leather and other bohemian accoutrements, and as part of an elaborate scheme to reunite Steven with his estranged fiancée by alleviating his sexual frustration and thus making him seem less needy and more desirable, the cable guy provides Steven with seduction music for his encounter with a prostitute by giving a savagely spectacular performance of Jefferson Airplane's 1970s psychedelic-folk hit "Don't You Want Somebody to Love?" in an adjoining room (Figs. 37a-b); finally, a game of Porno Password after the family dinner in the living room of Steven's parents, where, to Steven's agitation, the cable guy proves himself particularly virtuosic at this game of verbal improvisation—that is, especially skilled at using clues to draw out pornographic words from his partner—when his partner is Steven's fiancée (Fig. 38).

The cable guy is thus "permanently active in a game of construction and deconstruction of relationships" mediated through the category of fun.[71] And the cable guy is zany not just because he performs this affective

a b c

d e

FIGURE 35

a b

FIGURE 36

a b

FIGURE 37

activity but because he cannot seem to stop performing it. As with the Delta Airlines flight attendants interviewed by Hochschild, who spoke of difficulties "coming down" from their deep acting when their shifts ended, the work of producing affects like trust and conviviality that is supposed to be performed routinely by workers at access points spills over into the cable guy's "idle time."[72] Temporally as well as spatially unbounded and thus extremely difficult to quantify, the cable guy's relational work is also free: not financially compensated and willingly given. His activity is thus strikingly similar to both informal caring work in the household (difficult to measure even by the most sophisticated time-based studies, as feminist economists note) and the willingly donated unpaid labor Tiziana Terranova describes as a structural necessity for today's digital economy and for the creation of value on the Internet in particular.[73]

FIGURE 38

Note how this zany performer's passionate commitment to his work entails that he take on multiple short-term roles. It is precisely the cable guy's generic role as "service provider," in other words, that commits him to being a basketball player, a medieval knight, a rock singer, and a party guest, much in the same way Lucy's status as housewife and would-be actor commits her to being an agent, a saleslady, a magician's assistant, and a ballet dancer. All zanies, as Linda Montano's work-themed performances in the 1970s seemed to grasp so presciently, seem to be permanent doers of *Odd Jobs*. We can thus read the very multiplicity of these "temporary" roles—roles linked explicitly to fun and games that the cable guy, like Lucy, seems to play badly but also a little too well—as an index of a significant shift in the early 1970s in the capitalist organization of production which has been described in various and often overlapping ways by analysts from different fields: as a shift from "state-organized" to neoliberal, "disorganized" capitalism; from Fordism or standardized mass production to small-batch, just-in-time, and on-demand post-Fordism; or from Taylorism or scientific management to what McKenzie calls "Performance Management."[74] In a particularly influential study, Luc Boltanski and Eve Chiapello highlight the turn from the industrial "spirit of capitalism" analyzed by Weber to a contemporary, postindustrial spirit.

This new spirit subtends and lends moral support to a capitalism that has adjusted to and absorbed the "artistic critique" of the 1960s—though in a way that highlights the agency of that critique as much as it does capitalism's ability to recuperate it—by now encouraging workers, through a rhetoric of "connexionism," to bring their abilities to communicate, socialize, and even play to work.[75] In contrast to the isolation of workers, the fragmentation of the production process into individualized tasks, and their close supervision in the Fordist/Taylorist factory, the new capitalist work paradigm, which often explicitly draws on artistic analogies (and, as Nancy Fraser points out, a ghostly version of feminist discourse now floating detached from feminist social movements or knowledge formations),[76] places a premium on the autonomy and self-management of workers and emphasizes creativity, communication, and networking as opposed to control. Whatever set of terms used to describe capitalism in its effort to adjust to the economic crises of the early 1970s, analysts agree that the shift is one in which human competences once viewed as outside capital—affect, subjectivity, and sociability—are systematically put to work for the extraction of surplus value (however directly or indirectly). The zany performance of one role after another in *The Cable Guy* points to this new turn in the relations of production as part of a broader set of conditions that have increasingly produced capitalism's ideal worker as already described by Marx: the perpetual temp, extra, or odd-jobber—itinerant and malleable—for whom labor is ultimately made abstract and homogeneous. As new strategies of appropriation expand the sphere of production, the worker's role expands to become a grotesque metarole, one containing all "roles" and thus finally indifferent to their individual specificity.

Although earlier zanies like Rameau's nephew or Woody Woodpecker as the Barber of Seville seem already to reflect this dissolution of the worker into a succession of transient actions—and from that succession of individually distinct actions into a blur or stream of undifferentiated activity—the process reaches a historically significant peak with what Boltanski and Chiapello describe as the "new network morality" of post-Fordist capitalism (463). Under this new code of extraeconomic justifications (for the essential absurdity of capitalism's drive to endlessly increase profit ensures that it will always need some form of extrinsic, specifically moral legitimation), the ultimate standard for judging the worth of persons and things becomes, simply, "activity": "To be doing something, to move, to change—this is what is what enjoys prestige, as against stability, which is often regarded as synonymous with inaction" (155). For Boltanski and Chiapello, it is this "premium on activity, without any clear distinction between personal and even leisure activity and professional activity,"

that most clearly distinguishes the post-Fordist spirit of capitalism from the industrial spirit theorized by Weber, which legitimates itself by maintaining a clear division between working and domestic life (155). Whereas under the old code, the "active" are "quintessentially those who have stable, productive waged work," "activity" under the postindustrial spirit of capitalism becomes exactly what surmounts oppositions between "work and non-work . . . wage-earning class and non-wage-earning class, paid work and voluntary work, that which may be assessed in terms of productivity and that, which not being measurable, eludes calculable assessment" (109). The radically generalized concept of "activity" undermining these oppositions—oppositions historically grounded in and reinforced by the gendered division of labor—also points to a new effort to extract value from subjectivity or "character" itself. "In a connexionist world, the distinction between private life and professional life tends to diminish under the impact of [a confusion] between the qualities of the person and the properties of their labor power," leading to a historically unprecedented difficulty separating "affective bonds" from "useful relationships" (155). This in turn makes "social networking"—the task to which figures like the cable guy, Lucy Ricardo, and Adorno's imaginary "vice-president" seem much more explicitly committed than any of their zany antecedents— flexible neoliberal capitalism's most significant (and significantly hyped-up) activity. As Boltanski and Chiapello write:

> Activity aims to generate *projects*, or to achieve integration into projects initiated by others. But the project does not exist outside the *encounter* (not being integrated once and for all into an institution or environment, it presents itself as an action to be performed, not as something that is already there). Hence the activity par excellence is integrating oneself into networks and exploring them, so as to put an end to isolation, and have opportunities for meeting people or associating with things proximity to which is liable to generate a project. (110)

Although the putting of affect, subjectivity, and sociability to work becomes most concerted with the flexible "project capitalism" of the 1970s, Eva Illouz shows how the ground for this transition was initially prepared by the therapeutic workplace culture pioneered in the 1930s in the United States by Elton Mayo (what she calls "emotional capitalism").[77] More specifically, in the form of what Alan Liu calls the "postindustrial repositioning of leisure within work"[78] or the convergence of occupational with cultural performance that McKenzie describes in *Perform or Else*,[79] it is a development Nietzsche anticipates in *The Gay Science* under the rubric of what he calls "role faith." This is the main subject of the aphorism "How things will become ever more 'artistic' in Europe," one

of the relatively few moments in his writings in which Nietzsche talks explicitly about workers: "Even today, in our time of transition when so many factors cease to compel men, the care to make a living still compels almost all male Europeans to adopt a particular *role,* their so-called occupation. A few retain the freedom, a merely apparent freedom, to choose this role for themselves; for most men it is chosen" (302). Nietzsche continues, "The result is rather strange. As they attain a more advanced age, almost all Europeans confound themselves with their role; they become the victims of their own 'good performance'; they themselves have forgotten how much accidents, moods, caprice disposed of them when the question of their 'vocation' was decided—and how many other roles they might perhaps have been *able* to play; for now it is too late. Considered more deeply, the role has actually *become* character; and art, nature" (302). This difference between role play and role faith recalls a distinction Nietzsche draws in *The Birth of Tragedy* between the "coolness of the true actor," who "cannot blend completely with his images," and the "passionate actor," whose all-too-literal or naturalistic relation to his performing makes him neither Apollonian nor even properly Dionysian.[80] Nietzsche's indictment of the "passionate actor" is part of the text's diatribe against Euripides, who in turn represents how the Socratic impulse toward theoretical reflection in art—the desire to turn art into knowledge as opposed to "metaphysical comfort" about "life"—drives both the Dionysian and the Apollonian out of tragedy (59). The passionate actor no longer relates to these roles as appearances but as plans that he must "execut[e]" or make objectively real. "When I am saying something sad, my eyes fill with tears; and when I am saying something terrible and awful, then my hair stands on end with fright and my heart beats quickly," writes Nietzsche, quoting the "younger rhapsodist" from Plato's *Ion.* He then comments, "Euripides is the actor whose heart beats, whose hair stands on end; as Socratic thinker he designs the plan, as passionate actor he executes it. Neither in the designing nor in the execution is he a pure artist" (83).[81]

In "How things will become ever more 'artistic' in Europe," role playing similarly turns into a rational or instrumental pursuit: "The individual becomes convinced that he can do just about everything and *can manage almost every role,* and everybody experiments with himself, improvises, makes new experiments, enjoys his experiments; and all nature ceases and becomes art" (*The Gay Science,* 303). This playful, improvisational attitude—and the multiplicity, flux, and blurring of art with life that it seems to embrace—is one we might think an advocate of gay science would look on approvingly. With the rise of role faith, however, which Nietzsche describes as an "American" phenomenon spreading like a "dis-

ease" in Europe, another important metamorphosis takes place that he notes "does not merit imitation in all respects": "Whenever a human being begins to discover how he is playing a role and how he *can* be an actor, he *becomes* an actor" (303). As this universal lack of distance gives rise to an "entire society" of actors," "another artistic type is disadvantaged more and more and finally made impossible; above all, the 'great architects.'" Nietzsche elaborates, "The strength to build becomes paralyzed; the courage to make plans that encompass the distant future is discouraged; those with a genius for organization become scarce" (303). Although role faith is thus a development Nietzsche says he "fears," it is also one that fascinates him:[82] "It is thus that the maddest and most interesting ages of history always emerge, when the 'actors,' all kinds of actors, become the real masters" (303).

Role play's evil or zany twin, role faith, finally makes "performing" an object of considerable ambivalence in *The Gay Science* in a way that perhaps accounts for its not-so-gay tone.[83] This ambiguity surrounding performance is central also to *The Cable Guy*, a film about a worker at once excessively immersed in his "role" but also willing to experiment with any. This underscores the economically ambiguous status of his "service" for Steven, especially when we finally discover that the cable guy is not working for the Cable Company—or any company. In other words, although the film's zany is never not working, he is not an employee, making him less significant as an example of a specific class of worker (mental versus manual, blue-collar versus white-collar) than of a relationship to work in general that many researchers describe as increasingly pervasive across—while also sometimes reinforcing—preexisting class and gender divides.

It is this relationship that the Italian New Left has tried to capture in the concept of immaterial labor. Much of this discourse leans heavily on "Results of the Immediate Process of Production" (a text Marx originally intended but finally decided not to publish as the last chapter of volume 1 of *Capital*), in which Marx divorces the "unproductive" labor of actors, servants, teachers, doctors, and priests—labor in which the products are inseparable from the producer and/or her act of producing them—from "productive" labor, since, as Marx here argues, only labor that produces material goods, as opposed to services, can produce surplus value that can be converted into capital or "material wealth."[84] For Maurizio Lazzarato, Michael Hardt and Antonio Negri, and other theorists of the multitude, the term "immaterial labor" and its close relative "virtuosic labor" (as deployed by Paolo Virno in particular) thus refer less to the restructured labor practices in manufacturing and large-scale industry described

by Boltanski and Chiapello, Illouz, Hicks, and Hochschild (in *The Time Bind*) than to cultural and symbolic activities "not normally recognized as 'work' " since, as evinced most clearly in cultural industries and industries organized around the production and management of information, their products are "intangible" things such as "cultural and artistic standards, fashion, tastes, consumer norms, and, most strategically, public opinion."[85] In any case, the affective turn in the management of labor in the late twentieth century ("from controlling workers to empowering them, from giving orders to creating participatory interactions") that Lazzarato and others also invoke "immaterial labor" to index is clearly a politically ambiguous development.[86] Although it has a potentially progressive dimension that it would be foolhardy to deny (should workers *not* put affect or subjectivity into their work?), the new mandate that workers "become subjects of communication," Lazzarato writes, "threatens to be even more totalitarian than the earlier division between mental and manual labor, because [it] seeks to involve even the worker's personality and subjectivity within the production of value."[87]

The term "immaterial labor" risks perpetuating a false equation between "intangible" and "not material," as well as the mistake of regarding the work of those in jobs ranging from data entry to online teaching as intrinsically "unproductive."[88] If organized in a capitalist fashion, as Marx himself points out, using the example of teachers made into "wage laborers of the entrepreneur of the learning factory," any kind of labor can be made to produce surplus value for a capitalist (though not necessarily on a scale significant for society as a whole).[89] Yet the point behind the concept of immaterial labor is rightly not that there is no longer any economically, socially, or politically significant distinction between factory and cultural work, but rather that labor in general around the globe is increasingly marked by a tendency that Virno and Lazzarato find most conspicuous in cultural production and/or the production and management of information (as opposed to, significantly, "women's work"— more on this below): the "putting to work" of affects, relational skills, ordinary know-how, and other basic human capacities for the production of tangible as well as intangible goods.[90]

For the analysis of contemporary zaniness qua aesthetic of production in works like *I Love Lucy* and *The Cable Guy*, this is where things get tricky. The neo-Marxist account of immaterial or virtuosic labor, which is not explicitly gendered because it was not, as it very well could have been, primarily conceived or elaborated on the model of domestic or caring work in the sphere of reproduction but rather, as we have seen, on the model of cultural and artistic production, overlaps considerably with the

feminist account of affective labor, which *was*, and therefore *is*. Both concepts are about activity in which the products are not literally tangible or separable from the act of production; both are intended to highlight the erosion of the line between paid and unpaid labor, as well as capitalism's accelerating efforts to extract value from what Nietzsche calls "life." Both lay emphasis on "labor in the bodily mode," yet one is explicitly gendered, while the other is not.[91] Although Hardt and Negri dutifully cite Hochschild's classic study of emotional work in *Empire* and *Multitude* and fold it into their theory of immaterial labor as value-productive "biopower," they do so in a way that never fully engages with her study's real point; that is, never raising the question of what the feminized status of emotional work (and of the caring work in the reproductive sphere from which it derives) might mean for our understanding of immaterial labor. By never explicitly confronting the economic ramifications of its gender, Hardt and Negri never fully confront the cultural ramifications of the affective dimension of immaterial labor, even as they explicitly theorize the latter as a sign of the radically accelerated influence of culture on the economy (and, of course, vice versa) under late capitalism. Thus, as David Staples notes, "To suggest today, as Hardt and Negri do, that affective labor is *now* hegemonic within the field of class struggle may be correct, but also misleading in a way," since this claim "forgets" the way in which "women's work has long invested supposedly universal (not to mention global) wage and value production not only with energy but with affect and subjectivity too."[92] If the point bears repeating, as Staples notes, it is precisely because reproductive labor—labor that is itself cyclical—is always "cyclically forgotten" (119).

Leopoldina Fortunati, Kathi Weeks, and other feminist researchers have thus traced an alternative genealogy—one in which the affective labor specifically tied to the caring and household practices of women, and also to the jobs in the services sector that the reproductive/productive division of labor helped consolidate and define, plays the leading and exemplary role—of the same late twentieth-century phenomenon Hardt and Negri and others invoke the concept of immaterial labor to explain. This is again the transition from a Taylorized work culture to what Heather Hicks calls "soft work," performed "in an economy sustained by software, soft bodies, and soft management techniques" as opposed to the "industrial machinery, hard bodies, and . . . no-nonsense, command-and-control style of management" that the term "hard work" evokes.[93] Realigning the "signifiers of economic production with those of femininity" by "importing feminine conventions into the mechanics of work itself," as Hicks notes, in the United States this softening of work was made

possible by a series of paradigms privileging "irrationality, intuition, fluidity, faith, and emotion." In addition to the "human relations" movement pioneered by Mayo in the 1930s, these included Lemuel Boulware's effort to "sell" work to workers as an aesthetic commodity in the 1950s and the "self-actualization" theories of psychologist Abraham Maslow, which, as Hicks notes, directly inspired Betty Friedan's liberal feminist claims for paid work as the key to women's empowerment.[94] At the same time, and in a way that suggests that the privileging of cultural production in the neo-Marxist account of immaterial labor is not entirely off, Hicks notes that the softening/informalization/feminization of work was also facilitated by a new forefronting of the idea of work *as* culture, described as "the softest stuff around" in 1982 by what is still the best-selling business book in history.[95]

In the Marxist account of immaterial labor and the feminist account of affective labor, we thus have two concepts that for all their genealogical differences do end up finally covering much of the same territory, since the spheres of production and reproduction from which they were independently theorized have increasingly converged. If feminine conventions associated with caring labor in the reproductive sphere have entered the "mechanics" of productive work, caring labor itself has become industrialized and sold on the global market. This convergence makes the affective/relational work done by contemporary zanies like the cable guy and Lucy—strenuous work that calls for radical fluidity and thus incessant performing in one's self-presentation to others—interestingly ambiguous overall with regard to gender. What is the significance of this work's present-day gender ambiguity for the only aesthetic style in our repertoire that has historically crystallized around it?

Although zaniness did not start out as a particularly gendered aesthetic, since the late twentieth century it has clearly developed into an aesthetic for which gender is at least a question. The shift can be tracked back across several stages. It is with the industrial nineteenth century's hard division between productive and reproductive spheres that the affective/relational work done in unisex fashion by commedia dell'arte's zanies becomes most strongly codified as feminine. But after decades of being slowly phased into the twentieth-century workplace, the cultural association of emotional laboring practices with femininity has not disappeared but has become unstable. This destabilization takes place as a direct consequence of the deterritorialization of affective/relational work and thus, in a counterintuitive way, in tandem with the steady growth in numbers of women in the waged workforce around the globe. Thus although the paradoxically specific kind of nonspecific activity that zaniness has al-

ways encoded was tied in a much more secure way to femininity in the collective imagination of earlier centuries, it is at this very moment in the process of becoming radically generalized across all spheres of work. But this is a generalization that makes gender even more prominent, rather than less so, as an issue for the zany artifacts of our time.

In other words, we are living in a transitional moment in which the type of labor that the zany has always indexed, labor that was not always viewed as especially feminine but that for two centuries has been very much so, is just beginning, slowly but noticeably, to lose its gender specificity. This is due to what Kathi Weeks describes as the "increasing integration of what were imagined as the separate locations of production and reproduction" on multiple fronts: not only the ways in which "processes of production today increasingly integrate the labors of the hand, brain, and heart as more jobs require workers to use their knowledges, affects, capacities for cooperation and communication skills to create not only material but increasingly immaterial products," but also the ongoing and less talked-about transformation of caring and household work practices into "feminized, racialized, and globalized labor in the service sector" while "commodities continue to replace domestically produced goods and services."[96] Under these conditions, as Weeks notes, "social reproduction can no longer be usefully identified with a particular site, let alone imagined as a sphere insulated from capital's logics"—a development that from a feminist perspective has a hopeful as well as an ominous dimension (238). For if, as Fortunati famously argued in the 1970s, the "real difference between production and reproduction is not that of value/ nonvalue, but that while production both *is* and *appears as* the creation of value, reproduction *is* the creation of value but *appears otherwise*,"[97] the fact that production and reproduction are now "more thoroughly integrated in terms of both what is (re)produced and how it is (re)produced" suggests that with the post-Fordist deterritorialization of affective/ relational work, the labor of social reproduction finally seems to stand a chance of appearing as what it really is.[98] The irony is that this possibility emerges at the same historical moment in which "reproduction [can no longer] be identified with a particular gender" (238). In a way that the post-Fordist zaniness of Lucy and the cable guy seems to attempt to negotiate, the situation is thus objectively confusing. Since women and men continue to do different kinds of labor even as affective/relational labor "cuts across the older binary divisions of both space and gender" (with women around the world still remaining primary doers of caring and domestic work, whether paid or unpaid, for example), we are confronted with the "persistence of the gender division of work in a situation in

which the binaries of productive versus reproductive, waged versus un-waged, and with them, 'men's work' versus 'women's work' are increas-ingly inadequate" (239). This confusion about the gender of the kind of affective work zaniness indexes as it increasingly gets done across gender and class divides is producing mixed but strong emotions in both men and women, *which is exactly why gender matters to post-Fordist zaniness* in a way that strikingly distinguishes it from earlier versions of this modern aesthetic. In other words, because of the changes in the social location and cultural status of the affective/relational work it encodes, the *question* of gender becomes internal to post-Fordist zaniness, and this new emphasis on gender *as a point of uncertainty* is exactly what sets contemporary zaniness apart from its earlier incarnations.

Consider Richard Pryor once again as the "toy" in *The Toy*, a sexually charged term for the job of nanny to the spoiled, fun-pursuing scion of a Louisiana millionaire that Vietnam veteran Jack Brown finds himself forced to take after being unable to find work elsewhere during the depths of the 1970s recession. *The Toy* thus unfolds according to a logic that recalls the plot of Richard Wright's radio play "Man of All Work," in which Carl, the male African American protagonist, masquerades as a woman, Lucy, to get hired as a domestic servant for a wealthy white fam-ily.[99] As in the case of being a cable guy or housewife, the job of being nanny/toy requires Jack to play a number of other roles as well: coach, teacher, cook, playmate, newspaper editor, parent. What is the crucial step Jack has to take in order to secure this overarching position, which the film presents as quite explicitly feminizing? Blocked by overtly racist hiring policies from getting the job in investigative journalism for which he has been trained, and in danger of losing his house to the bank by foreclosure, Jack finally applies in desperation to the state unemploy-ment agency, under the name of Jackie, for a job as a "cleaning lady." "Jackie" is then hired by the agency middleman (Ned Beatty), on the pointed condition that "she" shave off her beard, to work as both a cleaner and food server in the household of obscenely rich businessman U. S. Bates (Jackie Gleason). Requiring his purchase of a new skirt, ruf-fled apron, and heels, this hiring of Jack as Jackie (and indeed, only as Jackie), which will eventually lead to his/her rehiring as Gleason's son's nanny and thus to his economic survival, marks the precise moment when the movie starts to get zany. Verbal jokes abound before this mo-ment, but none of the physical comedy for which Pryor is famous. It as if Jack's becoming zany—a process coextensive in this film with his gradual emergence as the virtuoso performer Richard Pryor—were directly predi-cated on a process of his becoming woman (Fig. 39). This is a point the

FIGURE 39

film wants so much to emphasize that it becomes willing to become a bit surreal to do it: are we seriously meant to think that no one at the Bates dinner party notices that the server in the high heels and frilly apron played by the debearded but still mustachioed Richard Pryor is a man?

Becoming zany, at least as imagined in this contemporary film about labor, thus seems to demand an unsubtle confrontation with gender. This also holds true for *The Cable Guy*. Why else would all the affectively imbalanced performances of this unemployed worker—his inappropriately vehement way of responding to the lighthearted challenge of, say, an after-work basketball game—be so urgently aimed at proving his adeptness at stereotypically male competences (competitiveness, sports, fraternal camaraderie)? Why else so much male drag—basketball costume, knight's armor, and other outfits? If we read the competitive "playgrounds" depicted in this film (basketball court, jousting arena) as allegories of the post-Taylorist workplace, the cable guy's efforts at strengthening bonds among men in these specific arenas, as if to mark them *as* specifically male, start to look not just desperate but compensatory. Note that for all the rhetoric of "fluidity" surrounding postindustrial work, the transition in the gender of the activity that the zaniness of these films indexes does not seem exactly fluid itself. Indeed, it is as if to underscore that these

changes in the culture of work are not experienced by male workers as easy to adjust to, but rather as confusing and awkward, that *The Toy* and *The Cable Guy* register them in crudely sexual ways, and thus in a zanier style of comedy.

For a film that deals even more directly with the impact of the post-Fordist turn on prevailing ideas of gender—if one more about zaniness than an example of it—we might finally consider *The Full Monty* (1997). This film tracks the devastating effects of long-term unemployment (including depression, sexual impotence, and suicidal tendencies) as experienced by a group of redundant male steelworkers from Sheffield. The closing of the steel factory, which in the film appears to have employed men only, is pointedly juxtaposed with the rise of new low-paying jobs in services and retail. It is also juxtaposed with the success of a textile factory, staffed entirely by women and supervised by the main character's ex-wife, which seems to have been capable of surviving the post-Fordist turn in a way in which the "male" steel factory could not (Figs. 40a-b).[100] How will the permanently laid-off male workers adjust to all these radical changes in England's former "industrial north" (Fig. 41)? By studying the performance of Jennifer Beals in *Flashdance* (Figs. 42a-b)—not coincidentally also a movie about a butch steel welder turned femme ballet dancer, in which this gendered change in occupation is explicitly facilitated by the intermediary, symbolically transgendered activity of "flashdance"—to become strippers for the entertainment, quite specifically, of women (Fig. 43).[101] Just as unemployed Jack needs to become Jackie in order to finally become a "toy," the solution to the postindustrial labor crisis in *The Full Monty* seems to be a cross between "sex-affective work" and performance art.

a b

FIGURE 40

FIGURE 41

The post-Taylorist workplace is not only a "virtuosic" workplace, lacking boundaries clearly defined by time or space; for the male zanies in *The Toy, The Cable Guy,* and *The Full Monty,* it is clearly also regarded as a feminizing one.[102] Post-Taylorist zaniness thus speaks in a surprisingly direct and even confrontational way to what Antonella Corsani calls the contemporary "'becoming-woman' of labor," a process that involves not only the "setting to work of feminine competences" in a way that comes to affect the very concept of labor (now understood as "activity that produces economic value, goods, and services on the basis of extra-economic human qualities such as language, relationship, ability, and affectivity"), but also a "generalization of specifically feminine conditions to a growing fraction of the active male population: precariousness, instability, and atypical contractual forms will no longer be exclusively the feminine condition, but will encompass all of human activity."[103] Laura Kipnis wryly notes that this is certainly not the kind of gender equality that feminists hoped to achieve; feminism's goal was to end the economic vulnerability of women, not to make men economically vulnerable as well (Fig. 44).[104] In any case the message in *The Cable Guy, The Full Monty,* and *The Toy* is clear: in order to keep earning a wage in the post-Fordist economy, male workers in advanced industrial nations will have to get zany, a process

a b

FIGURE 42

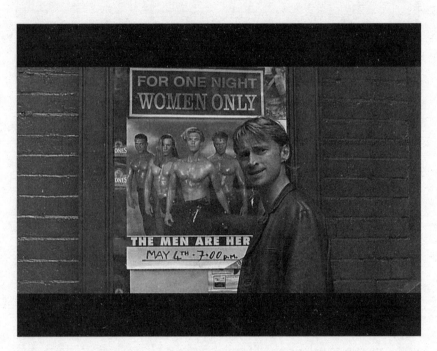

FIGURE 43

that means either overzealously defending masculinity and male homo-
social bonds in public arenas or embracing one's transformation into a
stripper/nanny/toy.[105]

Postwar zaniness in these filmed performances—not coincidentally
performances about the convergence of cultural and occupational
performing—thus encodes strong, if mixed, emotions on the part of men

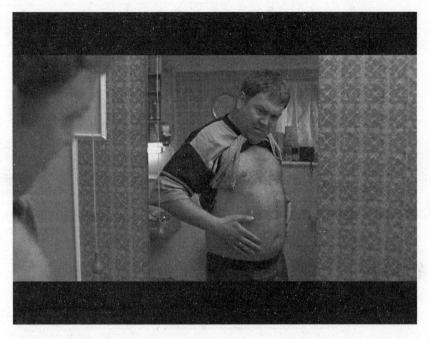

FIGURE 44

about the feminization of postindustrial work. From the other side of the
gender divide, as we can trace across another body of texts, the same style
points to equally strong/mixed emotions on the part of women about
capital's penetration into a set of competences once unambiguously des-
ignated feminine and safeguarded as such by traditional family arrange-
ments that are now showing increasing signs of weakening under the
conditions of global capitalism.[106] A response to shared conditions that
affect women and men differently, female postindustrial zaniness is thus
both like and unlike its male counterpart. One could even argue that it
involves an extra layer of ambivalence. For if an upside of the penetra-
tion of traditionally feminine activity by capital is a loosening of sexual
difference's symbolic hold on work overall (and thus a weakening of the
long-standing use of gender to justify disparities in the economic remu-
neration of work, which in turn reinforces gender-based inequality), a
possible downside for women would be a loss of the ways in which femi-
ninity has also made certain kinds of work culturally meaningful in ways
not entirely reducible to capitalism. Most significantly, female zaniness
not only includes the same mixture of negative and positive feelings about
the feminization of postindustrial work as its male counterpart (where
"feminization" means vulnerability and exploitation as well as a stronger

orientation toward collectivity and empathy), but also awareness that the deterritorialization of affective/immaterial labor across the reproductive/productive divide has not made affective/immaterial work in the household any less strenuous for women.

We have already seen how the zaniness of *I Love Lucy* turns domestic work into performance art in a trajectory that tellingly coincides with the gradual onscreen transformation of housewife and fictional character Lucy Ricardo into virtuoso and professional performer Lucille Ball. In recent comedic work, Karen Finley mobilizes zaniness to emphasize the same intimacy between virtuosic and domestic labor, but in the opposite direction: remaking famous performance artist Karen Finley into a fictional nameless housewife (Fig. 45). I am referring here to the transition Finley makes from being the ferocious live performer she was most famous for being in the 1980s into the less directly confrontational, but no less ferocious, frantically "*sweeping buffing dusting polishing waxing vacuuming baking beating blending chopping grating slicing dicing mix-*

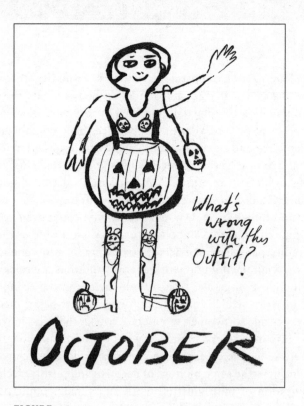

FIGURE 45

*ing making cleaning cooking freezing squeezing peeling blanching boil-
ing broiling roasting broasting simmering steaming sautéing poaching
frying browning burning oiling creaming folding whipping pureeing ic-
ing frosting adding cooking measuring scooping scrubbing stacking sort-
ing starching scalding bleaching folding ironing straightening washing
hemming mending crocheting knitting quilting knotting macrame embroi-
dering sewing needlepointing stitching soaking drying hanging"* protago-
nist of *Living It Up: Humorous Adventures in Hyperdomesticity*,[107] an
artist's book Finley explicitly singles out in her memoir (along with *Enough
Is Enough*, a parody of women's self-help and/or affect-management lit-
erature) as marking an important turning point in her overall career as a
performer (Fig. 46). The mission of *Living It Up*'s constantly alert, "non-
jobless unemployed"[108] protagonist, up by 4 a.m. and ready with a hot-
glue gun, is to help women manage the "guilty [feelings we have] that we
aren't making something out of nothing constantly in our hectic lives" by
finding "projects" in every occasion (94–95): "Have a little extra time?
Knit an entire shamrock to cover your house like a tea cosy!" (32). We
are also energetically urged, in a similarly exclamatory fashion, to labor
at producing a variety of almost all-too-material goods: "Underwear Sa-
chets" out of pine needles shed by a dying Christmas tree, hand-crocheted
sandwich bags for lunches of imaginary children, John Bobbit centerpieces

FIGURE 46

for the dinner table, bathmats out of human hair found in the shower drain (Fig. 47), and our own creatively decorated funeral caskets (Fig. 48). From the point of view of *Living It Up,* the defeminization of affective labor due to its post-Fordist deterritorialization, or movement across the spaces of reproduction and production, clearly has not decreased the intensity of the material as well as immaterial work still primarily done by women *in* the reproductive sphere. Indeed, as Finley's zany's hyperaestheticization of domesticity suggests, it perhaps even increases that intensity, as if the cultural expectations for women's household and caring labor in the home actually get raised *as a direct result* of the latter's migration into an association with post-Fordist, project-oriented "work culture." With its savage glee and vehemently italicized, exclamation-point-riddled prose, *Living It Up*'s particular way of highlighting the link between "women's work" and virtuosic labor *as precisely a link that has made little difference in mitigating the intensity of the former* thus brings out a feature of post-Fordist zaniness that I have not yet mentioned explicitly, but in some ways have been noticing all along: the zany is not just funny but angry.[109]

FIGURE 47

FIGURE 48

One finds this same mix of rage and elation in Laura Kipnis's recent crossover writings on sex, gender, and culture, where zaniness is used to underscore the counterintuitive intensification of affective/immaterial labor in the private or reproductive sphere even after the migration of this labor into the sphere of production would seem to make its status *as* value-producing labor clearer. Self-described as "erratic and overheated," Kipnis's zany tone in *Against Love: A Polemic* is thus explicitly correlated to the book's thematic focus on "private life in post-industrialism" and its transformation of sexual intimacy into the "latest form of alienated labor."[110] In a book that riskily courts a proximity to the romantic self-help genres it derides, *Against Love* celebrates adultery as a kind of style or aesthetic position-taking in its own right: a reckless attempt to "solve" the problem of what Kipnis calls "labor-intensive intimacy" (20), or the way in which late capitalist subjects try to escape the injunction to "work at love" even while knowing that this solution founders on contradiction:

> Yes, we all know that Good Marriages Take Work: we've been well tutored in the catechism of labor-intensive intimacy. Work, work, work; given all the

heavy lifting required, what's the difference between work and "after work" again? Work/home, office/bedroom: are you ever *not* on the clock? Good relationships might take work, but unfortunately, when it comes to love, trying is always trying too hard: work doesn't work. Erotically speaking, play is what works. . . .

 Yet here we are, toiling away. Somehow—how exactly did this happen?— the work ethic has managed to brownnose its way into all spheres of human existence. No more play—*or* playing around—even when off the clock. (18)

It is hardly surprising to see Kipnis's writing get zany in her effort to praise one kind of sex-affective practice (adultery) while condemning another (monogamy). Although only marriage gets singled out by Kipnis as "labor-intensive," it becomes clear that adultery takes just as much effort. Indeed, described in explicitly performative terms, adultery is celebrated and aestheticized not just as a performative style but more specifically as a kind of zaniness: "We players in the adultery drama will be especially beset, madly flinging ourselves down uncharted paths in states of severe aporia" (48). The sex-affective practice of adultery and the aesthetic about sex-affective labor that is post-Fordist zaniness are thus mirror images of each other in *Against Love*. Both are responses to the convergence of work and play that increasingly defines private *and* public life in late capitalism. And both, like Nietzsche's gay science, take the form of incessant experimentation: "Adultery is to love-by-rules what the test tube is to science: a container for experiments. It's a way to have a hypothesis, to be improvisational. . . . Like any experiment, it might be a really bad idea or it might be a miracle cure—transubstantiation or potential explosion" (9).

 Underscoring how affective/immaterial work remains as dominant in the sphere of reproduction even after it crosses the reproductive/productive divide, the "erratic and overheated" style of *Against Love* gets raised to an even higher intensity in *The Female Thing,* a book explicitly about femininity and feminist ambivalence about it. If the zany, like Kipnis's adulterer, is an "especially beset" person, "madly flinging [himself or herself] down uncharted paths in states of severe aporia," in *The Female Thing* this beset person is quite explicitly a woman, bombarded by the interpellating speech acts of "woman-positive" mass culture:

Girls: be thinner, sexier, more self-confident; stop dating creeps; get rid of those yucky zits; and put the pizzazz back in your relationship. Something needs *improving*: your lingerie, your stress levels, your orgasms (or lack of them). Are you in a "toxic friendship"? Is your career in the doldrums? Is your boyfriend lying to you? Why not go organic—eco-chic is hot! Here Are Nine Ways to Reinvent Your Body, Mind, and Social Life—you can do it, all

in your spare time, because you're fabulous. Or can be soon—just stop doubt-
ing yourself. (Self-doubt is *not* attractive.) Take this quiz, buy this amazing
new moisturizing deodorant (underarms get dry, too!), wax your eyebrows:
you'll feel *a lot better* once you do. (9)

If the zaniness of *Against Love* encodes vehement feelings about the re-
framing of sexual intimacy as a project or work, in *The Female Thing* it
registers ambivalence about femininity itself as a temporally unbounded
doing. Femininity, something no woman (or man) can ever stop working
at, is what makes contemporary subjects of gender zany. Since in its ma-
niacal frivolity, Kipnis's parody of the "girlfriend industry" veers unset-
tlingly close to its target (as in the case of *Against Love's* relationship to
romantic advice and self-help literature),[111] *The Female Thing's* gamble is
to see whether women's ambivalent attachment to femininity can be ef-
fectively analyzed through an equally zany feminism.[112]

What this explicitly feminist zaniness also indirectly registers, I suggest,
is the way in which, under the conditions of a neoliberal capitalism whose
"new network morality" bears a disquieting affinity to some of second-
wave feminism's core tenets (the critique of traditional authority and the
family wage),[113] feminism becomes "increasingly confronted with a strange
shadowy version of itself, an uncanny double that it can neither simply
embrace nor wholly disavow," in the form of a "general discursive con-
struct" now largely independent of feminism as a social movement com-
mitted to stamping out gender-based injustice (Fraser, 114). As Fraser
notes, "An offspring of feminism in the first, social-movement sense, this
second, discursive sense of 'feminism' has gone rogue," becoming some-
thing feminists would seem to be the masters of, but that in a deeper sense,
like Rameau's nephew in his relation to his performing, they "no longer
own and do not control" (114).

Certainly there is nothing inherently feminist—or even feminine—
about zaniness. As Kipnis implies, nothing could already be zanier or more
demanding vis-à-vis fun than the "girlfriend industry." Even the Girls
Gone Wild franchise singled out by Ariel Levy in *Female Chauvinist Pigs*
as a prime example of the "raunch culture" currently embraced by younger
women claiming to be sexually empowered is just as zany in its own
right as *Yams up My Granny's Ass* (an early, pre-postfeminist work of
Finley's).[114] The gender politics of postmodern zaniness are thus as am-
biguous as the gender of the aesthetic itself. But to say that the gender
of postmodern zaniness is ambiguous is not to say that it is a matter of
indifference. As both our male and female zanies have shown us, gender
clearly matters to, and becomes an issue for, this contemporary aesthetic
about work, even if the question of the style's own gender is never

resolved.[115] This makes zaniness, if not a feminist or even feminine aesthetic per se, a particularly meaningful aesthetic *for* feminist practice in our present, capturing both what Donna Haraway describes as the "paradoxical intensification and erosion of gender" under conditions of post-Fordism[116] and the compulsion to be fun that has long haunted feminist discourse in the characterological form of the feminist "killjoy" or "heavy."[117] As Lisa Duggan and Kathleen McHugh note in their parody of *The Gay Science,* "In the new millennium, fem(me)inism grapples with the thorniest issues—desire and humor."[118]

> How can these be serious, one might ask, in the face of rampant social injustice, inequality, racism, poverty? But this question of seriousness marks the very place where the enemies of women, of feminists, of racial others, of social justice, of equality have launched effective counter-attacks. Feminists "have no sense of humor," they are "anti-pleasure." (167)

In a Nietzschean prose bristling with italics, exclamation points, and subtitles such as "Why Fem(me) Science Is So Brilliant," Duggan and McHugh attempt to parry these "counter-attacks" by advocating "fem(me) science," a practice that they also immediately dismiss as a "joke": "Make no mistake, fem(me) science is a joke; a howl of laughter that would ridicule and demolish any notion of the feminine that takes itself seriously. Fem(me) science calls for a revaluation of all feminine values; it aims not to explain or instruct, but to evoke and provoke those passions frequently seething under controlled, objective, and didactic prose" (169). This attempt to deal with distinctively feminist as well as distinctively aesthetic problems— "desire and humor"—is also, of course, distinctively zany, marked by the same angry glee or euphoric ferocity as the text by Nietzsche that "fem(me) science" mimics.

On this aesthetically complex note of angry glee, let us close by taking a final look at *The Gay Science* and the affective contradiction its zany style has been noted by so many commentators to embody, one intensified by the work's explicit demand not just for a philosophy that rejects epistemology for aesthetics but for an aesthetics that is truly joyful.

The Zany Science

"Work" is one of *The Gay Science's* briefest aphorisms. It appears in the latter half of book 3, where, like the "Maxims and Arrows" of *Twilight of the Idols,* Nietzsche's aphorisms become radically shorter, giving the impression of rushing at readers with increased speed.

Work.—How close work and the worker are now even to the most leisurely of us!" (¶188, p. 204)

This closeness of work and the worker haunts all of *The Gay Science*. For although its experimental call for "modes of thinking that do not function as knowledge, that do not report and describe and depict, that mean instead to bring new things into the world"[119] is clearly a call for a vigorous aesthetics of production (in explicit contrast to a "feminine" aesthetics of reception, as Matthew Rampley argues),[120] it is by no means a call for an aesthetics of labor. It thus stands to reason that Nietzsche's verbal dart aimed at the modern worker's disquieting proximity to "the most leisurely of us" (an issue we might call the "cable guy problem") is followed quickly by another explicitly on the affective problem of joylessness:

> *Joyless.*—A single joyless person is enough to create constant discouragement and cloudy skies for a whole household, and it is a miracle if there is not one person like that. Happiness is not nearly so contagious a disease. Why? (¶ 239, p. 214)

The worker and the joyless person end up having a more dominant presence in these condensed texts than they would in a longer aphorism, thus reinforcing the theme of unwanted closeness or intimacy that both killjoy figures represent.

As I argued earlier, zaniness stands out among aesthetic categories for the way in which it foregrounds character itself as an aesthetic form.[121] Because zaniness is, at bottom, a style of and about action or doing, it cannot exist without some reference, however oblique or indirect, to an agent or doer. And because it also evokes situations or contexts in which acting or doing becomes precarious (including situations or contexts that may not literally include people, which is why things like wallpaper and pants can be zany), the aesthetic has to make some reference, however implicit, to a living agent endangered by that endangering activity. It is in this sense that the style calls attention to the representation of agents defined entirely by the specific nature of their activity, or by their affective relation to that activity, which is what I mean when I say that zaniness foregrounds the issue of character.

Like all of Nietzsche's texts, *The Gay Science* is packed with representations of human agents that can be sorted into three basic categories: historical figures (Homer, Beethoven, Kant, Wagner, Luther, Shakespeare, Napoléon, Zola, Flaubert), literary/fictional characters (Gil Blas, Hamlet, Baubo, Faust), and most of all, social types and/or stereotypes: actors, socialists, architects, state idolaters, "good men," Germans, Jews, vegetarians,

diplomats, soldiers, Chinese, leaders, Americans, servants, Buddhists, Christians, drunkards, ascetics, Asiatics, metaphysicians, workers, employ- ers, "great-souled men," "scientific women," "herd men," and many others. Although some of these agent-representations are literally characters, all are treated by Nietzsche, in some deep sense, as sociological or historical types. In other words, in Nietzsche's generically hybrid writing, none of these representations—including the fictional characters—can really be said to be characters such as one might find in a film or novel; rather, as bearers of various kinds of meaning used to perform a number of different exemplifying tasks, for Nietzsche they are more like chess pieces or ava- tars. Yet there is still a hierarchy and a division of labor among them, for, as many commentators have noted, the one figure who clearly does the most allegorical "service" for Nietzsche is woman.

To be sure, "woman" always immediately refracts into a multiplicity of types of woman in Nietzsche's writing, as Sarah Kofman, Jacques Derrida, and Kelly Oliver argue. Derrida in particular points to the "quite varied typology of women—the crowd of mothers, sisters, old maids, spouses, governesses, prostitutes, virgins, grandmothers" as evidence for the fact that "there is no one woman" in *The Gay Science*.[122] Yet one could de- scribe the same phenomenon in a different way: there is indeed one woman in *The Gay Science* forced to play an unusual plurality of female roles— and indeed, to perform a succession of strikingly varied theoretical tasks. In contrast to personages like Zola, Hamlet, and herd men, stable bearers of specific and more or less consistent ideas, woman in *The Gay Science* is a flexible, mobile figure on perpetual standby, who can be made to ex- emplify any thesis or value at any moment—including, as Luce Irigaray notes, values that explicitly contradict one another. "Truth or appear- ances, according to his appetite of the instant," as Irigaray writes, "She is—by virtue of her inexhaustible aptitude for mimicry—the living sup- port of all his staging/production of the world."[123] The ultimate mimic and support of the performative mimicry of others, woman is thus, in other words, Nietzsche's zany.

In accordance with how women in *The Gay Science* are both admired and despised for being "actors," this situation would seem to make Nietz- sche's concept of "performing" (and his concept of performing/staging as an act of production, in particular) feminine. Indeed, in a way that goes some distance toward explaining the text's zany/ambivalent affect over- all, woman provides the best example of the "instinctive" or somatically "incorporated" relation to knowledge that Nietzsche explicitly calls for in *The Gay Science* (and that he tries to enact or realize precisely through

his nonepistemological style of thinking, his "antitheory conducted in images, metaphors, similes").[124] This is because woman exemplifies both the "true actor" and the "passionate actor" for Nietzsche. As we saw earlier, the latter term is used in *The Birth of Tragedy* to designate the actor who relates to appearances so seriously that they no longer remain appearances to be beheld but rather become states to be "executed." In other words, the passionate actor (who, like Rameau's nephew, is not regarded as a genuine artist by Nietzsche), loses the distance from appearances that the "true actor" is able to maintain.

This is the case even when the appearance created by the woman/actor is one of "distance" itself, as in the case in "Women and their action at a distance." This aphorism from *The Gay Science* begins by drawing a contrast between two affective states that quickly become assigned to opposing genders: first, a state of embroiled activity, in which the male subject finds himself immersed by the "noise" of life, and a contemplative state of "quiet," in which woman seems to float over the chaos of existence serenely (and disinterestedly).

> All great noise leads us to move happiness into some quiet distance. When a man stands in the midst of his own noise, in the midst of his own surf of plans and projects, then he is apt to see quiet, magical beings gliding past him and to long for their happiness and seclusion: *women*. He almost thinks that his better self dwells there among the women, and that in these quiet regions even the loudest surf turns into deathly quiet, and life itself into a dream about life. Yet! Yet! Noble enthusiast, even on the most beautiful sailboat there is a lot of noise, and unfortunately much small and petty noise. The magic and the most powerful effect of women is, in philosophical language, action at a distance, *actio in distans;* but this requires first of all and above all—*distance*.

Unlike the man's tumultuous "surf of plans and projects," which is real, woman's "quiet" is an appearance or illusion: "Even on the most beautiful sailboat there is a lot of noise, and unfortunately much small and petty noise." What is ambiguous is what Nietzsche's woman's exact relationship to this aesthetic appearance is. Did she deliberately engineer this effect to attract the man? Or was its production unconscious or involuntary? This ambiguity is closely related to the very elasticity of woman's allegorical function in *The Gay Science,* and especially in Nietzsche's discussions of art and truth. At times "woman" is credited for holding what Nietzsche values as the only viable attitude toward "truth," which is a stance of amused indifference: "They consider the superficiality of existence to be its essence, and all virtue and profundity is for them merely a veiling of

this 'truth' " (¶ 64, 125). But at other times, as many commentators have noted, "woman" becomes a metaphor for truth itself, the seductively veiled or "distanced" thing that philosophers (and feminists) fervently want to "grasp" or "attain." In the first case, woman embodies a healthy distance from truth. In the second, she seems to lack distance from truth, for here she *is* truth. Regardless of woman's final position vis-à-vis truth, "truth" in *The Gay Science* is always meant as the opposite of "art." The question whether Nietzsche regards his "zany" as genuinely artistic thus remains open. For even when woman is expressly credited as the producer of feminine appearances and praised for her antiepistemological, explicitly aesthetic or performative relation to "truth" (as will to illusion or power), *The Gay Science* repeatedly denigrates "feminine" aesthetics, including that of male artists such as Wagner, Flaubert, and Zola.[125]

In a way that many are sure to find refreshing, Mary Ann Doane argues that there is no ambiguity for Nietzsche about woman's relation to illusion: "Her dissembling is not a conscious strategy. She has no knowledge of it or access to it as an operation. And this unconsciousness of the woman, her blindness to her own work, is absolutely necessary in order to allow and maintain [Nietzsche's] idealization of her."[126] Doane's reading is not based on *The Gay Science,* but on a moment from the notebooks posthumously published as *The Will to Power,* where Nietzsche does seem quite explicit on the issue. But if we take a closer look at the passage Doane refers to, it becomes clear that woman's dissembling is both "unconscious" *and* "deliberate."

> Given the tremendous subtlety of woman's instinct, modesty remains by no means conscious hypocrisy: she divines that it is precisely an actual naïve modesty that most seduces a man and impels him to overestimate her. Therefore woman is naïve—from the subtlety of her instinct, which advises her of the utility of innocence. *A deliberate closing of one's eyes to oneself—* Wherever dissembling produces a stronger effect when it is unconscious, it *becomes* unconscious.[127]

"Wherever dissembling produces a stronger effect when it is unconscious, it *becomes* unconscious." Note the syntactic similarity of this sentence to the one we encountered earlier describing a similar short-circuiting of the separation between performer and role: "Whenever a human being begins to discover how he is playing a role and how he *can* become an actor, he *becomes* an actor."

The fact that Nietzsche cannot move beyond this triangulation of labor, artistic performance, and gender, although he makes repeated efforts to do so, is in part responsible for *The Gay Science's* zany tone. The best

example of doing gay science, or of relating to "truth" as the experimental creation of masks and appearances, remains the artist or actor; the best example of how this creative relation to truth might become "instinctive" or somatically incorporated still seems to be woman. Yet both figures repeatedly lead back to the figure of the worker, whose "closeness" Nietzsche admits to feeling even in his most lighthearted or leisurely moments. Complicating things further is the fact that it is precisely "involuntariness and necessity" that characterize the creative state for Nietzsche, as Robert Pippin notes, not ironic self-fashioning (111, see also 109–111). In this sense, the image of the actor entirely identified with his role, like woman with her appearances and the worker with his projects, seems to be at once exactly what Nietzsche means by gay science and also its explicit antithesis. By Nietzsche's own account, gay science would seem most embodied in subjects who exist in rather than behind their deeds[128] and thus relate to them in an unconscious, instinctive way, not in a self who fashions his character from a position of ironic detachment, and especially not in a "postmodern" self who is nothing more than a "ghostly back-projection from the roles performed."[129] Perhaps the problem finally boils down, as Paul Patton also suggests, to the fact that the roles that workers, women, and actors seem so fully committed to—the roles that, according to Oliver, they "forget" they create—are in fact not self-created but rather scripted for them in advance (scripted, as Nietzsche explicitly notes about roles for women in particular, by men).[130]

Mimicry and performance thus become objects of clashing feelings for Nietzsche, even as his own texts are "always a matter of adopting personae and 'masks,' often the mask of a historian or scientist" (Pippin, 69). We have already seen Nietzsche's ambivalence about acting as the literal "execut[ion]" of affective states in The Birth of Tragedy (84, 83), and also in "How things will become ever more 'artistic' in Europe," where he is disquieted by the similarity between the actor's willingness to self-experiment and the "role faith" of the modern "American." In a later aphorism in The Gay Science, "On the problem of the actor," Nietzsche hesitates once again on this issue, although he is more specifically disquieted in this case by an overlap between the instincts of the performance artist and those possessed by women and Jews:

> The problem of the actor has troubled me for the longest time. I felt unsure (and sometimes still do) whether it is not only from this angle that one can get at the dangerous concept of the "artist"—a concept so far treated with unpardonable generosity. Falseness with a good conscience; the delight in simulation exploding as a power that pushes aside one's so-called "character," flooding it and at times extinguishing it; the inner craving for a role and

mask, for *appearance;* an excess of the capacity for all kinds of adapta-
tions that can no longer be satisfied in the service of the most immediate
and narrowest utility—all of this is perhaps not *only* peculiar to the actor?
(¶ 361, 316).

Why is Nietzsche compelled to distance himself from the "artist" here, as
"a concept so far treated with unpardonable generosity"? Because the
capacities of the performing artist that Nietzsche admires most—falseness
with good conscience; delight in simulation exploding as a power that
dissolves subjective boundaries; desire or craving for appearance or illu-
sion; an excess of the capacity for adaptation beyond utility—are shared
by types for whom these very same aptitudes do seem to serve utilitarian
ends: "[It] really is high time to ask: What good actor today is *not*—a Jew?
The Jew as a born 'man of letters' . . . is essentially an actor: He plays the
'expert,' the 'specialist' " (317). Next: "Reflect on the whole history of
women: do they not *have* to be first of all and above all actresses?" "That
Jews and women should be thus associated [by their 'histrionic gifts'] does
not seem at all insignificant," says Derrida in *Spurs,* which brilliantly links
the entire question of Nietzsche's style to gender. If we take a closer look
at "On the problem of the actor," however—which famously ends with the
sarcastic pronouncement "Woman is so artistic"—we can see how this
association is facilitated or prepared for by another figure whom Derrida
does not mention.

The very first thing Nietzsche says about the "instinct of adaptability" in
this aphorism is that it is one that "will have developed most easily in fami-
lies of the lower classes who have had to survive under changing pressures
and coercions, in deep dependency . . . always adapting themselves again
to new circumstances, who always had to change their mien and posture,
until they learned gradually to turn their coat to *every* wind and thus virtu-
ally to *become* a coat" (316). With the image of a "coat" that one "be-
comes" suggesting a uniform or livery, Nietzsche hints that it is the servant
who genealogically gives rise to the actor. "Accumulated from generation
to generation," this "lower-class" worker's instinct for wearing a mask, for
quickly adapting and reacting to any situation becomes, like the American
worker's "role faith,"

> domineering, unreasonable, and intractable, an instinct that learns to lord it
> over the other instincts, and generates the actor, the "artist" (the zany, the
> teller of lies, the buffoon, fool, clown at first, as well as that classical servant,
> Gil Blas; for it is in such types that we find the pre-history of the artist and
> often enough even of the "genius").[131]

There is thus an actual "zany" in *The Gay Science*,[132] embedded exactly in the middle of this discussion of the worker/actor relation, but this is not my main reason for citing it. Rather, I want to call attention to the style of the paragraph, which consists of an unusually long and grammatically irregular sentence that involves a strange looping movement. What is being argued, in a "world-historical" sense, is that the servant genealogically gives rise to the type of the actor as the former's instinct for adapting intensifies over time. But in the parenthetical remark that immediately follows, "the actor, the 'artist' " atavistically slides back into "servant." The dramatization of this regression in Nietzsche's prose involves moving us back through a chromatic series of types associated in varying degrees with the theater. In this implicit spectrum of intermediary steps between "artist" and "servant" lie "the zany, teller of lies, buffoon, fool, clown":

> the actor, the "artist" (the zany, the teller of lies, the buffoon, fool, clown at first, as well as that classical servant, Gil Blas [. . .]

But even at this point Nietzsche is not quite done. In a noticeably inexpedient zigzag, even after this dramatization of the intermediary steps by which the "actor, the "artist," might atavistically "degenerate" back into a "servant," we are strangely given another reenactment of the process going in the other direction. Before the parenthesis closes, we are told that it is the "classical servant," or the character of Gil Blas, the zany protagonist of Alain-René Lesage's early eighteenth-century picaresque novel, who is the progenitor of the artist and even the "genius":

> that classical servant, Gil Blas; for it is in such types that we find the prehistory of the artist and often enough even of the "genius."

The effect of this zigzagging back and forth, from the image of servility ("lower-class worker") to that of virtuosity ("the actor, the 'artist' "), back to servility ("classical servant"), and then to virtuosity again ("the 'genius' "), is an image of the synchronic and even recurring interchangeability of "artist" and "servant," even while it is being argued that one gave rise to the other historically. And at the center of the chiasmus indexing this interchangeability is "the zany."

The "lower-class" worker committed to the grotesquely expanded role of performing all roles, like "the 'artist' (the zany)," is thus like the woman described as "so artistic" in the last line of this aphorism on actors. Indeed, the image of the servant as a "coat" turned to a blowing wind points back to the image of the wind-filled "sails"—an image of feminine mystique—

in "Women and their action at a distance." The zany thus returns us once again to a convergence between worker and woman as figures that trouble Nietzsche's admiration for artistic performance in the exact same way. Both raise the question whether performing counts as virtuosity or servility, as leisure or labor; whether it exemplifies an art lightheartedly indifferent to truth or a kind of frenzied "role faith" consonant with various spirits of capitalism. It is easy to see how these uncertainties, inflected with gender as well as nation and religion throughout *The Gay Science*, might account for the book's mixed affective tonality, as reflected in the very aggressiveness of Nietzsche's denunciation in "Leisure and idleness" of those too frenzied by work to be lighthearted: "How frugal people have become regarding 'joy'! . . . More and more, *work* enlists all good conscience on its side; the desire for joy already calls itself a 'need to recuperate' and is beginning to be ashamed of itself" (¶ 329, 259). Thus linking "suspicion of joy" to the "breathless haste with which [Americans] work—the distinctive vice of the new world," which is "already beginning to infect old Europe with its ferocity," Nietzsche continues:

> Even now one is ashamed of resting, and prolonged reflection almost gives people a bad conscience. One thinks with a watch in his hand, even as one eats one's midday meal while reading the latest news of the stock market; one lives as if one always "might miss out on something." Just as all forms are visibly perishing by the haste of the workers, *the feeling for form itself, the ear and eye for the melody of movements are also perishing* (259; emphasis added).

The remarkable last sentence of this passage suggests one final idea about zaniness that we will need to consider: that this aesthetic of nonstop action and movement paradoxically registers a waning of the subject's aesthetic capacity to perceive action and movement *as form*. The phenomenon of zaniness thus indexes a vitiation of the very subjective capacity needed for its own aesthetic appreciation: the "ear and eye for the melody of movements" that, for Nietzsche, amounts to nothing less than the "feeling for form itself."

Under a mode of production that appropriates ever more diverse activities and the social arrangements that subtend them for the extraction of surplus value—to a point at which, from the perspective of both worker and capitalist, the formal distinctions between these activities blur—the rise of this performance-oriented aesthetic thus augurs the gradual effacement of an older kind of aesthetic subjectivity. By this logic, Nietzsche enables us to see how the arrival of a post-Fordist capitalism in which "rigid organizational hierarchies . . . give way to horizontal teams and

flexible networks," in which the transient form of action that is the project comes to dominate our understanding of all action and in which "awareness that [one] project will come to an end is always accompanied by the hope that a new project will follow,"[133] might simultaneously be the aesthetic category of zaniness's climax and vanishing point. If this is true, the historical trajectory of zaniness—the way in which it emerges as a modern aesthetic of action that eventually comes to index its own aesthetic ineffectuality or dissipation—would seem to mirror its internal or formal logic. For zaniness, as we have seen, is a style of acting that reflects a conception of life as a rapid succession of projects as these become immediately dissolved into a undifferentiated stream of activity.

In this manner, Nietzsche seems both right and wrong about the "perishing" of form, or of the subject's aesthetic capacity to perceive movement and action *as* form, under "American" conditions of production. Wrong, because we obviously continue to experience movement and activity, however rapid or anarchic, in an aesthetic or formal manner; we even have a special aesthetic term—"zany"—for our complex "feeling for" this kind of exaggerated activity. Right, because there is something precisely form-obliterating about the form that zany movement and action takes. There is moreover a noticeable waning of the zany itself in the present moment: certainly not as an aesthetic style—as a style of doing or performing one finds zaniness everywhere—but as an aesthetic judgment or verdictive speech act. "Zany" thus seems to be in the process of slowly vanishing from our lexicon of feeling-based evaluations, even as "cute" and "interesting" have come to dominate it. Ironically, this aesthetic category about high-affect performance is noticeably weak as a performative utterance, and particularly deficient in both verdictive and imperative force. And without the affective/performative force of an evaluation or demand— demand for universal agreement on a judgment of value based solely on feelings of pleasure and displeasure—"zany" loses its distinctiveness as an properly aesthetic judgment, becoming rather merely cognitive or descriptive. The aesthetic category of the zany, as such, thus becomes profoundly ambiguous and unstable.

One must therefore at least consider the possibility that postindustrial zaniness is not just an aesthetic about the shrinking distinction between work and play but also the shrinking of an aesthetic capacity caused by it. More specifically, it seems to be an aesthetic not so much about the waning of aesthetic perception as about the waning of aesthetic judgment's role in that perception. We might therefore say that zaniness is an aesthetic about the erosion of an older mode of aesthetic experience or relation to the aesthetic in general, which goes a long way toward explaining why it

can never be purely lighthearted. And why not *The Gay Science*? Because of Nietzsche's ultimate uncertainty here about whether "performing" is truly "artistic," which is an uncertainty he relies on two particular performers to dramatize. In this sense, the zaniness *of The Gay Science* is a style we might attribute to the presence of the zanies *in The Gay Science* and to what these zanies repeatedly direct our attention to: the increasingly ambiguous aesthetic status of "performance" under conditions of capitalist production, as exemplified in a notably precarious way by women and workers.

Afterword

THE CIRCULATION OF INFORMATION, the consumption of commodities, and the becoming-labor of performance lie at the heart of what I have been calling "our" aesthetic categories: certainly not the only noteworthy ones in a postmodern culture marked by a stunning variety of aesthetic styles and terms, but the ones that I would argue offer the most traction for grasping its aesthetic situation as a whole. As I hope to have shown in the preceding chapters, contemporary zaniness, cuteness, and interestingness are, at the deepest level, about performance, commodities, and information. At the same time, by calling forth specific powers of feeling, knowing, and acting in relation to these ordinary, if by no means uncomplicated, "objects," they play to and help complete the formation of a historically specific kind of aesthetic subject: "us."

As performative utterances that come masked as constatives, or intersubjective demands made in the guise of objective, third-person statements, aesthetic judgments produce a kind of illusion in everyday language that mirrors the illusory quality of aesthetic styles, the relatively codified ways in which cultural objects look or appear or seem.[1] This relation of accordance between what aesthetic judgment and style do—create some kind of semblance, whether rhetorical or perceptual—recurs in the case of specific aesthetic categories. To judge something or someone "cute" is to simultaneously eroticize and infantilize that object/person, while cuteness is a style about the sensuous appeal of the infantile. While interesting art is serial or ongoing and comparative and dialogic (as we saw in Chapter 2), to performatively call something "interesting"

(often with an implicit ellipsis, "interesting . . .") is to highlight and extend the period of an ongoing conversation. The judgment of the object as "interesting," with all its glaring conceptual indeterminacy, almost seems designed to facilitate the subject's formation of ties with another subject: the "you" whose subsequent demand for concept-based explanation might be read as the feeling-based judgment's secret goal.[2] In this manner, the function of the interesting as subjective judgment—to foster and prolong dialogue, to circulate information, and to bind subjects together—mirrors the interesting's meaning as objective style.

There is thus a satisfying harmony between the ways in which the cute and the interesting function as objective styles and subjective judgments, a harmony much like the pleasure-producing accord between the form of the object and the subject's capacities for cognition (a "purposiveness" perceived even in the absence of a concept under which to subsume that object) that Kant ascribed to beauty. Yet there seems to be no correlation between the contemporary style and judgment of the zany. The former is nothing if not high-affect, nothing if not shot through with subjectivity and desire. Yet what we do rhetorically when we now call persons or things "zany" seems to be merely to describe them in a detached, neutral, even somewhat dismissive way. It is almost as if the poles of this aesthetic category have somehow been switched: it is the objective style that seems saturated with subjectivity, and the subjective judgment that looks "objective." What are we to make of this asymmetry? Of the failure of style and judgment, aesthetic object and aesthetic subject, to harmonize or accord in the case of this particular aesthetic experience?

If what distinguishes the spirit of post-Fordist "network capitalism" from the spirit of industrial capitalism analyzed by Weber is "a premium on activity, without any clear distinction between personal and even leisure activity and professional activity,"[3] post-Fordist zaniness responds to an integration of "art" and "everyday life" realized very differently from the way in which the modernist avant-gardes imagined it. The role of the radical performing artist becomes particularly uncertain, Guillermo Gómez-Peña suggests, as the turn to personal expression and playful experimentation in the factory and office, in tandem with the rise of affective labor across gender and class divides, gives rise to a kind of ideologically bad zaniness he calls "mainstream bizarre": the mass-popular style of a neoliberal, multicultural age in which performances of "extreme identity" have become the status quo ("Just switch on *Jerry Springer*").[4] The developments Gómez-Peña identifies as forcing the contemporary performance artist to reevaluate his mission may also explain why the low-affect, barely evaluative judgment of the zany seems so strangely disconnected

from the high-affect, vehement style. The world of "mainstream bizarre"—
the same as the one in which one must "perform or else"—seems to be one
in which a hyperbolic dedication to the affective labor of "performing"
seems routinized rather than remarkable, pervasive rather than outra-
geous, and not obviously calling for a passionate response. In Chapter 3
we saw how similar issues trouble Nietzsche, who argues that the style
of frenetic, unstructured doing indexed by zaniness, which he explicitly
links to the accelerating tempos of industrial production, points to a
waning of the modern subject's ability to perceive doing as an aesthetic
form—points, that is, to a shift in the subjective capacities (powers of
feeling, acting, knowing) that define a historically particular kind of aes-
thetic subject or judge. There is a sense, then, in which style and judg-
ment in contemporary zaniness could be said to mirror one another after
all. "Zany" is noticeably weak as a judgment or performative utterance
(which is ironic, given its status as performative style), is noticeably lack-
ing in verdictive affect and force. But one could view this weakness as
precisely in accord with how the objective style of post-Fordist zaniness
qua aesthetic of desperate laboring/performing continually points to the
conditions of its own aesthetic ineffectuality.

The question of discord/accord between objective style and subjective
judgment in the case of a single aesthetic category like the zany is differ-
ent from the question of why certain aesthetic categories seem unevenly
prominent as styles and as judgments in culture. The interesting is cultur-
ally ubiquitous as a judgment but by no means easily or intuitively recog-
nizable as an aesthetic style. As I have just noted, the zany as a style of
desperate playfulness is virtually everywhere but is strangely recessive as
a term of judgment. What are we to make of this disconnection between
the cultural prominence of the two dimensions of our aesthetic categories?
It would seem in any case to raise a question about the role of judgments
or evaluations in aesthetic experience in general. Is aesthetic experience
dependent on appraisal? If the two cannot be structurally decoupled, is
it possible to speak of a historically specific waning of the former's force
within the latter?

The complex, unstable relations between style and judgment in the case
of our aesthetic categories thus bring us to a long-standing debate in the
philosophy of aesthetics. For Kant, for example, aesthetic judgment and
experience are inextricable, while for Nietzsche they have little or noth-
ing to do with each other.[5] Indeed, for Nietzsche, aesthetic experience is
precisely not the evaluation of a spectator but "engaged self- and world-
creation," a willful, performative imposition of value as opposed to a
claim founded on disinterested pleasure aiming at universal validity.[6]

Genette follows Kant in regarding the act of appraisal, in conjunction with what he calls "aspectual attention," as exactly what makes the "aesthetic relation" aesthetic. For Nelson Goodman, in contrast, the feelings that lead to spontaneous acts of appreciation/depreciation in Kant's and Genette's accounts are said to "function cognitively," moving explicitly away from judgments of liking or disliking to do intellectual or analytic work.[7] Although Goodman is by no means a Nietzschean, he is emphatic that the definitive element of aesthetic experience is not evaluation, and he attempts to justify this view by highlighting the overlap between the moods of both aesthetic experience and scientific inquiry; in both cases, "the drive is curiosity and the aim enlightenment."[8]

Whatever side in this debate one takes, both cast the relation between aesthetic judgment and aesthetic experience in binary terms: either evaluation is requisite for aesthetic experience, or it is not. What neither side ends up pondering is whether there might be a spectrum of verdictive force across the range of aesthetic judgments, and whether that degree of verdictive force fluctuates under differing historical conditions. This is a question the aesthetic categories in this study explicitly raise, first and foremost through their equivocality. Whether underwritten by weak feelings or conflicting ones, all three judgments are equally capable of functioning as praise or criticism in a way that is strikingly not the case for other "minor" judgments such as "glamorous" and "dumpy." The cute, the zany, and the interesting thus remind us of the fact (one strangely easy to forget or deny) that aesthetic, feeling-based judgments can include judgments based on mixed or equivocal feelings. Conversely, they also remind us of the way in which this basis in mixed feelings need not exclude judgment from being properly aesthetical—that is, a kind of judgment based on feelings rather than concepts or principles, yet necessarily and even compulsorily expressed in the form of objective, third-person statements, demanding a response from a real or imaginary other.

Yet the rise of the zany, the interesting, and the cute suggests a certain dialing down of the affective force of judgment (if not its total disappearance) in aesthetic experience and discourse in general. Autonomous artworks appear to make judgments of value or quality about themselves (an "appearing" that contributes to their overall aura or apparitional quality) and to make claims about their zaniness, cuteness, and/or interestingness in particular. "I'm interesting," says *Anonymous Sculpture: A Typology of Technical Construction*. "I'm zany!" says *Girls on the Run*. If there is a weakening of the verdictive dimension of postmodern aesthetic experience in general, it is counterintuitively more pronounced in the realm of autonomous art than it is in contemporary mass

culture, where judgments of conviction reign supreme. On reality television, in particular, activities like hairstyling, interior decorating, fashion design, cake making, wedding planning, and the preparation of haute cuisine seem shored up as aesthetic practices precisely by being emphatically and unequivocally judged. Indeed, what the "reality" in "reality television" seems increasingly to signal is this aestheticization of occupational activity, in a perfect marriage of aesthetic conviction with capitalist competition. An image of the sweating, beleaguered performer struggling with her materials and equipment while a clock runs down behind her seems to be a requisite element of all shows regardless of theme, as is, of course, the climactic submission of her output to be evaluated by a "panel of judges" who will determine if she will stay on for the next round.

Conviction is clearly central to the way in which these shows legitimate the artistic standing of para- or quasi-artistic practices. Yet it is difficult not to see the unequivocal appraisals of the dishes prepared or haircuts rendered as an allegorical shadow of the testing/challenging/evaluation of the "performance" of the post-Fordist worker.[9] Aesthetic conviction on reality television—and on reality television it is only judgments of conviction that count—is thus seamlessly merged with judgments of a purely professional or managerial sort. Even if "zany" is not rhetorically strong as an act either of praise or of depreciation, then, as a style it seems to have thoroughly saturated evaluative practice, as if the panoptic monitoring and assessment of the worker under Taylorism were now being offloaded onto a hyperbolically evaluative, judgment-crazy aesthetic culture. Mobilized precisely to aestheticize the evaluation of worker performance simultaneously with the product or work, the strenuous effort to reunite aesthetic experience with conviction on reality television might itself be described as zany.

It thus seems high time to conclude that however much based on weak or equivocal feelings, the zany, the cute, and the interesting are not really "minor" in the sense of being unimportant or marginal. The specific social transformations and/or aesthetic problems to which they intimately speak—the convergence of art and information; the loss of tension between art and the commodity form; the rise of an increasingly intimate public sphere and of an increasingly exchange-based private one; the proliferation and intensification of activity in both public/private domains that cannot easily be dichotomized into play or work—are ones that significantly affect the making, dissemination, and reception of all culture. These three particular categories thus help us totalize the contemporary repertoire of "aesthetic categories"; indeed, they help us understand

the meaningfulness of this very concept for doing aesthetic theory in general.

The best explanation for why the zany, the interesting, and the cute are our most pervasive and significant categories is that they are about the increasingly intertwined ways in which late capitalist subjects labor, communicate, and consume. And since production, circulation, and consumption are not just economic processes but also modes of social organization,[10] our experiences of the zany, the interesting, and the cute are always implicit confrontations with the imaginary publics that these ways of working, communicating, and consuming assume or help bring forth. Each aesthetic category calls up the image of, and invites us to think more deeply about, a social formation playing a prominent role in late twentieth-century debates about the nature of the contemporary: the mass-mediated postbourgeois public sphere, in the case of the interesting; the global multitude and its immaterial labor, in the case of post-Fordist zaniness; and the private or domestic sphere, in the case of cuteness. These modes or spheres of commonality are at once imaginary and real. They happen also to be controversial in a way that mirrors the equivocality of the aesthetic experiences that evoke them.

For example, can the circulation-based public sphere that gave rise to the "interessante" in the late eighteenth century be more than just a "facade of legitimation" in the mass-mediated present?[11] Even before devolving into the mere "publicity" of mass media, what is this collective entity's "degree of reality" in the sense of its ability to affect or transform the agency of other social entities?[12] Similarly, is the so-called multitude, a social formation explicitly underwritten by the concept of "immaterial labor" evoked and problematized by post-Fordist zaniness, an adequate substitute for more traditional ideas of class? Can it rectify, as its neo-Marxist theorists intend, the exclusion of women and unwaged but not nonworking subjects from the global proletariat, when the concept of labor used to support its existence is theorized on the basis of work in the culture industries rather than on women's work in the home?[13] Even if working conditions around the globe seem to make this new kind of megasocial or even post-social formation possible to imagine in ways it could not have been in prior centuries (and the zany comedies we examined in the preceding chapter invite us to imagine it, I argue, precisely by staging confusions about the gender of postindustrial labor), what agency or reality can such a radically dispersed, non-self-conscious collectivity really have?[14] Finally, the domestic realm evoked by cuteness has always been difficult to imagine as a collective agent or agency, even as its ideology, as Ann Douglas argues, proved pivotal in the making of nineteenth-century mass culture itself.[15] The agency/reality of this sphere of social

interaction is even more difficult to assess in a world in which so many of
its affective immaterial practices—from child rearing and care of the
elderly to cooking and cleaning to sex—have long been turned into com-
modities for the global labor market, creating a radical reshifting of fa-
milial organization (and indeed, what feminists call a "care deficit" across
the North/South divide).[16] If the rise of cuteness is a reflection of the sen-
timentalization of the public sphere or the rise of what Lauren Berlant
calls intimate publics, it is thus equally a response to the penetration of
the private sphere by the market, or to what happens when the reproduc-
tion of labor power, traditionally mediated through the institution of the
family and kinship, becomes mediated by the global market for labor
power as well.[17]

In their ability to evoke these images of contemporary commonality,
however controversial or unstable, the zany, the interesting, and the cute
surprisingly behave not unlike the beautiful with respect to Kant's *sensus
communis*. For Kant, the critique of beauty reveals how the faculty of
judgment, unlike any other faculty, presupposes the existence of other
humans in some kind of collective unity. In order to make an aesthetic
judgment, one needs—must somehow already have—a concept of the so-
cial of some sort. Similarly, the judgments/experiences of zaniness, cute-
ness, and interestingness all require and call up an idea of human beings
being with or among other human beings in a very specific way: as workers,
in a class or multitude; as sympathetic caregivers, in a domestic space; as
conversationalists, in a public. There is thus perhaps not as much of a
divide between the Kantian concept of beauty and our aesthetic catego-
ries as one might at first think (as we saw in detail in the chapters on the
cute and the interesting).

At the same time, these categories clearly put pressure on western phi-
losophy's most longstanding, beauty-based accounts of aesthetic experi-
ence in general. With its desire for an ever-closer mingling with its object,
cuteness is a direct violation of the equation of aesthetic semblance with
distance. And zaniness, an aesthetic about the clash between spontane-
ous, goalless play and the end-directed activity of work, obviously poses
a challenge for a theoretical tradition in which thinkers as divergent as
Nietzsche and Kant share, and place at the center of their accounts of art
and aesthetic experience, an idea of play as a "superfluity of energy" un-
yoked to any definitive end. Indeed, although aesthetic theory's long-
standing idealization of art as a symbol of the "lost utopia of unalienated
work" may have been influenced in more direct ways by the discourses
surrounding artisanal craft in criticisms of industrial society by eighteenth-
and nineteenth-century thinkers like Rousseau, Ruskin, and Morris, its
genealogy can be traced much further back (and further forward) to a

discourse defining play as radically indeterminate activity and thus as the antithesis of purposeful effort, from Kant's "free play" of the cognitive faculties (a situation in which the imagination and understanding are released from their normal chores) and Schiller's *On the Aesthetic Education of Man,* in which we find the most explicit and oft-cited equation of the aesthetic with play ("With beauty man shall only play, and it is with beauty only that he shall play"), to Hans-Georg Gadamer's effort to redefine play as an ontological structure or "mode of being of the work of art itself."[18]

The modern concept of "art-as-such," as M. H. Abrams reminds us, became possible only when literature, painting, music, sculpture, and theater were transformed into objects of consumption for a general public in the first decades of the eighteenth century.[19] Although the Greeks could speak of practices like shoemaking and agriculture alongside poetry or painting, "art" in modernity came to refer exclusively to a class of objects made explicitly for contemplation (136). In the subsequent rise of aesthetics as a theoretical discourse about this new type of object—a discourse now focusing on the perceiver's relation to a finished product rather than on the maker's involvement in a work in process, as in the case of Plato's theoretical writing—it is easy to see how aesthetic experience became synonymous with a contemplative "distance." At times what is involved is a spatial remove between perceiver and object, as in the case of Kant on the "safe" distance necessary for our experience of sublime nature.[20] In later, twentieth-century aesthetic theory inspired or informed by modernism, distance increasingly functions as a metaphor for the autonomy of the artwork, as evinced in Benjamin's definition of "aura" as "the unique phenomenon of a distance, no matter how close [the aesthetic object] may be," Adorno's account of the genuine work of art's self-conscious and guilty "separation" from "the social," and Fried's account of the modernist artwork's aloofness or indifference to its audience (an "antitheatricality" it is paradoxically compelled to constantly dramatize).[21] For the most part, however, the distance in aesthetic discourse is intrasubjective distance, referring to the subject's feeling of momentary disconnection from her own interests and desires, from Diderot on the actor's emotional detachment from his role to Freud's account of all art as the sublimation of passion.[22] The most influential account of this sort of mental distance is still, of course, the disinterestedness that underpins Kant's theory of beauty.[23] Cutting the subject off from "the satisfaction which we combine with the representation of the existence of an object" and thus from the link that "interest" provides to desire, no image of detachment has been more central to philosophical aesthetics or more directly violated by the aesthetic categories in this study than disinterestedness.[24]

Can distance, play, and disinterested pleasure—essentially images of freedom rather than compulsion or determination—still be considered reliable "symptoms of the aesthetic," if late capitalist culture's most pervasive aesthetic categories pose such a challenge to each as such? If not, should the aesthetic theory from which they derive be jettisoned? No, but also no. Zaniness not only requires but promotes a sense of remove from the situation of precarity it invokes. There is no experience of the cute without playfulness. And the idea of indeterminate or purposeless activity that underlies play is equally crucial for our experience of the interesting, which, as Schlegel notes, has no "endpoint" or determinate goal. Indeed, the interesting's lack of descriptive specificity strikingly mirrors the conceptlessness of the reflective judgment of beauty as conceived by Kant, while its discursivity and overt reliance on the logic of temporal succession make explicit the dialogism underlying all judgments of taste. Even the cute object's strangely powerful assertion of its powerlessness—its insistent demand for love and protection from a more powerful being nonetheless compelled to fulfill its needs—mobilizes a mix of affects that theorists from Edmund Burke to Elaine Scarry attribute to beauty, characterized by the latter in particular as the experience of something fragile, perpetually in danger of being crushed or destroyed, that for that very reason compels us to copy it.[25] Far, then, from simply mooting a theory of aesthetics based on beauty, or on the sublime in its structural opposition to beauty (as is increasingly the case in postmodern theory), the interesting, the cute, and the zany can in fact shed light on some of this theory's defining problems more vividly, making explicit what the older and more prestigious categories leave implicit or even structurally obfuscate.

Far also from being imperiled, as recent efforts to "rescue" beauty or "recover" the aesthetic might confuse us into thinking, aesthetic experience has come to saturate virtually every nook and cranny of the world that postmodern subjects inhabit. This book has been about aesthetic categories that register this fact—not coincidentally the aesthetic categories that we most frequently use—and that specifically respond to its wide-ranging implications. If "any given distribution of the aesthetic function in the material world is tied to a particular social entity," as Jan Mukařovský writes, the "manner in which this entity deals with the aesthetic function predetermines, in the final analysis, both the objective organization of objects intended to produce an aesthetic effect and the subjective aesthetic reaction."[26] The clunky language of this statement should not distract us from its basic and powerful point. By the way in which a society "deals with" the aesthetic function, Mukařovský simply means the degree of the aesthetic function's "intensive application" by that society, or whether its role is "hypertrophied" or "atrophied" in that society as a

whole.[27] If, in response to the loss of the sacred under conditions of secular, industrial modernity, the eighteenth and nineteenth centuries plunged headlong into a resacralization of the aesthetic, the contemporary moment seems defined by a desacralization of the aesthetic in turn, but a desacralization caused precisely by the aesthetic's hyperbolic expansion.[28] It is the hypertrophy of the "aesthetic function," not its atrophy, that makes the art and culture of the present moment so distinctive. The fact that this historical change can remain unacknowledged by contemporary aesthetic philosophy, or dismissed as marginal or unimportant to the accounts of aesthetic it provides, may have something to do with the discourse's remarkably enduring fixation on the opposition between art and kitsch, an opposition that is certainly not unuseful for theorizing art or for theorizing kitsch, but which often gets explicitly in the way of theorizing *the aesthetic*.

It is therefore aesthetic theory that needs resuscitation in our contemporary moment, not the aesthetic as such. To call attention to the most historically salient aesthetic categories for doing this theory in the present—or more precisely, to the most salient constellation or hierarchy of categories— is not to deny the continued significance of the beautiful and the sublime, or of any other aesthetic categories. It is, however, an effort to respond to the way in which contemporary aesthetic theory's reduction of its purview to the polarity of beauty and sublimity continues to impair its ability to recognize the theoretical significance of "aesthetic categories" as a finite and intensively variegated class, while also curtailing its ability to account for decades of aesthetic practice that have put increasingly direct pressure on its defining concepts and terms. By paying closer attention to the aesthetic categories that speak to the most significant objects and socially binding activities of late capitalist life—our affectively complicated relation to commodities, information, and performing, the ways in which we labor, exchange, and consume—one can at least make a start at closing the gulf between aesthetic theory and practice that began to open in the twentieth century, reenergizing the former by ensuring its continued relevance to the making, dissemination, and reception of culture in the present.

NOTES / ACKNOWLEDGMENTS / INDEX

Notes

Introduction

1. What I mean by "circulation" in this book—the technologically-mediated movement and dissemination of information, discourse, and commodities—overlaps but does not entirely coincide with what Marx means by the term. For Marx circulation is sale, the ceaselessly renewed process in which commodities are exchanged for money and money is exchanged for commodities. Neither production nor consumption, circulation is the "process in which commodities are transformed into prices: their realization as prices." For this reason, "not every form of commodity exchange, e.g. barter, payment in kind, feudal services, etc., constitutes circulation. To get circulation, two things are required above all: *Firstly:* the precondition that commodities are prices; *Secondly:* not isolated acts of exchange, but a circle of exchange, a totality of the same, in constant flux, proceeding more or less over the entire surface of society; a system of acts of exchange." In other words, for Marx, circulation is also the market, a "circle of exchange" mediated specifically by money as its medium or instrument. Karl Marx, *Grundrisse: Foundations of the Critique of Political Economy (Rough Draft),* trans. Martin Nicolaus (New York: Penguin, 1973), 186, 187.

 By "circulation" I do mean to imply (as Marx does) a "system of acts of exchange," where "exchange [appears to stand] between [production and consumption] as formal social movement" (ibid., 89). However, I also mean the term to refer to the kind of movement made possible by systems of transportation and communication, which for Marx actually belong to the sphere of production. For more on Marx's "reasons for classifying the transport industry in the realm of the production of value and surplus value, rather than in that of circulation," see Ernest Mandel's introduction to Karl Marx, *Capital,* vol. 2, trans. David Fernbach (New York: Penguin, 1992), 44–45. See also Marx, *Capital,* vol. 2, 226–227.

For Marx, the structure of exchange/circulation is ultimately determined by the "structure of production" (*Grundrisse*, 99). This, however, does not preclude Marx from speaking of an independent process of circulation. (Indeed, Marx devotes the entire second volume of *Capital* to "The Process of Circulation of Capital" precisely in order to show how only commodity production, and not the realm of circulation or exchange, can create surplus value for capital as a whole [see Mandel, introduction, 42].) Marx writes, "The conclusion we reach is not that production, distribution, exchange, and consumption are identical, but that they all form the members of a totality, distinctions within a unity. Production predominates not only over itself, in the antithetical definition of production, but over the other moments as well. . . . A definite production thus determines a definite consumption, distribution and exchange as well as definite relations between these different moments." Marx then immediately adds the following: "Admittedly, however, in its one-sided form, production is itself determined by the other moments. For example if the market, i.e. the sphere of exchange, expands, then production grows in quantity and the divisions between its different branches become deeper. A change in distribution changes production, e.g. concentration of capital, different distribution of the population between town and country, etc. Finally, the needs of consumption determine production. Mutual interaction takes place between the different moments" (*Grundrisse*, 99–100).

On circulation as a "cultural process with its own forms of abstraction, evaluation, and constraint, which are created by the interactions between specific types of circulating forms and the interpretive communities built around them," see Benjamin Lee and Edward LiPuma, "Cultures of Circulation," *Public Culture* 14.1 (2002): 191–213, 192. For an example of Marxist geography that does in fact refer to systems of transportation and communication as "circulation," see David Harvey, *The Conditions of Postmodernity: An Inquiry into the Origins of Cultural Change* (Oxford: Blackwell, 1989), 23.

2. On the "disappearance or impossibility" of the avant-garde, see Fredric Jameson, *Postmodernism; or, The Cultural Logic of Late Capitalism* (Durham, NC: Duke University Press, 1991), 167.

3. I mention just a few texts that take up these questions in a particularly focused way: art's relationship to the commodity: Theodor Adorno, *Aesthetic Theory*, trans. Robert Hullot-Kentor (Minneapolis: University of Minnesota Press, 1997); the relationship between art and theory or criticism: Jacques Derrida, *The Truth in Painting*, trans. Geoffrey Bennington and Ian McLeod (Chicago: University of Chicago Press, 1987); Friedrich Nietzsche, *The Gay Science*, trans. Walter Kaufmann (New York: Vintage, 1974); Arthur C. Danto, *The Philosophical Disenfranchisement of Art* (New York: Columbia University Press, 1986), especially "The End of Art," 81–115; and Jacques Rancière, *The Future of the Image*, trans. Gregory Elliott (London: Verso, 2007); the effects of the institutionalized basis of artistic production, circulation, and reception on this same relation: Pierre Bourdieu, *The Rules of Art: Genesis and Structure of the Literary Field*, trans. Susan Emanuel (Stanford, CA: Stanford

University Press, 1996); and Philip Fisher, *Making and Effacing Art: Modern American Art in a Culture of Museums* (Cambridge, MA: Harvard University Press, 1997); the ambiguous status of the contemporary avant-garde: Daniel Herwitz, *Making Theory/Constructing Art: On the Authority of the Avant-Garde* (Chicago: University of Chicago Press, 1993); and Paul Mann, *The Theory-Death of the Avant-Garde* (Bloomington: University of Indiana Press, 1991); the link or abyss between aesthetic and nonaesthetic judgments: Immanuel Kant, *Critique of the Power of Judgment,* trans. Paul Guyer and Eric Matthews (Cambridge: Cambridge University Press, 2000); Roland Barthes, *Camera Lucida,* trans. Richard Howard (New York: Hill and Wang, 1981); and Jameson, *Postmodernism.*

4. William Carlos Williams, "This Is Just to Say," in *The Collected Poems of William Carlos Williams,* vol. 1, *1909–1939* (New York: New Directions, 1991), 372; Frank O'Hara, "Personal Poem," in *Lunch Poems* (San Francisco: City Lights, 1964), 32–33; Lee Ann Brown, "Cafeteria," in *Polyverse* (Los Angeles: Sun and Moon Books, 2000), 25.

5. Hannah Arendt, *The Human Condition* (Chicago: University of Chicago Press, 1958), 52.

6. Linda Williams, "Film Bodies: Gender, Genre, and Excess," *Film Quarterly* 44.4 (Summer 1991): 2–13, 2.

7. Theodor Adorno, "Lyric Poetry and Society," in *Notes to Literature,* vol. 1, ed. Rolf Tiedemann, trans. Shierry Weber Nicholsen (New York: Columbia University Press, 1991), 37–54, 51.

8. I owe this point and much of the language in which it is formulated to an extraordinarily helpful communication about this project by Daniel T. O'Hara, e-mail to the author, 10/16/2010.

9. Susan Stewart, *Poetry and the Fate of the Senses* (Chicago: University of Chicago Press, 2002), ix.

10. Walter Benjamin, *Charles Baudelaire: A Lyric Poet in the Era of High Capitalism,* trans. Harry Zohn (London: New Left Books, 1973), 55; cited in Mary Ann Doane, *The Desire to Desire: The Woman's Film of the 1940s* (Bloomington: Indiana University Press, 1987), 32.

11. See Friedrich Schlegel, *On the Study of Greek Poetry,* trans. and ed. Stuart Barnett (Albany: State University of New York Press, 2001); and Kathleen M. Wheeler, ed., *German Aesthetic and Literary Criticism: The Romantic Ironists and Goethe* (Cambridge: Cambridge University Press, 1984), 32–40 and 46–47.

12. Alan Liu, *The Laws of Cool: Knowledge Work and the Culture of Information* (Chicago: University of Chicago Press, 2004).

13. On the interesting as the "measure of tension" between known and unknown, or between "the alterity of the object and reason's capacity to integrate it," see Mikhail Epstein, "The Interesting," trans. Igor Klyukanov, *Qui Parle* 18 (2009): 75–88, 79.

14. Susan Sontag, *On Photography* (New York: Picador, 2001), 111.

15. Ibid. As the reader may have begun to notice, many of the most direct commentators on the aesthetic categories in this study tend not to be fans.

16. Ibid., 174.

17. Liz Kotz, *Words to Be Looked At: Language in 1960s Art* (Cambridge, MA: MIT Press, 2007), 217.

18. Epstein, "Interesting," 78.

19. Thomas Mann, *Doctor Faustus,* trans. H. T. Lowe-Porter (New York: Everyman's Library, 1992), 67. Later in the same conversation, "interest" is described as "love from which the animal warmth has been withdrawn" (68).

20. Ibid., 184; Schlegel, *Athenaeum* #255, in Wheeler, *German Aesthetic and Literary Criticism,* 50.

21. Irving Sandler, "The New Cool-Art," *Art in America* 53.1 (February 1965): 99–101. See also Lawrence Alloway, "Systemic Painting," in *Minimal Art: A Critical Anthology,* ed. Gregory Battcock (Berkeley: University of California Press, 1995), 37–60, 59. Sandler's phrase was widely picked up by critics and artists as a signifier for postwar art in general. As James Meyer notes, an exhibition titled *Cool Art—1967* was held at the Aldrich Museum of Contemporary Art (Ridgefield, CT) in 1968. See Meyer, *Minimalism: Art and Polemics in the Sixties* (New Haven, CT: Yale University Press, 2004), 279n.17. In 2009 an exhibit called *New York Cool: Paintings and Sculpture* from the New York University Art Collection traveled to various sites around the country, including the Bowdoin College Museum of Art (April 17–July 19, Brunswick, ME) and the Hunter Museum of American Art (August 23–October 25, New York).

22. Barbara Rose, "ABC Art," in Battcock, *Minimal Art,* 292; originally published in *Art in America* 53.5 (October/November 1965): 57–69. For a prescient analysis of boredom and interest in the art of the 1960s that focuses on Rose's essay, as well as on criticism by Donald Judd and Michael Fried, see Frances Colpitt, "The Issue of Boredom: Is It Interesting?" *Journal of Aesthetics and Art Criticism* 43.4 (Summer 1985): 359–365. A longer version of this essay appears in Colpitt, *Minimal Art: The Critical Perspective* (Seattle: University of Washington Press, 1993), 101–132.

23. Amanda Anderson, "The Liberal Aesthetic," in *Theory after "Theory,"* ed. Derek Attridge and Jane Elliott (London: Routledge, 2011), 249–261, 259; emphasis added.

24. Ibid.

25. Epstein, "Interesting," 79.

26. Luc Boltanski and Eve Chiapello, *The New Spirit of Capitalism,* trans. Gregory Elliott (London: Verso, 2005), 132; Nancy Fraser, "Feminism, Capitalism, and the Cunning of History," *New Left Review* 56 (March–April 2009): 97–117. For both Fraser and Boltanski and Chiapello, the fact that capitalism finds itself forced to adjust to these critiques in the first place points as much to the critique's power as to its susceptibility to co-optation.

27. "Books: Come Back, Brothers Grimm," *Time,* May 26, 1967, http://www.time .com/time/magazine/article/0,9171,843848,00.html (accessed 1/15/2011); excerpted on front cover of Donald Barthelme, *Snow White* (New York: Scribner Paperback Fiction, 1996).

28. David Foster Wallace, "Mister Squishy," in *Oblivion: Stories* (New York: Little, Brown and Company, 2004), 3–66, 4.

29. Lori Merish, "Cuteness and Commodity Aesthetics: Shirley Temple and Tom Thumb," in *Freakery: Cultural Spectacles of the Extraordinary Body,* ed. Rosemarie Thomson (New York: New York University Press, 1996), 185–203, 186. This fine essay, which I regret to have only discovered late in the writing of this book, anticipates some of the points I make in this introduction and Chapter 1, though with a more specific emphasis on the relationship between white cuteness and the abjection of blackness in nineteenth-century American sentimental culture.

30. Thomas Pynchon, *The Crying of Lot 49* (New York: Harper Perennial Modern Classics, 1999), 52, 58.

31. The zany was a particularly prominent figure in early American alphabet primers, as Pat Crain shows in her study of these elementary vehicles of socialization, *The Story of A: The Alphabetization of America from "The New England Primer" to "The Scarlet Letter"* (Stanford, CA: Stanford University Press, 2000). I am grateful to Jacquelyn Ardam for the reference.

32. Pynchon, *Crying of Lot 49*, 51.

33. Nikolas Rose, *Governing the Soul: The Shaping of the Private Self* (London: Free Association Books, 1999), 70–71.

34. Ibid., 119.

35. The literature on this trend is now fairly extensive. See, for just a few examples, Arlie Hochschild, *The Managed Heart: Commercialization of Human Feeling* (Berkeley: University of California Press, 1983); Hochschild, *The Time Bind: When Work Becomes Home and Home Becomes Work* (New York: Henry Holt, 2001); Heather Hicks, *The Culture of Soft Work: Labor, Gender, and Race in Postmodern American Narrative* (London: Palgrave Macmillan, 2009); Eva Illouz, *Cold Intimacies: The Making of Emotional Capitalism* (Malden, MA: Polity Press, 2007); David Staples, *No Place like Home: Organizing Home-Based Labor in the Era of Structural Adjustment* (New York: Routledge, 2006); and Boltanski and Chiapello, *New Spirit of Capitalism*. See also Chapter 3 in this volume, "The Zany Science." For every critical/historical book on the affective turn in postindustrial labor, there is one in the business and management literature on how to harness it. See, for example, Marian Izatt-White, *Leadership as Emotional Labour: Managing the Managed Heart* (London: Routledge, 2011); and Martyn Newman, *Emotional Capitalists, the New Leaders: Essential Strategies for Building Your Emotional Intelligence and Leadership Success* (San Francisco: Jossey-Bass, 2008).

36. Merish, "Cuteness and Commodity Aesthetics," 186. When imagined as an actively desiring agent as well as a passive site for the projection of our own desires, the cute object evokes this description of the snack-cake icon in Wallace's "Mister Squishy": a "plump childlike cartoon face of indeterminate ethnicity with its eyes squeezed shut in an expression that somehow connoted delight, satiation, and rapacious desire all at the same time." Wallace, "Mister Squishy," 4.

37. Jan Mieszkowski. *Labors of Imagination: Aesthetics and Political Economy from Kant to Althusser* (New York: Fordham University Press, 2006), 115.
38. Ibid., 136.
39. What this in turn means, Mieszkowsi suggests, is that there is a paradoxical sense in which "interest always works against the logic by virtue of which it could appear as the expression of a given desire or end" (ibid., 136). Strange as it may seem to speak of "interests" as counterinterests without referring to the particular agendas of individuals or groups (since interests seem intrinsically "particular"), Mieszkowski shows how in Schlegel's account of the interesting, these references to conflict can co-exist with a lack of subjective determination and also with a certain kind of endlessness.
40. This rather excellent phrase is Jon McKenzie's. See his *Perform or Else: From Discipline to Performance* (London: Routledge, 2001).
41. My thanks to Christian Thorne for stressing this via the example of MTV's *Jackass*.
42. I am grateful to Sam See for pointing this out. Thanks also to Petra Dierkes-Thrun for a similar observation.
43. "Glorification of character": Susan Sontag, "Notes on 'Camp,'" in *Against Interpretation* (New York: Picador, 2001), 285.
44. Sontag, "Notes on 'Camp,'", 285; cited in George Baker, "The Other Side of the Wall," *October* 120 (Spring 2007): 106–137, 130.
45. Ibid.
46. Put most simply, the camp performer tends to be the author of the joke, whereas the zany performer can only be its object.
47. Merish, "Cuteness and Commodity Aesthetics," 187.
48. Marx, *Grundrisse*, 89; cited in John Guillory, *Cultural Capital: The Problem of Literary Canon Formation* (Chicago: University of Chicago Press, 1993), 319.
49. "Absolute commensurability of everything": Guillory, *Cultural Capital,* 323.
50. Although this tendency has been observed by diverse commentators (feminist sociologists, affect theorists, Marxists), one of its best-known formulations, under the rubric of "general intellect," is by Paolo Virno. See Virno, *A Grammar of the Multitude: For an Analysis of Contemporary Forms of Life,* trans. Isabella Bertoletti, James Cascaito, and Andrea Casson (New York: Semiotext[e], 2004).
51. Paul Mann, *Theory-Death of the Avant Garde,* 21.
52. Raymond Williams, "The Means of Communication as Means of Production," in *Culture and Materialism: Selected Essays* (London: Verso, 2006), 50–66, 50.
53. Herbert Marcuse, *One-Dimensional Man: Studies in the Ideology of Advanced Industrial Society,* intro. Douglas Kellner (Boston: Beacon Press, 1991), 80–81.
54. Robert Henke, *Performance and Literature in the Commedia dell'Arte* (Cambridge: Cambridge University Press, 2002), 23.
55. Mary P. Ryan, *The Empire of the Mother: American Writing about Domesticity, 1830–1860* (New York: Haworth Press, 1982), 36–37; cited in Bonita

Rhoads, "Poe's Genre Crossing: From Domesticity to Detection," *Poe Studies* 42 (2009): 14–40, 14; Ann Douglas, *The Feminization of American Culture* (New York: Avon/Knopf, 1978).

56. Harvey, *The Conditions of Postmodernity*, 23.

57. Henry James, "The Art of Fiction," in Walter Besant and Henry James, *The Art of Fiction* (Boston: Cupples, Upham, and Company, 1885), 60.

58. Mikhail Bakhtin, "Discourse in the Novel," in *The Dialogic Imagination: Four Essays,* ed. Michael Holquist, trans. Caryl Emerson and Michael Holquist (Austin: University of Texas Press, 1982), 260; Gilles Deleuze and Félix Guattari, "Percept, Affect, and Concept," in *The Continental Aesthetics Reader,* ed. Clive Cazeaux (London: Routledge, 2000), 465–488, 469.

59. Rita Felski, *Beyond Feminist Aesthetics: Feminist Literature and Social Change* (Cambridge, MA: Harvard University Press, 1989), 84.

60. But surely what 'interesting' meant to Schlegel in the 1790s is categorically different from what it meant to James a century later! Given the differences in national and historical context, how can you assume the two to be instances of the same aesthetic category, as opposed to qualitatively different categories only superficially designated by the same word?" Or: "Surely the agitated style of doing that you refer to as 'zany' in *Rameau's Nephew, The Gay Science* and *I Love Lucy* cannot be individual instances of the same style. Are you not projecting the late twentieth-century zaniness of Lucille Ball's comedy back onto the older artifacts, thus violating their historical/cultural particularity?

 Let me address the criticism of this imaginary interlocutor (not a straw man, because his questions are quite legitimate). The "historical/cultural particularity" that would automatically require a late eighteenth-century German literary critic and a late nineteenth-century American literary critic to be treated in isolation from each other often seems presupposed rather than justified (and often is invoked in a way that seems to feel no need to justify itself). It should also be noted that the proper objects of my study are precisely not these individual authors or artifacts but rather the aesthetic category of the interesting (and the zany and the cute). Moreover, in response to the idea that the shared use of "interesting" by figures like Schlegel and James is mere verbal coincidence, indicative of the imprecision of ordinary language rather than of a substantive meaning or problem under historical transformation, I am tempted to offer something along the lines of Austin's mild response when confronted with "loose usage" as a critique of the entire enterprise of linguistic philosophy: "People's usages do vary, and we do talk loosely, and we do say different things apparently indifferently. But first, not nearly as much as one would think." See J. L. Austin, "A Plea for Excuses: The Presidential Address," *Proceedings of the Aristotelian Society* 57 (1956–1957): 1–30, 9. A stronger response from a *longue durée* perspective is that the contexts of Schlegel and James's different theorizations of the interesting, or even Nietzsche's and Ball's enactments of zaniness, are not really all that different.

61. For as Althusser would argue, these concepts have histories that intersect with the histories of concepts in science, economics, politics, religion, and all the other various base and superstructural "levels," each with a "relative autonomy and independence . . . based on a certain type of articulation in the whole, and therefore on a certain type of dependence with respect to the whole." Louis Althusser and Étienne Balibar, *Reading "Capital,"* trans. Ben Brewster (London: Verso, 2009), 111; cited in Joshua Kates, "Period and Rupture; or, Le Tombeau de Louis Althusser" (unpublished manuscript), 1–35, 8.

62. Jacques Rancière, "Lyotard and the Aesthetics of the Sublime: A Counter-reading of Kant" in *Aesthetics and Its Discontents,* trans. Steven Corcoran (Malden, MA: Polity Press, 2009), 88–106, 97.

63. Ibid., 92.

64. Although cuteness and zaniness are prime examples of commercial aesthetics, they are also clearly central to the aesthetics of the postwar avant-garde. Lyotard's way of "saddling the avant-garde with the task of safeguarding artistic novelty against forms of reversion to outmoded expressions and compromises with commercial aestheticization"—as Rancière acerbically puts it, describing this move as "either the law of Moses or that of McDonald's" (ibid., 105)—thus seems to have taken place in a strange vacuum, as if things like pop art never happened.

65. Jean-François Lyotard, *Lessons on the Analytic of the Sublime,* trans. Elizabeth Rottenberg (Stanford, CA: Stanford University Press, 1994), 68. Jacques Rancière provocatively argues that the experience of beauty, as theorized by Kant and Schiller, partakes of the same oscillation: "It is not necessary to go looking in the sublime experience of size, power, or fear to discern a disagreement between thought and the sensible or to ground modern art's radicality in the play of attraction and repulsion. The experience of beauty, which is apprehended by Kantian aesthetic judgment in terms of a *neither . . . nor . . .* [in that the judge is 'subject neither to the law of the understanding, which requires conceptual determination, nor to the law of sensation, which demands an object of desire'], is already characterized by the double bind of attraction and repulsion. It consists in a tension between two opposed terms, namely a charm that attracts us and a respect that makes us recoil. The statue's free appearance, says Schiller, simultaneously draws us in with its charm and keeps us at a distance through the sheer majesty of its self-sufficiency. This movement of contrary forces at the same time puts us in a state of utter repose and one of supreme agitation. There is then no rupture between an aesthetics of the beautiful and an aesthetics of the sublime. Dissensus, i.e. the rupture of a certain agreement between thought and the sensible, already lies at the core of aesthetic agreement and repose." Rancière, "Lyotard and the Aesthetics of the Sublime," 97–98.

This is a bold but not a particularly convincing argument. My sense is that Rancière's dispute with Lyotard's "subliming" of the sublime, as it were (and his critique of what he takes to be Lyotard's peremptory dismissal and/or caricaturing of beauty), is pushing him to overexaggerate what he calls "agitation." This is certainly not the way Kant describes the pleasure of the beau-

tiful in the *Critique,* which makes no reference to "recoil" or "repulsion" and is explicitly not derived from the judgment of an autonomous or auratic work of art. In any case, the "double bind of attraction and repulsion" in this extremely willful reinterpretation of Kantian beauty is not the same as the clash of contrasting emotions in our experience of the zany. Most important, the judgment of beauty, even when aggressively reinterpreted in the way Rancière does above, remains unequivocally positive in its axiological charge. To judge something beautiful is to praise it. This is not the case for the aesthetic categories in my study.

66. Kant, *Critique of the Power of Judgment,* 140. Edmund Burke, *A Philosophical Enquiry into the Origin of Our Ideas of the Sublime and Beautiful,* ed. Adam Phillips (Oxford: Oxford University Press, 1990), 47.

67. Jan Mukařovský, *Aesthetic Function, Norm and Value as Social Facts,* trans. Mark E. Suino (Ann Arbor: Department of Slavic Languages and Literatures, University of Michigan, 1970), 38.

68. Hal Foster, *Design and Crime: And Other Diatribes* (London: Verso, 2002), 17.

69. "Neo–Art Nouveau world of total design": ibid., 25. Jacques Rancière, "The Aesthetic Revolution and Its Outcomes: Emplotments of Autonomy and Heteronomy," *New Left Review* 14 (March–April 2002): 133–151, 139–140. See also Rancière, *Future of the Image.*

70. "Aestheticization of common life": Rancière, "Aesthetic Revolution and Its Outcomes," 147.

71. "Global art system": Julian Stallabrass, *Contemporary Art: A Very Short Introduction* (Oxford: Oxford University Press, 2004), 28; Geoff Dyer, *Jeff in Venice, Death in Varanasi* (New York: Pantheon, 2009).

72. Friedrich Schiller, *On the Aesthetic Education of Man in a Series of Letters (English and German Edition),* trans. and eds. Elizabeth. M. Wilkinson and L. A. Willoughby (Oxford, UK: Oxford University Press, 1983), 109; cited in Rancière, "Aesthetic Revolution and Its Outcomes," 133. Schiller is speaking specifically of play, which he regards as capable "of bearing the whole edifice of the art of the beautiful and of the still more difficult art of living."

73. Thomas Crow, *Modern Art in the Common Culture* (New Haven, CT: Yale University Press, 1996), 77.

74. This is Crow's paraphrase of Greenberg, ibid., 76).

75. Ibid., 35.

76. Ibid., 215.

77. Jameson, *Postmodernism,* 4.

78. Ibid., 146–147, 121–122.

79. Hal Foster, *Design and Crime,* 25.

80. To put this another way, the cute, the interesting, and the zany are incapable of reinforcing the "hubris of art as a religion" in the way the sublime and beautiful frequently do. See Adorno, *Aesthetic Theory,* 197; quotation in main text is from the same page. See also Joseph Tabbi, *Postmodern Sublime: Technology and Writing from Mailer to Cyberpunk* (Ithaca: Cornell University Press, 1995); Bruce Robbins, "The Sweatshop Sublime," *PMLA* 117 (Jan 2002): 84–97; Amy Elias, *Sublime Desire: History and Post-1960s Fiction*

254 NOTES TO PAGES 22–24

(Baltimore and London: The Johns Hopkins University Press, 2001); Fredric Jameson, *The Geopolitical Aesthetic: Cinema and Space in the World System* (Bloomington: Indiana University Press, 1995). The sublime is a rare aesthetic experience, not an everyday one; one whose very significance resides in the fact that its intense feeling cannot be felt or sustained for long. Indeed, as Robbins in particular suggests, the fact that the experience of the sublime must be infrequent and fleeting is precisely what gives it its pathos (one in which intense feeling leads to a diminished sense of social agency) and makes it so well-suited for capturing the paradoxes and antiomonies that confront postmodern representation overall. By definition, the sublime is not an aesthetic that can be diffused, as the aesthetic categories in this study are, into the pores of culture. Thus while the sublime does "get at" something true and important about representation in postmodernity, its prominence and ubiquity in postmodern culture (as opposed to the more restricted realm of postmodern theories of culture) has perhaps been slightly exaggerated.

81. Fredric Jameson, *Archaeologies of the Future: The Desire Called Utopia and Other Science Fictions* (London: Verso, 2005), xv.

82. Ibid.

83. Epstein, "Interesting," 79. This makes the interesting, oddly, not unlike the Kantian sublime, which also involves two "phases" of subjective response (awe or fear followed by an "inspiriting" satisfaction about the subject's capacity for reason in its ability to mitigate that initial feeling of awe or fear).

84. Accordingly, when in a use of "zany" that was singled out by the mainstream media and given an unusual amount of attention *as* a politically significant, newsworthy use of language, Mitt Romney called Newt Gingrich "zany" during the race for the 2012 Republican nomination, it seemed a canny way to both discredit a political antagonist *and* to lightly dismiss him, on aesthetic grounds in both cases, as ultimately weak and unthreatening or "fun": "Zany is great in a campaign. It's great on talk radio. It's great in print, it makes for fun reading But in terms of a president, we need a leader, and a leader needs to be someone who can bring Americans together." Jeff Zeleny and Ashley Parker, "Romney Warns of Nominating 'Zany' Gingrich," *New York Times*, December 14, 2011. http://www.nytimes.com/2011/12/15/us/politics/changing -tack-romney-calls-gingrich-zany.html?_r=1 (accessed 12/14/2012]). Yet, ironically, Romney's very use of the evaluation "zany" (and simultaneous invocation of its maniacal and frivilous style) was *itself* perceived by the media as rhetorically weak and ineffectual—and also as anachronistic. As one journalist blogger put it, "Using "zany" is quintessential Romney—he's a little old fashioned and he could have chosen a much harsher word." Jennifer Rubin, "Morning Bits," 12/14/2011. http://www.washingtonpost.com/blogs/right-turn/post/ morning-bits/2011/12/14/gIQAcbdmuO_blog.htmlw (accessed 12/15/2011). I thank D. A. Miller for emphasizing the synonymy between "zany" and "crazy."

85. Rancière, "Lyotard and the Aesthetics of the Sublime," 97.

86. Natalie Angier, "The Cute Factor," *New York Times*, January 3, 2006. http://www.nytimes.com/2006/01/03/science/03cute.html?pagewanted=all (accessed 1/16/2012).

87. Denis Dutton, interview cited in Angier, "Cute Factor."
88. Merish, "Cuteness and Commodity Aesthetics," 201.
89. Here I am applying an argument Jennifer Fleissner makes specifically about the sentimental. Jennifer Fleissner, *Women, Compulsion, Modernity: The Moment of American Naturalism* (Chicago: University of Chicago Press, 2004), 166.
90. *The American Heritage® Dictionary of the English Language,* 4th ed., s.v. "zany," www.thefreedictionary.com/zany (accessed 7/21/2011).
91. This fact is all the more striking given how much illocutionary force the term actually has; to call something "interesting"—singling it out for one-self or others as an object of attention—is often the first and most crucial step in making it so. Lydia Davis, *Samuel Johnson Is Indignant: Stories* (New York: Picador, 2002), 1.
92. I am grateful to Franco Moretti for suggesting this.
93. Epstein, 82.
94. Jan Clausen, "My Interesting Condition," *The Journal of Sex Research* 27 (1990): 445–459, 453 ("euphemism"), 446 ("technically irreproachable"). Clausen's essay was originally published in *OUT/LOOK* 7, Winter 1990.
95. Mieszkowski, *Labors of Imagination,* 25. Yet for Kant, a judgment based on any sort of comparison, which would require apprehending the object in its generality, would not count as a genuine judgment of taste at all.
96. Martin Heidegger, *What Is Called Thinking?* (New York: Harper and Row, 1968), 5; cited in Epstein, "Interesting," 86.
97. Fleissner, *Women, Compulsion, Modernity,* 166.
98. Ibid.
99. Mieszkowski, *Labors of Imagination,* 158.
100. I have borrowed the "turnstile" metaphor from D. A. Miller, *Jane Austen, or, The Secret of Style* (Princeton, NJ: Princeton University Press, 2003), 59. "Symptoms of the aesthetic": Nelson Goodman, *Languages of Art: An Approach to the Theory of Symbols* (Indianapolis: Hackett, 1976), 252.
101. I am indebted to Ken Reinhard for this observation.
102. On the split between genius and taste, see Giorgio Agamben, *The Man without Content,* trans. Georgia Albert (Stanford, CA: Stanford University Press, 1999). Precisely because Kant is one of Agamben's primary culprits for producing this ideological split between maker-oriented and spectator-oriented aesthetics, it needs to be stressed that the contrast between genius and taste in the *Critique of the Power of Judgment* is by no means as straightforward as Agamben makes it seem. For Kant, genius requires taste, as Hannah Arendt underscores: "Kant says explicitly that 'for beautiful art ... *imagination, intellect, spirit,* and *taste* are required, and he adds, in a note, that 'the three former faculties are united by means of the fourth.' " Hannah Arendt, *Lectures on Kant's Political Philosophy,* trans. Ronald Beiner (Chicago: University of Chicago Press, 1982), 62, italics in original. For this reason, Arendt argues, for Kant, "The public realm is constituted by the critics and spectators, not by the actors and the makers. And this critic and spectator sits in every actor and fabricator; without this critical,

judging faculty the doer or maker would be so isolated from the spectator that we would not be perceived" (63).

103. Peter Rand, "Double Rainbow/Donald Judd Mashup" (2010), vimeo .com/14081289 (accessed 8/16/2011).

104. Hannah Arendt, "Labor, Work, Action," in *The Portable Hannah Arendt,* ed. Peter Baehr (New York: Penguin Classics, 2003), 178.

105. James S. Ackerman, "A Theory of Style," *Journal of Aesthetics and Art Criticism* 20.3 (Spring 1962): 227–237. For an edifying reading of Ackerman's argument, see Marsha A. Rockey, "An Analysis of Ackerman's Concept of Style," *Journal of Aesthetics and Art Criticism* 27.3 (Spring 1969): 331–334.

106. Frank Sibley, "Aesthetic and Non-aesthetic," in *Approach to Aesthetics: Collected Papers on Philosophical Aesthetics,* ed. John Benson, Betty Redfern, and Jeremy Roxbee Cox (New York: Oxford University Press, 2001), 33–51, 35.

107. Richard Neer, "Connoisseurship and the Stakes of Style," *Critical Inquiry* 32 (Autumn 2005): 1–26, 21. In this essay Neer explicitly argues that "connoisseurship is a form of criticism" (20).

108. Rodolphe Gasché, *The Idea of Form: Rethinking Kant's Aesthetics* (Stanford, CA: Stanford University Press, 2003). See in particular "The Arts, in the Nude," 179–201. Gasché suggests that "mere form" in Kant refers to the mind's active process of rendering an existing or predetermined concept indeterminate, a process he refers to as "denuding" (185).

109. Eric Blondel, "Nietzsche: Life as Metaphor," in *The New Nietzsche: Contemporary Styles of Interpretation,* ed. David Allison (Cambridge, MA: MIT Press, 1985), 150–175, 150.

110. I want to thank Anton Vander Zee, who has long worked on this question of form in theory, for making me self-conscious about it as well.

111. Mieszkowski, *Labors of Imagination,* 113.

112. Schlegel, *On the Study of Greek Poetry,* 77; cited in Mieszkowski, *Labors of Imagination,* 25.

113. George Kubler, *The Shape of Time* (New Haven, CT: Yale University Press, 1962), 4. Kubler tries to supplant the concept of "style" with that of "formal series" for this very reason, as well as because his idea of "formal series" makes it possible to track changes in the history of artifacts across a much wider variety of durations.

114. Bakhtin, "Discourse in the Novel," 259.

115. Raymond Williams, *Culture and Society, 1780–1950* (New York: Columbia University Press, 1983), viii.

116. Jameson, *Postmodernism,* 16 and 17.

117. Caroline A. van Eck, James McAllister, and Renée van de Vall, eds., *The Question of Style in Philosophy and the Arts* (Cambridge: Cambridge University Press, 1995), 17.

118. Jameson, *Postmodernism,* 117.

119. Van Eck, Mc Allister, and de Vall, *Question of Style,* 10.

120. Ibid., 9.

121. Edgar Wind, *Art and Anarchy: The Reith Lectures, 1960* (New York: Alfred A. Knopf, 1963), 11.

122. Van Eck, McAllister, and de Vall, *Question of Style*, 8.

123. The objective situation to which the style of the interesting emerges in response—that of an aimless pluralism—would find its subjective correlate in the figure of the romantic ironist, able to enter "lightly into diverse experiences, some familiar, others remote, without allowing himself to be caught in any" (Wind, *Art and Anarchy*, 14). Faced with the now-overdetermined act of selection from the sea of stylistic options, this ironic producer of interesting art remains radically undetermined by any style in particular, which is another reason that the "look" of the interesting appears to have fluctuated more than other aesthetic styles over time.

124. Mukařovský, *Aesthetic Function, Norm and Value*, 22.

125. Leonard B. Meyer, "Toward a Theory of Style," in *The Concept of Style*, ed. Berel Lang (Ithaca, NY: Cornell University Press, 1987), 21–71, 25.

126. Stephen Ullmann, *Style in the French Novel* (Cambridge: Cambridge University Press, 1957), 6; cited in Nelson Goodman, "The Status of Style," *Critical Inquiry* 1.4 (June 1975): 799–811, 799 n. 1. Goodman explicitly disagrees with this thesis.

127. Niklas Luhmann, *The Reality of the Mass Media*, trans. Kathleen Cross (Stanford, CA: Stanford University Press, 2000), 26. Mark Seltzer, *True Crime: Observations on Violence and Modernity* (New York: Routledge, 2006), 25.

128. Bourdieu, *Rules of Art*, 170.

129. "Literature has this constant advantage or disadvantage among the arts of occurring in the same medium as social relations themselves, that of language. All other arts in order to exist when not present have to be described instead of quoted." Fisher, *Making and Effacing Art*, 49.

130. On the "antihistoricism of business prophecy" and its "precision model of historical obsolescence," see Liu, *Laws of Cool*, 48. On the erasure of other kinds of history in management literature, see ibid., 68 and 69.

131. Danto, *The Philosophical Disenfranchisement of Art*, 16.

132. Bourdieu, *Rules of Art*, 242, 243. Just as art in an institutional culture of museums finds increasingly creative ways to internalize commentary (and thus, in a certain sense, to integrate relations of circulation or publicity into the process of production), the avant-garde will thus be marked by a structural tendency—as opposed to a cynically manipulative or consciously calculating one, Bourdieu always stresses—to integrate the whole history that makes its own intervention and therefore identity possible. In contrast to the more passive goal of reasserting "control" over the way in which the artwork will be historicized and critically received (Fisher's emphasis), Bourdieu's account emphasizes that the aim of this internalization is the more aggressive and activist goal of surpassing.

133. Paul Mann, *The Theory-Death of the Avant-Garde*, 6. Daniel Herwitz underscores, "Constructivism is created simultaneously in the metal workshop and in the pages of *LFF*. De Stijl is brought into being through the paint brush and through the pages of *De Stijl*. . . . Words are part of the

identity of the avant-garde, part of what makes it the thing it is." Herwitz, *Making Theory,* 179.

134. Fisher, *Making and Effacing Art,* 23.

135. Ibid.

136. Phyllis Tuchman, "Minimalism: Art of the Interesting," *Michigan Quarterly Review* 20 (1981): 210–215, 213.

137. For an overview and analysis of these debates, see Colpitt, *Minimal Art,* 116–125.

138. Paul Mann, *Theory-Death of the Avant-Garde,* 21.

139. The British group Art and Language expressed skepticism, for example, about the validity of attributing "institutional critique" to Dan Graham's photo-essay *Homes for America* solely on the basis of its having been distributed in a magazine. See Art and Language, "Voices Off: Reflections on Conceptual Art," *Critical Inquiry* 33.1 (2006): 113–135, 114, 119–120.

140. Paul Mann, *Theory-Death of the Avant-Garde,* 23.

141. Ibid.

142. Kotz, *Words to Be Looked At,* 223. Fredric Jameson, "Transformations of the Image in Postmodernity," in *The Cultural Turn: Selected Writings on the Postmodern, 1983–1998* (London: Verso Books, 1998), 93–135, 125.

143. George Oppen, "Of Being Numerous," in *New Collected Poems* (New York: New Directions, 2002), 165.

144. Stanley Cavell, *Philosophy the Day after Tomorrow* (Cambridge, MA: Belknap Press of Harvard University Press, 2005), especially 1–6, 7–27, 61–82. "As if words were magic": ibid., 172.

145. Ibid., 155–191.

146. Judgment for Kant thus implies the existence of another subjective faculty that, unlike other faculties such as the understanding and imagination, takes into account as a priori the existence of other humans capable of speech. See Arendt, *Lectures on Kant's Political Philosophy,* 75. Indeed, because for Kant what the pure judgment of taste refers to is less the object than the feeling of pleasure that counterintuitively follows from (rather than preceding) its judging and thus, in turn, the communicability of that feeling, as Hannah Arendt notes, "One judges always as a member of a community, guided by one's community sense, one's *sensus communis*" (75). There is thus, by extension, no aesthetic judgment without real or imaginary conversation, as Derrida similarly seems to hint in his reading of Kant's *Critique of Judgment* as concerned with "talk," or with the "discursivity *in* the structure of the beautiful and not only . . . a discourse supposed to happen accidentally *to* the beautiful." See Jacques Derrida, *The Truth in Painting,* 48 (emphases in original).

147. Mieszkowski, *Labors of Imagination,* 19.

148. Austin, *How to Do Things with Words,* eds. J. O. Urmson and Marina Sbisa (Cambridge, MA: Harvard University Press, 1994), 57.

149. Gérard Genette, *The Aesthetic Relation,* trans. G. M. Goshgarian (Ithaca, NY: Cornell University Press, 1999), 93; my emphasis.

150. Ibid, my emphasis.

151. As Simon Frith notes, "Value judgments only make sense as part of an argument and arguments are always social events." Frith, *Performing Rites: Evaluating Popular Music* (New York: Oxford University Press, 1996), 95; cited in Rita Felski, "The Role of Aesthetics in Cultural Studies," in *The Aesthetics of Cultural Studies,* ed. Michael Berubé (Malden, MA: Blackwell Publishing, 2005), 28–43, 35.

152. Guillory, *Cultural Capital,* 282.

153. Genette, *The Aesthetic Relation,* 92.

154. Elaine Scarry, *On Beauty and Being Just* (Princeton: Princeton University Press, 1999), 29.

155. Arendt, *Lectures on Kant's Political Philosophy,* 68.

156. Ibid., 74; Lyotard, *The Inhuman: Reflections on Time,* trans. Geoffrey Bennington and Rachel Bowlby (Stanford, CA: Stanford University Press, 1992), 110.

157. Georg Simmel makes a similar point from a different angle in his efforts to use "aesthetic valuation" as a model for understanding economic value. Although it is indisputable that "value is never a 'quality' of objects," Simmel argues, neither value's "deeper meaning and content, nor its significance for the mental life of the individual, nor the practical social events and arrangements based on it, can be sufficiently understood by referring [it] to the 'subject.'" For this reason, Simmel writes, "The way to a comprehension of value lies in a region in which that subjectivity is only provisional and actually not very essential." Georg Simmel, "Value and Money," in Cazeaux, *Continental Aesthetics Reader,* 305–321, 316.

158. Ross Wilson, "Dialectical Aesthetics and the Kantian Rettung: On Adorno's *Aesthetic Theory,*" *New German Critique* 104 (2008): 55–69, 57. Adorno, *Aesthetic Theory,* 175; cited in Wilson, 57. (Emphasis added by me).

159. Tom Huhn, "Kant, Adorno, and the Social Opacity of the Aesthetic," in *The Semblance of Subjectivity: Essays in Adorno's Aesthetic Theory,* ed. Tom Huhn and Lambert Zuidervaart (Cambridge, MA: MIT Press, 1999), 237–258. Huhn suggests that as an experience of subjective domination over nature, the main role of the account of the sublime is to highlight a constitutive misrecognition in the judgment of taste that in fact makes the critique of aesthetic judgment necessary: the "failure of aesthetic subjectivity to recognize itself as an agent" in the experience of beauty (240). Huhn describes this error as the "social opacity of the aesthetic," by which he means aesthetic judgment's blindness to its own social or intersubjective underpinnings: "In judgments of beauty, what we fail to discern—though it is just this failure that allows beauty to occur—is intersubjectivity, the versions of universal subjectivity unearthed by Kant's critique" (253). As evinced by our compulsion to speak of beauty as if it were a property of objects, "Subjectivity *realizes* itself in taste but fails to *recognize* itself therein, and thereby likewise fails to reproduce itself as social" (240, emphases in original). This success/failure "sets in motion the project of the sublime," since its very first task is to "remove from taste the presentation that allows it to misrecognize itself as objective." In this manner, the sublime

"registers the faults within the success of taste" in the same way in which Kant's critique of taste does, which is why it plays such an important role as a counterexample in that critique (thus seeming at once "inside" and "outside" it).

160. "Something cannot be barely beautiful; if something is beautiful then it must be in virtue of its nonaesthetic properties. Furthermore, realizing this is a constraint on our judgments of beauty and other aesthetic properties. We cannot just judge that something is beautiful; we must judge that it is beautiful in virtue of its nonaesthetic properties. In fact, we pretty much always do so, and not to do so would be bizarre. . . . Our aesthetic thought, therefore, is fundamentally different from our thought about colors, with which they are too often compared. Perhaps colors are tied in some intimate way to intrinsic or extrinsic physical properties of the surfaces of things, such as reflectance properties. But color thought does not presuppose this. One might think that colors are bare properties of things. But one cannot think that beauty is bare; it is essential to aesthetic thought to realize that the aesthetic properties of a thing arise from its nonaesthetic properties." Nick Zangwill, "Aesthetic Judgment," in *The Stanford Encyclopedia of Philosophy (Fall 2010 Edition)*, ed. Edward N. Zalta, http://plato.stanford.edu/archives/fall2010/entries/aesthetic-judgment (accessed 3/11/2011). Zangwill continues, "Of course, we might not have in mind every single nonaesthetic property of the thing, nor exactly how the nonaesthetic properties produced their aesthetic effect. But we think that certain nonaesthetic properties are *responsible* for the aesthetic properties and that without those nonaesthetic properties, the aesthetic properties would not have been instantiated." (Emphasis in original.)

161. Cited in Shierry Weber Nicholsen, *Exact Imagination, Late Work: On Adorno's Aesthetics* (Cambridge, MA: MIT Press, 1997), 18.

162. Nelson Goodman, *Languages of Art*, 247.

163. Frith, *Performing Rites*, 95.

164. Davis, *Samuel Johnson Is Indignant*, 48–49.

165. Mieszkowsi, *Labors of Imagination*, 136.

166. Arendt, *Human Condition*, 182. The interesting's unique way of disclosing the intersubjective foundations of aesthetic judgment in general is thus, for Arendt, already visible in the between-ness of "interest." Both terms point to how "action and speech go on between men . . . and they retain their agent-revealing capacity even if their content is exclusively 'objective,' concerned with the manner of the world of things [which] physically lies between [men] and out of which arise[s] their specific, objective, worldly interests." Interesting conceptual art, as we shall see in Chapter 2, is explicitly preoccupied with the infrastructural in-between, including systems for the circulation of information in particular. On the indexical relation between physical infrastructure and media (and on the centrality of this very relation for the aesthetic of the modern novel), see Kate Marshall's "Sewer, Furnace, Air Shaft, Media: Modernity Behind the Walls in *Native Son* and

Manhattan Transfer," in *Studies in American Fiction* 37.1 (2010): 55–80. On transportation in particular as "media," see also Fredric Jameson, *The Geopolitical Aesthetic: Cinema and Space in the World System* (Bloomington: Indiana University Press, 1995), 13.

167. Thomas Mann, *Doctor Faustus*, 48.

168. These acts of connoisseurship take place, in other words, in the simple act of selecting examples for discussion. Why single out *I Love Lucy* to elucidate the meaning of post-Fordist zaniness, as opposed to any of the hundreds of other artifacts (video games, cartoons, the novels of Thomas Pynchon and Ishmael Reed, the poetry of Madeline Gins and John Ashbery, and so on) which I also mention but do not in fact linger on in the same chapter? Because the zaniness of *I Love Lucy* is a more intense or concentrated, "better" or even "purer" zaniness; because zaniness comes to a certain head in the genres of performance and physical comedy. Some of my aesthetic choices (and therefore judgments) have required very little justification: who could contest the exemplarity of the cuteness of a commercial icon like Hello Kitty? In other cases, they demanded a great deal of justification immediately: what warrants choosing late twentieth century conceptual art as a particularly exemplary or privileged instance of the interesting when, as I myself note, virtually *anything* can be said to be interesting? Much of the work in Chapter 2 is thus devoted to answering this very question.

1. The Cuteness of the Avant-Garde

1. J. L. Austin, "A Plea for Excuses: The Presidential Address," *Proceedings of the Aristotelian Society* 57 (1956–1957): 1–30, 9.

2. Gertrude Stein, *Tender Buttons: Objects, Food, Rooms* (1914) (Los Angeles: Sun and Moon Books, 1991), 44; abbreviated *TB* in main text.

3. Jacques Rancière, *Aesthetics and Its Discontents,* trans. Steven Corcoran (Malden, MA: Polity Press, 2009), 104, 105.

4. Nick Zangwill, "Aesthetic Judgment," in *The Stanford Encyclopedia of Philosophy* (Fall 2010 Edition), ed. Edward N. Zalta, plato.stanford.edu/archives/fall2010/entries/aesthetic-judgment (accessed 7/12/2011).

5. Theodor W. Adorno, *Aesthetic Theory,* trans. Robert Hullot-Kentor (Minneapolis: University of Minnesota Press, 1997), 51; abbreviated *AT* in main text.

6. Nor is cute an epistemological aesthetic, as Elaine Scarry argues to be the case for beauty, a "starting place for education" for the way in which it "incites in us the longing for truth." Elaine Scarry, *On Beauty and Being Just* (Princeton: Princeton University Press, 1999), 31. As we shall see, cute incites and encodes a variety of longings as well, but the longing for truth is not one of them.

7. Frances Ferguson, *Solitude and the Sublime: The Romantic Aesthetics of Individuation* (London: Routledge, 1992), 43.

8. Ibid., 43, 48. William Ian Miller makes the same point in the course of distinguishing contempt from disgust. While disgust opposes love, "Not only are love and contempt not antithetical but certain loves seem to be necessarily intermingled with contempt. What is the judgment that some persons or animals are cute but a judgment of their endearing subordinance and unthreateningness?" William Ian Miller, *Anatomy of Disgust* (Cambridge, MA: Harvard University Press, 1998), 32.

9. Edmund Burke, *A Philosophical Enquiry into the Origin of Our Ideas of the Beautiful and Sublime,* ed. Adam Philips (Oxford: Oxford University Press, 1990), 135, 100.

10. Burke, *Philosophical Enquiry,* 135. On cuteness as an aesthetic of sleep and deformity, see Daniel Harris, *Cute, Quaint, Hungry and Romantic: The Aesthetics of Consumerism* (New York: Da Capo Press, 2001), 7.

11. Ferguson, *Solitude and the Sublime,* 45.

12. Ibid., 48.

13. Immanuel Kant, *Critique of Judgment*, trans. J. H. Bernard (New York: Hafner Press, 1951), 200; my emphasis. Guyer and Matthews translate the passage as follows: "We call buildings or trees majestic and magnificent, or fields smiling and joyful; even colors are called innocent, modest, or tender, because they arouse sensations that contain something analogical to the consciousness of a mental state produced by moral judgments." Immanuel Kant, *Critique of the Power of Judgment,* trans. Paul Guyer and Eric Matthews (Cambridge: Cambridge University Press, 2000), 228.

14. See Friedrich Schlegel, *On the Study of Greek Poetry,* trans. and ed. Stuart Barnett (Albany: State University of New York Press, 2001); Uvedale Price, *An Essay on the Picturesque: As Compared with the Sublime and the Beautiful; and, On the Use Of Studying Pictures, for the Purpose Of Improving Real Landscape* (London: J. Mawman, 1810). It is not a coincidence that "interesting" and "picturesque" are both aesthetic categories about aesthetic difference and/or variety, emerging in tandem with (and as if in direct response to) the pluralism of the eighteenth-century marketplace.

15. Frank Sibley, "Aesthetic Concepts," in *Approach to Aesthetics: Collected on Philosophical Aesthetics,* ed. John Benson, Betty Redfern, and Jeremy Roxbee Cox (New York: Oxford University Press, 2001), 1–23.

16. Even the affective contrast between the beautiful and sublime fails to acknowledge, and indeed seems to conceptually block, the idea of a gradient of feeling underlying the formation of a culture's finite and historically-specific repertoire of aesthetic categories.

17. Kant, *Critique of Judgment,* 114. Reference here to the Bernard translation, in the 1951 Hafner edition.

18. This continues to be the case even for contemporary philosophers who have taken an explicit interest in aesthetic judgments as a plurality. Nick Zangwill's principle of taxonomy in "The Beautiful, the Dainty and the Dumpy," for example, relies not on a gradient of feeling but on the difference between what he calls "verdictive" or purely evaluative aesthetic judgments (such as beauty) and "substantive" or descriptive ones (such as cute or dainty). For

Zangwill, the latter imply the former but not vice versa, a point he then uses to claim that judgments like "cute" merely describe a specific way of being beautiful. In this manner, Zangwill, even when he is explicitly theorizing aesthetic judgment on the basis of the concept of a variegated class of judgments, finally seems somehow to resist doing so, concluding that only "judgments of beauty should indeed be the central concern of aestheticians who are interested in the nature of aesthetic judgment." Nick Zangwill, "The Beautiful, the Dainty and the Dumpy," *British Journal of Aesthetics* 35.4 (1995): 317–329, 317.

19. Benjamin H. D. Buchloh, "Andy Warhol's One-Dimensional Art," in *Neo-Avantgarde and Culture Industry: Essays on European and American Art from 1955 to 1975* (Cambridge, MA: MIT Press, 2003), 467.

20. As "magnitude, force, quantity in its purest state," the sublime not only "denies the imagination the power of forms" but also denies nature "the power to immediately affect thinking with forms." Jean-François Lyotard, *Lessons on the Analytic of the Sublime,* trans. Elizabeth Rottenberg (Stanford, CA: Stanford University Press, 1994), 53–54.

21. Theodor Adorno, "Commitment," in *Notes to Literature,* vol. 2, trans. Shierry Weber Nicholsen (New York: Columbia University Press, 1992), 76–94, 92.

22. *Oxford English Dictionary,* s.v. "cute."

23. Lori Merish, "Cuteness and Commodity Aesthetics," in *Freakery: Cultural Spectacles of the Extraordinary Body,* ed. Rosemarie Garland Thomson (New York: New York University Press, 1996), 185–203, 193.

24. Merish accordingly traces the link between the "cute child" and the "freak" back to the nineteenth-century fad of "kid shows" centered on the commercialized display of adult little people impersonating children, of whom the most famous were Warren and Stratton. Their Tom Thumb wedding, as Merish notes, quoting P. T. Barnum's pamphlet on the event, significantly marked out a new public space for female spectatorship: "Ladies stood on tip-toe, some daring ones of small stature actually mounting the seats, so eager in their pleasurable excitement to see, that they overlooked the possibility of being seen" (ibid., 193). In conjunction with the rise of a nineteenth-century ideology of benevolent ownership, or what Merish elsewhere calls "sentimental materialism" (the feminized idea of tasteful consumption as a moral and/ or civic good), the cute thus helped legitimate white middle-class women as consumers and spectators, explicitly facilitating the feminization of commercial amusements like the circus, vaudeville, and the cinema (195); and it seems to have done so in part, Merish notes, by being deeply bound up with race. From the tumbling Topsy as counterpart to little Eva in *Uncle Tom's Cabin* to the duo of Shirley Temple and Bill Richardson in early American cinema and the black children adopted into white families played by actors Gary Coleman and Emmanuel Lewis in late twentieth-century sitcoms, the cute comic American child seems to have been consistently racialized (198). Indeed, cuteness arguably evolved in close association with minstrelsy and other aesthetic practices explicitly negotiating the experience of race as indelibly

shaped by American slavery, a system sustained precisely by the ideological conflation of kinship and ownership that the cute similarly activates. Cuteness is thus in many ways, as Merish suggests, a distinctively American phenomenon. Yet as we will see, it is by no means exclusively so.

25. Karl Marx, *Capital,* vol. 1, *A Critique of Political Economy,* trans. Ben Fowkes (New York: Penguin, 1992), 178.

26. Like Don Quixote, the commodity is indifferent to the "concrete, physical body" of other commodities: "A born leveler and cynic, it is always ready to exchange not only soul, but body, with each and every other commodity, be it more repulsive that Maritornes herself" (ibid., 179).

27. I would not have been alert to the tone of these comparisons if I had not read Keston Sutherland. See Keston Sutherland, "Marx in Jargon," www.world picturejournal.com/WP_1.1/KSutherland.html (accessed 7/30/2011). This article is reprinted in Keston Sutherland, *Stupefaction: A Radical Anatomy of Phantoms* (London: Seagull Books, 2011), 26–90.

28. Barbara Johnson, *Persons and Things* (Cambridge, MA: Harvard University Press, 2008), 22, 140.

29. Marx, *Capital, vol. 1,* 176–177.

30. Ibid., 126.

31. This is Jameson's point: *Capital* is not about labor, which as concrete activity has phenomenological properties, but rather about (socially necessary) labor power, which as pure quantity has none. It is thus in the largest sense a story about how capitalism produces the disappearance of quality. Fredric Jameson, seminar on *Capital,* UCLA, Department of Comparative Literature, spring quarter 2008.

32. Johnson, *Persons and Things,* 22.

33. As part of his larger polemical argument against "pure theory" readings of Marx that miss the significance of *Capital*'s literary dimensions as satire (and that reduce Marx's satirical assaults on the bourgeois reader to affectively neutralized portable concepts), Keston Sutherland suggests that it is a mistake to take the concept of fetishism in *Capital* seriously: "The most important fact about the 'concept' of fetishism in *Capital* [is that it is] a satirical and ersatz concept, insofar as it is a concept at all, and . . . derived not from poststructuralist reflection on problems of inscription but from Marx's ironic reading and *détournement* of an eighteenth century essay in racist ethnography." Sutherland, "Marx in Jargon." This is a bracing reading that makes significant interventions into Marx scholarship and literary criticism on multiple levels simultaneously. I would like to add only that while the account of fetishism in *Capital* is in fact doing all the formal work Sutherland attributes to it (the work of satire, of ironic *détournement,* of cleverly catering to but then mocking the bourgeois reader's investment in the theoretical disciplining of astonishment), it does not seem precluded on that basis from doing conceptual or theoretical work as well. The theory of fetishism is perhaps ersatz *and* true, which would explain why the phenomenon seems at once risible and significant to Marx.

34. Johnson, *Persons and Things,* 22.

35. Marx, *Capital,* vol. 1, 165.

36. Ibid., 138.

37. Theodor Adorno, *Minima Moralia: Reflections from Damaged Life,* trans. Edmund Jephcott (London: Verso, 1978), 228; abbreviated *MM* in main text.

38. Marx, *Capital,* vol. 1, 128.

39. Adorno, *Minima Moralia,* 120.

40. Robert Creeley, *The Company* (Providence, RI: Burning Deck, 1988), 40.

41. Johnson, *Persons and Things,* 20.

42. See Kanako Shiokawa, "Cute but Deadly: Women and Violence in Japanese Comics," in *Themes and Issues in Asian Cartooning: Cute, Cheap, Mad, and Sexy,* ed. John A. Lent (Bowling Green, OH: Bowling Green State University Popular Press, 1999), 97. This important essay traces how the comics industry in Japan transformed kawaii from the "complete absence of anything observably threatening" into a much more complex aesthetic capable of including "'cute'-girl action heroines from Japanese comics, who are often equipped with lethal powers" (94); a transition that, as we shall see, anticipates the transformations Takashi Murakami performs on his DOB character over time.

43. "What we love because it submits to us": Ferguson, *Solitude and the Sublime,* 48.

44. For a particularly explicit theory of aestheticization as objectification (and not just of feeling but of value), see Gérard Genette, *The Aesthetic Relation,* trans. G. M. Goshgarian (Ithaca, NY: Cornell University Press, 1999), 67–72.

45. Harris, *Cute, Quaint, Hungry and Romantic,* 5–6.

46. Russell Edson, "The Fight," www.americanpoems.com/poets/Russell-Edson /2492 (accessed 7/30/2011).

47. Russell Edson, *The Tunnel: Selected Poems* (Oberlin, OH: Oberlin College Press), 206 and 123.

48. Fredric Jameson, seminar on *Capital,* UCLA, Department of Comparative Literature, spring quarter 2008. This argument can also be found in Fredric Jameson, *Representing* Capital: *A Reading of Volume One* (London: Verso, 2011), 19–20.

49. Marx, *Capital,* vol. 1, 138.

50. Ibid.

51. Ibid., 128.

52. Sutherland, "Marx in Jargon."

53. Stein, *Tender Buttons,* 25.

54. Merish, "Cuteness and Commodity Aesthetics," 186.

55. Mary Ann Doane, *The Desire to Desire: The Woman's Film of the 1940s* (Bloomington: Indiana University Press, 1987), 32; also cited in Merish, "Cuteness and Commodity Aesthetics," 187. As Merish notes reading Doane's gloss of Walter Benjamin, cuteness might be regarded as a form of the "empathy with the commodity" Benjamin ascribes to the flâneur in the arcades. I second this but add that this empathy once again comes with an additional twist, for while the flâneur's empathy with the commodity is "fundamentally empathy with exchange value," or with the "point of view" of a commodity

that can be endlessly equated to and swapped for other commodities, cuteness actually seeks to arrest this endless chain of equivalencies through its redoubled or exaggerated fetishism, in which the commodity is imagined as something that we at once identify with and desire, but also something that identifies with and desires us. Walter Benjamin, *The Arcades Project,* trans. Rolf Tiedemann (Cambridge, MA: Belknap Press, 1999), 448; cited in Doane, *The Desire to Desire,* 32.

56. Harryette Mullen, *Recyclopedia: Trimmings, S*PeRM**K*T,* and *Muse and Drudge* (Saint Paul: Greywolf Press, 2006).

57. In its insistent femininity, cuteness highlights the long-standing centrality of gender to the theorization of all aesthetic experience. From the feminization of beauty and masculinization of the sublime by Burke; to Nietzsche's polemical contrast between a "womanly aesthetics" of reception and a masculine aesthetic of production; to Luce Irigaray's search for a feminine poetics capable of standing on its own against the language of phallocentrism, aesthetic theory has persistently relied on sexual difference as a way to shore up and sometimes formulate its own categories. (Although Scarry explicitly calls attention to Burke's gendering of the two categories, there is a sense in which her account of beauty replicates it, privileging beauty precisely for its being "not-male" and the "diminutive member" of the oppositional pair. See Scarry, *On Beauty and Being Just,* 83–84.) A great deal of work has been done on gender in Nietzsche's aesthetics. Of particular note are Matthew Rampley, *Nietzsche, Aesthetics, and Modernity* (Cambridge: Cambridge University Press, 2000), 190–214; Jacques Derrida, *Spurs: Nietzsche's Styles,* trans. Barbara Harlow (Chicago: University of Chicago Press, 1979), 206; and Kelly A. Oliver and Marilyn Pearsall, eds., *Feminist Interpretations of Friedrich Nietzsche* (University Park: Pennsylvania State University Press, 1998), usefully divided into "Nietzsche's Use of Woman" and "Feminists' Use of Nietzsche."

Conversely, the cuteness of *Trimmings* underscores just how much of an aesthetic phenomenon gender itself is. Whether expressed in the medium of language, music, gesture, clothing, genes, or hair—and gender always involves this expression/production on multiple biological and cultural levels simultaneously—femininity, masculinity, and all the genders in between are, at least in one crucial part, matters of sensuous appearance. Perpetually worked on, consciously and unconsciously, at every possible scale, gender is the ultimate *Gesamtkunstwerk.* This is precisely why gender is not insubstantial or disembodied, not easily assembled or disassembled at will, and not easily detachable from the other categories of social difference that contribute to its meaning. As Mullen notes in "Off the Top," a brief afterword to the first edition of *Trimmings,* published by Tender Buttons Press in 1991, the continuing association of "pink" and "white" with femininity, and thus of femininity itself with racial whiteness, has been as tenacious in American mass culture as the association of women of all races with "fluff" and "trim." Harryette Mullen, *Trimmings* (New York: Tender Buttons Press, 1991), n.p.

58. Wyndham Lewis, "The Revolutionary Simpleton," *Enemy,* no. 1 (January 1927); rpt. as *The Enemy,* ed. David Peters Corbett (Santa Rosa, CA: Black

Sparrow Press, 1994), 75–76; quoted in Mark McGurl, *The Novel Art: Elevations of American Fiction after Henry James* (Princeton, NJ: Princeton University Press, 2001), 8.

59. McGurl, *Novel Art,* 6. The "complete absence of anything threatening": Shiokawa, "Cute but Deadly," 94.

60. Wyndham Lewis, *The Art of Being Ruled,* ed. Reed Way Dasenbrock (Santa Rosa, CA: Black Sparrow Press, 1989), 162. The title of this essay (third in the series of four comprising the "Sub Persona Infantis" cluster) is "Buy Me an Air-Ball, *Please!"*

61. Lewis's account of this feminized blockage of the process of social maturation, as epitomized by the modern subject's relation to a puffed-up, massproduced commodity ("Buy me an Air-Ball, *Please!"*) is more ambivalent than it may seem, given that it also signifies the subject's resistance to joining the ranks of mature, responsible adults who plan and fight in endless wars. Thus, as Lewis notes, "The vulture and the eagle dispense with their terrifying finials and beaks, and paddle luxuriously . . . like doves. [. . .] If you do not 'grow up' (with the initiative, self-reliance, and so on associated with that action) there is no need to have an adult psychology either" (166). I'm indebted to Gopal Balakrishnan for our conversations about this passage.

62. Hannah Arendt, *The Human Condition* (Chicago: University of Chicago Press, 1958), 52. Lewis, *The Art of Being Ruled,* 162.

63. Ibid.

64. Ibid., 165. Yet the child, regardless of gender, is not a "sexually balanced" symbol; it is rather "so preponderantly feminine as almost to merge in the mother-figure on which it is dependent, and to which it is so close" (165). Like the overclose relation between body and clothing, consumer and commodity, dramatized in *Trimmings,* for Lewis the loss of distance between child and adult in cuteness is itself "preponderantly feminine" and is secured as such by a distinctively modern or industrial-age concept of intense maternal attachment.

 As Laura Kipnis notes, the concept of maternal instinct "arises at a particular point in history—namely when there was a social necessity for a new story. With the [reforms in child labor inspired by] the industrial revolution, children's economic value declined: and once children started costing more to raise than they contributed economically to the household, there had to be *some* justification for having them. Ironically, it was only when children lost economic worth that they became the priceless little treasures we know them as today. On the emotional side, it also took a decline in infant-mortality rates for parents to start treating their offspring with much affection—when infant deaths were high (in England prior to 1800 they ran between 15 and 30 percent for a child's first year), maternal attachment ran low. (Historian Lawrence Stone points out the common practice of giving a newborn child the same name as a dead sibling: children were barely even regarded as distinct individuals.) With smaller family size—birthrates declined steeply in the nineteenth century—the emotional value of each child also increased; so did sentimentality about children and the deeply felt emotional need to acquire

them." Laura Kipnis, *The Female Thing: Dirt, Sex, Envy, Vulnerability* (New York: Pantheon, 2006), 72–73.

65. Adorno, "On Lyric Poetry and Society," in *Notes to Literature,* vol. 1, trans. Shierry Weber Nicholsen (New York: Columbia University Press, 1992), 37–54, 37.

66. See Bill Brown, *A Sense of Things: The Object Matter of American Literature* (Chicago: University of Chicago Press, 2003), 2–8; Rae Armantrout, "Tone," in *Veil: New and Selected Poems* (Middletown, CT: Wesleyan University Press, 2001), 6.

67. On "world poems," see Paul Naylor, *Poetic Investigations: Singing the Holes in History* (Evanston, IL: Northwestern University Press, 1999). 72.

68. Rae Armantrout, "Ongoing," in *Veil,* 126.

69. William Carlos Williams, *Selected Essays* (New York: New Directions Publishing, 1969), 256.

70. Stephen Burt makes similar observations about this poem and about Armantrout's relation to metaphor. See Stephen Burt, "Where Every Eye's a Guard: Rae Armantrout's Poetry of Suspicion," *Boston Review* online, http://bostonreview.net/BR27.2/burt.html (accessed 7/30/2011).

71. Russell Edson, "The Toy-Maker," *Postmodern America Poetry A Norton Anthology,* ed. Paul Hoover (New York: W. W. Norton, 1994), 324. Although the toymaker is clearly capable of producing astonishingly powerful images—ones that disrupt and even shatter our conventional understanding of what a "toy" is—the object that most fascinates him, and that he clearly has the most affection for making, is one most would regard with contempt (if not disgust). If Baudelaire thus links poetry to the "barbaric toy, the primitive toy," in "The Toy-Maker," barbaric/primitive poetry seems to know that it will either be revered ("toy god") or despised ("toy shit"). Charles Baudelaire, "The Philosophy of Toys" (1853), reprinted in *EXIT, Imagen & Cultura,* http://www.exitmedia.net/prueba/eng/articulo.php?id=198 (accessed 8/1/2011); cited in Daniel Tiffany, *Toy Medium: Materialism and Modern Lyric* (Berkeley: University of California Press, 2000), 68.

72. Russell Edson, "The Melting," http://www.americanpoems.com/poets/Russell-Edson/2499 (accessed 1/29/2012).

73. Adorno, *Aesthetic Theory,* 12.

74. Rae Armantrout, "Scumble," in *Versed* (Middletown, CT: Wesleyan University Press, 2009), 34.

75. Walter Benjamin, "Old Toys: The Toy Exhibition at the Märkisches Museum," in *Selected Writings,* vol. 2, *1927–1934,* trans. Rodney Livingstone and others, ed. Michael Jennings, Howard Eiland, and Gary Smith (Cambridge, MA: Belknap Press, 1999), 98–102, 99.

76. Benjamin, "Toys and Play," *Selected Writings,* vol. 2, 119; "The Cultural History of Toys," *Selected Writings* vol. 2, 114

77. This economic struggle, which the "false simplicity" of the modern toy does in a genuine way reflect, is further mirrored by the toy as a "site of conflict, less of the child with the adult than of the adult with the child. For who gives the child his toys if not adults?" (Benjamin, "Toys and Play," *Selected Writ-*

ings, vol. 2, 118). Benjamin mentions how balls, hoops, tops, and kites were originally "imposed on [children] as cult implements"; these auratic objects "became toys only afterward," through acts of use or playing that directly contributed to the loss of that aura (ibid.).

78. *Selected Writings,* vol. 2, 278.

79. For a more extensive and more historical account of the relationship between poetry and kitsch, see Daniel Tiffany's forthcoming *Silver Proxy,* especially "Introduction: A Genealogy of Kitsch and Poetry."

80. Benjamin, "On the Mimetic Faculty," *Selected Writings* vol. 2, 720. For a detailed discussion of the mimetic faculty in Benjamin and its influence on Adorno, see Shierry Weber Nicholsen, "*Aesthetic Theory*'s Mimesis of Walter Benjamin," *Exact Imagination, Late Work: On Adorno's Aesthetics* (Cambridge, MA: MIT Press, 1997), 137–180.

81. Benjamin, "The Cultural History of Toys," *Selected Writings* vol. 2, *1927–1934,* 116.

82. Benjamin, "Old Toys," *Selected Writings* vol. 2, 101.

83. See Antonia Fraser, *A History of Toys* (London: Weidenfeld and Nicolson, 1966), 224. On the impact of the new child psychology on furniture and industrial design, see Adrian Forty, *Objects of Desire* (New York: Pantheon Books, 1986), 67–72.

84. Miriam Formanek-Brunell, *Made to Play House: Dolls and the Commercialization of American Girlhood, 1830–1930* (New Haven, CT: Yale University Press, 1993), 45.

85. Ibid., 41.

86. Ibid., 68.

87. Ibid., 90.

88. Sawaragi continues, "In one sense this cuteness was neutral, in another, it was controlling. Couldn't one call this 'rule by cuteness' rather than 'rule by power'?" Noi Sawaragi, "Dangerously Cute: Noi Sawagari and Fumio Nanjo Discuss Contemporary Japanese Culture," *Flash Art,* no. 163 (March–April 1992): 75. For an etymological history of kawaii from its classical usage in texts such as Murasaki's *Tale of Genji* to its expansion in the industrial era and late 1960s in particular, see Shiokawa, "Cute but Deadly."

89. Given the popularity of these two artists and of kawaii commodity aesthetics in general in the United States, there is clearly as much to say about the ideology of America's fondness for what it perceives as a distinctively Japanese cuteness as there is about that of Japan's fascination with its own.

90. For more on Kogepan, including a time line of its history, see www.san-x .co.jp/pan/nenpyou.html (accessed 8/1/2004).

91. For instance, the title piece of one of Nara's recent solo shows, "I DON'T MIND, IF YOU FORGET ME," consists of plastic-box letters that spell out the phrase in English. Each transparent plastic letter is packed with stuffed dolls (over 1,000 in total), copied after his signature children and animals, handmade by 375 Nara fans and sent to him explicitly for use in his installation. See Yoshimoto Nara, *I Don't Mind, If You Forget Me* (exhibition catalog, Yokohama Museum of Art, 2001).

92. According to Amanda Cruz, Murakami was inspired to do so in part by the business savvy of American director George Lucas, whose foresight in registering his characters allowed him to finance his own films. Cruz notes that Murakami's "registered character . . . has become so popular that there are barely altered counterfeits currently circulating due to the fact that Japan's lax copyright laws go unenforced in a society that shuns litigation." Amanda Cruz, "DOB in the Land of Otaku," in *Takashi Murakami: The Meaning of the Nonsense of the Meaning* (exhibition catalog, Annandale-on-Hudson, NY: Center for Curatorial Studies Museum, Bard College, 1999), 16.

93. Takashi Murakami, *Takashi Murakami: Summon Monsters? Open the Door? Heal? Or Die?* (exhibition catalog, Tokyo: Museum of Contemporary Art, 2001), n.p. Pagination in the catalog only begins with page 58. The quote appears on an unnumbered page divider labeled "Works Vol. 2 DOB."

94. Although Gould also explicitly refers to it as a process of becoming "cute," the scientific term for "progressive juvenilization as an evolutionary phenonemon" is "neoteny." See Stephen Jay Gould, "A Biological Homage to Mickey Mouse," in *The Panda's Thumb: More Reflections in Natural History* (New York: W. W. Norton, 1980), 95–107. Gould's account of Mickey's increasing cuteness as the key to his own "market survivability" over the decades draws on Konrad Lorenz's arguments about the innateness of our "affectionate response to babyish features" and the "neotenous nature of mankind" in general. In other words, on top of our unusually long periods of gestation and childhood, humans tend to have more juvenile features in general (relatively larger heads, for example) than other species.

95. Amanda Cruz, "DOB in the Land of Otaku," 16.

96. Harris's example of this way in which cute always seems to contain the "anticute" is the Hollywood film *Gremlins* (1984), which, in telling the story of adorable Oriental furballs that turn into malicious aliens when they are given water seems to allegorize how cute objects "often seem more in control of us than we are of them." See Harris, *Cute, Quaint, Hungry and Romantic*, 15.

97. The *manga* character is Noboru Kawasaki's Country General. See Takashi Murakami, "Life as a Creator," in *Takashi Murakami: Summon Monsters? Open the Door? Heal? Or Die?*, 130–147.

98. Ibid., 132–133.

99. Ibid., 132.

100. See Harris, *Cute, Quaint, Hungry and Romantic*, 7.

101. Isaac Goldberg, "As a Critic Has a Headache: A Review in Synthetic Form of the Works of Gertrude Stein, Past, Present, and to Come," in *The Critical Response to Gertrude Stein*, ed. Kirk Curnutt (Westport, CT: Greenwood Press, 2000), 256.

102. Henry Seidel Canby, "Cheating at Solitaire," in Curnutt, *Critical Response to Gertrude Stein*, 81.

103. H. L. Mencken, "Literary Survey," in Curnutt, *Critical Response to Gertrude Stein*, 248.

104. Stein, *Tender Buttons*, 43.

105. Self-conscious references to Andy Warhol abound in Murakami's work, from his flowers evoking Warhol's *Flowers* and his helium-balloon versions of DOB evoking *Silver Clouds* to the statue of the ecstatically masturbating boy whose title, *My Lonesome Cowboy*, harks back to Warhol's films *My Hustler* and *Lonesome Cowboys*. Given Murakami's indebtedness to Warhol, the link between Murakami and Stein suggests a much more surprising affinity between Stein and Warhol. This link between two figures not conventionally paired can further our understanding of Stein's poetics by highlighting aspects of her relationship to commodity culture that are often too quickly glossed over. Both Stein and Warhol had an interest in celebrity portraiture that ran alongside their interest in the representation of commodities and in specific commodity styles. Unlike other avant-garde artists in their cohort, both lacked antagonistic feelings toward consumer culture as such, although it could be argued, as an important corollary to Adorno's reminder that negative affects do not automatically ensure that artworks will be critical, that Stein's interest was in how poetry might be driven by commodity's culture's positive affects without necessarily becoming affirmative.

What Stein's Warholism *avant la lettre* most significantly illuminates, however, is that if *Tender Buttons* still contributes in one way or another to the modernist avant-garde's assault on the sentimentality of commodity culture, it does not do so by merely troping on cuteness in the way in which T. S. Eliot tropes on popular music in *The Waste Land* or Williams tropes on the language of popular journalism in *Paterson*—namely, by asserting poetry's distance from and power over these other cultural forms. Although the line between the appropriation of an existing aesthetic and participation in that aesthetic is often hard to gauge, it is Warhol's well-known innovation to have made work that turns on precisely this difficulty, placing it at the center of debates about the concept of art in general in an unprecedented way. Anticipating Warhol's uncanny knack for making art capable of commenting on the quality of decorative prettiness while simultaneously being pretty *(Flowers)*, on a kind of bovine cheeriness while also being cheery *(Cow Wallpaper)*, or on the diagram's aura of coldness or starkness while also being stark *(Dance Diagrams, Do It Yourself)*, *Tender Buttons* similarly manages to trope on cuteness while also being cute.

"Prettiness," "cheeriness," "starkness": I am reading Warhol's own corpus not just as a meditation on art and its relation to the commodity form but as an inquiry into the construction and function of aesthetic concepts and minor ones in particular. This approach to the Warholian project already seems to lurk in Buchloh's observation that "in his early career as a commercial artist [Warhol] featured all the debased and exhausted qualities of the 'artistic' that art directors and admen adored: the whimsical and the witty, the wicked and the *faux naïf*" (Buchloh, "Andy Warhol's One-Dimensional Art," 470). Yet I argue that rather than being a mere phase in his transition from professional illustrator to gallery artist, Warhol's engagement with

such aesthetic qualities as qualities takes the form of a much more deliber-
ate and methodical inquiry throughout his career.

106. Francis Ponge, *The Voice of Things,* trans. Beth Archer (New York: McGraw-
Hill, 1972), 147–148; hereafter abbreviated *VT.*

107. D. W. Winnicott, *Playing and Reality* (London and New York: Routledge,
1989), 5. Winnicott stresses that the transitional object is not in itself tran-
sitional, but an object that represents, and in representing allows the infant
to negotiate and eventually traverse, the "intermediate area between the
subjective and that which is objectively perceived" (3). In other words, it
designates an object that the infant recognizes as "not-me" yet still cannot
fully recognize as belonging to external reality, one that allows her to make
the transition from a quasi-hallucinogenic, inner psychic reality (in which,
in an illusion of omnipotence, the baby perceives all "not-me" objects as
her objects of her own creation) to an objective reality shared by others (in
which the infant acknowledges the separateness and prior and independent
existence of objects and persons). It is thus interesting to note that the tran-
sitional object's fate, in addition to that of surviving its aggressive cuddling/
mutilation, is also to become "decathected" or to lose meaning (5). The
implication here is that a loss of meaning becomes necessary for the very
concept of an external or shared reality, and thus for the ethical acknow-
ledgment of others as separate and autonomous from oneself. The objectiv-
ity of the object world becomes predicated on a subtraction of meaning, at-
tained by violently or excitingly mutilating an object and witnessing its
survival. One could extrapolate from this to make arguments for the "real-
ism" of *Tender Buttons* and Ponge's *Voice of Things.*

108. "Relaxing, slackening, and enervating of the fibers of the body, and a conse-
quent fainting, dissolving, and melting away for enjoyment": this is Kant's
paraphrase of Burke's argument about beauty in *Critique of Judgment.* See
Kant, *Critique of Judgment,* 118.

109. On the exclusion of taste as oral sensation from theories of aesthetic taste
(and also on aesthetic "taste" as paradoxically founded on distaste or dis-
gust), see Pierre Bourdieu, "Postscript," in *Distinction: A Social Critique of
the Judgment of Taste,* trans. Richard Nice (Cambridge, MA: Harvard Uni-
versity Press, 1984), and Jacques Derrida, "Economimesis," *Diacritics* 11
(Summer 1981): 2–25. For a compelling explanation of why this seemingly
private sense actually makes the most sense as the metaphorical foundation
of Kant's aesthetics, however, see Hannah Arendt, *Lectures on Kant's Politi-
cal Philosophy,* trans. Ronald Beiner (Chicago: University of Chicago Press,
1989), 66–68.

110. As Natalie Angier underscores, this is the aesthetic's explicitly biological
function: "As a species whose youngest members are so pathetically help-
less they can't lift their heads to suckle without adult supervision, human
beings must be wired to respond quickly and gamely to any and all
signs of infantile desire." Natalie Angier, "The Cute Factor," *New York
Times,* January 3, 2006. http://www.nytimes.com/2006/01/03/science/03cute
.html?pagewanted=all (accessed 1/16/2012).

111. Paul de Man, "Autobiography as De-facement," in *The Rhetoric of Romanticism* (New York: Columbia University Press, 1984), 75–76.
112. See Walter Benjamin, "On Some Motifs in Baudelaire," in *Illuminations: Essays and Reflections,* trans. Harry Zohn, ed. Hannah Arendt (New York: Schocken Books, 1969), 188.
113. Stephen Siperstein notes that "there might be a lot of interesting questions to ask about an idea of "cuteness" and its relation to human-animal relations . . . [and] the uncanny valley." See Stephen Siperstein. "A Journey Through the Uncanny Valley," February 1, 2011. http://envirohumanities. wordpress.com/2011/02/page/4/ (accessed 1/29/2012).
114. De Man, "Autobiography as De-facement," 78.
115. Jonathan Flatley, "Warhol Gives Good Face," in *Pop Out: Queer Warhol,* ed. Jennifer Doyle, Jonathan Flatley, and José Esteban Muñoz (Durham, NC: Duke University Press, 1996), 116. Flatley usefully clarifies that the reification/personification dualism in Marx's account represents the commodity as perceived from two distinct points of view: from the side of production and consumption, respectively.
116. See Bob Perelman and Francie Shaw, *Playing Bodies* (New York: Granary Books, 2004).
117. Harris, *Cute, Quaint, Hungry and Romantic,* 7.
118. Adorno, *Aesthetic Theory,* 53.
119. The Left's criticisms of the avant-garde gathered here are articulated in the following works: Bourdieu, *The Rules of Art: Genesis and Structure of the Literary Field,* trans. Susan Emanuel (Stanford, CA: Stanford University Press, 1996); Raymond Williams, *The Politics of Modernism: Against the New Conformists* (London: Verso, 1989); Peter Bürger, *Theory of the Avant-Garde,* trans. Michael Shaw (Minneapolis: University of Minnesota Press, 1984); Paul Mann, *The Theory-Death of the Avant-Garde* (Bloomington: Indiana University Press, 1991); and Adorno, *Aesthetic Theory.*
120. Barrett Watten, "The Constructivist Moment: From El Lissitzky to Detroit Techno," *Qui Parle* 11 (Autumn–Winter 1997): 64.
121. For an elaboration of this point, see Jan Mieszkowski, *Labors of Imagination: Aesthetics and Political Economy from Kant to Althusser* (New York: Fordham University Press, 2006), 19.
122. Roldophe Gasché, *The Idea of Form: Rethinking Kant's Aesthetics* (Stanford, CA: Stanford University Press, 2003), 185.
123. "Primitive, nondiscursive character" of poetry: see Tiffany, *Toy Medium,* 69. Barbara Johnson also gives a compelling but very different account of the power of muteness in "Muteness Envy," in *The Feminist Difference: Literature, Psychoanalysis, Race, and Gender* (Cambridge, MA: Harvard University Press, 1997), 129–156.
124. Adorno, *Aesthetic Theory,* 79; cited (with alternative translation) in Nicholsen, *Exact Imagination, Late Work,* 164. As evinced here, "muteness" is not always coupled with or meant to be read as synonymous with weakness in Adorno's text (although it *frequently* is, as when he describes artworks as "helplessly mute" before the question of purpose, above). As

Nicholsen's reading emphasizes in particular, the muteness of autonomous art for Adorno refers to its nondiscursivity, what we might even think of as its powerful refusal of conceptual signification.

125. Adorno, *Aesthetic Theory,* 78; cited (with altered translation) in Nicholsen, *Exact Imagination, Late Work,* 161.

126. Walter Benjamin, "On the Mimetic Faculty," in *Selected Writings,* vol. 2, 720–722; Benjamin, "Some Remarks on Folk Art," in *Selected Writings,* vol. 2, 278–279.

127. Harris, *Cute,* 13,

128. Nicholsen, *Exact Imagination, Late Work,* 162.

129. Adorno, *Minima Moralia,* 18.

130. For the observation about the link between the modernist prose poem and advertising copy, I am grateful to Rob Halpern.

131. What I am saying here about fetishism and reification in cuteness closely follows arguments Jameson makes about the meaning of these concepts for Adorno. See Fredric Jameson, *Late Marxism: Adorno, or, The Persistence of the Dialectic* (London: Verso, 1990), 180–181. Abbreviated *LM* in main text.

132. Ibid., 130.

133. Adorno, "On Lyric Poetry and Society," 42; abbreviated "LPS" in main text.

134. Adorno, "Presuppositions," *Notes to Literature,* vol. 2, trans. Shierry Weber Nicholsen (New York: Columbia University Press, 1992), 97. Quoted in Nicholsen, *Exact Imagination, Late Work,* 18.

135. Nicholsen, *Exact Imagination, Late Work,* 18.

136. Ibid., 6.

137. Adorno, *Minima Moralia,* 28.

138. "When Brecht or William Carlos Williams sabotages the poetic and approximates an empirical report, the actual result is by no means such an empirical report. By the polemical rejection of the exalted lyrical tone, the empirical sentences translated into the aesthetic monad acquire an altogether different quality" (Adorno, *Aesthetic Theory,* 123).

2. Merely Interesting

1. Pierre Macherey, *A Theory of Literary Production,* trans. Geoffrey Wall (London: Routledge, 1978), 3.

2. More specifically, an idea of art as determinate reflection as "form." From this moment onward, Walter Benjamin notes, "form no longer becomes the expression of beauty but an expression of art as the idea itself." This definition of form marks the first "retreat" of the "concept of beauty . . . from the Romantic philosophy of art altogether"; a retreat already heralded, in Schlegel's earlier work, by the rise of the interesting. Walter Benjamin, "The Concept of Criticism in German Romanticism," in *Selected Writings* vol. 1, *1913–1926,* ed. Marcus Bullock and Michael W. Jennings (Cambridge, MA: The Belknap Press of Harvard University Press, 1996), 116–200, 176–177.

3. Schlegel, *Seine prosaischen Jugendschriften* (Vienna, 1906), vol. 2, 426; cited in Benjamin, "The Concept of Criticism," 159. As Benjamin writes, "The immanent tendency of the work and, accordingly, the standard for its immanent criticism are the reflection that lies at its basis and is imprinted in its form." What is at stake for the romantics is thus the "foundation of a completely different kind of criticism . . . which is not concerned with judging, and whose center of gravity lies not in the evaluation of the single work but in demonstrating its relation to all other works and, ultimately, to the idea of art" (159). In this manner, for Schlegel and Novalis, criticism is the "completion, consummation, and systematization of the work" (159). Yet as Benjamin also importantly underscores, this separation of judgment from criticism (and especially the kind of judging based on formal rules) does not remove judgment from the romantic concept of criticism altogether (177). Rather, as Schlegel's epistemological aesthetic of the interesting suggests, the judgment of the work becomes implicit in the critical act of reflection itself. As Benjamin glosses, for Schlegel, "the criticizability of a work demonstrates on its own the positive value judgment made concerning it; and this judgment can be rendered not through an isolated inquiry but only by the fact of critique itself, because there is no other standard, no other criterion for the presence of a reflection than the possibility of its fruitful unfolding, which is called criticism" (159–160). In this manner, as Michael Warner notes citing the same passage, we see the first emergence of a concept of criticism which understands it as an act of "mimetic reflexivity, in which the critic is seen as making explicit a latent or hidden reflexivity in the text." Michael Warner, "Uncritical Reading," in *Polemic: Critical or Uncritical,* ed. Jane Gallop (New York: Routledge, 2004), 13–38, 17. The romantic theory of criticism (and theory of art as fundamentally criticizable) thus also leads to the first "overcoming . . . of dogmatic rationalism in aesthetics," in which form, once redefined as a determinate moment of the "absolute medium of reflection," can no longer be conceived as a "rule for judging the beauty of art" (Benjamin, "The Concept of Criticism," 158).
4. Warner, "Uncritical Reading," 17, 23.
5. Ibid., 23.
6. Indeed, Warner notes that the separation of judgment from criticism can be traced even further back to the conception of the *kritikos* in Aristotle, who "methodically distinguishes his critical judgment from the taste judgments of audiences or the publics of popular contests." Ibid., 25.
7. "Technicians of taste": Macherey, *A Theory of Literary Production,* 14; "dwindled to extinction" and the current identification of criticism with explanation and interpretation: Warren Montag, *Louis Althusser* (New York: Palgrave Macmillan, 2003), 51, 49. On the turn away from symptomatic reading, see Rita Felski, "Introduction," in *The Uses of Literature* (London: Blackwell, 2008), 1–22; Stephen Best and Sharon Marcus, "Surface Reading: An Introduction," *Representations* 108 (Fall 2009):1–21.
8. Montag, *Louis Althusser,* 51.
9. See Michel Foucault, *Archaeology of Knowledge,* trans. A. M. Sheridan Smith (New York: Routledge, 2002), 38.

10. Albert O. Hirschman, *The Passions and the Interests: Political Arguments for Capitalism before its Triumph* (Princeton, NJ: Princeton University Press, 1997), 33.

11. Isabelle Stengers, *Power and Invention: Situating Science,* trans. Paul Bains (Minneapolis: University of Minnesota Press, 1997), 85.

12. Bruno Latour, *Reassembling the Social: An Introduction to Actor-Network-Theory* (Oxford: Oxford University Press, 2007), 131.

13. Sol LeWitt notes, " 'Interests you' means it somehow makes a bridge between you and it, you and the object, you and the art object." Cited in Frances Colpitt, *Minimal Art: The Critical Perspective* (Seattle: University of Washington Press, 1993), 121.

14. Stengers, *Power and Invention,* 92.

15. Mikhail Epstein, "The Interesting," trans. Igor Klyukanov, *Qui Parle* 18.1 (2009): 75–88, 79.

16. Steven Knapp, *Literary Interest: The Limits of Anti-Formalism* (Cambridge, MA: Harvard University Press, 1993), 27.

17. Stanley Cavell stresses this compulsory aspect in his reading of Kant's aesthetic judgment. See Stanley Cavell, *Philosophy the Day after Tomorrow* (Cambridge, MA: Harvard University Press, 2005), 9, 67. See also, for an unfolding of the fuller implications of this reading of Kant, "Something out of the Ordinary," 7–27, and "Fred Astaire Asserts the Right to Praise," 61–82.

18. Cavell also speaks of his "deriving the task of criticism from Kant's portrayal of the universality and necessity of aesthetic judgment, namely as grounded in its demand of agreement with its response to its object as one of pleasure without a concept. Criticism accordingly becomes a work of determining, as it were after the fact, the grounds of (the concepts shaping) pleasure and value in the working of the object" (67).

19. Ibid., 6.

20. See Cavell, *Philosophy the Day after Tomorrow,* 9. Kant's work on aesthetic and moral judgments and Austin's ordinary-language philosophy both show how humans can exercise their rational faculties in ways not limited to the discovery of truths. Nelson Goodman and S. Chandrasekhar, among others, argue that this is the case even in science, where they claim aesthetic judgments (which are obviously not "truth-apt") have always played a role. SeeNelson Goodman, *Languages of Art: An Approach to a Theory of Symbols* (Indianapolis: Hackett, 1976), and S. Chandrasekhar, *Truth and Beauty: Aesthetics and Motivations in Science* (Chicago: University of Chicago Press, 1987).

21. Frank Sibley, *Approach to Aesthetics: Collected Papers on Philosophical Aesthetics,* ed. John Benson, Betty Redfern, and Jeremy Roxbee Cox (Oxford: Oxford University Press, 2001), 34, 35, 47.

22. Alexander Baumgarten, *Aesthetica* (Hildesheim, Georg Olms, 1961 [1750]), par. 1. Translated from the Latin by Marc Redfield, *Phantom Formations: Aesthetic Ideology and the* Bildungsroman (Ithaca, NY: Cornell University Press, 1996), 6.

23. Cavell, *Philosophy the Day after Tomorrow,* 67, 9.

24. One upshot of this is that there are no nonaesthetic features whose presence could ever rule out our judgment of something as interesting in the way in which bigness, roughness, and severe angularity rule out a judgment of something as cute. Sibley calls these "voiding characteristics," and they are a crucial way in which the justifications of aesthetic evaluations, like the evaluations themselves, fall under standards of performative happiness or unhappiness analogous to, but significantly different from, the logical standards of true or false. As in the case of complimenting, insulting, betting, cursing, condemning, and praising, justifications of feeling-based judgments cannot be said to be true or false, but the reasons one provides to support them can neutralize the act of justification or render it "infelicitous," as when, in an effort to justify my evaluation of a sculpture as cute in response to your skepticism or disagreement, I direct your attention to its threateningly enormous size, dangerously jagged edges, and cold and hard metallic casing. This act of "justification" cannot be said to be successfully completed—qua action, it never took place. More significantly, voiding characteristics make it possible for us to provide justifications for aesthetic judgments that can successfully refute or negate those of other judges. In other words, they enable me to supply reasons why I do not find the painting that you found "delicate" delicate but rather "bold" (as when I direct your attention to its large, heavily delineated swaths of saturated color placed against others of directly contrasting hue), reasons that are at least potentially capable of convincing you of the rightness of my judgment over yours. There are, however, no voiding characteristics for the judgment "interesting."

25. Friedrich Schlegel, *On the Study of Greek Poetry,* trans. and ed. Stuart Barnett (Albany: State University of New York Press, 2001), 99; hereafter abbreviated *OSGP.*

26. Giorgio Agamben, *The Man without Content,* trans. Georgia Albert (Stanford, CA: Stanford University Press, 1999).

27. "Beauty is . . . not the ideal of modern poetry; it is essentially distinct from the interesting" (Schlegel, *OSGP,* 99).

28. A. O. Lovejoy, "On the Meaning of 'Romantic' in Early German Romanticism: Part II," *Modern Language Notes* 32.2 (1917): 65–77, 72.

29. However suitable the beautiful is for alleviating this restless striving and yearning, for Schlegel it is so at one with its historical epoch that it cannot simply be reintroduced into modern use. He thus argues that critics will find it futile to appeal to beauty as a criterion for evaluating contemporary literature. Although at best the critic might find "a few exceptions" among modern writers whose work can be evaluated "to the degree to which they approximate the objective," "the *interesting* [nonetheless] remains the actual modern standard of aesthetic worth. To extend this point of view to Greek poetry is to *modernize* it. Whoever finds Homer merely interesting, desecrates him" (*OSGP,* 83).

30. As G. W. F. Hegel puts it: "Bondage to a particular subject-matter and a mode of portrayal suitable for this material alone are for artists today something past. . . . The artist thus stands above specific consecrated forms and configurations and moves freely on his own account, independent of the . . . mode of conception in which the holy and eternal was previously made visible to human apprehension." As the modern artist thus becomes a "tabula rasa," detached from any particular worldview, his productions become merely interesting. G. W. F. Hegel, *Aesthetics: Lectures on Fine Art,* trans. T. M. Knox, 2 vols. (Oxford: Oxford University Press, 1975), 1:605.

31. Translation modified by Jan Mieszkowski. See his *Labors of Imagination: Aesthetics and Political Economy from Kant to Althusser* (New York: Fordham University Press, 2006), 25.

32. Novalis, "On Goethe" #472, cited in *Classic and Romantic German Aesthetics,* ed. J. M. Bernstein (Cambridge: Cambridge University Press, 2003), 233. Another example is the form of critical writing preferred by Novalis and Schlegel themselves: the numbered series of aphorisms or fragments, written explicitly for publication in the serial form of the journal.

33. Mieszkowski, *Labors of the Imagination,* 26.

34. Ibid., 26–27.

35. "Anarchy" of modern literature: see Schlegel, *OSGP* 19, 20, 22, 29.

36. Ibid., 98–99.

37. Schlegel writes, "Schiller's treatise on sentimental poets has . . . expand[ed] my insight into the character of the poetry of interest. . . . If I had read it before this essay had been sent to the publisher, the section on the. . . . original artificiality of modern poetry would have been much less imperfect" (ibid., 97).

38. Schiller's "sentimental," Schlegel somewhat competitively implies, could in fact be regarded as a variable component of the broader aesthetic category of the "interesting." He writes, "The *sphere of interesting poetry* is not exhausted by . . . sentimental poetry, and an *analogon of style* could obtain in interesting poetry in accordance with the relation of the sentimental and characteristic" (ibid., 99; emphasis in original).

39. This conversion was again due in part, Lovejoy argues, to the influence of the intervening publication of Schiller's "On Naïve and Sentimental Poetry"; see Lovejoy, "On the Meaning of 'Romantic' in Early German Romanticism," 74.

40. Kathleen M. Wheeler, ed., *German Aesthetic and Literary Criticism: The Romantic Ironists and Goethe* (Cambridge: Cambridge University Press, 1984), 31.

41. Lovejoy, "On the Meaning of 'Romantic' in Early German Romanticism Part II," 67.

42. Leslie A. Willson, ed., *German Romantic Criticism: Novalis, Schlegel, Schleiermacher, and Others* (New York: Continuum, 1982), 108.

43. Ibid., 67. As Walter Benjamin underscores, "Hence, we are to understand . . . the essential meaning of the term 'romantic' as 'novelistic' [*romangemäss*]." Benjamin, "The Concept of Criticism," 173.

44. Ibid., 107.
45. "Eccentric oddities and failings": Schlegel, *OSGP,* 33. This shift accords with a transition noted by Anita Law in her quantitative research into the usage of "interesting" over the course of the eighteenth century in English fiction and travel writing (Anita Law, "Interesting, 1701–1800" [unpublished paper]). Although the term was predominantly associated with "subject" (as in subject matter) in the first half of the century, in particular with matters of politics, economics, law, and religion ("government policy, war, the oppressed, and one's relationship to god"), and also with what she calls "event-based nouns" (such as "circumstances"), Law argues that "from 1789 onwards interesting begins to adopt or attract a different type of noun": concrete objects like "road" in travel writing and persons or personal qualities in fiction. Bringing the findings from her research into dialogue with readings of *The Interesting Narrative of the Life of Olaudah Equiano, or Gustavus Vassa, the African: Written by Himself* and *Woman of Colour,* Law argues that by the late eighteenth century, "interesting" in English fiction becomes a way of negotiating the complex boundary between humans and objects. For this reason, Law suggests that "interesting functions as a type of personification," both in the case of things and in the case of persons positioned in the liminal space between person and thing: colonized subjects, slaves, women. It is in this particular context, she argues, that the interesting comes to mediate between experiences of familiarity and otherness: "Interesting does not just arbitrarily impose thingness onto people, or personhood onto thingness; the importance of interesting's emergence as an affective, rather than intellectual experience at this time period is that it names an experience of similarity and alterity, of person-object permeability—a disorienting feeling of eroding agency in the face of capitalism, colonialism, and empire—that could not be named because, in its newness and singularity, there was yet no language to express it" (14). On this basis, Law argues that the interesting as applied to persons, far from being objectifying and/or dehumanizing, has a strongly ethical and even Levinasian dimension that amid the recognition of familiarity nonetheless acknowledges the alterity of the other.
46. Wheeler, *German Aesthetic and Literary Criticism,* 128.
47. Benjamin, "The Concept of Criticism," 160, 175.
48. Ibid., 174–175.
49. Wheeler, *German Aesthetic and Literary Criticism,* 52, 53.
50. Ibid., 50.
51. Ibid., 108.
52. Although Schlegel admits to preferring "arabesques" such as Cervantes's *Don Quixote,* Diderot's *Jacques the Fatalist,* and Sterne's *Tristram Shandy* to the novels of Richardson and Fielding. See Friedrich Schlegel, "On Incomprehensibility" and "Athenaeum Fragments," in Wheeler, *German Aesthetic and Literary Criticism,* 32–40 and #116, 46–47. See also Schlegel, "Critical Fragments," in *German Aesthetic and Literary Criticism,* #117, 44: "Poetry can be criticized only by way of poetry. A critical judgment of an artistic production has no civil rights in the realm of art if it isn't itself a work of

art." For an excellent overview of all the various aspects of the German romantic literary project, see Wheeler, introduction to *German Aesthetic and Literary Criticism*, 1–27.

53. Ibid., 49.

54. Ibid., 109.

55. Willson, *German Romantic Criticism*, 110.

56. Wheeler, *German Aesthetic and Literary Criticism*, 64 and 65. What makes *Wilhelm Meister* "interesting" in particular is the way in which its episodic form demands a constant negotiation between part and whole; although readers are likely to be "uneasy" about the "differing nature of the individual sections," Schlegel notes, "the reader who possesses a true instinct for system, who has that sense of totality or that anticipation of the world in its entirety which makes [the character] Wilhelm so interesting, will be aware throughout the work of what we might call its personality and living individuality" (ibid., 65).

57. Wheeler, introduction to *German Aesthetic and Literary Criticism*, 2.

58. G. W. F. Hegel, *Introductory Lectures on Aesthetics,* trans. Michael Inwood and Bernard Bosanquet (New York: Penguin, 2004), 72. As in the case of the interesting, an experience of the "more" or "greater" that leads not to objective meaning but to subjective individuality, romantic irony for Hegel reflects that "concentration of the I into itself for which all bonds are broken."

59. Ibid., 72, 70.

60. For a more detailed commentary on Hegel's indictment of the interesting, see Edgar Wind, *Art and Anarchy: The Reith Lectures, 1960* (New York: Alfred A. Knopf, 1963), 11–15.

61. Hegel is emphatic: the work of art "should put before our eyes a content, not in its universality as such, but one whose universality has been absolutely individualized and sensuously particularized." G. W. F. Hegel, *Aesthetics: Lectures on Fine Art,* trans. T. M. Knox, 2 vols. (Oxford: Oxford University Press, 1975), 1:51.

62. Benjamin H. D. Buchloh, "Conceptual Art, 1962–1969: From the Aesthetic of Administration to the Critique of Institutions," in *Conceptual Art: A Critical Anthology,* ed. Alexander Alberro and Blake Stimson (Cambridge, MA: MIT Press, 1999), 519.

63. "Abstract proposition": Hegel, *Aesthetics,* 51. "The more poetry becomes science, the more it also becomes art. If poetry is to become art, if the artist is to have a thorough understanding and knowledge of his ends and means, his difficulties and his subjects, then the poet will have to philosophize about his art" (Schlegel, *Athenaeum* #255, in Wheeler, *German Aesthetic and Literary Criticism,* 50).

64. Willson, *German Romantic Criticism*, 120.

65. Wheeler, *German Aesthetic and Literary Criticism*, 49 and 50.

66. Silvan Tomkins, *Affect, Imagery, Consciousness,* 4 vols. (New York: Springer, 1962–1992), 1:347.

67. William James, *The Principles of Psychology,* 2 vols. (1890) (New York: Dover, 1950), 1:403. I am indebted to Joe DiMuro for this reference.

68. It could be argued that this attachment which particularizes the object (making it legible or accessible to experience) also, in doing so, particularizes itself; interest in a moral dilemma thus becomes a distinctively ethical interest; interest in authorial agency becomes a distinctively literary interest. The object that the feeling of interest "selects" seems to have the power to define the kind of interest we will want to say it always was. This susceptibility to immediate qualification by its object seems unique to the indeterminate feeling of interest. We do not, for example, particularize fear or joy based on the kinds of objects to which these feelings attach; we speak of ethical versus literary interest, but not of mountain lion versus thunderstorm fear. Interest is thus not just an objectively particularizing feeling, but a self-particularizing one. As the affect that underpins the interesting, an aesthetic experience of difference from kinds, it seems explicitly to invite us to differentiate *it* into kinds.

69. Edmund Husserl, *Experience and Judgment,* trans. James Spencer Churchill and Karl Ameriks (Evanston, IL: Northwestern University Press, 1975), 82.

70. Ambiguous and minimal though it may be, the interesting thus refers directly to our powers of cognition in a way in which the cute and the zany do not. Its temporalization reminds us that the perception of aesthetic form is not entirely separate from the activity of cognition, even if it eludes the grasp of determinative judgments. As Husserl underscores, there is nothing passive about the perception of the object of interest, just as for Kant (as read by Rodolphe Gasché), "form" is meant primarily as an activity that a subject performs rather than a thing that she perceives. See Rodolphe Gasché, *The Idea of Form: Rethinking Kant's Aesthetics* (Stanford, CA: Stanford University Press, 2003). This is all the more so given that Husserl eventually distinguishes the continuous, uninterrupted turning of the ego toward an object as "theme" from a "broader concept of interest" that would include it: one in which "acts of interest" are to be understood as "not only those in which I am turned thematically toward an object, perceiving it, perhaps, and then examining it thoroughly, but in general every act of the turning-toward of the ego, whether transitory or continuous, every act of the ego's being-with *(interesse)*" (ibid., 86). This split between intense, engaged "thematic" interest and a more general interest that also includes a more transient mode mirrors how the interesting seems to teeter always between attention and distraction. Although Husserl stresses that the intention of "turning-toward" is not yet volitional but rather "a moment of the striving which belongs to the essence of normal perception," he adds that at a "higher level, this striving can also take the form of a true act of will, a *will to knowledge*" (86; emphasis in original). He further clarifies that "the reason we speak of interest here is that a *feeling* goes hand in hand with this striving, indeed a positive feeling, which, however, is not to be confused with a pleasure taken in the object" since objects can also awaken interest when they are "disvalued" or have "abhorrent qualities" (85; emphasis in original).

71. Mieszkowski, *Labors of Imagination,* 112.

72. Epstein, "Interesting," 86.

73. Mieszkowski, *Labors of Imagination,* 113. Anita Law suggests something similar to this last point in her reading of *The Interesting Narrative of the Life of Olaudah Equiano,* arguing that "interesting" in the text is often deployed as an affective interface between colonized and colonizer (two people connected by an "interesting" object, or by aesthetic pleasure in the same object), and thus as a way of enabling the reader to "elide and smooth over difference" in a not entirely oppressive way. Law, "Interesting, 1701–1800," 12.

74. Mieszkowski, *Labors of Imagination,* 113.

75. See Sigmund Freud, "The Libido Theory" (1923), in *General Psychological Theory,* ed. Philip Rieff (New York: Collier, 1963), 180–184.

76. Teresa Brennan, *The Transmission of Affect* (Ithaca, NY: Cornell University Press, 2004), 128, 131.

77. Ibid., 105; emphases added.

78. Ibid., 24. However, it is intriguing to note how, just as politicians and economists talk frequently about interests but much less frequently about the interesting, Schlegel talks about the interesting without mentioning interest or interests. This suggests a certain uncoupling of the meanings of these two terms, or perhaps an explicit effort to distance them on Schlegel's part.

79. Brennan's account of a nonparticularized, zero-degree feeling, radically detached from and thus able to assist in the subject's recognition and qualitative differentiation of other feelings, thus assigns it the role of linking affect and cognition. Lyotard isolates a similarly indeterminate "feeling" that "orientate[s]" critical thought in his reading of Kant's theory of aesthetic judgment qua reflective judgment, in which a missing universal or rule must be found for a given particular, in contrast to "determining" judgments, in which particulars are subsumed under a rule already given. See Jean-François Lyotard, *Lessons on the Analytic of the Sublime: Kant's Critique of Judgment,* trans. Elizabeth Rottenberg (Stanford, CA: Stanford University Press, 1994), 7. As Lyotard glosses, Kant saw that aesthetic pleasure discloses something about "reflection" and therefore "critical thought" (which is by definition reflective since "it does not already have the concepts it seeks to use") that teleological judgments (also reflective) cannot (6). This is because aesthetic judgment—which "considered from the point of view of the 'soul' [as pure pleasure] has no claim to knowledge and . . . nothing other than itself to pursue"—represents reflective judgment in its most minimal state. Because "in aesthetic judgment, reflection is . . . stripped of its objective, teleological function," it holds the "secret of the 'manner' (rather than the method) in which critical thought proceeds in general" (6). What is this "manner"? "Thought must 'linger,' must suspend its adherence to what it thinks it knows. It must remain open to what will orientate its critical examination: a feeling" (7). Already in Kant, then, as Lyotard's gloss stresses, feeling seems mixed up with the operations of reflective thought, even though Kant repeatedly reminds us that aesthetic reflection "contributes nothing to the cognition of its object . . . [but] must only be allocated to the critique of the judging subject," or to a delimitation of her powers. See Kant, Introduction ¶VII to *Critique of Judgment;* cited in Lyotard, 5.

The minimal, indeterminate feeling underlying our contemporary judgments of the interesting is perhaps similar to this unqualified feeling that enables thought to "linger" in a manner that helps "orientate ... critique." Lyotard glosses: "Any act of thinking [for Kant] is ... accompanied by a feeling [of pleasure or displeasure] that signals to thought its 'state.' But this state is nothing other than the feeling which signals it" (11). The reflection that underlies critical thought is thus "first and foremost the ability of thought to be immediately informed of its state by this state and without other means of measure than feeling itself." It is thus disclosed in a unique way by aesthetic judgment, which in its basis on feeling rather than concepts "reveals reflection in its more 'autonomous' state, *naked,* so to speak" (6; emphasis in original). Similarly, the unqualified feeling of interest that underpins the interesting might be said to reveal it as aesthetic judgment in *its* most naked or minimal state, which perhaps explains why the interesting raises theoretical questions about feeling-based judgment—its essentiality or nonessentiality to aesthetic experience, its ambiguous relation to concept-based judgments, its relevance or lack thereof to critical interpretation—in a way in which other aesthetic categories in our contemporary repertoire do not.

80. Ralph Barton Perry, *General Theory of Value: Its Meaning and Basic Principles Construed in Terms of Interest* (Cambridge, MA: Harvard University Press, 1954), 115. For accounts of Perry's theory of interest and its influence on minimalist sculptor Donald Judd (who explicitly embraced "interesting" as an aesthetic standard for art), see David Raskin, "Judd's Moral Art," in *Donald Judd,* ed. Nicholas Serota (London: Tate Publishing, 2004), 79–95, and James Meyer, *Minimalism: Art and Polemics in the 1960s* (New Haven, CT: Yale University Press, 2001), 140–141.

81. Curiosity has been regarded as this drive behind theory by both pre- and post-Enlightenment philosophers. See Hans Blumenberg, *The Legitimacy of the Modern Age,* trans. Robert M. Wallace (Cambridge, MA: MIT Press, 1985). Perry, *General Theory of Value,* 115.

82. Perry, *General Theory of Value,* 115.

83. Cavell, *Philosophy the Day after Tomorrow,* 11.

84. Which is why Silvan Tomkins refers to the affect of interest, particularly in its ability to lead to startle ("which in turn evokes further interest") as a "double take" (*Affect, Imagery, Consciousness* 1:339). Edgar Wind suggests something to the same effect, quoting Thomas Love Peacock in *Headlong Hall* (1816): "'Pray, sir, by what name do you distinguish this character when a person walks round the grounds for the second time?" Wind, *Art and Anarchy,* 116 n. 20.

85. Philip Fisher, *Wonder, the Rainbow, and the Aesthetics of Rare Experiences* (Cambridge, MA: Harvard University Press, 1998), 1. See also Karl Heinz Bohrer, *Suddenness: On the Moment of Aesthetic Appearance,* trans. Ruth Crowley (New York: Columbia University Press, 1994).

86. Tomkins, *Affect, Imagery, Consciousness,* 1:348.

87. Ibid., 363, 349.

88. As Pamela Lee notes in *Chronophobia,* ongoingness is a kind of time as equally associated with Fernand Braudel's *longue durée* as with Hegel's idea of bad infinity. This relationship is the central focus of Lee's reading of Michael Fried's "Art and Objecthood" and her overview of the art of the 1960s in general. See Lee, *Chronophobia: On Time in the Art of the 1960s* (Cambridge, MA: MIT Press, 2006), 260–308.

89. Lyotard, *Lessons on the Analytic of the Sublime,* 55, 64.

90. Its simultaneously forward and backward temporal orientation would most likely be viewed by Perry as resulting directly from the feeling of interest, which he describes as an attunement between "expectation" and the "unfulfilled phases of a governing propensity . . . which is at any given time in control of [our] organism as a whole" (*General Theory of Value,* 183). On the "feeling of incompleteness" in relation to modern obsession and compulsion (and their temporalities), see Jennifer Fleissner, *Women, Compulsion, Modernity: The Moment of American Naturalism* (Chicago: University of Chicago Press, 2004), 61.

91. Perry, *General Theory of Value,* 250, 183.

92. Goodman, *Languages of Art,* 99–126. It is worth noting that this "forward reference in time" is also visible in the economic idea of interest as monetary appreciation.

93. The style of the "interesting" as theorized by Schlegel is relativistic in the sense of being an aesthetic about difference and comparative individuation; the judgment of the interesting, qua aesthetic judgment, is not. Although the interesting always implies the possibility of a future encounter with the object in which one's original evaluation of it might be revised, to call an object interesting is still to claim that it is objectively interesting. Indeed, to judge an object interesting is to claim that everyone who encounters it will have precisely this feeling, precisely this expectation of a future encounter in which his or her original evaluation of it might be revised. This claim for universal validity even in the absence of criteria (which for Kant is what finally separates aesthetic judgments from judgments of taste) may seem hard to reconcile with the suspicion that the aesthetic judgment of the interesting is specific to restricted discursive communities. I will be addressing this problem at the very end of this chapter.

94. The link between the interesting and the transitory is also implied in Gotthold Lessing's *Laokoon* in the course of his arguments about the significant differences between modern literature and classical art, including the way the former is not limited or reducible to the representation of the beautiful. Calling attention to plastic art's unfitness for depicting transitory states and its concomitant preference for depicting completed actions, Lessing gives the following example: "When, for instance, Laokoon sighs, imagination can hear him cry; but if he cries, imagination can neither mount a step higher, nor fall a step lower, without seeing him in *a more endurable, and therefore less interesting,* condition" (III, 124, my emphasis). Lessing thus implies that (1) "interesting" is an antonym for "endurable" and thus a synonym for "transitory," and (2) it is modern poetry or literature, in explicit contrast to

classical sculpture, that gives rise to the interesting, for as an art of transition, poetry/literature is particularly equipped to represent mixed, composite, or contradictory states: "The poet alone possesses the art of . . . combining negative with positive traits as to unite two appearances in one. . . . Must the poet abstain from the use of this device because artists are debarred from it? If painting claim to be the sister of poetry, let the younger at least not be jealous of the elder, nor seek to deprive her of ornaments unbecoming to her" (VIII, 125). Gotthold Lessing, *Laocoon*, trans. Ellen Frothingham (Latin), William Cullen Bryant (Greek) (New York: Farrar, Straus and Giroux, 1957 and 1965), excerpted in *Aesthetics: A Comprehensive Anthology*, ed. Steven M. Cahn and Aaron Meskin (Oxford: Blackwell Publishing, 2007), 124.

95. As Fisher writes, "With the sublime we have for two hundred years built up a more and more intricate theory for a type of art that we do not actually have and would not care for if we did have it" (Fisher, *Wonder*, 3).

96. Immanuel Kant, *Critique of Judgment*, trans. J. H. Bernard (New York: Hafner, 1951), 45.

97. For a more probing account of how the dialectic between the interesting and the boring becomes especially problematic for feminism and other political discourses invested in timeliness ("which inevitably embroils [feminism] in the relation among novelty, interest, and merit that characterizes modernity"), see Jane Elliott, "The Currency of Feminist Theory," *PMLA* 121 (October 2006): 1697–1703, 1700.

98. Agamben, *Man without Content*, 4.

99. "'That is beautiful,' said Kant, 'which gives us pleasure without interest.' Without interest! Compare with this definition one framed by a genuine 'spectator' and artist—Stendhal, who once called the beautiful *une promesse de bonheur*. At any rate he *rejected* and repudiated the one point about the aesthetic condition which Kant had stressed: *le désinteressement*. Who is right, Kant or Stendhal?" (Friedrich Nietzsche, quoted in Agamben, *Man without Content*, 1–2; emphasis in original). Nietzsche's tone underscores the counterintuitive way in which the interesting poses a challenge to disinterestedness from the perspective of affective weakness, for, as the following comment by Antonin Artaud similarly illustrates, the critique of "disinterested pleasure" most often tends to be made with emotional vehemence on behalf of the same: "To our disinterested and inert idea of art an authentic culture opposes a violently egoistic . . . i.e., *interested* idea." Antonin Artaud, *The Theater and Its Double*, trans. Mary Caroline Richards (New York, Grove Press, 1994), 10–11; cited in Agamben, *Man without Content*, 2–3 (emphasis in original). To Nietzsche's and Artaud's critiques of disinterestedness with and on behalf of strong feeling, we could add Pierre Bourdieu's, for whom the "pure" judgment of taste is so inextricably tied to class interests in the reproduction of invidious distinctions that disinterested "taste" comes to resemble its emotionally vehement opposite: distaste or disgust at the tastes of others. See Pierre Bourdieu, *Distinction: A Social Critique of the Judgment of Taste*, trans. Richard Nice (Cambridge, MA: Harvard University Press, 1984), 38. It is worth noting that Bourdieu features "interesting," along with "beautiful,"

"ugly," and "meaningless," as one of the four possible options for response in his surveys of French working-class tastes in *Distinction*.

100. On this topic, see Mark McGurl, *The Novel Art: Elevations in American Fiction after Henry James* (Princeton, NJ: Princeton University Press, 2001), and Dorothy Hale, *Social Formalism: The Novel from Henry James to the Present* (Stanford, CA: Stanford University Press, 1998).

101. Henry James, "The Art of Fiction," in *The Critical Muse: Selected Literary Criticism* (New York: Penguin, 1987), 191.

102. Ibid., 195.

103. James is quoting George Eliot: "In these frail vessels is borne onward through the ages the treasures of human affection." Henry James, preface to *The Portrait of a Lady*, ed. Patricia Crick and Geoffrey Moore (New York: Penguin Classics, 2003), 48. On the metaphor of the "house of fiction" and James's worry about the ability of the "mere slim shade of a presumptuous girl" to provide a sufficiently ample "subject" for it, see 47–51.

104. Ibid., 47. A Google search reveals 52 instances of "interest" or "interests," 31 instances of "interested," and 89 instances of "interesting" in *The Portrait of a Lady* (including the preface): 172 mentions of some variant of the word overall. This is roughly equal to the total number of references to "marriage," "marry," or "married": 171. If Schlegel seemed to make a deliberate effort to sever the concept of interesting from interests (perhaps in keeping with his effort to establish the former as an aesthetic category in the first place), this is clearly not the case for James.

105. Felski, *Beyond Feminist Aesthetics: Feminist Literature and Social Change* (Cambridge, MA: Harvard University Press, 1989), 84. Perhaps because of their status as historical subjects for whom this tension between the possible and the actual would seem especially acute in their own time, the most "interesting" characters in James's novels tend to be middle-class white women.

106. Epstein, "Interesting," 82.

107. Latour, *Reassembling the Social*, 45.

108. Mieszkowski, *Labors of Imagination*, 114.

109. Raymond Williams, *Keywords: A Vocabulary of Culture and Society*, rev. ed. (New York: Oxford University Press, 1985), 172–173; cited in Epstein, "Interesting," 81.

110. James, "Art of Fiction," 191–192.

111. Gertrude Stein, "Henry James," in *Gertrude Stein: Writings, 1932–1946 (Stanzas in Meditation, Lectures in America, The Geographical History of America, Ida, Brewsie and Willie, Other Works)*, ed. Catherine R. Stimpson (New York: Library of America, 1998), 153.

112. Uvedale Price, *Essays on the Picturesque*, ed. T. D. Lauder (1842, first published in 1794, revised and expanded 1810); cited in Wind, *Art and Anarchy*, 116 n. 20. To think further about the relation between the interesting and the picturesque (and the relation between the interesting and surprise), we might also examine, as Wind suggests in the same note, the following exchange from Thomas Love Peacock's satirical *Headlong Hall* (1816):

"Sir," said Mr. Milestone, "you will have the goodness to make a distinction between the picturesque and the beautiful."

"Will I?" said Sir Patrick, "och! but I won't. For what is beautiful? That what pleases the eye. And what pleases the eye? Tints variously broken and blended. Now, tints variously broken and blended constitute the picturesque."

"Allow me," said Mr. Gall. "I distinguish the picturesque and the beautiful, and I add to them, in the laying out of grounds, a third and distinct character, which I call *unexpectedness.*"

"Pray, sir," said Mr. Milestone, "by what name do you distinguish this character, when a person walks round the grounds for the second time?"

Mr. Gall bit his lips, and inwardly vowed to revenge himself on Milestone, by cutting up his next publication.

As that which includes surprise but immediately tempers it with repetition, "interesting" would seem to be a perfect retort for Gall to use against Milestone's catty challenge to his idea of an aesthetic of "unexpectedness." See Thomas Love Peacock, *Headlong Hall* (Middlesex: Echo Library, 2003), 25–26.

113. Mikhail Bakhtin, *The Dialogic Imagination: Four Essays,* trans. Caryl Emerson and Michael Holquist (Austin: University of Texas Press, 1982), 260.
114. I am indebted to Mark Goble for this point.
115. James, "Art of Fiction," 187.
116. Peter Brooks, *The Melodramatic Imagination: Balzac, Henry James, Melodrama, and the Mode of Excess* (New Haven, CT: Yale University Press, 1995), 13, 14.
117. Susan Sontag, "Nathalie Sarraute and the Novel," in *Against Interpretation: And Other Essays* (New York: Picador, 2001), 101.
118. Wayne Booth continues this tradition by proposing "interesting" as a "general criterion" for evaluating narrative fiction in *The Rhetoric of Fiction* (Chicago: University of Chicago Press, 1983), 124.
119. Susan Sontag, *On Photography* (New York: Picador, 2001), 111.
120. Ibid., 175.
121. Jacques Rancière, *The Future of the Image,* trans. Gregory Elliott (London: Verso, 2007), 16.
122. Roland Barthes, *Camera Lucida: Reflections on Photography,* trans. Richard Howard (New York: Hill and Wang, 1981), 26.
123. Ibid., 10.
124. For Rancière, the very opposition between the image as "raw material presence" and "discourse encoding history" underlying *Camera Lucida*'s misguided opposition of *punctum* to *studium*—an opposition that we might describe further as that between two temporalities, the sudden and the ongoing—was already historically obsolete by the nineteenth century, thanks in part to the emergence of the new "commerce in social imagery" that made *studium* possible: a joint production of newspapers, advertising, encyclopedias, and other widely circulated or distributed media, including the realist

novel, devoted to "creating around market products a halo of words and images that made them desirable; [and] assembling, thanks to mechanical presses and the new procedure of lithography, an encyclopedia of shared human inheritance: remote life-forms, works of art, popularized bodies of knowledge" (*Future of the Image*, 16). What followed was a more systematic exchange between art and this "major trade in collective imagery"; thus, in tandem with the launching of the "*Magasin pittoresque* and the physiognomies of the student, the lorette, the smoker, the grocer, and every imaginable social type," Balzac and Dickens began making "decoding signs written on stone, clothes and faces the motor of novelistic action" (16). The nineteenth century thus "witnesses an unlimited proliferation of the vignettes and little tales in which a society learns to recognize itself . . . by transposing the artistic practices of the image . . . into the social negotiation of resemblances. Balzac and a number of his peers had no hesitation about engaging in this exercise, ensuring the two-way relationship between the work of literature's images and manufacturing the vignettes of collective imagery" (16).

What the new intercourse between "artistic images" and the circulation of "social imagery" itself gives rise to, Rancière suggests, is the critical practices of Marx and Freud, who "sought to apply the procedures of surprise and decoding initiated by the new literary forms" precisely to the new "flood of social and commercial images." Just as "Balzac taught us to decipher a history on a wall or an outfit and enter the underground circles that contain the secret of social appearances," Rancière writes, "Marx teaches us to decipher the hieroglyphs written on the seemingly a-historical body of the commodity and to penetrate into the productive hell concealed by the words of economics" (17). The new exchange between the images of literature and society's "major trade in collective imagery" thus gives rise in turn to a remarkable "solidarity" between three kinds of activity: the "operations of art, the modes of circulation of imagery, and the critical discourse that refers the operations of the one and the forms of the other to their hidden truth" (18). We thus find the serial, generic, discursive, informational aesthetic of the merely interesting (Barthes's *studium*) not only at the conjunction of photography and the realist novel but also at the nexus of an increasingly intimate relationship between art, aesthetic judgment, and criticism. No other aesthetic category in our current repertoire points to this particular intersection.

125. Jack Burnham, "Systems Esthetics," in *Esthetics Contemporary,* ed. Richard Kostelanetz (Buffalo: Prometheus Books, 1978), 160–171, 165.

126. Liz Kotz, *Words to Be Looked At: Language in 1960s Art* (Cambridge, MA: MIT Press, 2007), 217.

127. Schlegel, *OSGP,* 20.

128. Burnham, "Systems Esthetics," 165. In 1970 Burnham organized the exhibition *Software: Information Technology; Its New Meaning for Art* for the Jewish Museum in New York.

129. Buchloh, "Conceptual Art, 1962–1969," 519.

130. Donald Kuspit, "Sol LeWitt: The Look of Thought," *Art in America* 63 (1975): 42–49. In contrast to Kuspit's account, Rosalind Krauss argues that

LeWitt's work was actually an obsessional parody of rationality in "LeWitt in Progress," *October* 6 (Fall 1978): 46–60; reprinted in Rosalind E. Krauss, *The Originality of the Avant-Garde and Other Modernist Myths* (Cambridge, MA: MIT Press, 1986). For an interesting reading of this debate, see Nicholas Baume, "The Music of Forgetting," in *Sol LeWitt: Incomplete Open Cubes,* ed. Baume (exhibition catalog, Wadsworth Atheneum, Hartford, CT, January 26–April 29, 2001), 21–22.

131. Mel Bochner, "The Serial Attitude," in Alberro and Stimson, *Conceptual Art,* 22–27, 26.

132. Burnham, "Systems Esthetics," 165.

133. Ed Ruscha, *Leave Any Information at the Signal: Writings, Interviews, Bits, Pages,* ed. Alexandra Schwartz (Cambridge, MA: MIT Press, 2002), 193.

134. Ibid., 29.

135. Buchloh, "Conceptual Art, 1962–1969," 520.

136. Gregory Bateson, *Steps to an Ecology of Mind: Collected Essays in Anthropology, Psychiatry, Evolution, and Epistemology* (Chicago: University of Chicago Press, 1972), 318.

137. Niklas Luhmann, *The Reality of the Mass Media,* trans. Kathleen Cross (Stanford, CA: Stanford University Press, 2000), 27.

138. Sol LeWitt, "Serial Project #1, 1966," *Aspen Magazine* 5–6 (1967), www .ubu.com/aspen/ aspen5and6/serialProject.html (accessed 2/3/2009).

139. Thomas Crow, *Modern Art in the Common Culture* (New Haven, CT: Yale University Press, 1996), 216. See Jeff Wall, "Dan Graham's Kammerspiel," in Alberro and Stimson, *Conceptual Art,* 504–513.

140. Crow, *Modern Art in the Common Culture,* 216.

141. Ibid., 217.

142. See Alan Liu, *The Laws of Cool: Knowledge Work and the Culture of Information* (Chicago: University of Chicago Press, 2004).

143. However, as an unequivocally positive judgment, "cool" significantly lacks the affective ambivalence of "interesting."

144. Buchloh, "Conceptual Art, 1962–1969," 519; emphases added.

145. Franco Moretti, *Signs Taken for Wonders: On the Sociology of Literary Forms* (London: Verso, 1983), 141.

146. Luhmann, *Reality of the Mass Media,* 50, 22.

147. Moretti, *Signs Taken for Wonders,* 141.

148. Luhmann, *Reality of the Mass Media,* 28.

149. Henri Man Barendse, "Ed Ruscha: An Interview," *Afterimage* 8.7 (February 1981): 8–10; reprinted in Ruscha, *Leave Any Information,* 215.

150. Dan Graham, *Eleven Sugar Cubes* and *Some Photographic Projects* (1970); Ira Haber, *36 Houses* (1970); Max Kozloff, "9 in a Warehouse," review, *Artforum* 7 (1969): 38–42; Mel Bochner, *Seven Translucent Tiers* (1967); *Art in Los Angeles—Seventeen Artists in the Sixties,* Los Angeles County Museum of Art (1981); Richard Olsen, *Sixteen Sentences* (1970); Allan Ruppersberg, *23 Pieces* (1970); Joe Tilson, "Five Questions Answered," *Art and Artists* (1969): 34–35; Rosemary Mayer, *41 Fabric Swatches* (1969); William Wegman, *3 Speeds, 3 Temperatures* (1970); Lawrence Wiener, *10*

Works (1971); Sol LeWitt, *46 3-Part Variations on 3 Different Kinds of Cubes* (1968).

151. John Coplans, "Concerning *Various Small Fires*: Edward Ruscha Discusses His Perplexing Publications," *Artforum* 5 (February 1965): 24–25; reprinted in Ruscha, *Leave Any Information*, 25.

152. Willoughby Sharp, "'. . . A Kind of a Huh': An Interview with Ed Ruscha," *Avalanche* 7 (Winter–Spring 1973): 30–39; reprinted in Ruscha, *Leave Any Information*, 64–72, 65.

153. Ibid.

154. Ed Ruscha, "Statement in Henry Hopkins, Fifty West Coast Artists," in Ruscha, *Leave Any Information*, 10.

155. Luhmann, *Reality of the Mass Media*, 28.

156. Henry James, "Preface to *The Awkward Age*," in *The Art of the Novel: Critical Prefaces by Henry James* (New York: Charles Scribner's Sons, 1934), 111. Although Richard Wollheim puts the stress on medium rather than genre per se, he underscores the same link, distinguishing "evaluations of interest" from "evaluations of quality" on the basis that whereas the latter "do not presuppose any specific . . . understanding of the art to which the work in which quality is found belongs," judgments of artworks as "interesting" exclusively "are made within, and are intended only to hold within, the framework of a given art." Richard Wollheim, "Why Is Drawing Interesting?" *British Journal of Aesthetics* 45 (January 2005): 3.

157. In 1982, Ruscha noted, "I've always felt that being an artist is more or less doing a variation on a theme. The work I'm doing now is just a variation on work I was doing 25 years ago" (*Leave Any Information*, 240). This is an accurate self-description. Indeed, Ruscha's entire career could be described as variations on themes generated from variations on the original übertheme of "variation on a theme" inaugurated by *Twentysix Gasoline Stations*. For example, the series of word paintings from the mid-1970s that includes *Sand in the Vaseline* (1974) and *Vanishing Cream* (1973), in which liquids like blueberry extract and cherry juice were used to dye fabrics such as moiré, rayon crepe, and satin (each word taking the form of a stain), was clearly a variation on the earlier *News, Mews, Pews, Brews, Stews, and Dues* (1970), a portfolio of screenprints made with axle grease, pie filling, raw eggs, and chocolate syrup. *News* itself is a variation on the earlier project *Stains* (1969), a boxed edition of seventy-five sheets of paper stained with materials used to remove images (bleach and spot remover, among others), as well as salad dressing, chocolate syrup, castor oil, mustard, and motor oil (152). Described by Ruscha as a "book" (154) and originally intended to be distributed as one, *Stains* in turn might be characterized as a variation on the photography books from the 1960s.

Similarly, the gritty "metro plots," that Ruscha began making with dots of acrylic paint near the turn of the century, such as *Gower, Beachwood, Franklin* (1998), are clearly variations on his series of graphite drawings of apartment facades from the mid-1960s, such as *Wilshire Blvd.* (1965), as well as the gunpowder-on-paper images of white paper strips coiled into

three-dimensional, vertically free-standing shapes of words, like *City* (1967), toward the end of the decade. Ruscha notes, "Streets are like ribbons . . . and they're dotted with facts. Fact ribbons I guess. That's subject matter to me" (transcribed from *LA Suggested by the Art of Ed Ruscha*, film produced and directed by Gary Conklin, 28 minutes, Mystic Fire Video, 1981; reprinted in *Leave Any Information*, 220–224, 224). Both the ribbons and the metro plots play on the themes of horizontality and urban sprawl that we see preoccupying Ruscha already in *Some Los Angeles Apartments, Real Estate Opportunities, Every Building on the Sunset Strip* (which folds out accordion-style into an actual paper strip dotted with buildings 27 feet long), and, of course, *Twentysix Gasoline Stations*. Like the strip in *Strip*, even the long, skinny oil paintings about time and space that Ruscha began making in the 1980s seem to unfurl from *Gasoline Stations: Five Past Eleven* (1989), roughly 5 feet high and just over 12 feet long; and, even more exaggerated in proportion, *Industrial Village and Its Hill* (1982) and *Ancient Dogs Barking—Modern Dogs Barking* (1980), which are less than 2 feet high and over 13 feet long. In their insistent horizontality, which suggests "the element of motion—traveling, covering space, a journey—and then the time that it takes to move" (Paul Karlstrom, "Interview with Ed Ruscha," California Oral History Project, Archives of American Art, Smithsonian Institution, October 29, 1980; March 25, 1981, July 16, 1981; October 2, 1981; edited and published for the first time in Ruscha, *Leave Any Information*, 172), these last "variations" point back to the importance of time, space, and the particular mode of their compression by modern transportation systems in Ruscha's works from the early 1960s. Just as "all [of them]] possess a ground line, a landscape line that is actually horizontal, all the way through," this horizontality has continued to inform what Ruscha calls "the highway of [his] work" in the present (*Leave Any Information*, 265): "I've always had this side-to-side paint action. I'm sort of a prisoner of this quasi-landscape idea anyway . . . horizontals that get into brushstrokes, that get into everything, and I guess that's what my work is made of" (275).

158. André Parinaud, "Interview with Daniel Buren," trans. Lucy Lippard, in *Six Years: The Dematerialization of the Art Object from 1966 to 1972 . . .*, ed. Lucy Lippard (1973) (Berkeley: University of California Press, 1997), 41–42.

159. Coplans, "Concerning *Various Small Fires*," 25.

160. Bernard Brunon, "Interview with Edward Ruscha," in Ruscha, *Leave Any Information*, 251.

161. Patricia Failing, "Ed Ruscha, Young Artist: Dead Serious about Being Nonsensical," in Ruscha, *Leave Any Information*, 228.

162. Sol LeWitt, "Paragraphs on Conceptual Art," *Artforum* 5 (Summer 1967): 83; reprinted in Alberro and Stimson, *Conceptual Art*, 12–16.14.

163. Krauss, *Originality of the Avant-Garde*, 253.

164. On the resistance to seeing temporal form as "form," see Stanley Fish, "Interpreting the Variorum," in *Is There a Text in This Class? The Authority of Interpretive Communities* (Cambridge: MA: Harvard University Press, 1982),

155; Peter Brooks, *Reading for the Plot: Design and Intention* (Cambridge, MA: Harvard University Press, 1992), 319; and Catherine Gallagher, "Formalism and Time," *Modern Language Quarterly* 61 (March 2000): 229–251.

165. David Hockney and Larry Rivers, "Beautiful or Interesting?" in *Theories and Documents of Contemporary Art: A Sourcebook of Artists' Writings,* ed. Kristine Stiles and Peter Selz (Berkeley: University of California Press, 1996), 224–225; emphases added.

166. Coplans, "Concerning *Various Small Fires,*" 24.

167. Lewis MacAdams, "Catching Up with Ed Ruscha," in Ruscha, *Leave Any Information,* 239.

168. Mary Ann Doane, *The Emergence of Cinematic Time: Modernity, Contingency, the Archive* (Cambridge, MA: Harvard University Press, 2002), 10.

169. Barendse, "Ed Ruscha," 8–10; reprinted in Ruscha, *Leave Any Information,* 213.

170. Luhmann, *Reality of the Mass Media,* 25.

171. David Boudon, "Ruscha as Publisher [or All Booked Up]," *Art News* 71 (April 1972): 32–36, 68–69; reprinted in Ruscha, *Leave Any Information,* 40–45, 41.

172. Ruscha's "fact ribbons" are also readable as efforts to give form to this invisible activity by similarly uniting the time-spaces of transportation and communication systems. In addition to referring to streets and highways, "fact ribbon," with its image of strips of paper coiled into words, suggests ticker tape, the continuously fed paper ribbon printed with stock quotations, as well as the columns of information in real estate, business, or classified sections of newspapers.

173. A. D. Coleman, "My Books End Up in the Trash," *New York Times,* August 27, 1972, D12; reprinted in Ruscha, *Leave Any Information,* 46–47.

174. Luhmann, *Reality of the Mass Media,* 28.

175. Ibid.

176. Willoughby Sharp, "'A Kind of a Huh': An Interview with Ed Ruscha," 66.

177. Pierre Bourdieu, "The Market for Symbolic Goods," in *The Rules of Art: Genesis and Structure of the Literary Field,* trans. Susan Emanuel (Stanford, CA: Stanford University Press, 1996), 141–173.

178. Alexander Alberro, *Conceptual Art and the Politics of Publicity* (Cambridge, MA: MIT Press, 2004).

179. Sam Hunter, introduction to *The Harry N. Abrams Family Collection* (exhibition catalog, Jewish Museum of New York, New York, June 29–September 5, 1966), n.p.; cited in Alberro, *Conceptual Art,* 7.

180. Alberro, *Conceptual Art,* 7.

181. Nina Kaiden, "The New Collectors," in Nina Kaiden, Bartlett Hayes, and Richard J. Whalen, *Artist and Advocate: An Essay on Corporate Patronage* (New York: Renaissance Editions, 1967), 13; quoted in Alberro, *Conceptual Art,* 13.

182. Alberro, *Conceptual Art,* 6. This may seem to contradict the fact that the 1960s were also a period of particularly intense art-critical activity, which became a "'serious discipline' in the US only at this time, and primarily

through the medium of *Artforum*" (Hal Foster, *Design and Crime: And Other Diatribes* [London: Verso, 2003], 105). Yet as Foster points out, the "very grandiloquence" of serious criticism in the 1960s and 1970s "betrays a certain desperation" that testifies to the situation Alberro describes, with its intensity reflecting an effort "to shore up a [critical as well as] aesthetic field that was pressured and fragile" (ibid., 119).

183. Lucy Lippard, interview with Ursula Meyer, in Lippard, *Six Years,* 7.

184. Patricia Ann Norvell, "Eleven Interviews, March–July 1969)" (unpublished tape recordings), cited in Lippard, *Six Years,* 87; emphases added.

185. Joseph Kosuth, "Introductory Note by the American Editor," *Art/Language* (February 1970), reprinted in Lippard, *Six Years,* 148

186. Lucy Lippard, in Douglas Huebler et al., symposium, WBAI-FM, New York, March 8, 1970, in Lippard, *Six Years,* 157.

187. Lippard wrote and said a great deal about certain artistic practices, but not about all of them. Even if by 1969 the critic had in fact become hard to distinguish from others performing the function of generating publicity for artists, the publicity for conceptual art that Lippard provided arguably functioned as a claim for its value in a much less overt form, with evaluation becoming tacitly embedded in the act of selecting what to publicize.

188. Steven W. Naifeh, *Culture Making: Money, Success, and the New York Art World* (Princeton, NJ: Princeton University Press, 1976), 96; quoted in Alberro, *Conceptual Art,* 9.

189. Joseph Kosuth, "Introductory Note by the American Editor," *Art/Language* (February 1970), reprinted in Lippard, *Six Years,* 148. This remark should reinvoke our suspicion that the aesthetic judgment "interesting" is exclusive to restricted discursive communities (groups defined precisely by the nonexistence of an "audience separate from the participants") in a way that seems incongruous with the claim to universal validity that distinguishes aesthetic judgments from judgments of taste. I will return to this problem at the end of this chapter.

190. Peter Osborne, ed., *Conceptual Art* (London: Phaidon Press, 2002) 88.

191. Baldessari continues, "It was important that the paintings were exhibited as a group so that the spectator could practice connoisseurship, for example comparing how the extended forefinger in each was painted." John Baldessari, *John Baldessari: Works, 1966–1981* (exhibition catalog, Municipal Van Abbemuseum, Eindhoven, May 22–June 21, 1981), 11; quoted in Osborne, *Conceptual Art,* 89.

192. Osborne, *Conceptual Art,* 89.

193. Wikipedia contributors, "John Giorno," *Wikipedia, the Free Encyclopedia,* http://en.wikipedia.org/w/index.php?title=John_Giorno&oldid=72291462 (accessed 11/25/2006).

194. Although this ease of circulation was a factor in the popularity of conceptual art in the mid-1960s and 1970s in Argentina, Brazil, Uruguay, Chile, and Spain, as Mari Carmen Ramírez notes (citing Simón Marchán Fiz), the aesthetic of Latin American conceptual art was explicitly political and thus in a certain sense fundamentally different from its "merely interesting,"

294 NOTES TO PAGES 161-172

"administrative" North American counterpart. Yet although Latin American conceptual art was more interested in the "specificity and communicative dimension of the aesthetic object," it was also significantly preoccupied with circuits of exchange and circulation, as Ramírez argues, and with the problem of "devaluation" in exchange in particular. See Mari Carmen Ramírez, "Blueprint Circuits: Conceptual Art and Politics in Latin America," in Alberro and Stimson, *Conceptual Art,* 550–563, 556.

195. On the "postal unconscious," see Mark Seltzer, "The Postal Unconscious," *Henry James Review* 21.3 (2000): 197–206.

196. Douglas Huebler, "Catalogue of First Exhibition to Exist Solely as a Catalogue in Which the Work and Its Documentation Appear," in Lippard, *Six Years,* 62.

197. Michael Fried, "Art and Objecthood (1967)," *Art and Objecthood: Essays and Reviews* (Chicago: University of Chicago Press, 1998), 149–172, 165.

198. Ibid.," 164.

199. For a much more extensive account of how Fried misread Judd in assuming that by "interesting" Judd was "denying the relevance of quality or value judgments," see Colpitt, *Minimal Art,* 122–125, and Meyer, *Minimalism,* 143–144. Both accounts draw on Judd's familiarity with Perry's explicit theory of interest as value, which is discussed in more detail in Raskin, "Donald Judd's Moral Art," 79–95, and David Raskin, *Donald Judd* (New Haven, CT: Yale University Press, 2010), 4–6.

200. For a more extensive account of Fried's use of time in "Art and Objecthood," see Lee, *Chronophobia,* 260–308.

201. Richard Serra and Philip Glass, *Long Beach Island, Word Location,* in Lippard, *Six Years,* 106–107.

202. Bruce Glaser, "Questions to Stella and Judd" (interview), ed. Lucy Lippard, in *Minimal Art: A Critical Anthology,* ed. Gregory Battcock (New York: E. P. Dutton, 1968), 158. *Art as Idea as Idea* (1967) is the title of one of Kosuth's serial projects.

203. Jonathan Flatley, "Art Machine," in Baume, *Sol LeWitt,* 95; Huebler, in Huebler et al., symposium, WBAI-FM, New York, in Lippard, *Six Years,* 156; and Mel Bochner, "Problematic Aspects of Critical/Mathematic Constructs in My Art," lecture, ICA London, April 1971, in Lippard, *Six Years,* 236.

204. "Discussions with Heizer, Oppenheim, Smithson," *Avalanche* 1 (Fall 1970), excerpted in Lippard, *Six Years,* 184.

205. Robert Barry, *Art Work* (1970), in Lippard, *Six Years,* 178.

206. Franco Moretti, *Graphs, Maps, Trees: Abstract Models for a Literary Theory* (London: Verso, 2005), 5.

207. I am grateful to Paul Gilmore for raising this question.

208. I am indebted to Aaron Kunin for this insight.

209. It is here, as well, that we can see why the interesting, although noticeably lacking the political (if not always progressive) symbolism of the sublime and the beautiful, is not entirely devoid of a politics of its own: certainly not a revolutionary politics, but rather a liberal, Habermasian politics of

expanding the public sphere and the discursive communities built around the particular kinds of circulating forms therein. On circulation as a cultural phenomenon, see Benjamin Lee and Edward LiPuma, "Cultures of Circulation," *Public Culture* 14.1 (2002): 191–213, 192.

210. The fact that the more utopian conceptual artists could be viewed as trying to recover this lost middle sheds light on their noticeable preoccupation with air. From Barry's released gases and Hans Haacke's *Airborne Systems* to exhibitions like *Air Art* and Art-Language's *Air Conditioning Show*, that fascination can be read as a response to the role of accelerated circulation in the ongoing capitalist process of modernization qua ephemeralization, in which "all that is solid melts into air." To put it most simply, in an age where nothing had more impact on the production and reception of advanced art than the new speeds at which art could be circulated, publicized, and sold, the most "interesting" conceptual work of the mid- to late 1960s aimed at slowing down the time of circulation, by representing the very challenges to visual representation that these technologies of circulation fostered, taking them up as either content or form. As the activity that transpires in the interval between the production and consumption of commodities, the faster circulation became, the more it eluded representation in time, occulting the "middle" or shrinking the "normal lag" between "invention" and "public acceptance" in an acceleration that, according to Alberro, established the basic conditions for the rise of conceptual art. "Normal lag . . .": Hunter, introduction to *The Harry N. Abrams Family Collection*, cited in Alberro, *Conceptual Art*, 7.

211. Kosuth, "Introductory Note by the American Editor," cited in Lippard, *Six Years*, 146.

3. The Zany Science

1. "Henri Bergson has pointed out in his *Laughter*, that the psychological calcifications which make an individual comical in an aesthetic sense . . . are bound up with his incapacity to cope with changing social situations, going as far as stating that, in a way, the concept of 'character' denoting a rigidified personality pattern impervious to life experience is comical per se." Theodor Adorno, *The Stars down to Earth*, ed. and trans. Stephen Crook (London: Routledge, 1994), 106.

2. Ibid., 115, 119, 109.

3. Henri Bergson, *Laughter: An Essay on the Meaning of the Comic*, trans. Cloudesley Brereton and Fred Rothwell (New York: Macmillan, 1911), 37.

4. Adorno, *Stars down to Earth*, 137. "Vice-president," 85; "isolated," 109.

5. On the question of the "degree of empirical backing" Adorno can claim for these arguments about audience, see Stephen Crook, "Introduction: Adorno and Authoritarian Irrationalism," *Stars down to Earth*, 26–27.

6. See Tom Watson, *I Love Lucy: The Classic Moments* (Philadelphia: Courage Books, 1999). The show also featured cameos of a wide range of professional performers playing themselves: Betty Grable, Tallulah Bankhead, Rudy Vallee, Orson Welles, Bob Hope, John Wayne, Ernie Kovacs, Ida Lupino, Richard

Widmark, Red Skelton, Maurice Chevalier, Fred MacMurray, and many others.

7. "Ball suddenly envisioned the proposed television series as a way to work with Arnaz, and through this, work on their marriage." Alexander Doty, "The Cabinet of Lucy Ricardo: Lucille Ball's Star Image," *Cinema Journal* 29.4 (Summer 1990): 3–22, 8. As Doty and others have noted, the television series initially proposed, as reflected in the pilot originally written by Madelyn Pugh, Bob Carroll, and Jess Oppenheimer about a bandleader and a movie actress, would have featured characters much more closely related to Ball and Arnaz. Lucille Ball and Desi Arnaz deliberately paved the way for this pilot by creating a touring vaudeville act in order to "convince certain skeptical CBS executives they could win public acceptance—and a commercial sponsor—as a performing married couple" (8). Under pressure to make the series more about "everyday people," it was decided that since a Latino man could not seem "everyday," Arnaz would continue to play himself; Ball would thus "relinquish her witty, accomplished movie star role" while also remaining "herself" in the role of Arnaz's wife (8). Of course, this repressed/relinquished star image—and the qualities of flexibility, virtuosity, and variety it connoted—would return in every episode precisely through the "basic incompetence of the Lucy Ricardo character" (10). As Doty puts it, "Ball showcased her film image and talents"—her essential flexibility and adaptability as an actor—"through the agency of Lucy Ricardo," the "zany . . . talentless housewife," which is to say that Ball's pliancy was made manifest through her fictional character's lack thereof (7).

8. "The French Revue" (November 16, 1953); "The Ballet" (February 18, 1952).

9. "The Million Dollar Idea" (January 11, 1954); "The Amateur Hour" (January 14, 1952); "Lucy Tells the Truth" (November 9, 1953); "Lucy Meets Orson Welles" (October 15, 1956); "The Girls Go into Business" (October 12, 1953); "Ricky's Hawaiian Vacation" (March 22, 1954).

10. Hot-dog vendor: "Lucy Meets Bob Hope" (October 1, 1956); hotel bellhop: "The Star Upstairs" (April 18, 1955); celebrity chauffeur: "Lucy Meets the Moustache" (April 1, 1960).

11. This body of labor-oriented feminist performance art from the 1970s (of which Montano is only a single and canonically minor example) anticipates the "relational aesthetics" of the late 1990s and early 2000s, though is rarely acknowledged as a significant antecedent in genealogical accounts of the latter. For the most influential text on "relational" art, see Nicolas Bourriard, *Relational Aesthetics* (Paris: Les Presse Du Reel, 1998). On the controversies surrounding relational art and the way in which it seems to merely celebrate the "nicer procedures of our service economy," see, for just a few examples, Hal Foster, "Chat Rooms," *Participation,* ed. Claire Bishop (Cambridge, MA: The MIT Press, 2006), 190–195, and Claire Bishop, "Antagonism and relational Aesthetics," *October* 110 (Fall 2004): 51–79. "Nicer procedures of our service economy": Foster, "Chat Rooms," 195.

12. Doty, "Cabinet of Lucy Ricardo," 10.

13. Ibid., 7.

14. Doty makes the same point; see ibid., 7.
15. Alexander Galloway, *Gaming: Essays on Algorithmic Culture* (Minneapolis: University of Minnesota Press, 2006), 105.
16. Walkabouts are street theater in which performers disguised as waiters, policemen, and nannies improvise encounters with the general public. Marvin Carlson, *Performance: A Critical Introduction,* 2nd ed. (New York: Routledge, 2004), 125–126.
17. I thank Frances Ferguson for pointing this out.
18. "De-Zanitized" (September 13, 1993). I'm indebted to Glenn Brewer for this reference.
19. Madeline Gins, *What the President Will Say and Do!!* (Barrytown, NY: Station Hill Press, 1984), 15, 16, 55, 56.
20. Robert Pippin, *Nietzsche, Psychology, and First Philosophy* (Chicago: University of Chicago Press, 2010), 6; Jacques Derrida, *Spurs: Nietzsche's Styles,* trans. Barbara Harlow (Chicago: University of Chicago Press, 1979); Kenneth Burke, *Permanence and Change: An Anatomy of Purpose* (Berkeley: University of California Press, 1954), 88.
21. Pippin, *Nietzsche, Psychology, and First Philosophy,* 32.
22. Friedrich Nietzsche, *The Gay Science: With a Prelude in Rhymes and an Appendix of Songs,* trans. Walter Kaufmann (New York: Vintage, 1974), See ¶ 11: "The task of incorporating knowledge and making it instinctive is only beginning to dawn on the human eye" (ibid., 85). For Pippin's discussion of this statement, see *Nietzsche, Psychology, and First Philosophy,* 39.
23. Jon McKenzie, *Perform or Else: From Discipline to Performance* (London: Routledge, 2001).
24. I am echoing Paolo Virno's glossing of Hannah Arendt's concept of the political in his account of "virtuosic labor." See Paolo Virno, *A Grammar of The Multitude: For an Analysis of Contemporary Forms of Life,* trans. Isabela Bertoletti, James Cascaito, and Andrea Casson (New York: Semiotext[e], 2004), 51.
25. Daniel Harris, *Cute, Quaint, Hungry and Romantic: The Aesthetics of Consumerism* (New York: Da Capo Press, 2000), 117.
26. Avital Ronell, "The Experimental Disposition: Nietzsche's Discovery of America (or, Why the Present Administration Sees Everything in Terms of a Test)," *American Literary History* 15.3 (Fall 2003): 560–574, 564.
27. Langdon Hammer, "But I Digress," *New York Times Sunday Book Review,* April 20, 2008, online, http://www.nytimes.com/2008/04/20/books/review/ Hammer-t.html. Accessed 6/2/2009.
28. Even the word "fun" is strangely not fun. Originally meaning a "cheat or trick; a hoax, a practical joke" (noun), or "to make fun or sport" (verb), "fun" enters the English language in the early eighteenth century as an action one involuntarily becomes an object of or subjected to. See *Oxford English Dictionary,* s.v. "fun." It refers here not to one's own feeling of enjoyment or pleasure, but to being the source of somebody else's. We thus find a primal social antagonism at the heart of fun. The *OED* notes that even the contemporary phrase "fun and games" is almost always used ironically, as in

"Mr. Brown expects the fun and games of tax haven subsidiaries to disappear with the new legislation" (*Globe and Mail*, 1970). More often designating explicitly punitive or military actions (the 1948 edition of *Partridge Dictionary of Forces' Slang* defines it as "any brush with the enemy at sea"), "fun and games" can also mean acts of terror, as evinced most starkly in the 1997 film *Funny Games* (remade for the United States in 2007), in which "two psychotic young men take a mother, father, and son hostage in their vacation cabin and force them to play sadistic 'games' with one another for their own amusement." See Internet Movie Database, http://www.imdb.com /title/tt0808279 (accessed 2/10/2008).

In its all too visibly strenuous efforts to try to make or produce fun, the zany's affective paradoxes are perhaps best captured by the productions of Forced Entertainment: "A pair of clowns in smeared make-up start an ugly fight that threatens to take over the stage. A delinquent cheerleader dances and yells. . . . Rock-gig roadies creep across the stage—bringing disco lights, new speakers and a microphone that no one really wants." In this production of *Bloody Mess*, as described by the Sheffield performance group's website (http://www.forcedentertainment.com/page/144/Theatre-Performances/85; accessed 3/2/2008), the image of workers/actors hauling these apparatuses for performing on stage seems intended to underscore their status as unwanted refuse or trash, much like the literal trashing of televisions and swimming pools in Wolf Vostell's Vietnam War–era *You-Happening* (1964). Here explicitly marrying the themes of entertainment and war, *You-Happening*'s final instructions to the participants similarly emphasize and degrade sociability at the same time: "Put on a gas mask when the TV burns and try to be as friendly as possible to everyone." Wolf Vostell, quoted by Allan Kaprow in *Assemblages, Environments, and Happenings* (New York: H. N. Abrams, 1966), cited in Tracey Warr and Amelia Jones, *The Artist's Body* (London: Phaidon, 2000), 97.

29. Julian Young, *Nietzsche's Philosophy of Art* (New York: Cambridge University Press, 1992), 92.
30. Wyndham Lewis, *The Art of Being Ruled,* ed. Reed Way Dasenbrock (Santa Rosa, CA: Black Sparrow Press, 1989), 113, 113, 118.
31. Pippin, *Nietzsche, Psychology, and First Philosophy,* 11.
32. See Malcolm Bull, "Where Is the Anti-Nietzsche?" *New Left Review* 3 (May–June 2000): 121–145, 125.
33. We might say that zaniness blocks gaiety (and vice versa), in the way that, say, a feeling of great surprise or incredulity can block or delay the feeling of anger. On this "blocking" capacity of the passions, see Philip Fisher, *The Vehement Passions* (Princeton, NJ: Princeton University Press, 2002), especially 28–39.
34. Friedrich Nietzsche, *Twilight of the Idols and The Anti-Christ,* trans. R. J. Hollingdale (New York: Penguin, 1990), 8.
35. Theodor Adorno, *Aesthetic Theory,* trans. Robert Hullot-Kentor (Minneapolis: University of Minnesota Press, 1997), 136. Nietzsche similarly raises the idea of art/beauty as a "promise of happiness" in the third essay of *On the Genealogy of Morals,* explicitly pitting Stendhal's phrase against Kant's

reception aesthetics. Friedrich Nietzsche, *On the Genealogy of Morals,* trans. Walter Kaufmann and R. J. Hollingdale, in *On the Genealogy of Morals and Ecce Homo,* ed. Kaufmann (New York: Vintage Books, 1967), essay 3, ¶ 6, 104 (emphasis in original).

36. Herbert Marcuse, *One-Dimensional Man: Studies in the Ideology of Advanced Industrial Society* (Boston: Beacon Press, 1991), 5.

37. Alan Liu, *The Laws of Cool: Knowledge Work and the Culture of Information* (Chicago: University of Chicago Press, 2004), 77.

38. See Raymond Queneau, preface to Gustave Flaubert, *Bouvard and Pécuchet,* trans. Mark Polizzotti (New York: Dalkey Archive Press, 2005), xxi. "Fortunately, they had Dumochel's mnemonic, a duodecimo volume bearing the epigraph: 'Fun while learning.'" See *Bouvard and Pécuchet,* 106.

39. "Southwest. Way Southwest. An Airline Success Story Tries to Keep Its Inner Quirk," *New York Times,* February 13, 2008, Business Section, 1, 10. Numerous commentators have noted the particular significance of this erosion of the work/play distinction for postmodern art and aesthetics. See, for example, McKenzie, *Perform or Else,* 93, on the pressures it puts on the performative/theatrical concept of liminality. On how postwar American artists have responded in different ways to the "increasingly blurred boundaries between work and leisure," see Helen Molesworth, "Work Ethic," in *Work Ethic,* ed. Helen Molesworth (University Park: Pennsylvania State University Press, 2003), 25–52, especially 39.

40. In a footnote to the fourth German edition of Marx's *Capital,* Engels writes: "The English language has the advantage of possessing two separate words for . . . two different aspects of labour. Labour which creates use-values and is qualitatively determined is called 'work' instead of 'labour'; labour which creates value and is only measured quantitatively is called 'labour,' as opposed to 'work.'" Karl Marx, *Capital,* vol. 1, *A Critique of Political Economy,* trans. Ben Fowkes (New York: Penguin Classics, 1992), 138. Fowkes adds, "Unfortunately, English usage does not always correspond to Engels' distinction." Like Fowkes, however, I have tried to adopt it wherever possible, although it is a crucial argument of this chapter that contemporary zaniness reflects a situation where all work (including what Marx would call "unproductive" work) is increasingly subsumed as labor by capital. Work, labor, and production are at times thus used synonymously in this chapter, but always self-consciously.

Affective exertion—whether on the part of the assembly-line worker or the in-flight attendant, the middle-school teacher or the unwaged parent—takes energy and depletes bodies; the restoration of the energy of any worker requires commodities. Given how physically exhausting affective labor can be, its increase or rise, like that of the "reproductive" labor of women, needs to be included as one of the factors in the calculation of "social labor" or socially necessary labor time, insofar as that calculation depends on a collective measurement of what is needed to revive and maintain the energy and ability-to-work of the worker in general. If the worker asked to put affect into her work ends up significantly more exhausted by the end of the day, that worker will need to consume more to revive her ability to work; that

more or extra required to maintain this kind of worker will therefore need to factored into the collective costs of living labor and therefore into the accounting of socially necessary labor time.

41. For an overview of the Marxist move to distinguish capitalist or "material production" (i.e., industrial production of commodities) from production in general, of the "extraordinary inadequacy of this distinction to advanced capitalism," and how it has suppressed the "material character of the productive forces which produce such a version of production," see Raymond Williams, "Productive Forces," in *Marxism and Literature* (Oxford: Oxford University Press, 1977), 90–100. Williams explains the attendant confusions: "If 'production,' in capitalist society, is the production of commodities for a market, then different but misleading terms are found for every other kind of production and productive force. What is most often suppressed is the direct material production of 'politics.' Yet any ruling class devotes a significant part of material production to establishing a political order. The social and political order which maintains a capitalist market, like the social and political struggles which created it, is necessarily a material production. From castles and palaces and churches to prisons and workhouses and schools; from weapons of war to a controlled press: any ruling class, in variable ways but always materially, produces a social and political order. These are never superstructural activities. They are the necessary material production within which an apparently self-subsistent mode of production can alone be carried on" (93). "The difficulty is that Marxists, at once insisting on and protesting against the practical subordination of all human activities to the modes and norms of capitalist institutions, were caught in a practical ambivalence. The insistence, in effect, diluted the protest" (92).

42. In a confusing way, all three kinds of work—one kind gendered while the two others are not—have been bundled into the concept of "immaterial labor" central to Michael Hardt and Antonio Negri's theory of multitude (which expands the class of worker to include the unemployed, nonworking, and women), although, as Leopoldina Fortunati and Kathi Weeks have made especially clear, the neo-Marxist concept of immaterial labor (which is not always or explicitly gendered) is more accurately a subset of the feminist category of affective labor (which is). I will be dealing with this issue in more detail later. See Leopoldina Fortunati, "Imaterial Labor and its Machinization," *Ephemera* 7.1 (2007): 139–157; Kathi Weeks, "Life within and against Work: Affective Labor, Feminist Critique, and Post-Fordist Politics, *Ephemera* 7.1 (2007): 233–249. On multitude, see Michael Hardt and Antonio Negri, *Empire* (Cambridge, MA: Harvard University Press, 2001) and Michael Hardt and Antonio Negri, *Multitude* (New York: Penguin, 2005).

43. This is Adorno's summary in *Stars down to Earth*, 106.

44. For this reason, the zany, while not incompatible with camp, cannot finally be conflated with camp. The subtle but important distinction between them holds even in camp performances that explicitly foreground the labor involved in the production (and concealment) of gendered and sexual identities. For a book-length study of camp as labor in the context of the U.S. film

industry (and as labor "that has shaped a way of knowing capital in its lived dimensions within production by queer male intellectuals" in particular), see Matthew Tinkcom, *Working Like a Homosexual: Camp, Capital, Cinema* (Durham, NC: Duke University Press, 2002), 2. For further discussion of the difference and potential tension between zaniness and camp, see my introduction.

45. Joseph Roach, *The Player's Passion: Studies in the Science of Acting* (Ann Arbor: University of Michigan Press, 1993), 122.

46. Ibid., 123.

47. Denis Diderot, *Rameau's Nephew and Other Works*, trans. Jacques Barzun and Ralph Bowen (Indianapolis: Hackett, 2001), 68. Cited in Roach, 124.

48. Jacques Barzun, preface to Diderot, *Rameau's Nephew*, 3.

49. Roach, *Player's Passion*, 124. For all his cutting dialogue, the nephew's performances thus cannot be adequately characterized as ironic; these performances seem far too zealously undertaken, far too thoroughly embodied. To put it another way, the nephew's roles clearly master him in spite of his mocking and indifferent attitude toward them; they are not, in this sense, *successfully* ironic performances. But neither are these performances what Nietzsche would call Dionysian; however frenzied, they do not result in a creative dissolution of boundaries, but rather in movement from one relatively well-defined role to the next. For a reading of Rameau's nephew as ironist, see Pippin, *Nietzsche, Psychology, and First Philosophy*, 110.

50. See Giorgio Agamben, *The Man without Content*, trans. Georgia Albert (Stanford, CA: Stanford University Press, 1999), 22–26.

51. "Thereupon he begins to smile, to ape a man admiring, a man imploring, a man complying. His right foot forward, the left behind, his back arched, head erect, his glance riveted as if on another's, openmouthed, his arms are stretched out toward some object. He waits for a command, receives it, flies out like an arrow, returns. The order has been carried out; he is giving a report. Attentive, nothing escapes him. He picks up what is dropped, places pillow or stool under feet, holds a salver, brings a chair, opens a door, shuts a window, draws curtains, gazes at master and mistress. He is motionless, arms hanging, legs parallel; he listens and tries to read faces. Then he says, 'There you have my pantomime; it's about the same as the flatterer's, the courtier's, the footman's and the beggar's.'" Diderot, *Rameau's Nephew*, 82–83. Note how the nephew seems to suggest that the work of the courtier is itself mimicry or acting, but not in any transgressive way.

52. I am indebted to Zarah Ersoff for this connection. E-mail to the author, 6/20/2011.

53. Gioachino Rossini, *Rossini's The Barber of Seville*, ed. Burton D. Fisher, Opera Classics Library Series (New York: Opera Journeys Publishing, 2005), 48–49.

54. Stanley Sadie and Laura Macy, eds., *Grove Book of Operas*, 2nd ed. (Oxford: Oxford University Press, 2006), 62.

55. Robert Henke, *Performance and Literature in the Commedia dell'Arte* (Cambridge: Cambridge University Press, 2002), 23.

56. Pierre-Louis Duchartre, *The Italian Comedy* (Mineola, NY: Dover Publications, 1966), 165.

57. Even if the sublime and the beautiful ultimately refer to structures or workings of the human mind, as Kant argues, this is not quite the same thing as their invoking or projecting an objectified, third-person representation of an actor or agent (whose mind works in this general way).

58. The etymology of "zany" thus has nothing to do with the psychological concept of insanity, as one might perhaps think, given the homophony of the two words in English, and the zany's associations with a hysterical or manic style of doing. It instead has everything to do with a specific character, defined in turn by a specific kind of doing or job, paradoxically defined, in turn, by its relatively informal nature. "Zanni" is in fact the Venetian pronunciation of "Gianni," which by the seventeenth century had become a general term for a porter or casual laborer from the mountain country of Bergamo *(OED)*. Yet we do find the ideas of job and insanity compellingly fused in the concept of "occupational psychosis" that Burke adopts from Dewey—a passionate mind-set or "imaginative superstructure," much like Weber's "spirit" of capitalism, that harmonizes with and helps sustain a society's dominant mode of production—in the course of developing his own "dramatistic" or performance-based theory of human relations. Burke's main example is a "salesman, sick of the day's work and determined to think no more of it until tomorrow, [who] will go to a motion picture and watch in delight the building-up of some character with precisely the brass, the ingenuity, and the social life which are the ideals of his calling." Burke explains, "In this sense he is not getting away from the matters of salesmanship at all, for he is watching the kind of character that exemplifies the ideal feelings and methods that equip him for the business of selling." Burke, *Permanence and Change*, 38.

59. Henke, *Performance and Literature in the Commedia dell'Arte*, 27.

60. Ibid., 9.

61. See Horace Walpole, "Letter to the Hon. H. S. Conway (October 6 1785)," in *The Letters of Horace Walpole, Earl of Orford: Including Numerous Letters Now First Published from the Original Manuscripts*, vol. 4 (Philadelphia: Lea and Blanchard, 1842), 379.

 Wyndham Lewis explicitly refers to Nietzsche as a mountebank, anticipating what Malcolm Bull calls the element of "fairground trickery" in his address to his bourgeois readers: "Nietzsche, got up to represent a Polish nobleman, with a *berserker* wildness in his eye, advertised the secrets of the world and sold little vials containing blue ink, which he represented as drops of authentic blue blood, to the delighted populace. They went away, swallowed his prescriptions, and felt very noble at once" (Lewis, *Art of Being Ruled*, 113). After this moment in the text, Lewis redirects his satire of Nietzsche and the "frenzy of poetic zeal [with which] he alternately browbeat and implored the whole world to be *aristocrats*" at the philosopher's "naturally enchanted" readers (113), especially those eager to identify with Nietzsche's call for an aesthetics of production rather than reception. He begins by quoting Nietzsche:

Oh, how repugnant to us now is pleasure, coarse, dull, drab pleasure, as the pleasure-seekers, our "cultured" classes, our rich and ruling classes, usually understand it! How malignantly we now listen to the great holiday-hubbub with which "cultured people" and city-men at present allow themselves to be forced to "spiritual enjoyment" by art, books, and music, with the help of spirituous liquors! How the theatrical cry of passion now pains our ear, how strange to our taste has all the romantic riot and sensuous bustle which the cultured populace love become (together with their aspirations after the ex- alted, the elevated, and the intricate)! No, if we convalescents need an art at all, it is *another* art—a mocking, light, divinely serene, divinely ingenious art, which blazes up like clear flame, into a cloudless heaven! Above all, an art for artists, only for artists! (Nietzsche, *The Gay Science;* quoted in Lewis, *Art of Being Ruled,* 115)

Lewis asks us to visualize the passionate identification of Nietzsche's read- ers with Nietzsche's text above:

Imagine ... the average "pleasure-seeker" of our "cultured classes" ... reading the above passage. They would be very annoyed while reading about the "pleasure-seekers of the cultured classes" and their "coarse, drab, and dull pleasures." But they would have read above that after an illness you were apt to be of a much "merrier disposition," "more wicked," and "more childish," "a hundred times more refined than ever before." (116)

Lewis proceeds to give a blow-by-blow reenactment—something almost akin to an interpretive dance—of Nietzsche's readers, responding in turn, mimetically, to Nietzsche's text: "They clap their hands ecstatically and 'child- ishly.' A HUNDRED TIMES MORE REFINED THAN EVER BEFORE!" (116). Taking advantage of the ironic function of free indirect discourse, Lewis adds, "It would be *they* who had the illness: they who were now conva- lescent, and feeling so naughty and devilish. For had they not just been in a nursing home, for a cosmetic operation, or haemorrhoids, for a fortnight? Yes, it was extraordinary how well you felt after being ill!" (116).

Then they come to MOCKING, LIGHT, VOLATILE, DIVINELY SE- RENE, etc. *Could* a better description have been found of what *they* liked, of what *they* were? It was all so true! "Above all, an art for artists, only for art- ists!" Were not *they* artists? Was not Nero an artist? Were not *all* people of the best stamp (except Lady This or Mrs. That, of course) artists?
So it is easy to imagine them (interrupted at this point by the visit of a friend) going off and being more *mocking, light, volatile, and divinely serene,* all at once, than ever before! (116–117)

Bristling with italics, exclamation points, and sneer quotes, Lewis's way of satirizing the bourgeois reader's eagerness to identify with Nietzsche's ad- dressee looks and sounds a lot like Nietzsche, ironically making Lewis seem

more like a zany imitator than a debunker of this "vociferous showman." This is the case even as Lewis is accurately registering the fact that Nietzsche's addressee in *The Gay Science* seems to have no real existence: "Nietzsche was always addressing people who do not exist. To address passionately and sometimes with very great wisdom *people who do not exist* has this disadvantage . . . that there will always be a group of people who, seeing a man shouting apparently at somebody or other, and seeing nobody else in sight, will think it is they who are being addressed" (116).

62. Antonio Fava, *The Comic Mask in the Commedia dell'Arte: Actor Training, Improvisation, and the Poetics of Survival,* trans. Thomas Simpson (Evanston, IL: Northwestern University Press, 2007), 56.

63. Henke, *Performance and Literature,* 123.

64. We see the same mania for "occult and pseudo-erudite knowledge" (and the same travestying of the figure of the "Renaissance man") in the character of Old Gregg from the British television comedy series *The Mighty Boosh,* a vaguely racialized and explicitly feminized zany, clad in a pink tutu, who kidnaps and holds people captive in his underwater cave for what seems like the sole purpose of displaying his skills at various liberal arts or "humanities": painting, singing, dancing, and promoting Bailey's Irish Cream. As he plaintively yet aggressively asks his captive audience, "Do you love me?" Old Gregg might strike humanists in the academy as not only a figure for the (feminized) affective laborer but for the teacher of increasingly esoteric or devalued skills, like an eighteenth-century dancing master finding himself suddenly desperate for pupils by the first decades of the industrial nineteenth century. I am indebted to Seth Lerer for this disquieting comparison and to Eric Hayot for my introduction to Old Gregg, postmodernity's update of Rameau's nephew.

65. Note how it is crucial that the activities be varied; *Bouvard and Pécuchet* would be a lot less zany if the series of enterprises its two protagonists so fervently embark on stayed within a horizon of more closely related practices.

66. See Jean-Christophe Agnew, *Worlds Apart: The Market and the Theater in Anglo-American Thought, 1550–1750* (Cambridge: Cambridge University Press, 1988).

67. Anthony Giddens, *The Consequences of Modernity* (Stanford, CA: Stanford University Press, 1991), 91.

68. On "front" versus "backstage behavior," see Erving Goffman, "Regions and Region Behavior," *The Presentation of Self in Everyday Life* (New York: Anchor Books, 1959), 106–140. Arlie Russell Hochschild, *The Managed Heart: Commercialization of Human Feeling* (Berkeley: University of California Press, 1983), 38–48.

69. Georg Simmel, "The Metropolis and Mental Life," trans. Edward A. Shils, in Simmel, *On Individuality and Social Forms,* ed. Donald N. Levine (Chicago: University of Chicago Press, 1971), 324–329; reprinted from *Social Sciences III Selections and Selected Readings,* vol. 2, 14th ed. (Chicago: University of Chicago Press, 1948).

70. In spite of his being the technology's ostensive agent or representative, this is just one of many ways in which the cable guy's actions seem surprisingly antitelevision, or aimed against the medium's purported antisociality.

71. Fava, *Comic Mask*, 112.

72. See Hochschild, *Managed Heart*, 4.

73. See, for example, the essays collected in Nancy Folbre and Michael Bittman, eds., *Family Time: The Social Organization of Care* (London: Routledge, 2004). Tiziana Terranova, "Free Labor: Producing Culture for the Digital Economy," *Social Text* 63 (Summer 2000): 33–58; reprinted in Terranova, *Network Culture: Politics for the Information Age* (London and Ann Arbor, MI: Pluto Books, 2004), 73–97.

74. McKenzie, *Perform of Else*, 6.

75. Luc Boltanski and Eve Chiapello, *The New Spirit of Capitalism*, trans. Gregory Elliott (London: Verso, 2005).

76. Nancy Fraser, "Feminism, Capitalism, and the Cunning of History," *New Left Review* 56 (March–April 2009): 97–117, 114.

77. Eva Illouz, *Cold Intimacies: The Making of Emotional Capitalism* (Malden, MA: Polity Press, 2007).

78. Liu, *Laws of Cool*, 163.

79. See McKenzie, *Perform or Else*, 137–174. McKenzie also gives a reading of the passages from *The Gay Science* I single out below; see 256–258.

80. Friedrich Nietzsche, *The Birth of Tragedy and The Case of Wagner*, trans. Walter Kaufmann (New York: Vintage, 1967), 83.

81. In thus relating to appearances as plans to be executed or made real, the passionate actor thus anticipates the will-to-truth position in Nietzsche's philosophy. As Kelly Oliver notes, using Jacques Derrida's typology in *Spurs*, this is a position eventually occupied by both the metaphysical philosopher and the woman-as-feminist, or the desexed, "castrated woman," who, unlike the "castrating" woman-as-artist (who embraces feminine appearances *as* appearances), seeks what Oliver calls a "science of women," or to know what Nietzsche witheringly calls "'woman as she really is.'" Friedrich Nietzsche, *Beyond Good and Evil*, trans. Helen Zimmern, in *The Complete Works of Nietzsche*, vol. 6, ed. Oscar Levy (New York: Russell and Russell, 1964), 182; cited in Kelly Oliver, "Woman as Truth in Nietzsche's Writing," in *Feminist Interpretations of Friedrich Nietzsche*, ed. Kelly Oliver and Marilyn Pearsall (University Park: Pennsylvania State University Press, 1998), 66–79, 69.

82. As Gilles Deleuze notes, it is typical of Nietzsche to find something "admirable and dangerous" about reactive forces. See Gilles Deleuze, *Nietzsche and Philosophy*, trans. Hugh Tomlinson (London: Continuum, 2006), 62.

83. McKenzie also discusses this passage in *Perform or Else*; see 256–258.

84. See Karl Marx, "Results of the Immediate Process of Production," in *Capital*, vol. 1, trans. Ben Fowkes (New York: Penguin Classics, 1992), 1038–1049. One could enter into a debate here about whether services and other kinds of labor resulting in commodities that do not exist separately from the producer or act of producing can ultimately sustain the expansion of capital as a whole

(and therefore the system of capitalism proper). It should be clear in any case that by calling certain kinds of labor "unproductive," Marx does not mean any kind of moral disparagement. "Unproductive" labor means "not productive in a specifically capitalist sense," labor that leads only to the production of surplus value on a limited scale.

85. Maurizio Lazzarato, "Immaterial Labor," in *Radical Thought in Italy,* ed. Paolo Virno and Michael Hardt (Minneapolis: University of Minnesota Press, 1996), 133–150, 133.

86. McKenzie, *Perform or Else,* 57. See also Arlie Hochschild, *The Time Bind: When Work Becomes Home and Home Becomes Work* (New York: Henry Holt, 1997), 204–205.

87. Lazzarato, "Immaterial Labor," 136.

88. For a critique of the false antithesis between the intangible and the material (and the way it completely ignores conceptions of matter in twentieth-century physics), see Daniel Tiffany, *Toy Medium: Materialism and Modern Lyric* (Berkeley: University of California Press, 2000).

89. See Marx, "Results," 1048. Paolo Virno makes this point as well in *Grammar of the Multitude,* 54.

90. This is the main thing that distinguishes zaniness from the modern and frequently racialized aesthetic I call animatedness, although it is possible for them to exist together, just as modes of Fordist production continue to exist alongside post-Fordist ones. Whereas animatedness encodes industrial capitalism's objectifying mechanization of the human body (especially in its racially inflected versions), zaniness involves the subjectification of processes of production and their infusion with affect and personality. Whereas animatedness suggests impersonal and standardizing forces acting on a body from the outside, zaniness points to a body driven passionately from within. Whereas the problem animatedness poses is thus one of alienation (the worker estranged or separated from his own actions and feelings), zaniness poses the much stranger problem of not enough alienation. For while animatedness evokes a human being stripped of its affect and personality in the interests of performance efficiency (the modernist image of human as puppet, automaton, or robot), zaniness confronts us with a certain overproduction of subjectivity, of charisma and personality, that exceeds consumer demand (the postmodernist image of the cable guy, the housewife, the toy). Sianne Ngai, "Animatedness," *Ugly Feelings* (Cambridge, MA: Harvard University Press, 2005), 89–125.

91. Michael Hardt and Antonio Negri, *Empire* (Cambridge, MA: Harvard University Press, 2000), 293.

92. David Staples, "Women's Work and the Ambivalent Gift of Entropy," *The Affective Turn: Theorizing the Social,* ed. Patricia Ticineto Clough with Jean Halley (Durham, NC: Duke University Press, 2007), 119–150, 125.

93. Heather Hicks, *The Culture Of Soft Work: Labor, Gender, and Race in Postmodern American Narrative* (London: Palgrave Macmillan, 2009), 3.

94. Ibid., 3, 7, 2.

95. Thomas Peters and Robert Waterman, *In Search of Excellence: Lessons from America's Best-Run Companies* (New York: HarperCollins, 1982); cited in Hicks, *Culture of Soft Work,* 2.
96. Weeks, "Life within and against Work," 238.
97. Leopoldina Fortunati, *The Arcane of Reproduction: Housework, Prostitution, Labor, and Capital,* trans. Hilary Creek, ed. Jim Fleming (Brooklyn: Autonomedia, 1995), 8; cited in Staples, "Women's Work," 122.
98. Weeks, "Life within and against Work," 238.
99. The family's patriarch immediately tries to sexually assault Lucy/Carl, prompting his angry wife to shoot Lucy/Carl, which in turn discloses the truth of Carl's cross-dressing. As Carl says toward the end of the play, "I was a woman for almost six hours and it almost killed me." Richard Wright, "Man of All Work," in *Eight Men* (New York: Harper Perennial, 2008), 109–154, 154.
100. Also surviving the loss of the steel factory, or continuing to perform after its demise (in one of the film's more poignant ironies), is the former factory's brass band.
101. I would argue that *Flashdance,* set against the background of the now-defunct steel industry in Pittsburgh, is also a story about the feminization of late twentieth-century labor, even though its main character, Alex (Jennifer Beals), is female. (Women can obviously be feminized, too.) If the narrative underlying the film's Cinderella story of a factory welder becoming a ballet dancer is that of an entire society's painful but ultimately successful conversion from an industrial to a postindustrial economy, the iconography of the film works hard to correlate this story about economic change with Alex's individual trajectory of "becoming woman." It is not an exaggeration, in fact, to say that the worker-hero of *Flashdance* is butched up at the film's "industrial" beginning precisely so she can be made femme by its "postindustrial" end.

 It is crucial here that the thriving steel plant at which Alex works in the film was a blatantly nostalgic anachronism. By the year of the film's release, mills in Pittsburgh had already laid off 153,000 workers. Indeed, two decades before the free-trade agreements of the 1990s that would accelerate the global exportation of manufacturing labor to the third world, U.S. steel factories were rapidly closing in the late 1970s because of lowered demand from global recession, the 1973 oil crisis, the opening of nonunion "minimills," and competition from Germany and Japan. None of this is legible in the film's story. Yet because it was shot on location, *Flashdance* inadvertently gives us several ill-omened views of Pittsburgh as an industrial wasteland, including unused railways and a portentously closed steel mill right across town. Although Pittsburgh did manage to shift its economic base from heavy manufacturing to higher education, medicine, and services by the 1990s—becoming a postindustrial "success" story indirectly mirrored by the film's upbeat ending—the shift came with a drastic drop in its population, which shrank from around 660,000 in 1960 to 330,000 in 2000. For these facts, see the well-researched entry at http://en.wikipedia.org/wiki/History_of_Pittsburgh#Collapse_of_steel.

It is against the backdrop of this painful industrial transition that the film plays out its story of feminization. Alex is the only woman we see at the steel factory, yet her male coworkers do not seem to notice her sexual difference. The film repeatedly asks us to compare her with noticeably more femme women across various class divides. One is the socialite ex-wife of Alex's boss (Belinda Bauer); the other is Alex's best friend Jeanie (Sunny Johnson), a cocktail waitress who eventually becomes a stripper and pole dancer—a sex-affective activity that the film carefully represents as just one step "down" from the slightly more artistic "flashdance" and one step "up" from prostitution—after Jeanie gives up her dream of being a professional ice skater. Alex, on the other hand, pumps iron with her equally hard-bodied male colleagues, "eats like a pig," and is accompanied throughout the film by an enormous male pit bull. When she is not in her butch welding gear (helmet, industrial goggles, overalls, work boots), her workout clothes, or her pop dance costumes (surprisingly androgynous, including suits with enormous, 1980s-style shoulder pads), she is clad almost exclusively in bulky sweatshirts, work boots, and jeans.

All this masculine iconography seems set up at the beginning solely for the purpose of having its polarity reversed in conjunction with Alex's transition from steel-mill worker to student ballerina. Her feminizing switch from industrial to postindustrial labor, from unionized factory job to "virtuosic" work, is significantly mediated, however, through flashdance, a more "informal" kind of work that the film positions in a deliberately transitional zone between industrial labor and "unproductive" labor, work and play, and masculinity and femininity. If welding steel is unambiguously labor and ballet is unambiguously art, flashdance is somewhere in between. Its economic status in the film is not just transitional but ambiguous: Alex does flashdance to pay for her ballet-school tuition, thus turning it into a bridge between welding and dancing; at the same time, she describes it as a pleasurable activity that allows for creative expression and artistic autonomy in its own right. These subtle distinctions in the kinds of work Alex does, which could easily be measured on a scale of varying degrees of "virtuosity," are once again carefully correlated to shades of gender: if welding steel is masculine labor, and classical ballet is feminine performance/art, flashdance, the intermediate "step" between these two activities (more "immaterial" than welding but less "virtuosic" than ballet), is presented in the film as half masculine, half feminine. Although as erotic dance, the genre flashdance belongs to is feminine, its style is fast, aggressive, and conspicuously athletic or physically demanding. For all its sexual expressiveness, flashdancing evokes exercise designed to train and harden the body in the high-artistic tradition of Émile Jacque-Dalcroze's eurhythmics (one of the first attempts in modern dance to integrate art and physical culture) and Rudolph Laban's disciplinary-movement choirs (explicitly based on the rhythms of Taylorized work), as opposed to the femme/lyrical tradition of Isadora Duncan. Flashdance thus at first seems unambiguously androgynous, a dance genre stably fixed between two genders as well as two labor

paradigms. But interestingly, Alex's first flashdance in the film is a dance explicitly about metamorphosis, in which a character in a square-shouldered man's suit eventually casts that suit aside, like an empty shell, and steps out wearing practically nothing but makeup, spangles, and heels (which is also the moment when the dance picks up speed, difficulty, and grace). The "transitional" performing that facilitates Alex's shift from the steel mill to the ballet academy (i.e., flashdance, for which she earns a wage she can use to pay tuition) is thus defined in the dance itself as performing that makes a butch femme. Like post-Fordist zaniness (though the film is not itself zany), *Flashdance* represents the economic transition from industrial to postindustrial labor as an explicitly gendered transition.

This explains why the film finds it necessary to make Alex a steel-factory worker in the first place. Why not keep things simple, in accord with the film's basic Cinderella plot, and just tell the story of an exotic dancer who "bravely fights her way off the stripper pole" and into a posh ballet school? Yet it would be reductive to say that *Flashdance* is just a Cinderella story. However facile it may be in this respect, the film also engages in a direct meditation on the relationship between sex-affective labor and postindustrial labor, or the social distinctions reinforced by the distinctions among pole dancing (sex work), ballet (cultural work), and sexy but "artistic" pop dance (a mixture of both). What the theme of the steel industry, with its distinctively masculine iconography, adds to this already-interesting reflection on the relationship between three kinds of distinctively feminine performing (striptease, exotic dance that is not striptease, and classical ballet) is intensified pressure on the question of labor's gendering in general.

102. For a much more detailed and nuanced reading of gender in *The Full Monty*, which also argues that the film depicts the feminization of work in a positive as well as a negative light, see Heather Hicks, "Postindustrial Striptease: *The Full Monty* and the Feminization of Work," *Colby Quarterly* 36.1 (March 2000): 48–59.

103. Antonella Corsani, "Beyond the Myth of Woman: The Becoming-Transfeminist of (Post-)Marxism," *SubStance* 112 (2007): 107–138, 126. As Donna Haraway presciently noted in "Cyborg Manifesto" (1985), "Work is being redefined as both literally female and feminized, whether performed by men or women. To be feminized means to be made extremely vulnerable; able to be disassembled, reassembled, exploited as a reserve labor force; seen less as workers than as servers; subjected to time arrangements on and off the paid job that make a mockery out of a limited work day; leading an existence that always borders on being obscene, out of place, and reducible to sex." Donna Haraway, "A Cyborg Manifesto: Science, Technology, and Socialist-Feminism in the Late Twentieth Century," in *Simians, Cyborgs, and Women: The Reinvention of Nature* (New York: Routledge, 1991), 166; cited in Hicks, "Postindustrial Striptease," 48.

104. Laura Kipnis, *The Female Thing: Dirt, Sex, Envy, Vulnerability* (New York: Pantheon, 2006), 31.

105. Do these male-oriented films present the feminization of postindustrial labor that zaniness registers as something entirely bad for workers? Heather Hicks suggests not. As she argues about *The Full Monty* in particular, although the film at first seems a perfect illustration of Haraway's claim that whether one is a man or a woman, to be "feminized by one's work means to be made extremely vulnerable" (see note 92), it also "brings images of collectivity and skill together in an alternate, positive image of feminization" by mobilizing the theme and medium of dance (Hicks, "Postindustrial Striptease," 50). The recoding of work's feminization as positive (according to Hicks's reading of the film) thus requires mediation by an idea of art, and more specifically an ideological image of art as unalienated labor, one that we might want to hold up against Boltanski and Chiapello's description of the third, "connexionist" spirit of capitalism and its absorption of the aesthetic as a ready alibi for flexible labor. (On post-Fordist capitalism's capture of the "artistic critique" of the 1960s, see Boltanski and Chiapello, *The New Spirit of Capitalism,* 38, 419–472). The feminization of postindustrial work thus reflects and becomes roughly synonymous with the aestheticization of postindustrial work, aligning aesthetics itself with femininity and labor in a strange configuration that, as we will soon see, becomes a particular problem for Nietzsche's aesthetic philosophy.

106. This is occurring not just in the richest or high-GDP capitalist countries but also, in different ways and for different reasons, in the poor ones from which women have increasingly migrated to labor in the rich ones as nannies, care providers, and maids.

107. Karen Finley, *Living It Up: Humorous Adventures in Hyperdomesticity* (New York: Doubleday, 1996), inside cover matter (no page numbers).

108. Corsani, "Beyond the Myth of Woman," 108.

109. If an upside of this reach into traditionally feminine activity by capital is a loosening of sexual difference's symbolic hold on work overall, one that over time would seem to potentially diminish the longstanding impulse to gender work or use gender to justify disparities in its remuneration in the first place (a circle in which the gendering of work reinforces economic disparities and economic disparities participate in shoring up the logic of sexual difference), a possible downside for women would be a loss or relinquishment of the ways in which concepts of femininity have also made certain kinds of work meaningful in ways that are not entirely or necessarily bad (and indeed, in ways that are not entirely reducible to capitalism). Thus in women-oriented zany texts, the way in which "highly flexible modes of postindustrial work open the way to gender redefinition" (Hicks, *Culture of Soft Work,* 59) arguably gets met with an extra layer of ambivalence beyond that which we already see in films such as *The Cable Guy* and *The Toy,* since women's response to the feminization of work in general (whether performed by women or men) includes not only the same contradictory mixture of negative and positive feelings about femininity itself, but also contradictory feelings about what it might mean to no longer consider certain affective and/or relational activities as a specific provenance of women,

and thus about what it means to relinquish the positive gendered connotations of these ways of doing as ideological weapons in political struggles for social and economic quality.

110. Laura Kipnis, *Against Love: A Polemic* (New York: Pantheon, 2003), 21.

111. This seems due in part to Kipnis's goal of producing a popular feminist criticism, which for her entails reading women's culture without being immediately dismissive of its own set of aesthetic pleasures, which have clearly played a role in maintaining the psychological attachment of feminists to the images of femininity it produces. Indeed, far from attempting to dissolve the aesthetic styles of the girlfriend industry, *The Female Thing* seems to want to harness them for itself in order to produce a feminist critique of "the female thing" that will itself be widely accessible, pleasurable, and popular.

112. The convergence between productive and reproductive practices in both postindustrial working and private life (as the zany texts by women emphasize) returns here as an uneasy intersection between a zany object (femininity) and an equally zany method (feminist parody): "Feminism ('Don't call me honey, dickhead') and femininity ('I just found the world's best push-up bra') are in a big catfight, nowhere more than within each individual female psyche" (Kipnis, *Female Thing*, 6).

113. This is Nancy Fraser's argument in "Feminism, Capitalism, and the Cunning of History." Although at first Fraser seems to want to leave open the question of whether the affinity is spurious or coincidental or deeper and structural, her argument finally comes down on the side of the latter: "Second-wave feminism has unwittingly provided a key ingredient of the new spirit of neoliberalism" in its critique of the family wage, which now "supplies a good part of the romance that invests flexible capitalism with a higher meaning and moral point" (110). As in the case for "democracy," second-wave feminism's critique of the family wage, in particular, becomes an "empty signifier of the good, which can and will be invoked to legitimate a variety of different scenarios, not all of which promote gender justice" (114), and which can even serve to "intensify capitalism's valorization of waged labor" in ways that directly exacerbate gender-based inequity (111).

114. Ariel Levy, *Female Chauvinist Pigs: Women and the Rise of Raunch Culture* (New York: Free Press, 2005).

115. Gender is an issue for the zany *precisely because* it is an aesthetic about work, an activity still fundamentally organized and informed by changing concepts of sexual difference, if in different ways and to different degrees under different modes of production.

116. Donna Haraway, "A Manifesto for Cyborgs: Science, Technology, and Socialist Feminism in the 1980s," *Socialist Review* 80 (1985): 65–108, 87; cited in Weeks, "Life within and against Work," 239.

117. As Mary Ann Doane puts it, "The pressures are great—the pressure to feel pleasure, the pressure to laugh, the pressure to not feel excluded from the textual field of dominant mass culture." See "Masquerade Reconsidered: Further Thoughts on the Female Spectator," in *Femmes Fatales: Feminism,*

Film Theory, Psychoanalysis (New York: Routledge, 1991), 33–43, 42. On the feminist killjoy, see also Sara Ahmed, *The Promise of Happiness* (Durham, NC: Duke University Press, 2010).

118. Lisa Duggan and Kathleen McHugh, "A Fem(me)inist Manifesto," in *Brazen Femme: Queering Femininity,* ed. Chloe Brushwood Rose and Anna Camilleri (Vancouver: Arsenal Pulp Press, 2002), 165–170, 167.

119. Christian Thorne, "Against Joy" (unpublished manuscript), 5.

120. Matthew Rampley, *Nietzsche, Aesthetics, and Modernity* (Cambridge: Cambridge University Press, 2000), 193.

121. For an interesting approach to character as form (and specifically as the form of a "collection"), see Aaron Kunin, "Characters Lounge," *Modern Language Quarterly* 70.3 (September 2009): 291–317.

122. Derrida, *Spurs,* 187. See Sarah Kofman, "Baubô: Theological Perversion and Fetishism," trans. Tracy B. Strong, in Oliver and Pearsall, *Feminist Interpretations of Friedrich Nietzsche,* 1–49, and in the same volume, Oliver, "Woman as Truth in Nietzsche's Writing," 66–80. Oliver provides a particularly helpful breakdown of the subcategories of woman, building on ones introduced by Derrida in *Spurs*: the feminist or desexed, "castrated woman" who shares the philosopher's will-to-truth in her desire to disclose "woman as she really is" and thus relate to truth as something existing to be discovered; the "castrating woman," who shares the artist's will-to-illusion, love of appearances, and relation to truth as something one creates; and finally, slightly overlapping with the last category, the "affirming woman," who embraces Dionysus's love of flux and change, embodies will-to-power, and has no need for truth at all, standing outside its discourse as the "inarticulate 'truth' " of what Nietzsche in *The Birth of Tragedy* calls the "Original Mother, who, constantly creating, finds satisfaction in the turbulent flux of appearances" (cited in Oliver, 76). Oliver elaborates, "Unlike the metaphysician who discovers a foundation for action and the artist who creates a foundation, the affirming woman is the self-perpetuating Dionysian force who has no need for a foundation" (76).

123. Luce Irigaray, "Veiled Lips," in Oliver and Pearsall, *Feminist Interpretations of Friedrich Nietzsche,* 107.

124. Pippin, *Nietzsche, Psychology, and First Philosophy,* 121.

125. See Rampley, *Nietzsche, Aesthetics, and Modernity,* 199–200. In Rampley's careful analysis of this "twisting and turning from the feminine to the masculine," he argues that inconsistencies like these result from the fact that Nietzsche uses sexual difference "strategically," with "masculine" denoting an aesthetics from the "active" standpoint of the artist (a "giver") and "feminine" denoting an aesthetics from the "passive" standpoint of the spectator (a "receiver"). In a manner that recalls the controversial distinction between productive and unproductive or reproductive labor, "Nietzsche is here 'dealing with a very old philosopheme of production,' whereby masculinity has always has always been regarded as the productive gender against the sterility of the feminine" (211). Yet even according to this reading confu-

sions remain, for there are numerous moments in which "woman" is expressly credited as producer of her various aesthetic effects.

126. Doane, "Veiling Over Desire: Close-ups of the Woman," *Femmes Fatales,* 44–75, 59.

127. Nietzsche, *The Will to Power,* trans. Walter Kaufmann and R. J. Hollingdale (New York: Random House, 1968), 425; cited in Doane, *Femmes Fatales,* 59.

128. This is Pippin's reading of Nietzsche's comment in *On the Genealogy of Morals* that "there is no 'being' behind doing, effecting, becoming; the 'doer' is merely a fiction added to the deed—the deed is everything." See Nietzsche, *On the Genealogy of Morals* I, ¶ 13; cited in Pippin, *Nietzsche, Psychology, and First Philosophy,* 74. Pippin's reading deviates from Oliver's interpretation of Nietzsche. For Oliver, when the "castrating woman" (the woman as artist/actor) becomes "seduced by her illusion," begins to "believe that the illusion she created is the source of her power [and thus] forgets that she created the illusion," "cling[ing] fanatically" to it, the will to illusion comes to serve the life-denying instincts rather than life-affirming ones and thus becomes the very antithesis of gay science. The fact that readers of Nietzsche as knowledgeable as Pippin and Oliver have come up with such divergent readings of this identification (the actor entirely identified with his role, the woman entirely identified with her illusion, the worker entirely identified with his projects) testifies to my point about Nietzsche's overarching uncertainty about acting in *The Gay Science.*

129. Paul Patton, "Postmodern Subjectivity: The Problem of the Actor (Zarathrustra and the Butler)," *Social Analysis* 30 (December 1991): 32–41, 35. The problem with the latter in particular for Nietzsche, Patton explains, is that such a "shadowy and insubstantial bearer of masks" would seem incapable of desire, lacking the "necessary identification with and commitment to those occupations which might enable the kind of willed activity that leads to creation beyond itself," or what Nietzsche elsewhere calls "self-overcoming" (37).

130. See Friedrich Nietzsche, *Twilight of the Idols,* "Maxims and Arrows," ¶ 13, 33.

131. As an afterthought, Nietzsche adds that "in superior social conditions, too, a similar human type develops under similar pressures; only in such cases the histrionic instinct is usually barely kept under control by another instinct; for example, in the case of 'diplomats.' Incidentally, I am inclined to believe that a good diplomat would always be free to become a good stage actor if he wished—if only he were 'free' " (*Gay Science,* ¶ 361, 317)

132. The German word is *Possenreißer.*

133. Boltanski and Chiapello, *New Spirit of Capitalism,* 110–111.

Afterword

1. On aesthetic judgments as performatives disguised as constative statements, see Jan Mieszkowski, *Labors of Imagination: Aesthetics and Political Econ-*

omy from Kant to Althusser (New York: Fordham University Press, 2006), 19; and Stanley Cavell, *Philosophy the Day after Tomorrow* (Cambridge, MA: Belknap Press of Harvard University Press, 2005), especially 155–191. On the way in which aesthetic predicates can make it seem as if value judgments follow from factual ones, see Gérard Genette, *The Aesthetic Relation*, trans. G. M. Goshgarian (Ithaca, NY: Cornell University Press, 1999), 92.

2. See Cavell, *Philosophy the Day after Tomorrow*, 11.
3. Luc Boltanski and Eve Chiapello, *The New Spirit of Capitalism*, trans. Gregory Elliott (London: Verso, 2005), 155.
4. Guillermo Gómez-Peña, *Ethno-Techno: Writings on Performance, Activism, and Pedagogy* (New York: Routledge, 2005). See especially "Culturas-in-extremis: Performing against the Cultural Backdrop of the Mainstream Bizarre," 45–64. "Just switch on *Jerry Springer*": back cover.
5. Andrew Seligsohn writes, "When Nietzsche speaks of the self as a work of art, he does not speak the language of judgment, and when he speaks the language of judgment, it is typically to call attention to the silliness of Kant's deployment of the concept." See Andrew J. Seligsohn, "Aesthetic Experience, Aesthetic Judgment?" *Theory and Event* 4.4 (2000), muse.jhu.edu/journals/theory_and_event/v004/4.4r_seligsohn.html (accessed 2/12/2011).
6. Ibid.
7. Nelson Goodman, *Languages of Art: An Approach to a Theory of Symbols* (Indianapolis: Hackett, 1976), 248.
8. Ibid., 262.
9. In accordance with what Herbert Marcuse calls the "performance principle." Herbert Marcuse, *Eros and Civilization: A Philosophical Inquiry into Freud* (London: Routledge, 1987), 35. For a discussion of Marcuse's "performance principle" in conjunction with Lyotard's similar notion of "performativity," see Jon McKenzie, *Perform or Else: From Discipline to Performance* (London: Routledge, 2001), 159–162.
10. Raymond Williams, "The Means of Communication as Means of Production," in *Culture and Materialism: Selected Essays* (London: Verso, 2006), 50–66, 50.
11. "Facade of legitimation": Oskar Negt, Alexander Kluge, and Peter Labanyi, "The Public Sphere and Experience," *October* 46 (Autumn 1988): 60–82, 61.
12. In "degree of reality" I am borrowing a concept from object-oriented ontology. Graham Harman, "Real Objects and Pseudo-objects: Remarks on Method" (paper presented at "Hello, Everything: Speculative Realism and Object-Oriented Ontology," UCLA, December 2010).
13. It goes without saying that this gendered division of labor continues to have a direct impact on the economic valuation of specific kinds of waged work around the globe. For a lucid discussion of this issue, see Kathi Weeks, "Life within and against Work: Affective Labor, Feminist Critique, and Post-Fordist Politics," *Ephemera* 7.1 (2007): 233–249.
14. Harman, "Real Objects and Pseudo-objects."

15. Ann Douglas, *The Feminization of American Culture* (New York: Knopf, 1978).
16. Arlie Hochschild, "The Culture of Politics: Traditional, Post-modern, Cold-Modern, and Warm-Modern Ideals of Care," *Social Politics* 2 (1995): 331–346; cited in Rhacel Salazar Parreñas, "The Care Crisis in the Philippines: Children and Transnational Families in the Phillipines," in *Global Woman: Nannies, Maids, and Sex Workers in the New Economy*, ed. Barbara Ehrenreich and Arlie Hochschild (New York: Metropolitan Books, 2003), 39–54, 39.
17. On intimate publics, see Lauren Berlant, *The Female Complaint: The Unfinished Business of Sentimentality in American Culture* (Durham, NC: Duke University Press, 2009). On kinship as medium, see Linda Nicholson, "Feminism and Marx: Integrating Kinship with the Economic," in *The Second Wave: A Reader in Feminist Theory*, ed. Linda Nicholson (New York: Routledge, 1997), 131–146.
18. "Lost utopia of unalienated work": cited in Donald Burton Kuspit, *Redeeming Art: Critical Reveries* (New York: Allworth Press, 2000), 166; also cited in James B. Gilbert, *Work without Salvation: America's Intellectuals And Industrial Alienation, 1880–1910* (Baltimore: John Hopkins University Press, 1977), 96. Friedrich Schiller, *On the Aesthetic Education of Man: In a Series of Letters*, trans. and ed. Elizabeth M. Wilkinson and L. A. Willoughby (New York: Oxford University Press, 1967), 107. Hans-Georg Gadamer, *Truth and Method* (New York: Continuum, 2004), 103. Even Gadamer's account remains bound to the idea of play as "absence of strain," as "movement . . . not only without goal or purpose but also without effort" (105).

 As if in a fear of cuteness *avant la lettre*, Schiller feels compelled immediately to defend his equation of beauty with play against charges of "belying" the "dignity of beauty" or reducing it "to the level of frivolous things." To do so, he argues that playing is conducive to a specific state of mind, referring to the Greeks who "banished from the brow of [their statues of gods] all the earnestness and effort which furrow the cheeks of mortals . . . freed those ever-contented beings from the bonds inseparable from every purpose, every duty, every care, and made idleness and indifference, the enviable portion of divinity; merely a more human name for the freest, most sublime state of being." In a neat reversal of the trajectory by which "disinterestedness" enables the "free play" of subjective faculties in Kant, in Schiller it is "play-drive" that culminates in "indifference" (*Gleichgültigkeit*, a word that, as his English translators note, does not so much indicate affectlessness as a state of affective equilibrium, something like "the middle zone of a magnet where the attractive powers of the two ends neutralize each other"). For Schiller, playing thus leads not to the absence of affective involvement but to a feeling of detachment from these involvements that will be reflexively felt in turn as equanimity. Yet nothing could be less serene or full of equanimity than zaniness, an aesthetic about our utter embroilment in rather than detachment from situations, and in which playing and working and pleasure and displeasure are inextricably mixed.

19. See M. H. Abrams, "Art-as-Such: The Sociology of Modern Aesthetics," in *Doing Things with Texts* (New York: W. W. Norton, 1991), 135–158, 136–137.

20. Immanuel Kant, *Critique of the Power of Judgment,* trans. Paul Guyer and Eric Matthews (Cambridge: Cambridge University Press, 2000), 145.

21. Walter Benjamin, "The Work of Art in the Age of Mechanical Reproduction," in *Illuminations: Essays and Reflections,* ed. Hannah Arendt, trans. Harry Zohn (New York: Schocken Books, 1969), 222. On art's distance from the "society at which it shudders" (226), see Theodor Adorno, *Aesthetic Theory,* trans. Robert Hullot-Kentor (Minneapolis: University of Minnesota Press, 1997), especially 1–14 and 225–259. On art ignoring the beholder, see Michael Fried, *Absorption and Theatricality: Painting and Beholder in the Age of Diderot* (Chicago: University of Chicago Press, 1988). For an account of the importance of "distance" qua "cultivated detachment" for the Victorians, see Amanda Anderson, *The Powers of Distance: Cosmopolitanism and the Cultivation of Detachment* (Princeton, NJ: Princeton University Press, 2001).

22. See Denis Diderot, *The Paradox of Acting,* trans. Walter Herries Pollock (London: Chatto and Windus, 1883); Sigmund Freud, *Civilization and Its Discontents,* trans. and ed. James Strachey, intro. Louis Menand (New York: W. W. Norton, 2005). In Edward Bullough's classic 1912 paper "Psychical Distance as a Factor in Art and as an Aesthetic Principle," distance is conceived less as a thing than as an act—that of "separating the object and its appeal from one's own self by putting it out of gear with practical needs and ends"—invoked to explain virtually everything aesthetic theory seeks to cover, from the "aesthetic consciousness" of the spectator and the "artistic temperament" of the artist to the entire system of fine arts. See Edward Bullough, *Aesthetics: Lectures and Essays by Edward Bullough,* ed. Elizabeth M. Wilkinson (Stanford, CA: Stanford University Press, 1957), 96.

23. Adorno refers to this radically disconnected and disconnecting pleasure as "castrated hedonism." Adorno, *Aesthetic Theory,* 11. Adorno adds, "It is striking, incidentally, that an aesthetic that constantly insists on subjective feeling as the basis of all beauty never seriously analyzed this feeling" (14). Subtly playing Freud against Kant, he also writes: "The doctrine of disinterested satisfaction is impoverished vis-à-vis the aesthetic: it reduces the phenomenon either to formal beauty, which when isolated is highly dubious, or to the so-called sublime natural object. The sublimation of the work to absolute form neglects the spirit of the work in the interest of which sublimation was undertaken in the first place. This is honestly and involuntarily attested by Kant's strained footnote, in which he asserts that a judgment of an object of liking may indeed be disinterested, yet interesting; that is, may produce interest even when it is not based on it" (10). The "strained footnote" Adorno is referring to in *Critique of Judgment is* ¶ 3, fn. 2.

24. Kant, *Critique of the Power of Judgment,* ¶ 2, 90.

25. This interplay between fragility and power is reflected in the design of Scarry's *On Beauty and Being Just,* a slim volume decorated with a delicately rendered watercolor of eggshells that nonetheless makes fairly aggressive

claims against feminist, queer, and postcolonial critiques of beauty (and, perhaps most aggressively, never identifies any of them by name).

26. Jan Mukařovský, *Aesthetic Function, Norm and Value as Social Facts,* trans. Mark E. Suino (Ann Arbor: Department of Slavic Languages and Literatures, University of Michigan, 1979), 18.

27. Ibid.

28. On the rise of melodrama as a response to the loss of the sacred, see Peter Brooks, *The Melodramatic Imagination: Balzac, Henry James, Melodrama, and the Mode of Excess* (New Haven, CT: Yale University Press, 1995).

Acknowledgments

My deepest thanks go to friends who responded in generous detail to nearly all of this book: Franco Moretti, Mark Seltzer, Jennifer Fleissner, and Anne Cheng. I am also grateful to Elisa Tamarkin, Daniel T. O'Hara, Mark Goble, Gopal Balakrishnan, Eleanor Kaufman, Eric Hayot, Aaron Kunin, Chris Looby, Joe DiMuro, Paul Gilmore, Ken Reinhard, Christian Thorne, Mimi McGurl, Alex Woloch, Rachel Lee, Heather Love, Amy Hungerford, Robert Kaufmann, Joe Rezek, Rob Halpern, Joseph Nagy, and Martin Hägglund for incisive exchanges about issues raised in individual chapters. Special thanks to the Southern California Americanist Group, 2004–2007.

I am not sure how I would have gotten through the last stages of this project without my research assistant, Glenn Brewer, and his professionalism, patience, and unflagging sense of humor. I am also grateful for the assistance of Dalglish Chew.

Warm thanks to the people who invited me to give talks or presentations related to the material in this book from the fall of 2002 to 2012. I am indebted to organizers and audiences at the ASAP Inaugural Conference, Brown University, the School of Critical Studies at the California Institute of the Arts, Concordia University, Emory University, Harvard University, the Huntington Library, Indiana University, Johns Hopkins University, MLA, Narrative, the New School, the Oakley Center at Williams College, the University of Pennsylvania, Pomona College, Post45, Princeton University, Stanford University, UC Berkeley, UCLA, UC Santa Cruz, the University of Chicago, the University of Illinois at Chicago, the University of Virginia, Yale University, and York University. For particular acts of kindness in conjunction with these events and others, I want to thank Amy Elias, Ben Lee, Omri Moses, Brent Dawson, Daniel Williams and Jake Risinger, Jennifer Fleissner, Chris Nealon, Jonathan Culler and Cathy Caruth, Kate Eichhorn, Ann Snitow, Michael Brown, Bob Perelman, Francie Shaw, Nancy Bentley, Anne Cheng, Gavin Jones, Terry Castle, Elisa Tamarkin, Charles Altieri, Joshua Clover and Jen Scappetone, Joel Burges, Chris Looby and Cindy Weinstein, Kyla

Wazana Tompkins, Oren Izenberg, Lauren Berlant, Jennifer Wicke, Steve Arata, Jessica Pressman, Sam See, Sharla Sava, Tisa Bryant, and Douglas Kearney. Thanks also to the Vancouver Kootenay School of Writing, especially Donato Mancini and Andrew Klobucar, for inviting me to present a draft of "The Zany Science" for its 2008 Positions Conference. A special thanks to Adam Jasper and Sina Najafi at *Cabinet* for their kindness and interest in this project.

Jay Fliegelman, Barbara Johnson, Barbara Packer, and Stacy Doris each made a significant impact on my life as well as on my thoughts in this book, and I continue to miss them.

This book was written across and with generous assistance from two institutions. A year at the Stanford Humanities Center and another as a Barbara Thom Postdoctoral Fellow at the Huntington Library proved crucial in early stages of research and writing. I am also grateful for a 2007 Charles Ryskamp / American Council of Learned Societies Fellowship, a fellowship designed specifically for recently tenured faculty that could not have come at a better time. Warm thanks to Tim Stowell, Tom Wortham, Rafael Pérez-Torres, and especially my dear friend Ali Behdad for their support at UCLA. I also want to thank my past chairs at the English Department at Stanford for years of encouragement and support: Rob Polhemus, Ramón Saldívar, and Jennifer Summit. Thank you to Lindsay Waters and Shanshan Wang at Harvard University Press. A particular thanks to my skilled copyeditors, Charles Eberline and Michael Haggett.

I am grateful to all the poets mentioned in this book for permission to quote their work. A special thank you to Sonnabend Gallery, Blum & Poe Los Angeles, John Baldessari, Ed Ruscha, Francie Shaw, Karen Finley, and Yoshitomo Nara for their permission to reproduce images and generosity about fees. Thanks to the Ngais, who of course include Justin Klein and Richard Nguyen Sloniker and to all the McGurls, especially Georgia.

Early versions of sections in this book appeared in *Critical Inquiry* and in *PMLA*. I am grateful to the editors of these journals for their permission to reprint here. Special thanks to Jay Williams, managing editor at *Critical Inquiry*.

The year I wrote the first essay in what would eventually become this book was also the year in which I met Mark McGurl. I thank him for ten years of intellectually heady, sometimes zany, always interesting conversation about practically everything.

Chapter Credits

1. Portions of the Introduction first appeared in the essay "Our Aesthetic Categories," *PMLA* 125.4 (2010): 948–958 and in the interview, "Our Aesthetic Categories: An Interview with Sianne Ngai," by Adam Jasper and Sianne Ngai, *Cabinet* 43 (Fall 2011), 45–51.

2. Portions of Chapter 1 first appeared in the essay "The Cuteness of the Avant-Garde," *Critical Inquiry* 31.4 (Summer 2005): 811–847.

3. Portions of Chapter 2 first appeared in the essay "Merely Interesting," *Critical Inquiry* 34.4 (Summer 2008): 777–817.

Illustration Credits

Introduction

1. John Baldessari, Detail of *Choosing (A Game for Two Players): Green Beans* (1, 2, 3, and 4 of 9), 1972. Color photographs, text. 9 @ 12" × 22" each. Courtesy of the artist.

Chapter 1: The Cuteness of the Avant-Garde

2a–b. Cute frog sponges, photos by author.
3. "The Girl from Paris" (American Mechanical Doll Works Company, 1895).
4. Yoshitomo Nara, untitled drawing ("Black Eye, Fat Lips, and Opened Wound"), 2001. Color pencil on paper. Courtesy of the artist.
5. Yoshitomo Nara, *Slight Fever,* 2001. Acrylic on cotton, mounted on fiber-reinforced plastic plate. 70.75 diameter, 10.5 deep. Courtesy of the artist.
6. Yoshitomo Nara, *Fountain of Life,* 2001. Fiber-reinforced plastics, lacquer, urethane, motor, water. 68.9" high × 43.31" diameter. Courtesy of the artist and Blum & Poe, Los Angeles.
7. Yoshitomo Nara, untitled drawing ("Jap in the Box"), 2001. Color pencil on paper. Courtesy of the artist.
8. Takashi Murakami, *DOB with Flowers,* 1998. Oil on canvas. 405 × 405 mm. Courtesy Blum & Poe, Los Angeles. ©1998 Takashi Murakami/Kaikai Kiki Co., Ltd. All rights reserved.
9. Takashi Murakami, *DOB in the Strange Forest (Red DOB),* 1999. Fiber-reinforced plastics, resin, fiberglass, acrylic, and iron. 1,520 × 3,040 mm (twelve elements). Photo by Christie's Images, Ltd. ©1999 Takashi Murakami/Kaikai Kiki Co., Ltd. All rights reserved.
10. Takashi Murakami, *And Then, and Then and Then and Then and Then (Red),* 1996–1997. Acrylic on canvas mounted on board. 2,800 × 3,000 mm (2 panels). Courtesy Blum & Poe, Los Angeles. ©1996–1997 Takashi Murakami/Kaikai Kiki Co., Ltd. All rights reserved.
11. Takashi Murakami, *Guru Guru,* 1998. Vinyl chloride and helium gas. 3,380 × 2,690 × 2,690 mm. Courtesy Tomio Koyama Gallery. ©1998 Takashi Murakami/Kaikai Kiki Co., Ltd. All rights reserved.
12. Takashi Murakami, *The Castle of Tin Tin,* 1998. Acrylic on canvas mounted on board. 3,000 × 3,000 mm. Courtesy of Blum & Poe, Los Angeles. ©1998 Takashi Murakami/Kaikai Kiki Co., Ltd. All rights reserved.
13. Masohiro Mori, *The Uncanny Valley,* 1970. Simplified version of figure from article in *Energy* 7.4. ©2005 Karl F. MacDorman and Takashi Minato.
14. Francie Shaw, *Playing Bodies #37,* 2000. Latex on canvas. 18" × 18". Courtesy of the artist.
15. Francie Shaw, *Playing Bodies #23,* 2000. Latex on canvas. 18" × 18". Courtesy of the artist.

Chapter 2: Merely Interesting

16. Ed Ruscha, *Various Small Fires and Milk,* 1964. Softcover artist's book, 48 pages, 16 offset reproductions of black-and-white photographs (book cover and pages 1, 2, 5–8, 15, 16 pictured here). 5.5"×7". Courtesy of the artist.
17. Bernd and Hilla Becher, *Cooling Towers,* 1961–1987 (2003). Nine black-and-white photographs. 68.25"×56.25". Courtesy Sonnabend Gallery.
18a. John Baldessari, *Pointing: T.V. Set,* 1969. Color photographs on museum board. 28.75"×42.5". Courtesy of the artist.
18b. John Baldessari, *Pointing: Circle,* 1969. Color photographs on museum board. 28.75"×42.5". Courtesy of the artist.
19. Baldessari, *Commissioned Painting: A Painting by Pat Purdue,* 1969. Acrylic and oil on canvas. 59.25"×45.5". Courtesy of the artist.
20. On Kawara, *I Got Up At . . . ,* 1974–1975. Ninety postcards with printed rubber stamps. 3.5"×4" each and 4"×6" each. Courtesy of The Museum of Contemporary Art, Los Angeles.

Chapter 3: The Zany Science

21. *I Love Lucy,* "The Ballet," February 18, 1952 (tiff 3).
22. *I Love Lucy,* "The Million Dollar Idea," January 11, 1954 (salad dressing).
23. *I Love Lucy,* "Lucy Tells the Truth," November 9, 1953 (magician's assistant 1 and 2).
24. *I Love Lucy,* "Lucy Tells the Truth," November 9, 1953.
25. *I Love Lucy,* "Lucy Meets Bob Hope," October 1, 1956.
26. *I Love Lucy,* "Lucy and Superman," January 14, 1957.
27. *I Love Lucy,* "Lucy and Superman," January 14, 1957.
28. *I Love Lucy,* "Lucy Is Envious," March 29, 1954.
29. *I Love Lucy,* "Lucy Does a TV Commercial," May 5, 1952.
30. Crazy Eddie advertisement, circa 1980.
31a–g. *The Toy.* Dir. Richard Donner, Columbia Pictures, 1982.
32. From the *Recueil Fossard,* dated around 1570s–1580s. Woodblock print in bound volume held by the National Museum of Fine Art, Stockholm.
33. From the *Recueil Fossard,* dated around 1570s–1580s. Woodblock print in bound volume held by the National Museum of Fine Art, Stockholm.
34. From the *Recueil Fossard,* dated around 1570s–1580s. Woodblock print in bound volume held by the National Museum of Fine Art, Stockholm.
35a–e. *The Cable Guy.* Dir. Ben Stiller, Columbia Pictures, 1996.
36a–b. *The Cable Guy.* Dir. Ben Stiller, Columbia Pictures, 1996.
37a–b. *The Cable Guy.* Dir. Ben Stiller, Columbia Pictures, 1996.
38. *The Cable Guy.* Dir. Ben Stiller, Columbia Pictures, 1996.
39. *The Toy.* Dir. Richard Donner, Columbia Pictures, 1982.
40a–b. *The Full Monty.* Dir. Pater Cattaneo, Redwave / Channel Four / Twentieth Century Fox Productions, 1997.
41. *The Full Monty.* Dir. Pater Cattaneo, Redwave / Channel Four / Twentieth Century Fox Productions, 1997.

42a–b. *The Full Monty.* Dir. Pater Cattaneo, Redwave / Channel Four / Twentieth Century Fox Productions, 1997.

43. *The Full Monty.* Dir. Pater Cattaneo, Redwave / Channel Four / Twentieth Century Fox Productions, 1997.

44. *The Full Monty.* Dir. Pater Cattaneo, Redwave / Channel Four / Twentieth Century Fox Productions, 1997.

45. Karen Finley, detail from *Living It Up: Humorous Adventures in Hyper-domesticity* ("What's wrong with this outfit?"), 1996.

46. Karen Finley, detail from *Living It Up: Humorous Adventures in Hyper-domesticity* ("sweeping buffing dusting"), 1996.

47. Karen Finley, detail from *Living It Up: Humorous Adventures in Hyper-domesticity* ("How to make Mom a hair bathmat"), 1996.

48. Karen Finley, detail from *Living It Up: Humorous Adventures in Hyper-domesticity* ("Making your very own casket").

Index

Abrams, M. H., 240

Acker, Kathy, 8

Ackerman, James, 29

Adorno, Theodor, 2, 6, 22, 23, 40, 54, 59, 63, 70, 72, 117, 171, 271n105; *Aesthetic Theory*, 16, 42, 100–109, 273–274n124, 316n23; on art's autonomy, 101–109, 240; on kitsch, 101–104, 105–107; "Lyric Poetry and Society," 3; *Minima Moralia*, 63, 101, 102–103, 104, 107; on music, 6, 47; on "muteness" of poetry, 98–100; prose style of, 101; "The Stars down to Earth," 174–175, 203

aesthetic categories: and capitalism, 13–14; as equivocal judgments, 19; and failure, 26–27; and history, 14–15, 16–18, 32, 56; as metacategory, 56–59; and resistance to institutionalization, 16; sociality of, 11–12; as styles, 29–34; triviality of, 18, 19, 21, 22–23, 24, 32, 38, 58–59, 237. *See also* aesthetic judgments; cute(ness); interesting; zany

aesthetic judgments, 2, 11; covert aspects of, 40, 41, 44–45, 47–48; and detachment, 6; minor versus major, 53–59; and relativism, 38–39; as speech, 38–42, 44–47; versus nonaesthetic judgments, 43–44, 48–51, 55–56, 118–120, 126, 128, 135, 144, 165, 260n160, 277n24. *See also* aesthetic categories; cute(ness); interesting; zany

affect, 1–2, 7, 9–13, 16, 18–19, 22–24, 28–29, 34, 41, 44, 46, 53–54, 57, 60, 63–67, 85, 91, 98, 101, 113, 116–117, 168, 186–192, 197–203, 206–242. *See also* aesthetic categories; aesthetic judgments; affective labor; immaterial labor; interesting: low affect of; Nietzsche, Friedrich: *The Gay Science*; work: emotionalization of

affective labor, 1, 3, 7, 16, 207–208, 218–220, 234–235, 299–300n40, 300n42, 304n64, 309n101. *See also* immaterial labor; post-Fordism

Agamben, Giorgio, 27, 135, 255n102, 285n98

Air Conditioning Show (Art-Language), 295n210

Alberro, Alexander: *Conceptual Art and the Politics of Publicity*, 155, 158

Alighieri, Dante, 126

Althusser, Louis, 23, 96, 252n61

Anderson, Amanda, 6

Andre, Carl, 156

Andrews, Bruce, 8

Angier, Natalie, 24–25, 272n110

Animaniacs (cartoon series), 182

Antin, Eleanor: *Blood of the Poet Box*, 143, 168

Arendt, Hannah, 3, 29, 41–42, 46, 69, 260n166; *Lectures on Kant's Political Philosophy*, 258n146

Stengers, Isabelle, 113–114, 115, 117
Stevens, Wallace, 117
Stewart, Susan, *Poetry and the Fate of the Senses*, 4
style: definition of, 29; and history, 31–33; instability of, 30–31; as subjective versus objective phenomenon, 29; versus form, 30; and whateverness of, 34
sublime, 18, 20, 22, 23, 253–254n80; Kantian, 19, 43, 57, 58, 165, 254n83, 302n57
Sutherland, Keston, 62, 67, 100, 264n33
Svevo, Italo, 140

Tabbi, Joseph, 22
Taylorism, 174, 201, 202, 207, 237
Terranova, Tiziana, 200
Tom and Jerry (cartoon series), 185, 191
Tomkins, Silvan, 129, 133–134
The Toy (film), 7, 183, **183**, 210–211, **211**, 212, 213
Trakl, George, 108
Trecartin, Ryan, 2, 12
Trivial Pursuit (game), 135
Tuchman, Phyllis: "Minimalism: Art of the Interesting," 36
Turgenev, Ivan, 140

Ullman, Stephen, 34
uncanny valley (Masohiro Mori), 91–92, **92**
Uncle Tom's Cabin (Stowe), 263n24
use-value, 61–62, 63, 66, 67
utopia, 13, 63, 86, 239, 294n208

value: as aesthetic judgment, 40–41. *See also* exchange-value; use-value
Verlaine, Paul, 104
video games, 7
Virno, Paolo, 205, 206, 250n50

Wagner, Richard (composer), 223, 226
Wall, Jeff, 145, 146
Wallace, David Foster, 140; "Mister Squishy" 8, 9, 249n36
Warhol, Andy, 80, 271–272n105
Warner, Michael, 111–112, 275n3, 275n6
Watten, Barrett, 97
Weber, Max, 201, 203, 302n58
Weeks, Kathi, 207, 209, 300n42
Wheeler, Kathleen, 125
Wiener, Lawrence, 158
Williams, Linda, 3

Williams, Raymond, 97, 138, 189, 300n41
Williams, William Carlos, 3, 64, 70, 108, 271n105
Wilson, Ross, 42
Wind, Edgar, 138, 286–287n112
Winnicott, D. W., 89, 272n107
Winnie the Pooh (cartoon character), 66
Wittgenstein, Ludwig, 29
Wollheim, Richard, 290n156
women, 4, 10, 11, 43, 54, 61, 67–68, 76, 175, 189, 206–238. *See also* affective labor; femininity; feminism; immaterial labor
Wordsworth, William, 92; *Essays upon Epitaphs*, 92; Lucy poems, 95
work: emotionalization of, 10; feminization of, 210–222, 307–309n101, 310–311n109; joylessness of, 223. *See also The Cable Guy*; domestic sphere; Fordism; *The Full Monty*; immaterial labor; Marx, Karl (and Marxism); post-Fordism; Taylorism; zany: confusion of work and play
Working Drawings and Other Visible Things on Paper Not Necessarily Meant to be Viewed as Art (exhibit), 144
Wright, Richard: "Man of All Work," 210

Young, Julian, 186
YouTube, 28

Zangwill, Nick, 43, 260n160, 262–263n18
zany: anarchism of, 12; attachment to character form, 9, 11, 174, 193–197, 204–205, 223–230; comedy of, 174, 178–179, 185–186, 189; confusion of work and play, 1, 7, 13, 23, 27, 178, 181–184, 188–189; 204–208, 231–232; differences from camp, 12, 250n46, 300–301n44; and empathy blockage, 8, 10–11; etymology of, 195, 302n58; and failure, 25, 26; and gender, 207–222; history of, 14–15; as noun, 9; origins of, 192–197; as performative utterance, 231; and politics, 13, 254n83; and queer performance, 12; as short-term roleplaying, 201, 202–203; situational anxiety of, 10; stylized violence of, 185, 186–187; as verb, 8, 9
Zola, Émile, 223, 224, 226
Zukofsky, Louis: *A*, 70